THE
LITERATI
MODE

THE LITERATI MODE

*Chinese Scholar Paintings,
Calligraphy and Desk Objects*

Sydney L. Moss Ltd.
51 Brook Street, London W1Y 1AU, England

Catalogue by Paul Moss
Designed by Kumar Pereira Design Associates Limited
Photography by Lucinda Douglas-Menzies
Printed in Hong Kong by Yu Luen Offset Printing Factory Ltd.
Published by Andamans East International Ltd.

CONTENTS

ACKNOWLEDGEMENTS

It's true that all the men you knew
Were dealers who said they were through
With dealing every time you gave them shelter.
I know that kind of man — it's hard to hold the hand of anyone
Who is reaching for the sky just to surrender.

And then sweeping up the jokers that he left behind,
You find he did not leave you very much, not even laughter.
Like any dealer he was watching for the card
That is so high and wild he'll never need to deal another.
He was just some Joseph looking for a manger.

The Stranger Song *by Leonard Cohen*

To that small band of loyalists, those happy few, who really did want to see this catalogue entitled "Son of the Return of In Scholars' Taste", I'm sorry. It just wouldn't go with the rabbits.

Many thanks and much appreciation for advice and translation to Hugh Moss and Roderick Whitfield. For further help, thanks to Arnie Chang, Bob Hall and Nick Grindley. The freely offered opinions of Roger Bluett, Tony Carter and Brian Morgan on jade handling pieces were most valuable. I am eternally grateful to Brian for his description of the jade chimera, no. 117, as "rump-fed".

Thanks also to Ulrich Hausmann for his essay on handwarmers; to Lucinda Douglas-Menzies, who took every single photograph; to Linda Littell, who edited and published; and to my other colleagues, Graham Gemmell, Gerard Hawthorn and Lee Moss, who organised, fetched and carried and did other back room stuff.

Thanks and love to Ruth and Oliver, despite trauma, illness, hardship and trails of wanton destruction.

This is the third and, theoretically, last in a planned series of catalogues and exhibitions on the endlessly diverse subject of artworks which reflect the culture of the Chinese scholar class and some of the individuals who comprised it. It follows on the heels of *Documentary Chinese Works Of Art In Scholars' Taste* (April 1983) and *Emperor Scholar Artisan Monk: The Creative Personality In Chinese Works Of Art* (December 1984). I do hope, at some time, to produce further publications, perhaps on a smaller scale or more particular themes; but for the moment it seems that this format has served its purpose well. The areas of painting and calligraphy and also desk/scholastic objects do require as much high-quality illustration, extensive explanation and sympathetic presentation as they can possibly get, and I shall doubtless feel constrained in some way to offer them to a public in at least as much depth in the future. However, it seems unlikely that for very long one will be able to practically or financially afford to find and save the broad range and quantity of works of art in this field which we have managed over three exhibitions.

The level of serious interest in these fields is growing fast, with a concomitant rise in value and also in competition from other dealers, collectors and institutions; one heartening factor is that increased availability of fine works may accompany, if only temporarily, the newly achieved plateaux of activity and cost. Later this year there will be an extensive exhibition and symposium in Hong Kong relating to the Chinese scholar and his artefacts. The Metropolitan Museum of Art in New York is considering establishing a permanent gallery for scholars' desk objects to complement its major holdings of painting and calligraphy, and several other American museums are planning exhibitions and galleries in the same field. We regularly hear from collectors new to the subject who intend to concentrate their efforts in one specific area, or collect across the spectrum of scholar works of art, or redirect their collecting habits towards some aspect of literati art related to their previous interests. My hope is that our own broad experience in and depth of feeling for the field, together with the new avenues and friendships which our exhibitions have opened up for us, will enable us to take part in the coming scramble for literati artworks and come away with at least a proportionate number of the very best of them. It is certainly not too late for those who are interested to make a serious collection in these fields, though I suspect that it may be less possible to play and to dabble than it has been these past few years.

The title of the catalogue, *The Literati Mode*, arose of its own volition because of another two-month stint of solitary, staring at times unseeing at the blinking screen of my word-processor. I feel fortunate that the success of my self-imposed exhibition format permits, or obliges me to withdraw from the world of commerce for long periods at a time, to immerse myself in some measure of study, research, translation and the uninterrupted examination of works of art, as well as absorption in the lives and works of long-dead Chinese scholars and artists. It is a healthy antithesis to that other necessary and enjoyable practice of rushing around the world meeting collectors and authorities and learning in a complementary (but too hasty) fashion from them and their works of art. In addition to the infatuation with aspects of the scholar ideal to which I owned in a previous introduction, which may be a vital requisite for anyone wishing to get under the skin of the milieu, I am, quite simply, able to learn far more at these relatively undistracted times, often in surprising and rewarding directions. The life of the recluse (vowing not to cut my hair until the catalogue is finished, the frustrated and unsightly last fling of a sixties' adolescence as dead as the ideal of the Chinese scholar, has proved an unexpectedly practical move in the coldest spell for forty years) leads also to some introspective musings which I shall now inflict upon you in my habitual circumambulatory manner.

Two fictional characters, somehow related, have returned to haunt these meanderings. One is the pathetic clerk Joseph Grand in Albert Camus' *La Peste*, whose secret obsession is the masterful

literary effort which he composes at every solitary moment, never managing in his extreme of perfectionism to complete even the first sentence. The other is the hero of a short story by Jorge Luis Borges, who painstakingly writes a book which is, word for word, identical to *Don Quixote*. Borges finds this incredible in a twentieth-century world which has changed so much from Cervantes' time; we must also be grateful to it for inspiring this gem from the Manchester University Press *Critical Quarterly*: "Menard's exemplary rewriting of Cervantes' parody in a post-Nietzschean, post-William Jamesian era, to produce a text described by his apologist as 'almost infinitely richer', 'more ambiguous', though 'verbally identical' with the 'Quixote', persuades the Borgesian critic to what is known in literary theory as an extreme 'conjuncturalist' position, one from which the author is seen merely as a valorising construct of reading and the determinants of textural meaning are seen in inhering neither in the text itself nor in its originary context, but in the context or conditions of its recipient."

This silliness is echoed, more sensibly, in a fascinating section called "The Importance of Art" in *The Aristos* by John Fowles, a writer who uses obscure words only when they express his meaning precisely.

2. The practice and experience of art is as important to man as the use and knowledge of science. These two great manners of apprehending and enjoying existence are complementary, not hostile. The specific value of art for man is that it is closer to reality than science; that it is not dominated, as science must be, by logic and reason; that it is therefore essentially a liberating activity, while science — for excellent and necessary causes — is a constricting one. Finally and most importantly, it is the best, because richest, most complex and most easily comprehensible, medium of communication between human beings.

3. Art best conquers time, and therefore the *nemo* (the anti-ego, or nobodiness). It constitutes that timeless world of the full intellect (Teilhard du Chardin's *nöosphere*) where each artefact is contemporary, and as nearly immortal as an object in a cosmos without immortality can be.

4. We enter the *nöosphere* by creating, whereby we constitute it, or by experiencing, whereby we exist in it. Both functions are in communion; 'actors' and 'audience', 'celebrants' and 'congregation'. For experiencing art is experiencing, among other things, that others have existed as we exist, and still exist in this creation of their existing.

15. All art both generalizes and particularizes; that is, tries to flower in all time, but is rooted in one time. An archaic statue, an abstract painting, a twelve-tone sequence may mainly generalize (all time); a Holbein portrait, a haiku, a flamenco song may mainly particularize (one time). But in the portrait of Ann Cresacre by Holbein I see one sixteenth-century woman and yet all young women of a certain kind; in this austere and totally unrooted concatenation of notes by Webern I hear nonetheless the expression of one particular early twentieth-century mind.

16. This balance between particularization and generalization that the artist struggles to achieve, nature achieves without struggle. The butterfly is unique and universal; it is both itself and exactly like any other butterfly of its species. The nightingale sings to me as it sang to my grandfather, and his grandfather; it is the same nightingale and not the same nightingale. It is now and it is ever. Through the voice I hear — and Keats heard — this passing night I enter reality two ways; and at the centre meet my richer self.

20. Both in the creator and the spectator, art is the attempt to transcend time. Whatever else it may be and intend, an artefact is always a nexus of human feelings about time; and it is no coincidence that our current preoccupation with art comes at the same time as our new realization of the shortness of our duration in infinity.

Fowles goes on, having demonstrated at one level the timeless interrelationship between creator, object and spectator, to point out the vital importance of the spectator to the creator, as well as vice-versa.

21. Inside this fundamental relationship with time, the artist has used his art, his ability to create, for

three main purposes; and he has two main tests of success.

22. His simplest purpose is to describe the outer world; his next is to express his feelings about that outer world, and his last is to express his feelings about himself. Whichever of these purposes he has in mind, his test may be that he satisfies himself or it may be that he satisfies and pleases others. It is probable that all three purposes are present, and both tests satisfied, in varying degrees in almost every artefact. The simplest and most unemotional realism, mere description, still involves the selection of the object described; any expression of feeling about the outer world must obviously also be an expression of the artist's inner world; and there can be few artists so self-sure that the approval of others means nothing to them. For all that, there have been great shifts of emphasis during the last two hundred years.

His arguments about Western art and the Renaissance have different emphases when applied to Chinese art, but Fowles writes very much to the point about style and content, art and craft, genius and craftsman, and I could have reproduced many more of his conclusions.

In our roles as recipients, interpreters, translators and above all enjoyers of works of art (on occasion, Menard-like, in layers and folds which the original artist, patron or contemporary critic could not have experienced) we alone perceive their worth, their reality. Each work of art speaks privately and in a different language to each viewer, at varying levels depending of course upon the object and the viewer. The subjective viewpoint is all-important, whether or not it was to the artist; in fact, it is precisely in this field of scholar art, of all areas of Chinese antiquities, that the modern Western triumph of individual expression and style over 'outer' cultural content applies. Content is, however, pervasive and important, an underrated element in the appreciation especially of objects rather than painting and calligraphy.

In the case of any work of art, it is another, related concept which is vital; that of the artist's intent. Therein lies the root of much misunderstanding, primarily because of the place of archaism. Judged by modern artistic standards most old Chinese artists and certainly craftsmen were imitative and derivative, even if their treatment of classic models incorporated some personal style or innovatory element. The archaistic development upon a tried and trusted theme can best be compared to the musician's variations upon a composition, or the actor's interpretation of a play.

Archaism was the ambience of mythic reality within which the Chinese artist or craftsman moved, and was necessarily his inspiration. Our own study of phases of archaism in works of art is not very far advanced, and is helped by such comparative groupings as the small number of variant jade chimera carvings offered in this exhibition, each of them derived at different stages from earlier models in a complex spiral of imitation and adaptation, layer upon layer. Similarly, I hope that the comparative groupings of *tzu-t'an* wood desk furniture, metal *ju-i* sceptres and especially the survey of copper handwarmers will prove useful as well as interesting.

Myth and reality surround, in addition to conditions of dangerous imbalance induced in my brain after two months of pseudo-academic isolation, the writing style of a labyrinthine, Boschian novel by the neglected American writer William Gaddis, *The Recognitions*. Its 956 pages deal with forgery: artistic, spiritual and emotional, vividly full of insights through densely-written, only vaguely coherent but coruscating dialogue and grotesqueries of detail, peopled with such unforgettably-named characters as the literary agent Agnes Deigh and, for me the archetype of New York dealers, Recktall Brown, corrupt and manipulative, finally squashed by a suit of armour (genuine). Although there are many passages dealing illuminatingly with fakery, connoisseurship, critics and the experience of art, perhaps more relevant here is this excerpt from a long, rambling letter written in rose madder by one of the many more than half-mad heroines:

"A law-maker, unable to formulate laws, can be a painter, or a land, where laws when broken, punish, not the offender, but the law-makers, can produce painters. A painter in any other place must struggle to be what he is.

Rooted within us, basic laws, forgotten gladly, as an undesirable appointment made under

embarrassing pressures, are a difficult work to find. The painter, speaking without tongue, is quite absurdly mad in his attempt to do so, yet he is inescapably bound toward this.

To recognize, not to *establish*, but to *intervene*. A remarkable illusion?

Painting, a sign whose reality is actually, I, never to be abandoned, a painting is myself, ever attentive to me, mimicking what I never changed, modified or compromised. Whether I, myself, am object or image, they at once, are both, real or fancied, they are both, concrete or abstract, they are both, exactly and in proportion to this disproportionate I, being knowingly or unknowingly neither one nor the other, yet to be capable of creating it, welded as one, perhaps not even welded but actually from the beginning one, am also both and what I must, without changing, modifying, or compromising, be.

The painter concerned for his mortal safety, indifferent because he fears to scrutinize, paradoxically sacrifices that very safety, for he will not be allowed to escape painting.

He will make paintings or they will revolt and make him, unhappy being in the grasp of them. He compulsively must, then, live them cold as they are, static, perversely with warmth and movement he cannot know but feel painfully, a bird with broken eggs inside.

On the other hand, a no-painter — resourceful as he may be, cannot paint. He cannot say, well, 'I did not get the job but I shall say I got it anyhow'—by this distortion of facts he deludes, not himself, but other persons, until, that moment arrives to receive the reimbursement. With nothing of value to show the fact will disappear. There is no fact but value.

The painter knows, sadly enough, that experience does not suffice unto itself, has no proportion, dimension, perspective, mournfully he eats his life but is not allowed to digest it, this being reserved for others, not knowing, but who must somehow, at any sacrifice, be made to know, then punished for the sight of this knowledge, by aiding it on its journey from brain to brain.

It does not seem unreasonable that we invent colors, lines, shapes, capable of being, representative of existence, therefore it is not unreasonable that they, in turn, later, invent us, our ideas, directions, motivations, with great audacity, since we, ourselves having them upon our walls. What rude guests they prove to be, indeed: although paintings differ from life by energy a painter can never be a substitute for his paintings, so complete so independent as reality are they. Imagine the pleasure they enjoy at this."

Writers, like artists, enjoy an immortality of sorts: always a Chinese concern, as Borges conjectures of Ch'in Shih-huang-ti, who built the Great Wall and burnt the books for the protection of his soul and that the embodiment of his absolute will should live for ever—and as Robert Jay Lifton describes of Mao Tse-tung. Their works sometimes aspire to a mythic status and a personality of their own; being possessed of this inherent magic force, which we have lost through alienation and cynicism, they rise above dry academe, or mere materialism, and when they speak to us we respond.

And so to bed, said Zebedee.

Paul Moss

N.B. In this catalogue, a number of works of art have been reproduced larger than life-size to clearly illustrate details. The actual size of all objects is listed in the description.

TUNG CH'I-CH'ANG
1555–1636

tzu: Hsüan-tsai.
hao: Ssu-pai, Ssu-weng, Hsiang-kuang (chü-shih).
posthumous name: Wen-min.
hall name: Hsüan-shang chai.
From Shanghai; went to school and lived in Sung-chiang, Kiangsu.

TUNG Ch'i-ch'ang, the pivotal literati figure of the late Ming period, was a *chin-shih* of 1589, and became a bachelor and later compiler of the Hanlin Academy. In 1594 he served as tutor to Chu Ch'ang-lo, who became the short-lived T'ai-ch'ang emperor twenty-six years later. This appointment came about through the good offices of his mentor Wang Hsi-chüen (1534–1611), grand secretary to the Wan-li emperor. In 1596 Tung was sent to Changsha to represent the Emperor at a princely ceremony, and in the next year was sent to Kiangsi to conduct the provincial examinations. In 1599 he was appointed to the dual office of assistant to the provincial judge of Hu-kuang, and commissioner of education of the same province. Although this was a promotion Tung declined the posts, claiming illness; due either to the factionalism at court, rife in the Wan-li reign; instigated jealous manoeuvrings because of favouritism towards Tung; or, perhaps, given the opposition of a powerful clique, the appointment was a humiliation in comparison with some more substantial office which he might have expected. From this time on Tung was very cautious about the official posts he accepted; although he emerged in 1604 to a take the post of Hu-kuang education commissioner, he resigned in 1605 after a student protest at a local examination. From then until 1622 he lived in retirement; although he was called on occasion to fill some post or another, he seems to have declined them all. Full details are given in his entry in *Eminent Chinese of the Ch'ing Period*.

In 1622 Tung was appointed director of the Court of Sacrificial Worship, and made a director of the compilation of the Wan-li emperor's "veritable records". He presented his compilation in 1624, and in 1625 gladly accepted the sinecure presidency of the Board of Ceremonies in Nanking, which removed him from the battle between the eunuch Wei Chung-hsien and the Tung-lin party in Peking. A year later he resigned the post and retired. Late in 1631, after the eunuch party had been brought to justice, he served as head of the Supervisorate of Instruction of the Heir Apparent, retiring on grounds of old age in 1634. He died two years later and was buried near Suchou. A year later he was given the posthumous title of Grand Tutor of the Heir Apparent, and in 1644 was posthumously named Wen-min.

Wen Fong's essay in *Images of the Mind*, pp. 166–178, offers perhaps the most cogent explanation of Tung's development and critically influential position as the most important painter, calligrapher, collector and art theorist of the Ming and early Ch'ing period. It outlines his interest in the radical individualistic philosophy of Li Chih (1527–1602) and, in poetry, in the anti-revivalist Kung-an school of the three Yüan brothers. The influence of these current intellectual trends on his thinking was not so much their radicalism and abhorrence of imitation (Tung greatly respected the old masters and advocated close study of them) as an identity with their Ch'an Buddhist-like notion of the intuitive leap. By the late 1590s Tung had largely formulated his theories, identifying the transmission of artistic orthodoxy, and dividing painters into the Northern and Southern schools. Tung attacked the indiscipline, purposelessness and conventionality of late Ming painting, advocating such thorough understanding and mastery of old masters' styles and intent that the artist could rise above concern with technique and, reaching an innate naivety of approach, transform the achievement of the old master into his own creation.

Tung Ch'i-ch'ang, never under illusions about his own significant place in history, single-mindedly set about the creation of his definitive collection, seeking out major works by Wang Wei, Tung Yüan, Chü-jan, Huang Kung-wang, Wu Chen, Ni Tsan, Wang Meng and other vital predecessors in the orthodox lineage he promulgated. His own position as painter and critic was inseparable from his activity as a connoisseur-collector; he saw himself as a "Great Synthesis", and advocated for others too

the ideal of taking from each artist a model of one feature (trees, rocks, or distant mountains) and fusing that with the most successful features of other painters' works, translating them with his own inventions into a personal, synthesised vision. Upon finally obtaining Huang Kung-wang's *Dwelling in the Fu-ch'un Mountains* in 1596 he wrote in a colophon to it: "I remember when I was in the capital, after morning audiences, I used to chase after the censor-adviser Chou, asking to see this scroll. It was like visiting a great treasure-trove, going there empty and returning full. I used to think how lucky I was to enjoy such a wonderful day, nourishing both my mind and my spleen Now I have acquired the scroll It is my teacher! It is my teacher! (The wonders of) any single mountain and all five (cosmic) peaks are gathered here!"

Although Tung's early painting style contained elements derived from Huang Kung-wang, later borrowing rather more from Ni Tsan, in fact, he essentially evolved an entirely new approach to painting, "stripping himself naked", reducing features of their painting to diagrammatic formulae and constructing new, abstract forms, which no longer relied on the vertical, sequential arrangement of landscape but in which elements of fore-, middle and background loom or recede apparently randomly, interlocking and undulating with spirit-essence, in all parts of the landscape.

He deconstructs and then reconstructs the scene, avoiding pictorial representation, in an entirely intellectual conception of arranging solids and voids and different textures, rising and falling in an abstract visualisation. For this reason Tung Ch'i-ch'ang is the most difficult of Chinese painters to understand and appreciate. Tung's advice for avoiding "the narrow path of tracing and imitation" was to treat painting as calligraphy: "When a scholar turns to painting, he should apply to it the methods of writing unusual characters in the grass or clerical script, making his trees resemble curved iron bars, and mountains look as if they were drawn in the sand (with deep and round brushstrokes). The narrow path of (seductive) sweetness and vulgarity should be avoided absolutely. His painting will then have a scholarly breath. Otherwise, even if a work shows high technical competence, it already falls into the pernicious ways of a professional craftsman; it is then beyond all hope and remedy. If a painter could only free himself from the bondage (of craftsmanship) he would be like a fish escaping the net". His ideal of reducing landscape to pure brushwork was the conception of a calligrapher. He recorded that he took up calligraphy seriously in about 1571, when he was sixteen, first following the T'ang styles of Yen Chen-ch'ing (709–785), Liu Kung-ch'üan (778–865) and Yü Shih-nan (558–638) and then the earlier Chin manners of Chung Yu (151–230) and Wang Hsi-chih (ca. 307–ca. 365), which he felt he could not master. (It is reported, though, that the initial impulse for his serious study of calligraphy came at the age of seventeen, when he placed second to his cousin at the annual prefectural school examination in Sung-chiang. Considering himself superior to his cousin, Tung was told that his papers were excellent, but his handwriting was poor.) For twenty years he studied the Sung masters, finally succeeding in capturing "some moments of understanding".

He became a great admirer of Mi Fu, and Tung's individual treatment of a writing style derived from Mi is evident in the majority of his smaller calligraphies. Much of his *ts'ao* script is based on that of Huai-su (ca. 735–800). He appears less radical in his writing than in his approach to painting, but in just the same way Tung insisted that "no calligrapher could imitate ancient styles without transformation". By the age of thirty-five he was recognised as a master of calligraphy, particularly in his elegant but also powerful *hsing* and *ts'ao* styles, and was a strong influence on calligraphers throughout the late Ming and Ch'ing periods.

Tung took every opportunity to travel widely (he exhorted artists to "travel ten thousand miles and read ten thousand books") and inspect the collections of connoisseurs in all parts of the empire, making good use of his long periods of official inactivity. He was very fortunate in his early twenties to be employed by the great collector Hsiang Yüan-pien (1525–1590) in Chia-hsing, Chekiang. Later on, from the late 1590s through the 1630s, Tung often stayed at the Hua-t'ing (Sung-chiang) home of his mentor Wang Hsi-chüeh, and became tutor to Wang's grandson, Wang Shih-min, as well as his painting teacher. Through him, Tung was the conduit for the transmission of the orthodox lineage to

the Six Orthodox Masters of Early Ch'ing and imperial endorsement and Tung's calligraphy was instituted as a model for examination candidates which resulted, of course, in Tung's own revolutionary revivalist style itself degenerating into a convention. Calligraphically, this is nowhere better seen than in the Ch'ien-lung emperor's own writing, which is based on Tung's. But Tung's new approach to brush vocabulary was also indispensable to the seventeeth-century Individualist masters, who based their personal styles on observation of nature rather than the old masters.

One of the Four Great Calligraphers of the late Ming, with Hsing T'ung (1551–1612), Chang Jui-t'u (see no. 8) and Mi Wan-chung (1570–1628), Tung's calligraphy, like his paintings, is illustrated in almost every book on the subject. One of the best publications showing a wide range of his paintings, with a little calligraphy, is *Bunjinga Suihen*, vol. 5. For fine examples of calligraphy, see *Images of the Mind*, no. 26, pp. 362–365; *Traces of the Brush*, fig. 1b, p. 24; *Chinese Calligraphy*, nos. 60–62; *Shodo Zenshu*, pl. 6–25, figs. 3, 19 and 20; and *Comprehensive Illustrated Catalog of Chinese Paintings*, nos. A17–101, A17–102, A18–049, JM1–109, JM3–171. *Ming Tung Ch'i-ch'ang mo-chi*, the twentieth volume of the National Palace Museum's *Ku-kung shu-fa* series, 1975, is devoted to Tung's writing. Fu, *Traces of the Brush*, p. 134, considers that his "early writing (describing a colophon written at the age of 55) is superior, as his calligraphy became stylised with old age. However, the Elliott example in *Images of the Mind*, written when Tung was in his seventies, is not only strong, balanced and graceful, but is written with originality and verve.

1 AN ESSAY "ON PAINTING HORSES", IN TS'AO-HSING-SHU
A handscroll in ink on silk.

Headed *Hua-ma pien* (essay on painting horses) and reading:

A steed in a noble gentleman's stable whose appearance is depicted in a painting:
Its hair and iron hoofs are depicted with a sheen, like jade. The steed runs (but in the painting does not move) with power like thunder. However, strangely it raises no dust (because it is in a painting). This is the work of an excellent artist who can silence his critics. The steed is from a precious breed and highly valued from its youth. Those that may be exchanged for ten thousand rolls of silk are inferior to the steed in this noble gentleman's stable. It was pulling a cart loaded with flowers and the wheels were turning, frightening the birds away. If the steed can serve you with its mane trimmed (like a war horse) it can cover ten thousand *li* in a day like a whirlwind.

Signed Tung Ch'i-ch'ang shu (wrote), with three intaglio seals of the artist: Hsüan-shang chai (rectangular, cropped), T'ai-shih shih (square) and Tung Hsüan-tsai shih (square).
The calligraphy measures 100 × 10 1/4 inches.

Mounted with three colophons.

The first, separately written on silk brocade, is by Ku Shun (1765–1832; *tzu*: Hsi-han, Wu-keng; *hao*: Nan-ya, Hsi-lu; from Suchou). He was a *chin-shih* of 1802, an official and a precocious talent in poetry and literature. In his calligraphy (*k'ai-shu* after Ou-yang Hsün, and also *hsing, ts'ao, fen* and *li* scripts) he was regarded as having "deeply entered the ancients". He was a fine painter in ink of narcissus, after Chao Meng-chien, prunus (hoary and antique) and orchids, which were elegant and moist. He did not follow a particular school, and his style was very natural; late in life he taught painting himself. The colophon reads: Ku Shun of Wu-hsien (Kiangsu Province) and Yang Chün of T'ai-ho (Anhui Province) both inspected this painting at the Yan-shou-yan-chai (Merciful-longevity Inkstone Studio) south of the Hsüan-wu city (Honan Province).
With three square seals of the writer: Ku Shun chih-yin (intaglio, Contag & Wang 3), Hsiao-ts'ao hsiao-shih chih chü (relief, Contag & Wang 4) and Ting-hai sui-tso (intaglio, Contag & Wang 19). The last seal may indicate that the colophon was written in 1827.

The second colophon, written on paper with the third, is by Po Jung (1769–1842; *tzu*: Hsiao-shan; *hao*: Yeh-yüan; from Peking). A *chin-shih* of 1799, one of the most celebrated classes of the Ch'ing dynasty, with 73 competitors (including Po) entering the Hanlin Academy, he was an official, rising to be President of the Board of Works, 1833–1834.
The colophon reads: Tung Ch'i-ch'ang said, "Calligraphy should best be executed with the brush tip hidden but one should not confuse this with unclear brushwork." This piece of calligraphy shows the brush tip with every stroke and yet it retains a rustic and powerful atmosphere. Thus one can feel the depth of his understanding of antiquity!
Inscribed by Po Jung of Luho (Hopei Province) with one seal of the writer: Jung Yin (square, intaglio).

The third colophon is by Ch'en Yung-kuang (1768–1835; *tzu*: Shih-shih; *hao*: Shih-ssu). A disciple of the Confucian writer Yao Nai (1732–1815), he edited a supplement to Yao's collected letters in 1823. In 1798 Fang Tung-shu (1772–1851), a disciple of Yao in Nanking from 1793; lived as a tutor in Ch'en's house in Hsin-ch'eng, Kiangsi. In 1832 Ch'en helped Yü Cheng-hsieh (1775–1840) collate Ku Tsu-yu's *Tu-shih fang-yü chi-yao* in Peking. See no. 32 for a colophon (the eighth, probably dating from 1824) by Ch'en Yung-kuang to a Ch'ien Tu handscroll.

The colophon reads: I do not like calligraphy and I do not understand post-Ch'in and T'ang dynasty brush work. However, if I see good models of calligraphy and works by past sages I cannot be tired when appreciating them. For example, Su Tung-po could not drink but liked to watch others drink. Tsai An asked me to inscribe a genuine work, *On Painting Horses*, by Tung Ch'i-ch'ang on behalf of a friend. I have inspected it several times and I am amazed by its richness of spirit—it is as if it is a good horse.

Inscribed: by Ch'en Yung-kuang of Hsin-ch'eng, Kiangsi, with one seal of the writer: Ch'en Yung-kuang yin (square, intaglio and relief).

Tsai An was the *hao* of Li Pei-hsu, a native of Szechwan and a famous calligrapher who studied under Ho Shao-chi (1799–1873).

There are four collectors' seals: two (identical) reading Yao-ch'ing ching-chien (square, intaglio), seem likely to be those of Lo Shu-hsün (*hao*: Yao-ch'ing; from Shang-yü, Chekiang), a painter of flowers and creatures after Yün Shou-p'ing, and the father of Lo Chen-yü (1866–1940), the well-known connoisseur-dealer-collector, archaeologist and bronze script calligrapher. The other two square relief seals, both perhaps belonging to the same collector, are unrecorded. They read Ch'iao-sung pi-wan, and Chen- ? Chang ? chen-ts'ang (incompletely impressed).

The label, or title slip, Tung Wen-min's "On Painting Horses" ink treasure, is signed: Hsiang-yü chen-shang with one seal: Hsiang-yü yin-hsi (square, relief), with a date of autumn of the *keng-tzu* year (1840 or 1900). This may indicate that the scroll was also in the possession of Yao Fu-k'uei (*tzu*: Hsiang-yü; from Ch'ang-lieh, Kiangsu), an 1851 graduate and a minor Lou-tung school painter.

孫登無語

萬足失

回首

經末如

他檻上

歡神及

死陰苦

貝壽拂

與奚自

一日千

里如梏

風

董其昌書

重文敏公畫馬篇墨寶

庚子九秋湘漁珍賞

畫馬篇
尹庚攄上
驄鷫主于
青中二
毛連欽歸
鐵色備生
光耀玉
勒馬
不壽
冰雷權
壽蹶踏無
蒼埃盛若
隱代採
妙年道

文敏謂李伯雅貴蕥鋒然不得
以糊為菲詳此書筆之出鋒
而竹不夾淳厚之筆尤其蕥釀
於古者深矣
湖海白謙記

余性不喜書於晋唐以來用筆之瀘都
無兩解然見佳帖及前賢墨蹟極說之
然一辟韓東坡不能飲而喜觀人飲飲也
戴蓐侍御為友人翁素題董宗伯畫馬
篇真蹟余反復觀歎其神駿亦妙
支公之謂良馬也
江西新城陳用光題

吳縣顧蓴太和楊峴同觀於宣
武城南之仁壽硯齋並記

CH'EN HUNG-SHOU

1599–1652, Ch'en's birthdate is alternatively given as 1598.

tzu: Chang-hou.

hao: Lao-lien, Lao-ch'ih, Fu-ch'ih, Hui-ch'ih, Hui-kung, Wu-ch'ih, Lien-tzu, Yün-men-seng, Lien-sha-mi, Chiu-p'in-lien-t'ai-chu-che.

hall names: Pao-kuan t'ang, Hsiu-chi t'ang.

From Chu-chi, Chekiang.

CH'EN Hung-shou was the most important figure painter of the late Ming period. In addition he was a fine landscape and bird and flower painter, and a leading poet and calligrapher; in each of these aspects of his art he developed an innovative and highly personal style. He came from a family of officials; his great-grandfather and grandfather held relatively high office, but his father failed to advance beyond the bachelor's (*hsiu-ts'ai*) degree, retreated from public life and embraced Buddhism. Both of these aspects of his father's life affected Hung-shou deeply, and his father died aged thirty-five *sui*, when Hung-shou was only nine *sui*. At sixteen his grandfather died, and at eighteen his mother. Ch'en's eldest brother, Hung-hsü, intended to raise him (an alternative account says that he appropriated the inheritance), but Hung-shou resolved to be independent and left his family to live in Shao-hsing, a centre of intellectual and political activity. Ch'en's contact with such figures as Liu Tsung-chou and Huang Tao-chou, who were concerned about corruption at court and the disintegration of Ming dynastic power, aroused his patriotic consciousness.

From a very young age Ch'en was talented as a painter. He studied landscape and bird and flower painting under Lan Ying, but was soon considered to have surpassed his master.

He taught himself in unorthodox fashion by repeatedly copying, and changing out of recognition, fine outline works by Li Kung-lin and Chou Fang; his figural style was also believed to have been influenced by Kuan Hsiu and Wu Tao-tzu. Chao Meng-fu influenced Ch'en's extraordinary, three-dimensional colouring style, which was achieved with a layering technique. Ch'en failed the metropolitan examinations twice, but purchased an official position in 1640. During his three-year stint in the capital, the Ch'ung-chen emperor appreciated his art and permitted Ch'en to copy works in the imperial collection. He became more famous with each visit to Peking, and was known with the established figure painter Ts'ui Tzu-chung as "Ch'en of the South, Ts'ui of the North".

In 1643 Ch'en left the capital, well-known as an artist but politically disillusioned. When the Ming fell many of his friends died defending it, or committed suicide; he rejected the possibility of doing the same, and never recovered from the sense of failure and bitterness with which the decision left him. When Nanking fell to the Ch'ing in 1645, he entered a monastery in Shao-hsing, and in 1646 fled to the hills, perhaps as a result of some anti-Manchu activity. Six years later he returned to his home, where he died. This late, unhappy period, in which he took several Buddhist names, painted a large number of Buddhistic subjects and often behaved as if deranged, was one of his most creative and productive phases.

In addition to his fame as a painter, calligrapher and poet, Ch'en was noted for his outline figural illustrations to a number of classic and popular works, as well as for his freedom with wine and women. His vivid, sensitive poetry and writings, published after his death by his artist son Ch'en Tzu, are full of emotion and straightforward sentiments, nobly expressed with charged and moving language, often dealing with themes such as mistreatment by corrupt officials.

In calligraphy, Ch'en created a school of his own. Considering that since Chung Yu and Wang Hsi-chih had not followed any of the old masters, neither should he; rather he "culled the ideas of the ancients" through his own feelings, after arduous study of their work. His early brushwork was rounded and fluid, but strong elements of archaism and deliberate awkwardness were already apparent. Later on his style became lean and supple, with an even more powerful archaism and fluency. He usually composed both poetry and calligraphy rapidly, when drunk, writing with the same thin, long-tufted brush used for drawing his fine-line paintings. His calligraphy was very highly thought of, and ranked in the "untrammelled" class. As Tseng Yu-ho Ecke writes (*Chinese*

Calligraphy, no. 73): "Independent writings of his in large size are rarely seen. This running script is representative of his style. It is as linear as his painting. In the wirelike lines are both moisture and dryness, thick and thin tonalities. Thus he sensitively created a pictorial space over the flat surface."

For a couplet in Ch'en's characteristic *hsing-shu*, see *Lok Tsai Hsien Couplets*, no. 2. A hanging scroll in the Art Museum, Princeton, from the Elliott collection, is in the same two-line format favoured by Ch'en as the example offered here (Ecke, *Chinese Calligraphy*, no. 73, and *Images of the Mind*, no. 33, with a date of post-1644 suggested), as is another in the National Palace Museum, Taiwan (*Style Transformed*, no. 087, with a suggested date of ca. 1638–1644). We offered a fine bamboo wristrest carved with Ch'en's *hsing* calligraphy in the same two-line format in *In Scholars' Taste*, as no 50.

2 QUATRAIN IN HSING-SHU
A hanging scroll in ink on paper.

In my sickness, my dream is sharp and clear.
My boat selects a location to anchor deep in the lake in the hills.
Beneath a bridge, with prunus and willows, I happen to meet my old companion.
Along a palm flanked way, a fairy reaches a pavilion in the mist.

Signed Hung-shou, with three seals of the artist: Ch'en Hung-shou yin (square, intaglio), Chang-hou (square, relief) and Lien-tzu (oval, relief).
The piece measures 49 7/8 × 11 1/4 inches.

From the Wong Nan-p'ing collection, Hong Kong.

病中霞境十分清冊擇山溪雲作桜
樣橋邊舊殿�𣏾閱𢑥子之� 真学

吳綬

CH'IEN KU

1508–ca. 1578

tzu: Shu-pao.
hao: Ch'ing-shih.
From Suchou, Kiangsu.

CH'IEN Ku was orphaned at an early age, and had little or no formal education until, as an adult, he became a pupil of Wen Cheng-ming; supposedly introduced to Wen by the bibliophile Ch'ien T'ung-ai (1475–1549). Ch'ien Ku would go every day and read the classics omnivorously in the Wen family's extensive library, and eventually he became an avid book collector, devoting himself to copying and collating old texts. He edited several works; one, a study of the literary remains and topographical records of Suchou, *Wu-tu wen-ts'ui hsü-chi*, may have been revised by his elder son, Ch'ien Fu, who is also described as working into his old age from dawn to dusk copying and editing old texts. Both Ch'ien Fu and a younger son, Ch'ien Hsü, were also landscape artists. Ch'ien Ku was considered a fine poet and, although poverty-stricken, traced his descendancy back to the king of Wu-Yüeh (Ch'ien Liu, 852–932); he had a seal, Wu-Yüeh-wang i, carved to this effect. Ku became so engrossed in his studies and painting, which he practised only in his leisure time, that he quite neglected his own household. On one occasion Wen Cheng-ming visited his ramshackled home and wrote the two characters Hsüan-ch'ing (empty jar) over the door (a pun on his art name, Ch'ing-shih, "jar hall", or "rice-bin studio"). Ch'ien replied with a smile, "My meaning exactly". His poetry collection was published under the title *Hsüan-ch'ing-shih shih*, and he has his own entry in the *Dictionary of Ming Biography*.

Ch'ien Ku was admitted into the immediate circle of Wen Cheng-ming, and was his pupil in painting as well as in literary matters, but as a painter he was more independent than most other members of the group. His style is recorded as having been derived from that of Wen's teacher and friend, Shen Chou, but in fact Ch'ien Ku is notable for some personal variations on the sixteenth-century Suchou Wu school style, and as Siren observes (*Chinese Painting*, vol. IV, p.191): he must also have been familiar with T'ang Yin's art; see for example *Im Schatten Hoher Bäume*, col. pl. 9. no. 18. However, he did often paint in Wen's style, sometimes direct copies of his works; as Clapp points out (*Wen Cheng-ming: The Ming Artist and Antiquity*, p. 39): "Such capable but overshadowed personalities as Ch'ien Ku, Chü Chieh and Wen Po-jen mastered Wen's styles so expertly that it is almost impossible to distinguish between their copies after him and their paraphrases of him. A good part of the works now under Wen's name must have been executed by these painters or others close to him". Some of Ch'ien's larger works do breathe the spirit of Wen Cheng-ming's landscapes (such as the fine example in the Shanghai Museum; *Gems of Chinese Painting*, no. 59); and Ch'ien quite often favoured the tall, narrow hanging scroll format for them, but he was quite capable either in that format or, especially in smaller works and handscrolls, of entirely different styles.

Fu, *Studies in Connoisseurship*, p. 96, in discussing a 1578 fan in Princeton by Ch'ien, describes his work as lucid, modest and charming, quoting a traditional source: "He excelled in landscape and figures. His notions of brushwork were devoid of vulgarity; therefore those who elevate scholar painting regard him as important". Lawton, *Dictionary of Ming Biography*, p. 236, quotes Ch'ien's own attitude to his painting and derivation from earlier models: "Painting is a fusion whereby an artist takes a spiritual model to revive the breath of heaven. In daubing the void between fineness and coarseness, I guide the brush only. Afterwards, if that which I have painted grasps the original concept, how can it be said to be arranged or planned?"

The Princeton fan, delicately coloured and refined, compares well with the Morse collection's 1560 *Lan-t'ing Gathering* handscroll (Whitfield, *In Pursuit of Antiquity*, no. 4), now in the Metropolitan Museum. Ch'ien's upright brush produces thin, pliant contours, and the serenely relaxed and elegant figures, characteristically rather larger in relation to the landscape than is typical of the Wu school, integrate intimately and successfully with the spatial arrangement. The faces of his figures are also more varied and lively than is usual in Wu school painting. This feature is even more evident in the

12

Cleveland Museum of Art's 1572 *Fisherman's Joy* handscroll (*Eight Dynasties of Chinese Painting*, no. 187), which demonstrates Ch'ien's interest in narrative and genre scenes, adding liveliness to his refined brushwork, and evidencing familiarity with the work of Che school painters such as Tai Chin and Wu Wei, perhaps through the influence of Ch'en Shun, another Wen Cheng-ming pupil. *The Pageant of Chinese Painting* illustrates six landscapes by Ch'ien, three of them remarkably similar to Che school landscapes in style and composition, the other three demonstrably Wu school (nos. 580–585). Both Metropolitan and Cleveland handscrolls are illustrated and discussed in Hyland, *The Literati Vision: Sixteenth Century Wu School Painting and Calligraphy*, pp. 66–71, with a tall, narrow landscape (fig. 40) which again combines features of the styles of Wen Cheng-ming and Shen Chou. One point which might be mentioned here is in the discussion of Ch'ien's *Lan-t'ing Gathering* handscroll: "Similarities in composition suggest this painting may have provided the inspiration for Sheng Mao-yeh's *Orchid Pavilion Gathering* of 1621". In fact, as we observed in discussion of the 1592 *Lan-t'ing Preface* rubbings handscroll (*Emperor Scholar Artisan Monk*, no. 6, p. 35) Ch'ien's composition was based on the Prince Chou engraving of the scene, in turn based on Li Kung-lin's handscroll. Presumably Sheng Mao-yeh's version was derived from the same model.

Ch'ien Ku was a relatively prolific painter, with several examples recorded in a long work span, with dated examples between 1529 and 1578; Siren, *Lists*, mentions thirty-five, and *Comprehensive Illustrated Catalog of Chinese Paintings* shows fifteen works. The range of his stylistic interests, even outside the Wu school proper, is one of the most striking features of this body of work. Characteristic of the majority of his Wu school landscapes, though, is an elegant, quiet mood, a refined understatement and clarity of brushwork (and colour, where present). Sherman Lee described it well in discussing Ch'ien's interesting versions of Shen Chou's studies of Tiger Hill (*Some Problems in Ming and Ch'ing Landscape Painting*, p. 475): "If we examine some of the works assigned to Ch'ien Ku, we see a talented artist with some of the complicated elegance and refinement of Wen Cheng-ming, but who could paint in a simpler way, as did Shen Chou and Wu Chen before him. Even when brusque, his most typical characteristic remains, a manner of curvilinear drawing, of defining figures and features with rounded contours. His compositions tend to be somewhat conventional". The example offered here from Ch'ien Ku's mature period (one of many examples confounding a traditional date of death of 1572), while agreeing with that description, is a rarity even among so many surviving paintings in its derivation from Yüan models, particularly that of Ni Tsan. Wen Cheng-ming's own relatively fruitless pursuit of Ni Tsan's spirit must have been a factor in Ch'ien Ku's all too infrequent interest.

3 SPARSE WOODS AND AUTUMN WATERFALL (1576)
A hanging scroll in ink on paper.

A simple pavilion rests on a flat, lakeshore promontory, with tall trees beside it, and a further clump of trees growing from foreground rocks. In a zigzag composition, more trees grow on a comparable promontory on the opposite bank. At the lake's far shore a precipitous waterfall crashes onto rocks and finds its way through them into the calmer water. Trees grow on the rocky mounds to either side of the central feature, which build up massive forms culminating in the large rounded peak above the cleft whence the waterfall emerges; beyond are distant hills.

Inscribed: In the eighth, autumnal month of the *ping-tzu* year (1576), I made this "su lin ch'iu huo" (thinly planted groves of trees and autumn gully, or pool), for presentation to you, sir, Mr. Huai-yü. The recipient may have been Hou Ch'eng-tsu, a Ming dynasty military commander from Shanghai; his *tzu* was Huai-yü.
Signed Ch'ien Ku, with two square seals of the artist: Shu-pao (intaglio, Contag & Wang 4) and Hsüan-ch'ing shih (relief, Contag & Wang 12).
There is one collector's seal in the lower left corner: Shih Hsi-mei chien-shang t'u-shu (square, intaglio). The owner is not recorded.
The painting measures 59 × 18 7/8 inches.

From the Wong Nan-p'ing collection, Hong Kong.

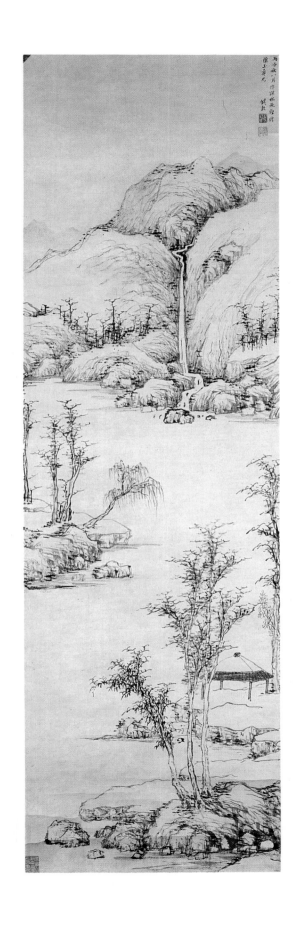

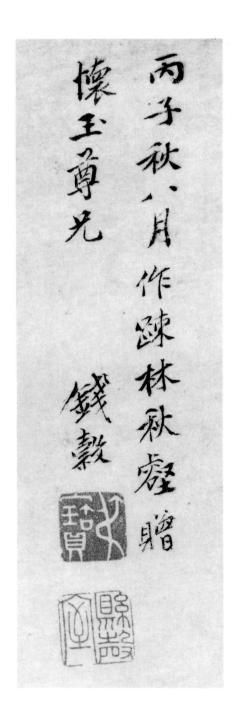

丙子秋八月作踈林秋靄贈
懷玉尊先
錢穀

TING YÜN-P'ENG
1547–ca. 1621

tzu: Nan-yü.
hao: Sheng-hua chü-shih.
From Hsiu-ning, Anhui.

TING Yün-p'eng learned the art of painting from his father, Ting Tsan, and by 1577 had settled in Sung-chiang, Kiangsu, living in a Ch'an Buddhist monastery. There he became a member of the local literary circle of Tung Ch'i-ch'ang, Mo Shih-lung and Ch'en Chi-ju; he lived in Sung-chiang until 1585. Tung praised him in several colophons for his *pai-miao* or "iron-wire" outline figure paintings of Buddhist and Taoist divinities, and it is for this outline style that Ting is best known. His work constituted a unique late Ming revival of a manner perfected by the master Li Kung-lin (ca. 1040–1106). Relevant to his *pai-miao* style is his activity as a designer of woodblock plates illustrating ink-cake decoration for the Anhui inkmakers' catalogues *Fang-shih mo-p'u* and *Ch'eng-shih mo-yüan*. For details see *Shadows of Mt. Huang*, pp. 25–33, and also *In Scholars' Taste*, where we offered a Ch'eng Chün-fang workshop ink as no. 142.

Ting Yün-p'eng was also a talented landscape painter, although it seems that his fame (he enjoyed at least as dazzling a reputation then as now) largely rested upon his fine-line brush style. As Siren observes of his eclectic ability in two pages of discussion of Ting's work in *Chinese Painting*, vol. V: "Ting Yün-p'eng was evidently highly accomplished and had a command of the brush that none of the literati or amateurs could equal. He might have reached a more prominent place in the history of Ming painting if he had not been haunted by the ambition to equal the old masters in illustrative paintings." *Shadows of Mt. Huang* (Cahill, ed., p. 58) discusses the versatile nature of Ting Yün-p'eng's activities, pointing out that even if he was a "professional" painter, his level of education and the significance of his activity raised him to a higher status. In some of the landscape paintings, dating from throughout his career, the influence of the Suchou Wu school is evident, as are other stylistic influences with which he came into contact. A few early works, though, compare favourably with landscapes of Wen Cheng-ming, in the treatment of space and form within an elongated format. Some other works, both early and late, relate to the later, poetic manner of Suchou landscape. Ting also painted landscapes in a style reminiscent of the early development of the Anhui "school"; he probably studied with Chan Ching-feng, the first Anhui painter and theorist. This dry manner, derived from the Yüan masters (especially Ni Tsan and Huang Kung-wang) equally presages the Sung-chiang style of Tung Ch'i-ch'ang. Cahill (*Shadows of Mt. Huang*, p. 36), observes that Ting may have been involved with literati painting theory and might have acted as an influence on Tung Ch'i-ch'ang, as well as having been influenced by him, for at least part of his career. For published landscapes illustrating Ting's eclectic range see *Shadows of Mt. Huang*, fig. 1 (a dry Yüan-style mountain scene dated 1585) and fig. 10, a wet ink fan dated 1616; and *Zauber des chinesischen Fächers*, no. 18, a Wu school fan dated 1597.

4 STUDY AMONG AUTUMN WOODS (1578)
A long hanging scroll in ink and light colours and wash on paper.

On a grassy riverside promontory two scholars sit on mats in a thatched pavilion dwarfed by various deciduous trees and a tall pine. The leaves of one tree have already turned a delicate brown; another still bears white blossoms. The hut is matched for size by a huge "*T'ai-hu*" pierced rock of satisfactorily contorted form, which sits immediately beside it, appearing partially to grow out of the water. At the entrance to the pavilion a low table bears a book and two incense vessels, while at a little distance a servant boy fans a brazier to make tea for his master and the guest. A zigzag bridge leads via a riverside path at the base of the cliff (both are bordered with a low open balustrade) to the living quarters, again a low open structure surrounded by clusters of bamboo within a wicker fence. There is visible a large, low *kang* completely covered with scroll paintings and books or albums, evidence of the occupant's

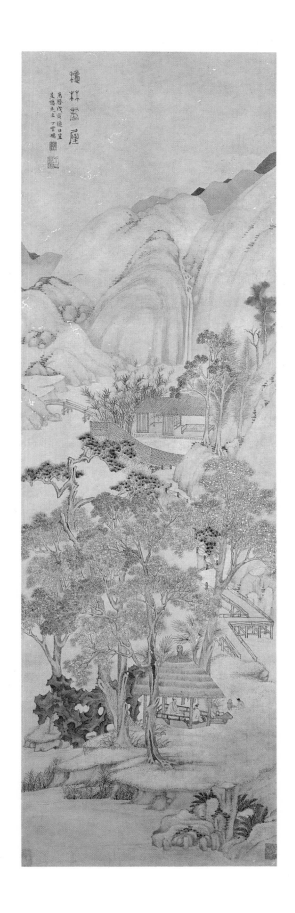

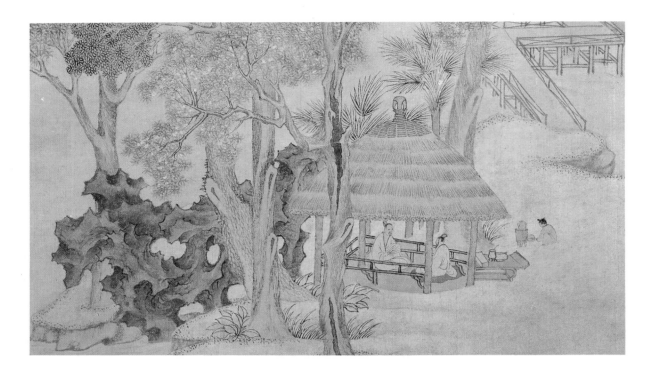

scholarly cultivation in the gentle wilderness. A further low bridge leads past a waterfall at the head of the valley into the ever-ascending hills and mountains in the far distance. Ting's method of representing the rockwork of the hills is one of the most interesting aspects of the painting. Instead of the densely layered brushwork typical of his literati masters he has chosen to delineate a very few contours with pale brown colouring and some mineral green *t'ien* dotting, and permit large areas of light wash to suggest the bulging bulk of the vertiginous hills. This engenders an atmospheric effect of pastoral softness for not only the scholar's civilised retreat, but also the distant mountains; it also has the important function of not detracting from the sharp, hard-edged form of the foreground weird rock as a focal point of the composition. Format and style are very much after the manner of Wen Cheng-ming.

Entitled in archaic *chuan* (seal) script: Ch'iu-lin shu-wu (Autumn Woods Study).
Dated to an autumn day in the *wu-yin* year of the Wan-li period (1578), and dedicated to Mr. Hsing-lou. The owner of this engaging art name (Star Pavilion) is not recorded, but it was also an actual name of a star, and features in a phrase meaning "a pavilion as beautiful as the North Star" in a poem by Liu Wei.
Signed Ting Yün-p'eng, with two seals of the artist: Nan-yü (rectangular, intaglio) and Ting Yün-t'u yin (square, part relief, part intaglio).
There are two collectors' seals: one of Wang Li-po, Wang Li-po shih-chia ts'ang (ca. seventeenth-century); and the other of P'an Cheng-wei (1791–1850), the famous early ninetheenth-century Kuangtung collector, P'an shih T'ing-fan lou ts'ang (Contag & Wang 6).
The painting measures 56 1/2 × 17 1/4 inches.

Ex P'an Cheng-wei collection.
Recorded in P'an's *Ting-fan lou shu-hua chi hsu*, vol. 2.
Listed in Ferguson, *Li-tai chu-lu hua-mu*, vol. 1, as being in Shao Sung-nien's *Ku-yüan ts'ui-lu* (Ch'ing).

This is a rare, very early work in Ting's oeuvre. Most authorities list his period of activity beginning from 1584, but there is a landscape painting in the National Palace Museum, Taiwan, dated 1575, and an album in the same museum painted between 1577 and 1578. This latter album is interesting in another regard, since it is signed Ting Yün-t'u, the same variant name as appears on the second artist's seal on this painting; the unusual use of this early name of Ting's serves as a corroboration for art historians. Indeed, the fine handscroll in the Nelson Gallery–Atkins Museum, Kansas City, of *Five Forms of Kuan-yin*, itself datable to about 1578–1580, bears a colophon by Ting's friend Tung Ch'i-ch'ang to the effect that "Ting Nan-yü . . . was at that time over thirty and the skill is marvellous. From this time on he was never so skillful and he became careless". While this may seem like a back-handed compliment, probably made because the two were not so closely associated later, it implies some considerable output around the late 1570s at the very latest. A comment upon a 1614 landscape in the Cleveland Museum of Art is also relevant in terms of Ting's development (both this and the *Five Forms of Kuan-yin* handscroll are discussed in *Eight Dynasties of Chinese Painting*): "In its low-key colour washes, charred ink tones and limited vocabulary of texture strokes, Ting's 1614 landscape displays a conservative literati quality which differs greatly from his early work." While the Cleveland landscape does indeed appear radically different from our earlier scene, and seems more technically traditional in its components, at least, we find in the description of low-key colour washes and limited textural strokes, confirmation that some elements of Ting's Suchou Wu school landscape style remained constant in some form or another despite overall developments in other directions.

For the most comprehensive survey of Ting Yün-p'eng's work see *Style Transformed: A Special Exhibition of Works by Five Late Ming Artists*, National Palace Museum, Taipei, 1977; Ting is the first of the five artists discussed. It illustrates a fan dated 1576 (no. 001), the Ting Yün-t'u *lohan* album dated 1577–1578 (no. 002) and also a tall Wu landscape dated 1583 which is somewhat comparable to the example above in composition, especially with regard to the features of the pine trees and balustraded path around the cliffside. This landscape is similarly inscribed in a rather spidery seal script.

LU CHIH

1496–1576

tzu: Shu-p'ing.
hao: Pao-shan (-tzu).
From Wu-hsien (Suchou), Kiangsu.

LU Chih was the best painter in Wen Cheng-ming's circle, after Wen himself, Lu's landscape teacher. A "lofty scholar" from a local gentry family, who advanced only to the early stages of the civil examinations and avoided official life, he became one of the very few Suchou Wu school painters to overcome the total domination of Wen and establish his own idiosyncratic style. A poet, essayist, calligrapher (pupil of Chu Yün-ming) and painter of landscapes and birds and flowers, he gained a reputation for uprightness of character and an aloof, antisocial nature, with eccentricities of habit which grew more pronounced with age.

Never an *habitué* of rich patrons' parties, he retired probably in the early 1550s to live in poverty in a rustic estate at the foot of Mount Chih-hsing, southwest of Suchou; where he lived until the end of his days writing, painting and tending chrysanthemums. He is described as having modelled his life on T'ao Yüan-ming (or, alternatively, Ni Tsan). Of the many anecdotes about Lu, one of the most pervasive is that of how difficult it was to obtain his paintings by offering money; he insisted that: "I paint for my friends, not because I'm poor." Even his friends were said to be most circumspect about asking for paintings, which were however freely given.

Lu's flower paintings, said to be based upon those of the Five Dynasties' artists Hsü Hsi and Huang Ch'üan, sometimes incorporating birds, are very fine, often brightly coloured, and popular in Far Eastern collections. Critically, though, it is for his landscape painting that Lu Chih is now highly regarded, and the vast majority of his works represented in Western collections are landscapes.

He was capable of absorbing the styles of any number of early masters, but seems to have settled, through the influence of the two great Suchou painters a generation or so before him, Shen Chou and Wen Cheng-ming, into a personal interpretation of the two Yüan masters Wang Meng and Ni Tsan. A few large, imposing scrolls appear to be based upon Northern Sung monumental models, but their required massiveness seems less suited to the delicate, linear style in which Lu excelled. For examples of Lu's work in various styles in landscape, as well as flowers, birds and outline, see *The Pageant of Chinese Painting*, pls. 610–618. His most characteristic landscape style captures the spare, airy clarity of Ni Tsan, despite adding crowded compositional details, relieving the ink monochrome with colour washes and strong red or green mineral colouration and layering rhythmic, often contorted, rocky constructions.

As Cahill comments of his work in *Parting at the Shore*, p. 240: "Lu is perhaps the supreme master of that special mode of landscape cultivated in sixteenth-century Soochow that treats the local scenery as neat, fragile, cleansed of clutter; appeals to tactile sensation are avoided in such paintings, as are overt emotional statements; figures and buildings are depicted with a light ingenuousness that expresses, as the artist intended it should, disengagement from mundane reality. If we find this attitude in the paintings and their artists escapist, we must say the same of most of the rest of Soochow culture and remember that this was a period when attempts at political or social action were unlikely to achieve any beneficial effects and were quite likely to bring about the extinction of the well-intentioned official who made the attempt, sometimes with his entire family."

Lu's avoidance of tactile sensation, the opposite path taken to the other major student of Wen Cheng-ming, Ch'en Shun (1483–1544), manifests itself in a cool detachment, a light touch and a tonal paleness, despite the use of colour. His is an aesthetic rather than an emotional concern with the creation of often abstract forms, and the sometimes awesome scenery he depicts seems less dynamic than constructed according to geometric principles. On the other hand, in such a work as the Freer Gallery's *Autumn Colours at Hsün-yang* (*inter alia*, Cahill, *Chinese Painting*, p. 133) the refined delicacy of touch is unmatched in Ming painting; although never exactly intimate, it demonstrates a lyrical aspect of his range of styles. With its sharp brushwork, complex composition and crystalline

clarity of abstract construction, Lu's most characteristic work represents a significant contribution towards the development of contemporary painting. His interlocking mountain formations were derived from Huang Kung-wang through Wen Cheng-ming, but he used a finer, drier brush, applying the *ts'un* strokes of angular rock outlines with the side of the brush in Ni Tsan's manner. The cubist and intricate rocks are far more complex and overlapping than Ni's clean lines, though, with bent lines interweaving and flattening the forms; little spatial tension is involved. Siren, *Chinese Painting: Leading Masters and Principles*, vol. IV, p. 221, considered that Lu gave his very best when working on a relatively small scale. He seems to be have been dismissive of the power and effectiveness of Lu's larger landscapes, but it is true that in minor works both Lu's charming and brilliant, gemlike compositions are more immediately appreciable; it is difficult to be overwhelming and intricate simultaneously. In any event, the fan format was one which was relatively new in early-to-mid sixteenth-century Suchou, and Lu was among those who satisfactorily responded to its strictures and demands, with his interest in compositional axes and diagonals.

One other area in which Lu was innovative was in the device of alternating closed and open views, seen in the Drenowatz handscroll, *Song of the Great Land of Wu* (*A Thousand Peaks and Myriad Ravines*, fig. 10, dated 1534), and more fully developed in the Kansas City handscroll, *Streams and Rocks* (*Eight Dynasties of Chinese Painting*, no. 182, dated 1549). Both of these extensive compositions incorporate clefts or hidden valleys comparable to that in the fan shown here. Caves and grottoes were common motifs in Wu school painting, symbolic or at least indicative of safe, spiritually pure seclusion. Lu's treatment of such features, as seen in the Shanghai Museum's hanging scroll, *Cloudy Peaks and Wooded Valley* (*Gems of Chinese Painting*, no. 57, and also in *Chinese Paintings of the Ming and Qing Dynasties*, no. 18) or in the Taipei National Palace Museum's *Jade Cave on an Immortal's Mountain* (*Parting at the Shore*, pl. 120), accents the otherworldly nature of these strange natural formations, a wish-fulfilling escape from the mundane into a heightened spiritual frame of existence; exactly because of the flat, angular designs of his rockwork and the cool, atonal detachment of his atmosphere. This element in Suchou painting was carried to an extreme towards the end of the Ming by the likes of Wu Pin.

Lu Chih was one of those middle-Ming painters who sometimes painted real landscapes of local scenery (like other Wu school painters he often painted Stone Lake, for example), a practice which as Cahill has demonstrated was carried to an entirely different extreme by Chang Hung (see no. 6). However, his landscapes more often depict, or take as their point of departure, semi-genre legendary subjects such as the Journey to the Red Cliff, The Song of the Lute, or Peach Blossom Spring.

Barnhart observes, in describing *Planting Chrysanthemums* (Peach Blossom Spring, no. 27, ca. 1550), the valley opening up beyond Lu's depiction of his own reclusive garden may be intended to suggest the legendary hidden paradise; already arrived at for Lu in his life of retirement, friendships and remote gardens; Suchou was, after all, the city of gardens. Such a blending of idealised local scenery and suggestions of equally idealised tales of poignant nobility may be a key to the subject matter of many of Lu's compositions.

Other landscape fans by Lu are generally looser in style and more open compositionally. *Comprehensive Illustrated Catalog of Chinese Paintings* shows six such, from a Japanese collection, the Metropolitan Museum, Rietberg Museum and Honolulu Academy of Arts. The Metropolitan's example (A1–066), with its strongly one-sided cliff composition, and even more so the Honolulu example (A38–015), dated 1565, compare somewhat to the present landscape, but neither presents such a tortuous rock mass. Perhaps the most comparable fan in terms of bulk and complexity is the Crawford collection's *Brocaded Sea of Peach-Blossom Waves*, likewise on gold paper (illustrated Weng, *Chinese Painting and Calligraphy*, no. 40, *Poetry on the Wind*, no. 18, and *Friends of Wen Cheng-ming*, no. 20). None of these fans, though, incorporates the "hidden valley" motif mentioned in the handscrolls above.

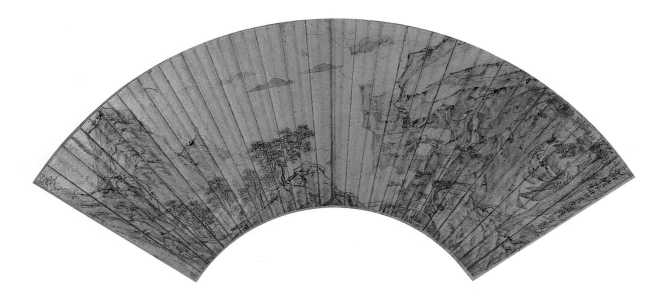

5 RUSTIC RESIDENCE NEAR A HIDDEN VALLEY (1553)
A fan in ink and colours on gold paper, mounted on card.

A complex of huts lies within a fence in a depression at the foot of steep cliffs; on its other side, beyond a rocky outcrop, clouds rise up from a precipitous void. Over this empty gap a simple footbridge leads to the overhanging, massive cliff opposite, a further, cloud-wreathed cliff beyond it. A noble pine clings to the outcrop which the bridge joins, beside a sheer waterfall. Within a vertical cleft, gashed into the rock formation, can be seen a winding river with trees growing upon its steep banks. Clouds half-obscure the trees, and cut off the top of the hidden valley. From the viewpoint of the retreat complex, miles away in the misty distance lie five undefined masses, either islands in a sea or mountain peaks jutting above the clouds. Their formation is very much like the islands in the *Song of the Great Land of Wu* handscroll.

Dated to the fourth month of the *kuei-ch'ou* year of Chia-ching (1553), and signed Pao-shan Lu Chih made, with one square, intaglio seal of the artist: Lu shih Shu-p'ing (rubbed).
There are three collectors' seals on the fan: Sung-fu (rectangular, relief), Fu-ya (one circular, one square, relief), and Shih-feng chien-ts'ang (rectangular, relief). The last may be the seal of Ch'en Lin, a Ch'ing poet and landscape painter, *hao*: Shih-feng, recorded as coming from Sung-chiang or Shanghai. The fan measures 18 15/16 × 6 1/16 inches.

CHANG HUNG
1577–1652

tzu: Chün-tu.
hao: Hao-chien.
From Wu-chün (Suchou), Kiangsu.

FOR full details of Chang Hung see *Emperor Scholar Artisan Monk*, where we offered a very fine 1638 handscroll, *Peach Blossom Spring*, and a rare 1641 album of sixteen fans depicting scenes around Nanking and Suchou, as nos. 9 and 10. The most extensive introduction to the artist is Cahill, *The Compelling Image: Nature and Style in Seventeenth-Century Chinese Painting*, with a chapter devoted to Chang (pp. 1–35). The author addresses the theoretical and practical polarities of seventeenth-century art, pulling between naturalistic representations of actual landscape and the orthodox literati argument that landscape should represent spiritual values beyond form. Tung Ch'i-ch'ang (see no. 1) is held to be the champion of the literati position, arguing that a painting which actually looked like what it purported to represent, rather than being seen through "a dense curtain of antique style", was vulgar and common; while Chang Hung is considered the most extreme exponent of realistic landscape painting of the period. Chang is sometimes described as the last master of the Wu school; despite his stature among Suchou painters no follower of weight succeeded him.

Chang's early works, and several of those of his mature period as well, are relatively conservative and traditional in style, betraying the influence of such Suchou Wu school masters as Wen Cheng-ming, Shen Chou and Lu Chih. He rarely completely escaped this influence, but as his confidence grew he began more and more to experiment with techniques. A few works eschew traditional brushwork, taking to an extreme a pointillist, virtually impressionist style which is apparent in small doses in otherwise ordinary works.

His colouring, again, is often most unusual, attempting to render realistically the greens and browns of hills, sometimes without any ink line, and to liven and point up details of narrative scenes. He tried to evoke seasons and times of the day with a sensibility to colour which had not been tried before, often approaching the feel of European watercolours; a radical development in the late Ming.

Indeed, the design techniques which Chang used to draw viewers into his unconventional compositions — steep diagonals across the picture; foreshortened foreground elements, lending proportion to the scene and placing the viewer outside and above it; zigzagging recession with stages marked by buildings diminishing in size, or a fixed bird's-eye viewpoint— all seem likely to have been influenced by European engravings, available to Chang at the Jesuit mission in nearby Nanking. Chang Hung painted many of his landscape compositions in the fan format, as did most Ming Suchou Wu school painters; ten of the forty-six works listed by Siren are fans. Very often they include some of his more interesting compositions, although of course his major works are in a larger format. *Comprehensive Illustrated Catalog of Chinese Paintings* shows twenty-six works by Chang, including albums, demonstrating above all else the extraordinary range of his work, which must have been relatively prolific. For a collaborative painting of bird, rock and camellia by Lan Ying, Ch'en Hung-shou and Chang Hung, ca. 1645, see *Studies in Connoisseurship*, p. 117.

For comparable examples of Chang's use of his pointillist technique, demonstrating within a small format unusual treatments incorporating boating scenes and pavilions obscured by trees, see *The Restless Landscape*, pl. 16, a 1627 album leaf depicting the Chih Garden, from the Vannotti collection, Lugano; and *Comprehensive Illustrated Catalog of Chinese Paintings*, JM13–011–8/10, an album leaf of similarly diagonal composition from the Sen-oku Hakko kan collection, Tokyo.

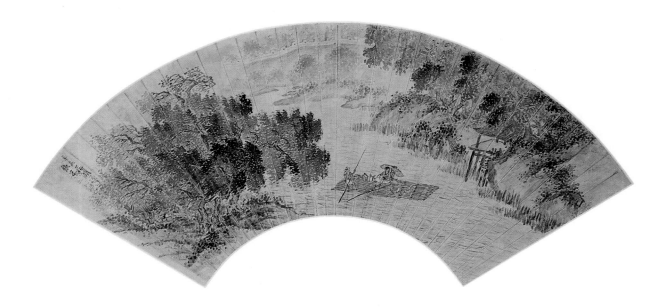

6 RAFTING ACROSS A STORMY RIVER (1611)
A fan in ink and light colours on paper, mounted on card.

A scholar sits at ease under an umbrella on a large raft as two boatmen pole him across the river, a "picnic box" and a tied-up bag beside him, and his boy attendant peering out from behind him. The choppy water and the trembling leaves of the dotted foliage suggest that they are pushing into a strong headwind. Nearly hidden by the foreground grove of leafy, atmospheric trees to the left of the composition is a small pavilion, and the raft is making for a stilted boathouse on the far shore. The castellated wall at the rear, where the river takes a turn, implies that the gentleman is making a visit to the neighbouring estate; a public ferry would perhaps be a more permanent craft. Within the limited format a compositionally strong diagonal arrangement, with the effective impression of atmospheric dimension and recession into distance, contrives by the device of concealing the architectural details to focus attention on the central feature of the raft, its passenger and crew.

Dated to the second month of the *hsin-hai* year (1611), and signed Chang Hung, with two rubbed, square seals of the artist: Chang Hung (intaglio), and Chün-tu (relief).
The painting measures 19 3/4 × 6 3/4 inches.

This fan is the earliest recorded dated work by Chang Hung; a 1613 landscape of Mt. Shih-hsieh from the National Palace Museum, Taiwan, is illustrated in *The Compelling Landscape*, pl. 1.6. However, an extraordinary splashy-ink painting of P'u-t'ai, strongly Ch'an in feeling and a further indication of the range of Chang's work, likewise from the imperial collections and illustrated in *The Pageant of Chinese Painting*, no. 689, bears an inscription by Wang Chih-teng (1535–1612), and so may date from around the same time as our fan, or before. It is interesting to see how even at this early date Chang was, for example, placing the onlooker outside and above the scene, and using some quite unconventional techniques and schema, while still maintaining the spirit of the Wu school tradition.

CH'ENG CHIA-SUI

1565–1644

tzu: Meng-yang.
hao: Chi-an (lao-jen), Sung-yüan (lao-jen, chü-shih, tao-jen).
From Hsiu-ning, Anhui; lived in Chia-ting, Kiangsu.

CH'ENG Chia-sui's date of death is usually given as 1643, but according to his biography in Hummel, *Eminent Chinese of the Ch'ing Period* (although he was a Ming figure) he died in January or February 1644, some months before the fall of Peking.

Born in Hsiu-ning, Anhui, he spent most of his life (about fifty years) in Chia-ting, Kiangsu, about twenty miles northwest of Shanghai. Failing to pass the official examinations and, according to Siren, military tests as well, he decided to pin his hopes on a literary career, and was famous as a poet by the age of thirty.

Ch'eng travelled widely. He was a friend of the famous official, poet and historian Ch'ien Ch'ien-i (1582–1664) and stayed with him for long periods, more than once at his country villa, Fu-shui shan-chuang, near Ch'ang-shu, Kiangsu, discussing poetry and art. The first visit was in 1617. The next year he accompanied his friend Fang Yu-tu (*chin-shih* of 1616) when Fang went to take up his position as magistrate of Ch'ang-chih, Shansi, and after three years there he went to Peking where he met Wang Wei-chien (*chin-shih* of 1595), at that time as famous as Tung Ch'i-ch'ang.

While living at Chia-ting, Ch'eng made several literary friends, notably the poets T'ang Shih-sheng (1551–1636) and Lou Chien (d. 1631); the three came to be known as the "Three Elders of Lien-ch'uan". Ch'eng was also a close friend of the Chia-ting painter Li Liu-fang; the four are known as the "Four Masters of Chia-ting"; when Hsieh San-pin (*chin-shih* of 1625) was magistrate of Chia-ting he published their poems under that title. Two other collections of Ch'eng's poems were banned during the Ch'ing dynasty.

Chia-ting was the major centre of bamboo carving in the late Ming period and it seems plausible that Ch'eng, like Li Liu-fang, actually turned his hand to carving. The *Chung-kuo i-shu-chia cheng-lüeh* relates that Ch'eng and Li would go out with Chu Ying (Chu Hsiao-sung, the most famous of the three Chu family carvers) looking for suitable trees and bamboo stands to select and carve.

In addition to several poetic publications Ch'eng was an essayist, and also compiled a gazetteer of the Hsing-fu monastery on Mount P'o, Kiangsu, which is praised for its style in the *Ssu-k'u Catalogue*. In 1641 he retired to Hsiu-ning and died early in 1644. Posterity knows Ch'eng much better as a painter than as a poet, although he was not prolific. He was unforthcoming when asked for examples of his brush, and is said to have taken up to a year to "finish and polish" some paintings. Tung Ch'i-ch'ang, ten years his senior, held him in high esteem as a true scholar-painter. Indeed, he was included by Wu Wei-yeh (1609–1676) in the group of late Ming literati painters known as the "Nine Friends of Painting," with Tung Ch'i-ch'ang, Wang Shih-min, Wang Chien, Shao Mi, Chang Hsüeh-ts'eng, Pien Wen-yü, Yang Wen-ts'ung and Li Liu-fang.

Ch'eng Chia-sui's painting style derives from the four Yüan masters, particularly Ni Tsan. Art-historically, he may be regarded with Li Liu-fang as related to the early development of the Anhui school, and as a precursor to the Four Wangs. His large paintings have a freedom and broadness of execution characteristic of some of the younger "Nine Friends" like Li Liu-fang and Yang Wen-ts'ung. Some critics consider that his smaller work, which is finer and with more imaginative detail, is more successful; Siren calls him an "intimist". *Shadows of Mt. Huang* (Cahill, ed.) devotes a sub-chapter to Ch'eng and Li (whose family also originally came from Anhui), and observes in both: "A preference for simple compositions, a heavy dependence on line, often quite dry, for the definition of form, and the building of volumes by overlapping squared, angular elements rather than applying texture-strokes, all corresponding to similar elements in the painting developing in Anhui in the same period".

The description of a landscape after Ni Tsan in the Sackler collection, dated 1630 (Fu, *Studies in Connoisseurship*, V) likewise points out Ch'eng's linear style: whether the composition be dense or spare, the "linear visualisation of form and serenity of mood link the two extreme styles to one master

. . . . the same flexible brushtip, the same interest in the precise and spare use of rich ink dots for emphasis and contrast . . .''. Fu further comments: that a comparison of Ch'eng's style with that of Li Liu-fang "reveals basically similar structural concepts in both composition and individual forms and may provide visual evidence of Ch'eng's influence on Li, but while Ch'eng stressed the building of form by a thin, tensile line, with very little wash, Li Liu-fang preferred the rounder, wet line and developed a dotting method with wash which was adopted later by Ch'a Shih-piao (1615–1698)''.

Not many of Ch'eng's paintings are published. Kei Suzuki, *Comprehensive Illustrated Catalog of Chinese Paintings* shows only six, half of them ink fans. Two published ink fans in the Ni Tsan manner seem particularly comparable to the early example we offer here. One gilt fan dated 1630 demonstrates similar broadly-hatched loose strokes for the banks of the foreground promontory (*Shadows of Mt. Huang*, fig. 12) and the other, on plain paper, utilises more of a contrast of wet and dry ink tones (*Zauber des chinesischen Fächers*, no. 23), but both adopt the ultra-spare and restrained composition in Ni Tsan style, with the far shore in an almost straight line across the top of the composition and a low promontory leading in from the right foreground. Ch'eng also painted birds and flowers in ink; his 1616 fan in the Metropolitan Museum is of a cockerel by a tree, with other plants and bamboo (*Comprehensive Illustrated Catalog of Chinese Paintings*, A–130), but it is on the pure spirit of his landscapes that his high reputation rests. As *Studies in Connoisseurship* states (p. 98): "His quality of brushline was one which had a solid basis in calligraphic discipline, but the act of painting was for him a pleasure, and there is little sense of struggle or tension in his forms Ch'eng's paintings show one direction a man of culture slightly younger than Tung Ch'i-ch'ang might take in the late Ming. His entrance into the orthodox line was too early in its development for his work to display the full fruits of Tung's stylistic redirection, and unlike Tung he left no critical writings to indicate the theoretical basis of his art. In his art and life, however, we see the literati amateur style exemplified''.

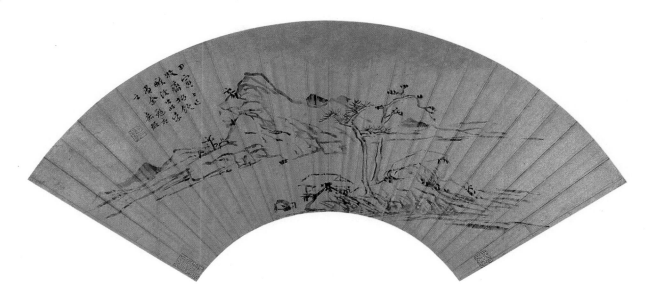

7 **RIVER LANDSCAPE AFTER NI TSAN** (1614)
A fan in ink on gold paper, mounted on card.

From a rocky foreground promontory grow a pine and another simple, spare tree, by a hut built out over the water. On the far shore two or three equally sparse trees grace a bleak, mountainous landscape.

Inscribed: Dated to the third month (the Shang-chi festival) of the *chia-yin* year (1614); Mu-chai (Ch'ien Ch'ien-i, 1582–1664; he too has his own entry in Hummel, *Eminent Chinese of the Ch'ing Period*) invited me to drink. Having become intoxicated I executed this, constraining myself to do it properly.
Signed Chia-sui, with one seal of the artist: Meng-yang (square, relief and intaglio).
With two relief seals of a collector: Tsao Shao-mei. He is unrecorded.
The fan measures 20 5/8 × 6 3/4 inches.

tzu: Ch'ang-kung, Wu-hua.

hao: Erh-shui, Kuo-t'ing, Po-hao-an (tao-che), Chieh-tzu chü-shih.

From Ch'üan-chou, Fukien.

CHANG Jui-t'u was a high official, a fine poet and painter and a great calligrapher of the late Ming. His works are rarely found in Chinese collections and references, primarily because of the political stigma attached to his name through his connection with the infamous eunuch Wei Chung-hsien in the T'ien-ch'i period of late Ming. Recently his reputation has been rehabilitated by Chang Kuang-yüan, in a series of three articles in the *National Palace Museum Bulletin*, Taipei, vol. XVI, issues 2, 3 and 4 (1981). Japanese connoisseurs and critics have always rated Chang very highly, both as a painter and a calligrapher, and the majority of his works are or have been in Japanese collections. Y. Yonezawa, *Painting in the Ming Dynasty*, 1956, considered him at least on a level with Tung Ch'i-ch'ang as a painter, and stated that: "he must be regarded as one of the most outstanding of the Ming". Chang has always been considered, even by contemporaries and authorities prejudiced because of his supposed official shortcomings, as one of the Four Great Calligraphers of late Ming, with Hsing T'ung, Mi Wan-chung and Tung Ch'i-ch'ang.

Chang's father, Chih-t'ing was a skilled literary man and something of a calligrapher, and among Chang's elder relatives a few were magistrates. From early on Chang established a local reputation as a scholar, though he was already thirty-four when he attempted the prefectural examinations of 1603. As he missed the following national examination in Peking the next year, it was not until 1607 that he tried and passed the examination with the well-placed rank of *kung-shih*, and was eligible to try for the palace *chin-shih* examination.

Answering a test question, set by the emperor, in a controversial fashion, Chang placed third of the three hundred participants, passing with flying colours and a ready-made reputation. He was appointed to a position as compiler in the National Academy, with the rank of Grand Historian. In 1610 Chang went home for two years for reasons of health; upon his return to Peking in 1613, aged forty-five, he was sent with another Grand Historian, Wei Tao-ch'ang, on a mission to Yünnan. Their business quickly accomplished, Chang returned home to Fukien by a circuitous, sightseeing route through Kueichou, Hunan and Kiangsi before returning to the capital, a journey which took him over six months, visiting many mountains and beauty spots.

From 1620, when Chang was promoted to a new position in charge of the Crown Prince's household, to 1625 when he became Vice-minister of Rites and 1626, when he was elevated to the Grand Secretariat, Chang's rise took place against a background of decaying imperial power and corrupt factionalism at court. In 1620 the Wan-li emperor, who had originally favoured Chang because of his bold performance in the palace examination, died; as did the Crown Prince, thirty days after his reign commenced, under suspicious circumstances. He was succeeded in 1621 by the T'ien-ch'i emperor, Hsi-tsung, a weak and youthful individual with a predilection for carpentry, who was content to let affairs of state slide into the hands of the eunuch Wei Chung-hsien. Wei's intrigues and his battles with the Tung-lin party at court left the empire's government in a parlous spiral of decay which eventually resulted in the disintegration of the dynasty twenty-odd years later. As Chang and other officials had been active in the cabinet towards the end of his reign, with constant promotions, when the emperor died in August 1627 they were charged with corrupt association with the eunuch Wei; Chang was stripped of honours and sentenced to three years' imprisonment, which he avoided by the alternative payment of a fine.

Chang Kuang-yüan has demonstrated that this was not an immediate charge; indeed, in the interim Chang had been named vice-premier of the cabinet by the new Ch'ung-chen emperor. It was only after he had offered his resignation eleven times and the opposition Tung-lin faction had been restored to power that Chang was eventually disgraced at the instigation of the emperor. The assembled officials had omitted to include Chang in a list of 161 traitors because there was no evidence that he had done

anything; the Ch'ung-chen emperor's reason was that, as a great calligrapher, Chang had acceded to eunuch Wei's request that he brush an inscription for a tablet in a shrine to Wei. Chang Kuang-yüan quite convincingly shows that Chang Jui-t'u was an honest official caught up in the hopelessly confused and cut-throat politics of the time who, after he managed to extricate himself from the turmoil of court, was never happier than in seeking truth in Buddhist philosophy, living in comparative rural poverty and indulging his talents in painting, poetry and calligraphy; most of his great works date from this late period. Indeed, four years after Chang's death in 1641, the Ming pretender T'ang-wang set up court in Fuchou with the support of Huang Tao-chou and a group of loyalist ministers under the reign title Lung-wu, and issued a proclamation restoring all of Chang's former titles and honours, bestowing upon him the posthumous name Wen-yin. Chang's son Ch'ien-fu (see the comments on the Ch'en Hsien album, no. 12) knew the Huang-po monk Mu-an and possibly Yin-yüan as well, and it was through this connection that so many of Chang Jui-t'u's works in calligraphy and painting went to Japan, where they had a considerable stylistic influence.

Chang's calligraphy is well-known and has been much discussed. One of the greatest of Ming calligraphers, probably among his most outstanding works are the huge and majestic hanging scrolls, written with the tip of a slanting brush in his favoured, characteristic *hsing-ts'ao* script, but with characters each a foot or a foot-and-a-half in size. A huge couplet from the Crawford collection, displayed in the Metropolitan Museum of Art, New York (illustrated Ecke, *Chinese Calligraphy*, no. 66) and a fine hanging scroll in the Tokyo National Museum, each over nine feet tall, convey the power with which these works are imbued; it is difficult to credit that when dealing with such sheer scale Chang was able to successfully maintain the controlled freedom and the expressive ink-play of smaller formats. On a more intimate level Chang was also capable of greatness in his writing, although in that case he was naturally able to vary and modulate the tonality of his ink more; he was always forceful, fluid and independent in character.

Chang's landscape painting is less well-known, although there are several fine examples in Japanese and Western collections. The large hanging scrolls in ink on silk of his late period are mostly of a simple basic construction, with extremely well-defined weird rock constructions and often a misty foreground; in them, Chang seems more interested in semi-calligraphic brush effects and a decorative stylisation than in the forms and their structure. He never devolves, despite the exaggerated nature of his rock clusters, into the wild fantasy landscapes of his Fukienese contemporary Wu Pin. These larger paintings are dominated by a strongly vertical rhythm, and although some of them resemble each other rather too much, individually they are successful. A particularly appealing and unrepresentative example is illustrated by Cahill, *The Distant Mountains*, pl. 88; a splendidly atmospheric work with a strongly Southern Sung feeling to it.

Siren, *Chinese Painting: Leading Masters and Principles*, vol. V, p. 48, observes that: "Chang Jui-t'u's individual genius has found the most appealing expressions in minor paintings or sketches on album leaves in which he has noted down fugitive impressions of open waters with rocky islands, mountains rising through low mist, or promontories with a few trees, i.e. records of actual observations rendered with a swift and sensitive brush."

Chu-tsing Li, *A Thousand Peaks and Myriad Ravines*, suggests for Chang's painting: "three stages of development. The first is represented by the paintings of the 1620s which he painted more or less in the tradition of the late Wu school, with realistic subject matter, misty effects and an interest in refined brushwork. At this time, his work was quite soft, somewhat close to some of the works of Sheng Mao-yeh and Li Shih-ta. In the second stage, which covered the first years after his exile and return in the early 1630s, he began to take an interest in the elements which became typical of his late style — strange rocks, lonely pines and atmospheric effects, all in rather complex compositions. Most characteristic of this period are the two paintings now in the Seikado collection in Japan, one of which is dated 1631. In his last years he became much bolder and more powerful; he built up the strange rock forms, and eliminated the more intricate compositions and the mistiness. Representative of this last

stage are the Drenowatz painting of 1640 and the *Listening to the Waterfalls in High Pavilions* in the Abe Collection at the Osaka Municipal Museum. In these last works, because of his simplified composition and concentration on large and powerful forms, there is a heightened sense of drama."

Probably Chang did develop in his maturity a predilection for noble, grandiose conceptions in both painting and calligraphy, and that may, as a general rule, define his direction. He was, however, equally capable, late in life, of writing in smaller formats — there are numerous examples — and of painting with his misty Wu school refinement well to the fore. A 1638 handscroll in six sections, in the Sumitomo collection, Oiso, includes the usual vertical, dramatic precipices and waterfalls, admirably adapted to the handscroll format, but also one leaf is as wet and misty as anything produced earlier on (Kei Suzuki, *Comprehensive Illustrated Catalog of Chinese Paintings*, JP 68–026). Although there are a reasonable number of small-format paintings by Chang (he was not a very prolific painter), handscrolls and especially hanging scrolls predominate. Apart from the extremely early fan offered here, only one other landscape fan is published, from the Lan-ch'ien-shan-kuan collection, Taiwan (Kei Suzuki, S4–016). It is similarly misty and wet, but is undated and seems to be more traditional in flavour than our unusual example. A somewhat comparable 1624 inky landscape handscroll is illustrated in *Chinese Literati Paintings From The Jorakuan Collection*, no. 14.

8 STREAMS AND MOUNTAINS IN MIST AND RAIN (1614)
A fan in ink on gold-dusted paper, mounted as a hanging scroll in Japanese fashion, with double fitted and inscribed box.

Using the semi-circular fan format to impose a cleverly distorted field of vision, the landscape reveals an off-balance foreground to the left of centre with rounded, undefined rocks topped with clusters of misty pines, with a rural retreat hidden among them. From that foreground two features meander into the distance: on the left (straight, if one inclines one's view to that angle) a rocky stream, and on the right an extremely misty, impressionistic line of trees. Above and behind them roll layer upon layer of mountain ranges, with bands of mist rising from the valleys, all suggested with light and heavy wet brushstrokes in the style of Mi Fu, or perhaps Kao K'o-kung; in parts anticipating by some fifty years the dense and ghostly trees of Kung Hsien.

With an inscription by the artist: Hsi-shan yen-yü (Stream, mountain, mist, rain), done in the summer of the *chia-yin* year (1614), and signed Jung-shih, T'u.
With two seals of the artist: Jung-shih (double seal, square, relief) and Jui-t'u chih yin (square, intaglio). The name Jung-shih must represent an unrecorded early art name of Chang's.
The painting measures 21 3/8 × 7 inches.

The Japanese inner box bears on its outer lid a title and attribution, and inside an inscription: "Meiji, the eighth month of 1894, inscribed at the Rakuzando by Komura", with two seals: Kitamen and Komura giofu. There are three further collectors' seals inside the box.

Chang's adoption of this unusual style, experimental both in brushwork and composition, must be related to the fact that he had concluded his six-month "southeastern ramble" in only the spring of the same year, 1614. If he was looking for a painting style with which to convey the beautiful and inspirational scenery of his lifetime's journey through the exotic and semi-tropical humid countryside of Kueichou and Kiangsi, then it was perhaps natural to borrow the manner of Mi Fu; the unexpected aspect of it is that he managed the presumably unfamiliar style so well. This painting is dated a good ten years before other known dated works by Chang, but we may judge that, as he was 45 at the time of its execution, he was already a competent painter and calligrapher.

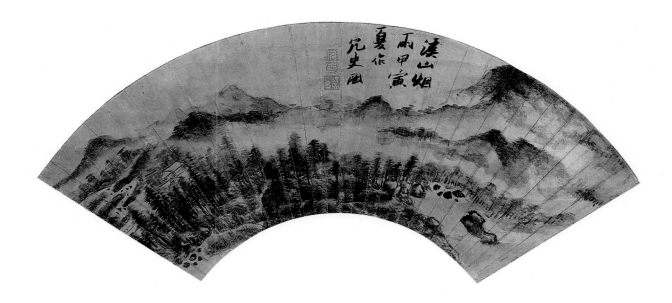

CHENG YÜAN-HSÜN

1598–1645, Cheng's birthdate is alternatively given as 1604.

tzu: Ch'ao-tsung.

hao: Hui-tung.

From Hsiu-ning, Anhui; lived in Yangchou later in his life.

CHENG Yüan-hsün was a minor Anhui school painter, better known as an important collector of paintings and as the uncle of the great seal-carver and Anhui painter Ch'eng Sui (we offered a rare seal by Ch'eng in *Emperor Scholar Artisan Monk*, as no. 96). Born into a wealthy Anhui literary and connoisseur family, Cheng Yüan-hsün was a scholar and official (*chin-shih* of 1643), for a short time placed in charge of the Chih-fang-ssu, an office dealing with statistics, maps, tribute and so on. He was a friend of Tung Ch'i-ch'ang, who came to Yangchou to visit Cheng, discuss paintings and inspect his collection. It was in Cheng's anthology *Mei-yu-ko wen-yü*, published about 1627 or 1630, that Tung's theories about the "correct line of orthodox transmission", dividing old masters into the Northern and Southern schools, first appeared, entitled *Lun-hua so-yen*. Tung modestly avoided mentioning himself as the current embodiment of orthodox lineage, but Cheng dutifully did it for him, appending a note: "In painting of our dynasty, Shen Chou and Tung Ch'i-ch'ang belong to the correct line of transmission; they can be linked directly to the Sung and Yüan masters of the past." (Cahill, *The Distant Mountains*, p. 14).

Cheng was also interested in rock gardens. The unique book of Chi Ch'eng, an early seventeenth-century painter and garden architect, *Yüan-yeh* (Garden smith) was first published in 1635 with three prefaces; one by Chi dated 1631, one by the politician and dramatist Juan Ta-ch'eng dated 1634, and a third by Cheng Yüan-hsün dated 1635. It deals in detail with such items as choice of locale and view, doors and windows, lattice screens and balustrades, rockery mounds and selection of individual rocks (*Dictionary of Ming Biography*, p. 216).

Ch'eng Sui lived for a while in Yangchou with his uncle, and Cheng Yüan-hsün probably knew most or all of Ch'eng's circle of *i-min* friends, such as Ch'ien Ch'ien-i, Wan Shou-ch'i, Chou Liang-kung, Fang I-chih, Ch'a Shih-piao and Hung-jen. Cheng was a painter more interested in theory than in practice, stylistically more influenced by Tung Ch'i-ch'ang's interpretation of the old masters' models than by radical new currents. Cahill, *Shadows of Mt. Huang*, pp. 68–69, in discussing a large ink landscape by Cheng in the Suchou Municipal Museum (fig. 15; also in the museum's catalogue, no. 29) points out in it surface references to Huang Kung-wang and Shen Chou, at the level of structure and style combining elements of Tung Ch'i-ch'ang's Sung-chiang school and the still-emerging Anhui school. A rather loose and unsatisfactory album leaf by Cheng, also illustrated in *Shadows of Mt. Huang* as no. 39, declares its allegiance to Tung Yüan but, as Cahill points out, owes much more to the later Tung; it is "more an expression of taste and stylistic allegiance than a picture, and is to be appreciated as such". Hardly any other paintings by Cheng are published.

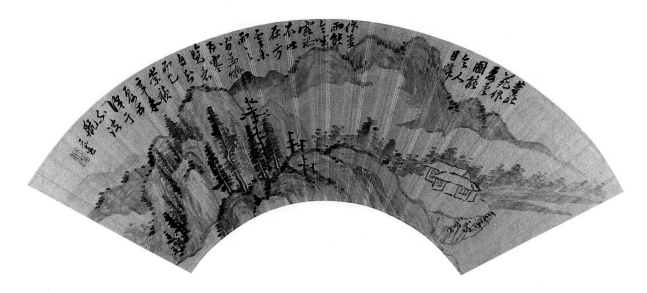

9 **LANDSCAPE AFTER TUNG YÜAN** (1631)
A fan in ink on gold-dusted paper, mounted on card.

A cluster of various spindly and stumpy trees, in light and dark ink, stand on a foreground hill, with a low, two-hut retreat on a flat bluff to the right. Behind the retreat mist rises above impressionistic foliage. Various mountain peaks and ranges lie beyond, and an outcrop in the middle distance has a line of tall pines marching up a ridge to its peak. The conception is derived very much through the line of Tung Yüan, Shen Chou and Tung Ch'i-ch'ang.

With an inscription by the artist: Tung Pei-yüan (Tung Yüan) painted *Summer Clouds*; it can make a man's eyes water; his *Summer Rain* can make guests don more clothing. This painting is of a landscape with gathering clouds before the rain. Whether one feels hot or cold depends on the feeling of the viewer.
Dated Ch'ung-chen period, the fifth month in summer of the *hsin-wei* year (1631), at the Pu-po hang (no waves barge: probably a hall name of Cheng's — another Ming scholar, Ch'eng Te-liang, had a hall called Pu-po kuan).
Signed Yüan-hsün, with two square seals of the artist: Yüan-hsün (relief) and Ch'ao-tsung (intaglio).
The painting measures 21 3/16 inches × 6 11/16 inches.

The large landscape in the Suchou Municipal Museum is also dated 1631.

WANG SHIH	tzu: Wu-ni.
mid-17th century	From Ch'ang-sha (Suchou), Kiangsu.

An alternative name is also recorded for Wang, of T'ai-ts'ang, but sources are confused as to whether it was an art name or a place name (T'ai-ts'ang, Kiangsu). Since Wang signed his paintings Ch'ang-sha Wang Shih it seems likely that he came from Suchou, as recorded.

WANG Shih is recorded as a fine figure painter, whose landscapes followed Sung and Yüan models. He is recorded in both the *Ming-hua-lu* (chapter 8) and the Ch'ing dynasty's *Kuo-ch'ao hua-cheng-lu*; one encyclopaedic source records him as a Ming painter (*Chung-wen ta-tz'u-tien*) and another as a Ch'ing painter (*Chung-kuo mei-shu-chia jen-ming tz'u-tien*), so it seems likely that his career spanned the transitional period from Ming to Ch'ing. The latter source records a fan painted by Wang, called *Chiao Sui and the Five Constellations, of stately appearance* (Chiao Sui was a T'ang figure, sometimes listed as one of the Eight Immortals), dated to the eighth year of the Shun-chih period (1651).

Another fan by Wang Shih, depicting the Lan-t'ing Pavilion by a bamboo grove in a thickly wooded mountain landscape, with scholars and attendants by the stream, is illustrated in Kei Suzuki, *Comprehensive Illustrated Catalog of Chinese Paintings*, as no. JP30–294–9. From the Taitsu Hashimoto collection, it is dated cyclically to (presumably) 1635.

10 SCHOLARS CONVERSING IN A LAKESIDE PAVILION (1637)
A fan in ink on silver-dusted paper, mounted on card.

Two scholars in loose robes relax in the uplifting surroundings of a rustic lakeside pavilion, built on stilts with a thatched roof and awning. A boy attendant brings more wine to a table crowded with incense vessels and books as they chat animatedly. A gnarled tree partially obscures and overhangs the pavilion with a cascade of near and distant wet textured brushstrokes, while on the far shore a rocky stream empties into the lake, the nearby wet foliage dotting echoing the humid, dripping, atmospheric ink-play of the tree. The profuse brushwork of foliage detail and the empty space of the lake set off the fine, expressive figural lines of the scholars, presenting a successful, compact composition.

Dated *ting-ch'ou* year (presumably 1637), a spring month, and dedicated to Mr. Fu-sheng, elder brother in poetry (not recorded).
Signed Ch'ang-sha Wang Shih, with one seal of the artist: Min-ch'ing ou-meng (square, relief).
There is one collector's seal to the lower left: Ch'in-shu (?; rectangular, relief). The owner is not recorded.
The painting measures 19 1/2 × 6 1/4 inches.

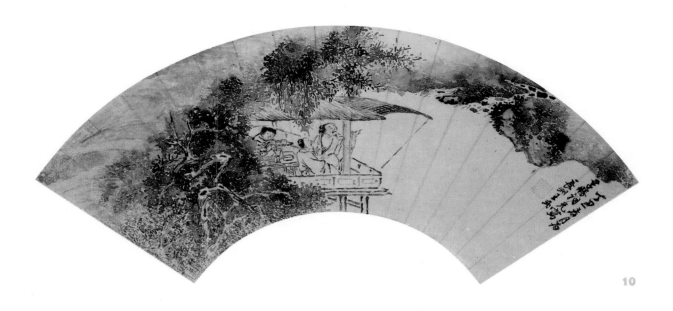

10

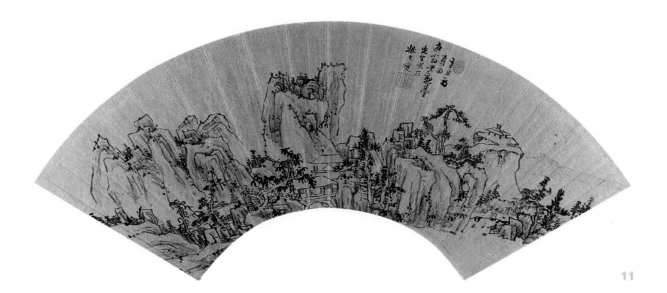

11

YAO WEN-HSIEH
1628–1693

tzu: Ching-san.
hao: Keng-hu.
late hao: Huang-nieh shan-ch'iao.
hall names: Wu-i t'ang, Tz'u-chin yüan.
From T'ung-ch'eng, Anhui.

YAO Wen-hsieh was a poet, writer and student of ancient writings, as well as a painter. A *chin-shih* of 1659, he was made magistrate of K'ai-hua, Yünnan, and later filled a palace position with the title of Chung-shu. A rare talent, he was famous in the K'ang-hsi period. His landscape painting is described as of the *miao* (wonderful, or third) class, with sparing yet rich brushwork and light, elegant use of colour. On Yao's painting of his garden, the Tz'u-chin yüan, the scholar and poet Chu I-tsun (1629–1709) wrote in praise of him: "He put his art before himself, like Li Kung-lin".

Extremely few works by Yao Wen-hsieh are published. Kei Suzuki, *Comprehensive Illustrated Catalog of Chinese Paintings*, shows only two; a tall, mountainous hanging scroll in the Yuji Eda collection (JP14–020) and a fine eight-leaf album in the Wango H.C. Weng collection, New England (A13–006). The album, which appears to be dated 1662, demonstrates that Yao was capable of painting in an eclectic range of styles, drawing from the manners of such old masters as Huang Kung-wang, Ni Tsan and Mi Fu. Two or three leaves have a strong flavour of the Anhui school about them, although T'ung-ch'eng, Yao's birthplace, was a considerable distance from Huang-shan, and he could not politically have held serious *i-min* sentiments as a servant of the Ch'ing. One leaf (4), painted with loose brushwork, in Huang Kung-wang's style, strikingly similar to the fan offered here, represents a fascinating and very rare composition which completely ignores the rectangular boundaries of the album leaf format. An appealing but unremarkable scene of huts among rocks and trees on either side of a river, it resembles a detail photograph of some larger composition, such as a handscroll; the landscape continues on all four sides, completely filling the page and paying no attention at all to the abrupt halt in its progress in all directions. Such an experimental example, considering Yao's evident range, awareness of current modes and his control over them, suggests that if only there were more comparable works extant he would merit study and attention.

11 VISITING A FRIEND IN HIS MOUNTAIN RETREAT (1661)
A fan in ink and light colours on gold-dusted paper, mounted on card.

Three loosely constructed yet strong and convincing mountainous forms dominate the scene, with misty blue hills at a far distance behind them. In a central cleft in the rocks is set the scholar-hermit's retreat, pleasantly situated with a variety of pine and other trees to either side, in contrasting wet and dry ink. On the right of the composition a visitor approaches the hut complex over a low bridge, while above him a low pavilion sits on a bluff, commanding a fine view.

With an inscription by the artist: Early summer of the *hsin-ch'ou* year (1661), for the correction of elderly relative Mr. Chu-weng. This art name of the recipient is not recorded.
Signed Yao Wen-hsieh, with two seals of the artist: Hsüeh-ch'ih (oval, relief), and Ching-san Hsieh (square, intaglio).
The painting measures 20 3/8 × 6 5/8 inches.

CH'EN HSIEN
active 1634–1677

names and seals: Ta-hsüan, T'ai-hsüan, Feng-shan-yin, Hsi-san, Chien pi-mo yin shuo-fa, Pan-t'u seng, Chan-k'uei, Yu-sou, Hua-shan tao-jen, Fo-tzu Ch'en Hsien, Ts'ui-kuang t'ing.

From Chekiang; lived at the Ch'an Buddhist Yen-fu monastery on Mount Chiu-jih, Nan-an district, Ch'üan-chou prefecture, Fukien.

CH'EN Hsien is the subject of a monograph by Aschwin Lippe, "Ch'en Hsien, Painter of Lohans" in *Ars Orientalis*, vol. 5, 1963, pp. 255–258, with a note in vol. 6, 1966, pp. 223–224. One of the important works described therein, the handscroll of Buddhist deities in the Freer Gallery, Washington D.C., is also illustrated in part and discussed in Lawton, *Chinese Figure Painting*, as no. 33, as well as in *Kokka* magazine, no. 568. Ch'en was a Chinese Ch'an monk painter of the Huang-po sect (Japanese: Obaku). The monk Yin-yüan Lung-ch'i (Japanese: Ingen Ryuki, 1592–1673) who left China for Japan in 1654 and is regarded as the founder of the sect there, and the monk Mu-an Hsing-t'ao (Japanese: Mokuan Shoto, 1611–1684) who succeeded Yin-yüan as abbot, very frequently wrote on Ch'en's paintings. Chi-fei (Japanese: Sokuhi, 1616–1671) also wrote on some of them.

Dated examples of Ch'en's few published works are from 1634 (Metropolitan Museum album), 1636 (Mampukuji Kuan-yin album), 1643 (Freer handscroll), 1654 (Mampukuji temple Patriarchs album) and 1672 (a single leaf in the Yabumoto collection, Japan, with a dated colophon by Hui-lin). It is possible, of course, that Hui-lin's colophon was added to an earlier painting by Ch'en, and that his period of activity should remain, as previously suggested, ca. 1634–1654. However, an alternative might well be that when Ch'en's calligraphic collaborators had all left Fukien for Japan he lost the motivation to paint as much. They certainly took a large number of his works with them; several are preserved in the Mampukuji at Uji, on the outskirts of Kyoto, the headquarters temple of the Obaku sect in Japan. After 1654, or 1657 when Chi-fei left, he may still have painted on rare occasions. He may still have been alive in 1676, the date of Mu-an's inscription on his large white-robed Kuan-yin painting in the Takami collection, Nagasaki.

Nearly all of Ch'en's paintings are stylistically very similar; he painted primarily various Buddhist *lohans* and patriarchs, and forms of Kuan-yin. In one or two of the few hanging scrolls, which were rarely very large, he incorporated landscape elements such as a pine tree or, for example, the fine rock and pine setting for Sakyamuni at the opening of the Freer handscroll; but for the most part he painted figures in an outline style with touches of colour but no background. One unusual medium-sized hanging scroll is the expressive *Ta-mo crossing the Yangtze on a large gourd*, in the British Museum (Kei Suzuki, *Comprehensive Illustrated Catalog of Chinese Paintings*, E15–128). What little landscape element we do see is rather well executed, in a late Che school manner. The outline style he characteristically used is successfully mobile, with well-modulated ink tones, but without much tension or graphic power. His placement is sure, and even on those compositions without short poems or inscriptions at the top or tucked into a corner one has the suspicion that he left space for writing.

What is most interesting technically about Ch'en's Buddhist figures, and often gives them a peculiarly lifelike effect, is the use of colour and shading for facial detail — he uses light colour for heightening other elements, but it is the un-Chinese way in which the coloured, chiaroscuro features fit in with the flowing ink lines of the robes that surprises the viewer. It appears to be a Western usage, but in fact the painting style is a millennium old in China, and is a Buddhist painting manner derived from Indian figural style, along with the religion. As Lippe points out, portraits such as that by the Ch'an master Wu-chun, datable to 1238 and now in the Tofukuji, demonstrate that it was a manner which continued in that school of religious painting, at least. Where Ch'en differs markedly from traditional religious painting is in the uncouth realism used for at least some of his irreverent depictions of sacred deities. Ch'en seems more interested in experimenting with features, postures and expressions drawn from his observations of local people, both lay and holy.

12 VARIOUS FORMS OF KUAN-YIN (before 1654)

Album of ten leaves in ink and light colour on silk, mounted in Japanese fashion in brocade covers with brocade folder and inscribed box, with three colophon leaves by Huang-po calligraphers.

The first colophon leaf is a quatrain by Yin-yüan:
At all times, Kuan-yin reveals her merciful heart of joy and her optimistic personality. With her helping hand, she saves millions of lives by reaching into the absolute. And done, she is content.
Signed Yin-yüan Lung-ch'i of Huang-po, with three seals of the artist: Yin-yüan chih yin (square, intaglio), Lung-ch'i (square, relief) and Chu-an Mu-tz'u (rectangular, relief).

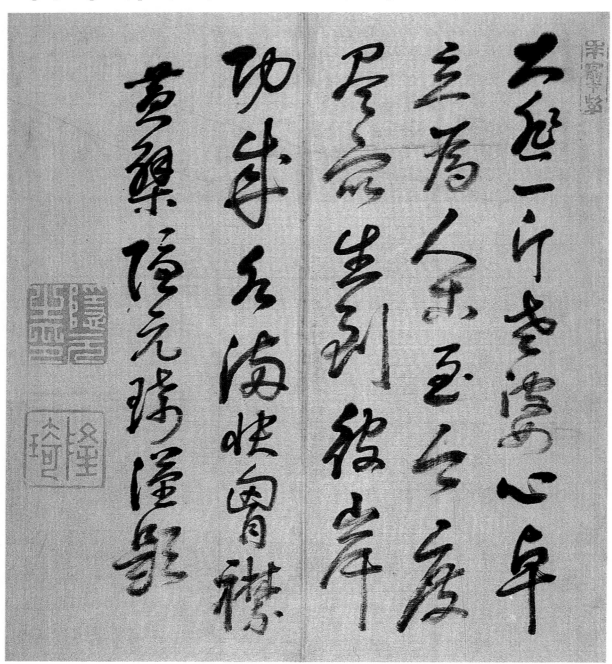

The second colophon leaf is a poem by Mu-an:
Sitting with a troubled heart, legs raised,
I ponder the ability I possess compared to that of others.
I believe that the mountain should not be white, but green as they are.
Time, like clouds across the sky, flies and will prove me right.
Signed Mu-an shan-seng of Huang-po inscribed.
With three seals of the artist: Shih-chieh T'ao yin (square, intaglio), Mu-an shih (square, relief) and
Mu-an (oval, relief).

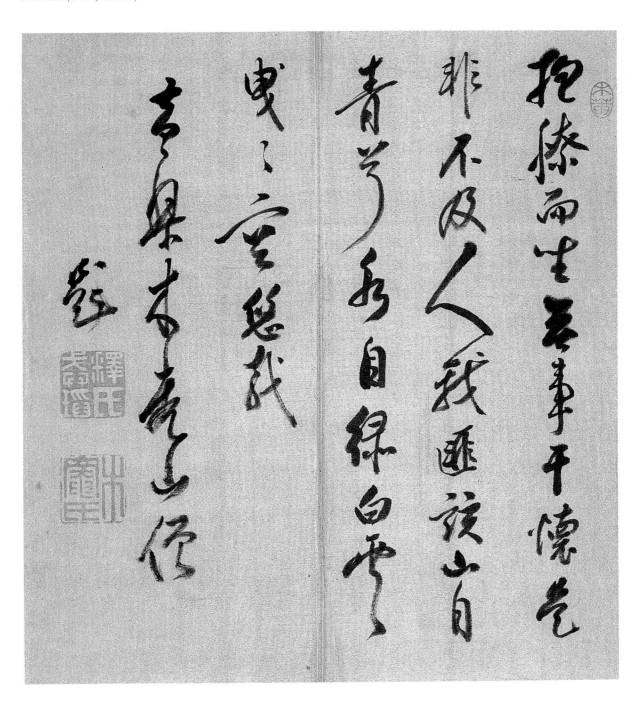

a. Kuan-yin sitting on rocks, with an alms bowl by her side.
Signed Ch'en Hsien, with one seal of the artist: Ch'en Hsien (large, square, relief; repeated throughout much of the album).
This leaf is similar to leaf 19 in the Mampukuji album of 1636.

b. Kuan-yin, sitting on a mat, wearing a diadem with *O-mi-to-fo* and holding a *ju-i* sceptre; a young attendant presents her with a scriptural scroll, or reads from it.
Signed Ch'en Hsien, with one large seal: Ch'en Hsien.
This leaf is similiar to leaf 16 in the Mampukuji album of 1636, and also fairly comparable to an uninscribed leaf in the Ching-yüan chai collection, Berkeley.

c. Kuan-yin, sitting on a mat of leaves, makes obeisance to a small statue of the Buddha which is on a flat-topped rock together with a censer.
Signed Ch'en Hsien, with one large seal: Ch'en Hsien.
This leaf is similar to leaf 10 in the Mampukuji album of 1636.

d. Kuan-yin sitting on a mat, with one arm on an extravagant arm-rest, with bowls of fruit at her side, while her young attendant offers a lotus to a passing bird.
Signed Ch'en Hsien with one small square relief seal: Ch'en Hsien.
This leaf is very similar both to leaf 12 in the Mampukuji album of 1636, and to the leaf dated 1672 in the Yabumoto collection.

a

b

c

d

e. Kuan-yin sitting almost absent-mindedly on a round straw mat, with a small pile of scrolls beside her, holding a cup and a small spray of leaves.
Signed Ch'en Hsien, with small seal: Ch'en Hsien.

f. Kuan-yin, sitting on a square mat in voluminous robes, leans over towards a small bird which hovers next to her.
Signed Ch'en Hsien, with small seal: Ch'en Hsien.
This leaf is similar to leaf 13 in the Mampukuji album of 1636, and also to a single leaf in the Sen-oku Hakko kan collection, Tokyo.

g. Kuan-yin half leans back on her mat, with books and scrolls behind her, as she admires a bowl of fruit.
Signed Ch'en Hsien, with large square relief seal: Chien pi-mo yin shuo-fa.

h. Kuan-yin sits simply and demurely in meditation on a small round mat, two scrolls and a vase with a prunus spray behind her.
Signed Ch'en Hsien, with small seal: Ch'en Hsien.

e

f

g

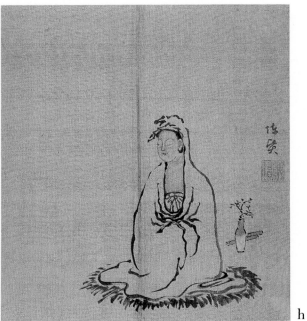

h

i. Kuan-yin sits full face on an highly decorated mat on which are laid a *ju-i* sceptre and three elaborate vessels. Her body jewellery, broad, imposing features and the agitated lines of her robe create a powerful impression.

Signed Ch'en Hsien, with large seal: Ch'en Hsien.

This leaf is similar to leaf 4 in the Mampukuji album of 1636 which, though more detailed, does not appear to be as effective as this example.

j. Kuan-yin relaxes in a high-backed bamboo chair, holding a rosary, with her robe falling open.

Signed Ch'en Hsien, with two large seals: Ch'en Hsien and Chien pi-mo yin shuo-fa.

The final colophon leaf was written by a less famous Huang-po monk, Tu-hou (Dokukō, or Dokkō, 1624–1688). He was one of the twenty-three disciples of Yin-yüan, who awarded him with his seal of enlightenment in 1672, and he founded the Kanshoin, a sub-temple of Mampukuji.

The colophon reads:

The scenery is lively and striking as birds fly and fish jump among the rock garden. The omniscient Kuan-yin with her all-seeing eyes hopes for all things.

He signs his name Han-sung (Kansho) fa-ti hsing-shih, making obeisance.

With three seals of the writer: Yang-lin (square, relief), Fang-wai chien-jen (square, relief) and Pu-ju-chiao (rectangular, intaglio).

Each leaf measure 9 5/8 inches × 8 5/8 inches.

An article in the *National Palace Museum Bulletin*, Taipei, vol XVI, no. 4 (1981), the second of a series on Chang Jui-t'u (see no. 8), discusses his connection with the Huang-po sect through his son, Chang Ch'ien-fu, a friend of Mu-an. It mentions a 1643 handscroll by Ch'en Hsien with inscriptions by Mu-an (at the beginning) and Ch'ien-fu. This handscroll is probably the Freer example, where (in *Chinese Figure Painting*) the writer of the quatrain has been misread as Chang Ch'ieh-shih. The calligraphy of Huang-po monks such as Yin-yüan and Mu-an was very much influenced by Chang Jui-t'u's style, as well as the pervasive manner of Tung Ch'i-ch'ang. They introduced quite a different flavour into Japanese Zen calligraphy.

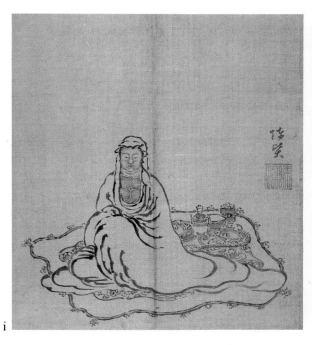

i

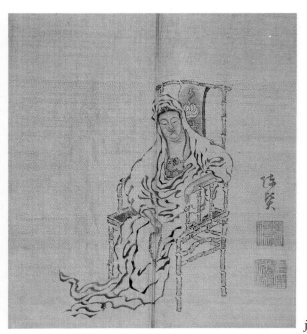

j

CHUANG CHIUNG-SHENG tzu: Yü-ts'ung.

1627–1679 **hao:** Tan-jen, Tan-an (chü-shih).
From Wu-chin, Kiangsu.

CHUANG'S birthdate is usually given as 1626, with few details of his later life known; as *Chung-kuo mei-shu-chia jen-ming tz'u-tien* professes to know more accurately such matters as his age at death, I shall follow their dating of his birth as well.

Chuang Chiung-sheng was a *chin-shih* graduate of 1647 and a court painter to the Shun-chih emperor. In addition to competent work as a painter mostly of small landscapes "filled with a scholarly spirit", he could paint elegant ink orchids and prunus, and was also known as a poet, antiquarian and calligrapher. Chuang and Tai Ming-shuo were the major court painters of the time, apart from the Shun-chih emperor himself, who is recorded as an innovative finger painter. Tradition relates that "the emperor once visited the Academy and on the walls there saw a landscape by Chiung-sheng which pleased him very much. He gave orders that brushes and paper should be sent to the painter so that he should do more works. Chuang then made a picture of a fabulous horse to show his aspirations. The emperor was delighted with it and presented the painter with a golden bowl and two robes, appointing him tutor of the heir apparent and a reader to the emperor".

Published paintings by Chuang, of which there are very few, date between 1652 and 1665, and betray an eclectic approach to the styles of various old masters. Generally Chuang seems to have followed Yüan models, modulated by the brushwork style of Shen Chou; Siren observes through study of two works that "neither possesses a very intimate individual character, but they reveal the brushwork of a highly trained painter who has paid more attention to the Yüan and early Ming masters than to those of the Sung period. He, too, looks backward, but not as far as Tai Ming-shuo, and his conceptions are more independent". In fact, as can be seen from the example here, Chuang was wideranging enough in style to attempt the unfashionable Southern Sung style of Hsia Kuei as well as the accepted canon of Southern school masters.

13 LANDSCAPE AFTER HSIA KUEI
Mounted in Japanese fashion as a hanging scroll in ink and colours on silk, with fitted wooden box.

A scholar wanders along a riverside path among scattered bamboo towards a low bridge with elegant willow trees on the other side, their delicate, waving forms echoing the arching of the bamboo stands opposite. In the distance a steep escarpment of precipitous mountains, with another range far beyond, rises above atmospheric banks of mist which nearly obscure the heavily wooded foothills.

With an inscription by the artist: Hsia Chung-kuei (Hsia Kuei) was the last (i.e. the best) man of the Southern Sung (*nan-tu*, southern ferry, means, in reference to the Sung period, to cross the Yangtze southwards in the flight from the north, leading to the establishment of the Southern Sung capital at Kaifeng). The Ma family, father and son (Ma Yüan and Ma Lin) were never his peer.
Signed Chiung-sheng, with two square seals of the artist: Chuang Chiung-sheng yin (relief) and Tan-an (intaglio).
The painting measures 18 1/4 × 11 5/8 inches.

Provenance: N. Hammer, ex G.J. Schlenker collection.
Formerly on loan to the University Art Museum, University of California, Berkeley.
Published: Kei Suzuki, *Comprehensive Illustrated Catalog of Chinese Paintings*, vol. 1, A32–013.

Kei Suzuki illustrates only three other paintings by Chuang: two fans, and a handscroll in the Asian Art Museum of San Francisco. Siren lists only seven works, and illustrates a tall hanging scroll in *A History*

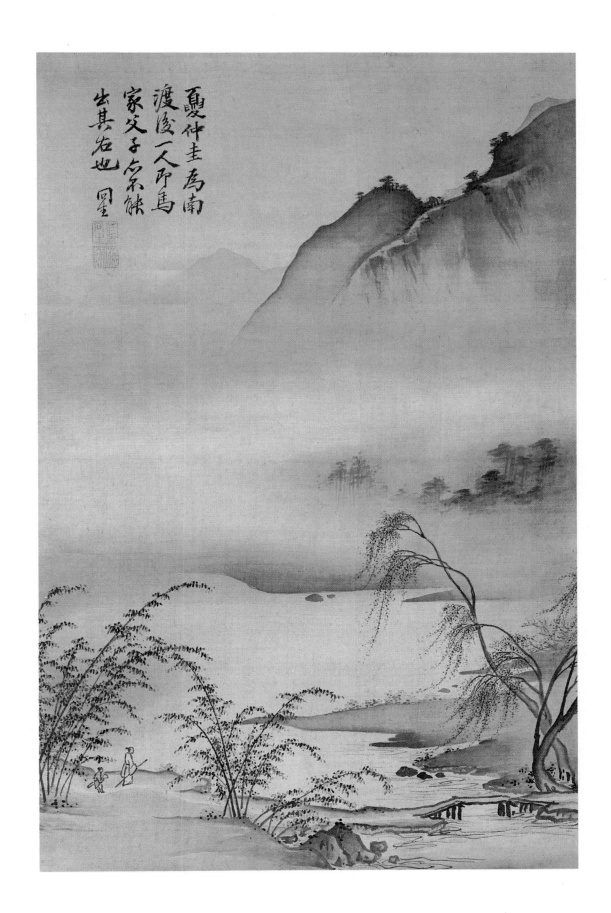

of Later Chinese Painting, vol. II, pl. 166b.

See Whitfield, *In Pursuit of Antiquity*, pp. 114–115 for evidence that Chuang acquired the great Northern Sung artist Chü-jan's masterpiece *Mist Floating on a Distant Peak*, and was furthermore well acquainted with Wang Chien, and probably Wang Hui and other orthodox masters. Wang Hui painted a copy of the painting for Ta Ch'ung-kuang.

There is considerable doubt about the authenticity of nearly every painting attributed to Hsia Kuei; see Kei Suzuki, "Hsia Kuei and the Pictorial Style of the Southern Sung Court Academy", *Proceedings of the International Symposium on Chinese Painting*, pp. 417–461. However, the unsigned masterpiece *The Remote View of Hills and Streams*, thought to be by the master and now in the National Palace Museum, Taipei, at last affords an excellent survey of various aspects of Hsia Kuei's style, genuine or not. The handscroll is reproduced in full, in a separate monochrome pocket fold-out, to accompany the above *Proceedings*. Details of Chuang's painting such as the fine bamboo might have been directly borrowed from that handscroll or from other Palace collection works by or attributed to Hsia, as they were certainly otherwise very rare even at that time.

In the case of Chuang, and similarly that of Ta Ch'ung-kuang, it is quite possible that court officials, painters and connoisseurs in their own right, might have had unequalled opportunities very early in the Ch'ing to inspect and copy the great rarities in the Imperial collections, even though the collections were not as extensive as they became in the Ch'ien-lung period; and may occasionally have been able to use their position to acquire major early works such as the Chü-jan.

TA CH'UNG-KUANG
1623–1692

tzu: Tsai-hsin.

hao: Chiang-shan wai-shih, T'ai-hsin, Feng-chen, Shih-ch'ing tao-jen, Chün-hsüan, Ch'an-kuang.

Ta also styled himself Yü-kang chü-shih, or Yü-kang sao-yeh tao-jen. Late in life, living on Mao-shan and studying Taoism, he changed his *ming* to Ch'uan-kuang, and his *hao* to I-sou, I-kuang and Chiang-shan i-kuang. At that time he used a seal reading T'ieh-weng ch'eng-hsi i-sou.

studio name: Sung-tzu k'o.

From Tan-t'u, Kiangsu.

TA Ch'ung-kuang (sometimes given as Tan Ch'ung-kuang or Chung-kuang) was a *chin-shih* graduate of 1652, and became an Imperial Censor. He is best known as a calligrapher, writing in the style of Su Tung-p'o, with strong influences of Mi Fu and Tung Ch'i-ch'ang (the latter particularly in his large hanging scrolls, which are generally too rich and loose). He was classed as one of four great calligraphic masters with Chiang Chen-ying, Wang Shih-hung and Ho Ch'o, and was much esteemed at the time. Ecke, in *Chinese Calligraphy*, illustrates a fine poem in handscroll format written by him, dated 1655, as no. 81, and *Shodo Zenshu* one of his typical large, flowing hanging scrolls (vol. 21, pl. 60). Ta was known as a scholarly gentleman with free and easy manners, and as a connoisseur. He was the author of well-known and useful treatises on calligraphy (*Shu-fa*) and on painting (*Hua-ch'üan*). The latter book became quite famous to students of painting, partly because of its sound practical advice as to details of landscape composition. Siren renders parts of it in *Chinese Painting*, vol. V, pp. 124–125.

As a painter Ta was eclectic and perhaps more capable than has been appreciated. Living first in the capital, then in Kiangsu (probably the leading regional artist away from the chief cultural centres), a hermit for much of his later life, he was nonetheless closely associated with Wang Hui and Yün Shou-p'ing, and was also friendly with other well-known painters. Siren lists a 1671 landscape in Shen Chou style by Ta bearing a poem by Yün, as well as a Yüan style landscape of about the same time, bearing colophons by both Wang and Yün. In 1673 Wang Hui painted a fine album of twelve leaves after old masters for Wang Shih-min, titled *In Pursuit of Antiquity*, now in the Morse collection: see Whitfield *In Pursuit of Antiquity*, no. 16, pp. 119–142. Wang Shih-min sought out colophons by such diverse writers as Yün Shou-p'ing, the Anhui master Ch'eng Sui, Ch'a Shih-piao and Ta Ch'ung-kuang, who added five encomiums. Ch'a Shih-piao (see no. 15) was a friend of Ta, and painted an album for him in 1670; two years later Ta asked his friend Wang Hui to embellish it with moss dots and ink washes. Fu, *Studies in Connoisseurship*, pp. 154–155, considers Ta's friendship with Ch'a and his acquaintance with painters from Anhui and the Lake T'ai region to be a significant parallel to Ch'a's own crossing of the supposed dividing line between orthodox and individualist painters in the early Ch'ing period. Siren likewise considers (*Chinese Painting*, vol. V., p. 125) that: "In his treatise Ta Ch'ung-kuang appears as a representative of the new movement in landscape painting that grew up in various places during the latter half of the century and formed the general background for the so-called individualists who injected more creative imagination and, at the same time, more penetrating naturalism into Chinese landscape painting". Ta was not a prolific painter; at least, not very many of his works have survived. Siren lists only thirteen works by him, dating between 1660 and 1687; we have already noted a calligraphic work dated 1655.

Kei Suzuki, *Comprehensive Illustrated Catalog of Chinese Painting*, illustrates only five works, ranging from relatively dry scenes in Yüan style to one of Ta's favoured manners, that of Shen Chou, most suited to his calligraphic looseness. As the *T'ung-yin lun-hua* has it: "Sometimes he painted landscapes of a very pleasant and attractive kind, filled with noble feelings. He was able to express it all at the tip of his brush, because of his expert connoisseurship. His paintings were rich but not vulgar, soaked (with ink) but not turbid. If one compares him with those painters of the world who had brush but no ink, or ink but no brush, he stands as high above them as the sky above the earth."

Very few of Ta's landscapes reveal this refined sensibility expressing itself in the mode of Southern Sung lyricism, a most unusual style for painters of the period to employ, even if through the conduit of Wen Cheng-ming, as stated in the inscription to the present example. A misty landscape after Mi Fu in the collection of Professor Cheng Te-k'un (*Mu-fei ts'ang-hua k'ao-p'ing*, p. 41) is one indication of such a mood surfacing in Ta's work, but even more to the point is a landscape dated 1679 in the Taitsu Hashimoto collection, Japan, exhibited at the Museum Yamato Bunkakan, Nara, in 1980, catalogue no. 42. Although its lyrical prettiness has been modified by an expressive loaded brush in the Shen Chou style, both in feeling and composition it is very close to the rare example offered here.

14 GENTLEMAN BY PINE BROOK, with an inscription by Yün Shou-p'ing.
A hanging scroll in ink on paper.

A lone scholar sits on a flat promontory by a rushing stream, the solitary gnarled and jagged pine above him symbolic of his noble purity of heart and capacity to withstand hardship. He stares into nothingness, or more accurately in the general direction of the mountain rising steeply into the top right of the composition. The rocks are treated in an extraordinary fashion, most unexpectedly for a calligrapher, with an application of random, flat, darker dabs and strokes on gradated ink washes, to give an impression of mistiness and permit the tree to stand out all the more sharply. This represents a personal reworking of Southern Sung conventions, with details of the composition borrowed from the masters Hsia Kuei and Ma Yüan, but altered markedly in spirit, presumably through the influence of Wen Cheng-ming's version.

With three square relief seals of the painter: Chiang-shan wai-shih, Ta Tsai-hsin and Chiang-shan wai-shih Ta Ch'ung-kuang Tsai-hsin fu yin.
With an inscription by Yün Shou-p'ing (1633–1690), one of the Six Orthodox Masters of Early Ch'ing: *The Gentleman by Pine Brook* was painted by Wen Cheng-ming. Censor Ta made a copy from the original capturing both the form and the spirit. Its untrammelled manner supersedes the original; how could the common artist even dream of such an achievement? Yün Shou-p'ing inscribed. We offered a rare 1680 ink landscape by Yün after Fang Ts'ung-i in *Emperor Scholar Artisan Monk*, as no. 16.
With three rectangular seals of Yün: Yüan-k'o (intaglio), Yün Ko (relief) and Cheng-shu (intaglio).
The painting measures 25 × 13 inches.

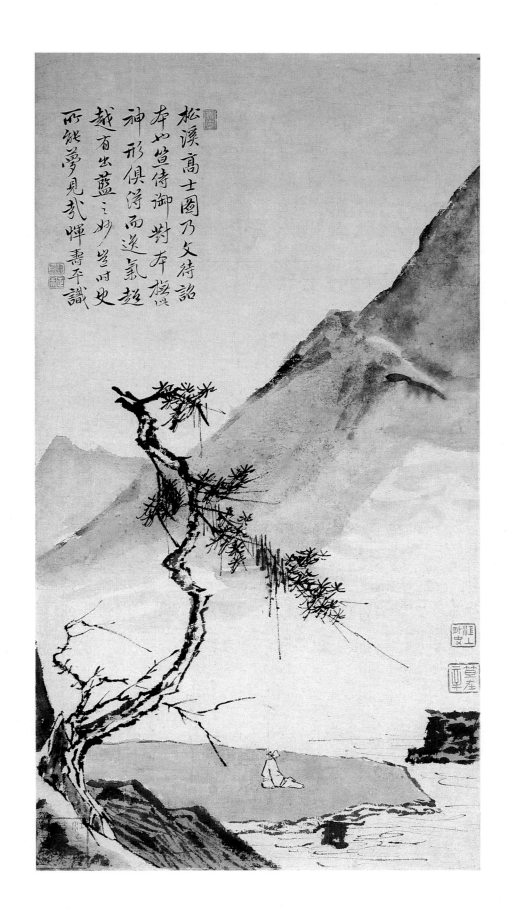

松溪高士圖乃文待詔
本山莊侍御對本摹寫
神形俱得而逸氣超
越有出藍之妙壬申時史
所能夢見武惲壽平識

CH'A SHIH-PIAO
1615–1698

tzu: Erh-chan.
hao: Mei-ho (san-jen), Lan-lao, Hou i-mao sheng.
From Hsiu-ning, Anhui; after 1670 lived much of the time in Yangchou.
Ch'a is grouped with Hung-jen, Sun I and Wang Chih-jui as one of the Four
Great Masters of Hsin-an, or Hai-yang (Anhui).

CH'A Shih-piao was a graduate of the late Ming dynasty and the scion of a wealthy family of connoisseurs, who took up painting and calligraphy after the advent of the Ch'ing. Several details of his life are recorded in *Emperor Scholar Artisan Monk*, where we offered an unusual calligraphic hanging scroll by Ch'a as no. 15. He was a prolific painter, and a majority of serious collections include at least one example of his work. Art-historically he is most interesting and difficult to define or place, partly because the quality of individual works may range unevenly from the brilliant to the mediocre, and partly because of his personal position in the early Ch'ing period in the cross-currents of stylistic influences of the day.

Virtually all of Ch'a's early paintings, and in its essentials his early calligraphy too, were very much within the spare, skeletal vein of conceptualisation of form realised by Ni Tsan and transformed by Hung-jen, the pivotal master of the Anhui school. Ch'a was the first and only one of Hung-jen's pupils or associates to successfully break away from that vision, though he later became quite eclectic in style. Critics observed that he had a "broad style" and a "fine style", which is accurate as far as generalisations go; in fact, Ch'a worked after the manner of such old masters as Mi Fu, Wu Chen, Kuo Hsi, Huang Kung-wang and Tung Yüan. Even early on, his Ni Tsan style demonstrates the influence of Tung Ch'i-ch'ang as well as of Hung-jen, and in his mature period an experimental splashy, expressive style shows the impression Shen Chou's painting made on Ch'a.

He kept a foot in both the individualist and the orthodox camps; indeed, as the perceptive analysis Fu, *Studies in Connoisseurship*, pp. 152–155 shows, it has not yet been fully appreciated how both in his stylistic range and in his personal contacts Ch'a demonstrates the artificiality of a sharp critical distinction between the two camps in the seventeenth century. In addition to Ch'a Shih-piao's fascinating circle of cultured friends and patrons in Yangchou, he was also close to such diverse individualist and orthodox artists from elsewhere as Ta Ch'ung-kuang (see no. 14), Wang Hui, Wang Shih-min and even the younger Tao-chi. *Studies in Connoisseurship* demonstrates some influence of Ch'a upon Tao-chi's development (Tao-chi praised him for possessing the same quality of "pure elusiveness" as Hung-jen) and makes another relevant point, contrasting Hung-jen's landscapes with similar works of Ch'a Shih-piao. "Ch'a's overall use of ink is moister, his ink gradations darker, and his brushline much less tense and attentive to the articulation of the joints and angles of forms. He tends to use an upright brush (as opposed to Hung-jen's oblique brushhold) moving in a relatively quick and jagged rhythm (as opposed to Hung-jen's slower, more consistent and penetrating pace). These are some of the brush qualities which become Ch'a's 'broad' style."

Ch'a Shih-piao appears to have been something of a dilettante in his artistic development; compositional brilliance evidently came easily to him, and his best works can be seen essentially as essays in personal stylistic interpretation of a poetic nature, rather than the articulation of some artistic vision; his lesser works, while never mechanical, tend to be uninspired and sometimes insipid. However, this apparent indulgence in understated and effortless brushwork epitomises the scholar-painter's ethic: artistic freedom in composition and brushwork as an offshoot of one's discipline and accomplishment in calligraphy.

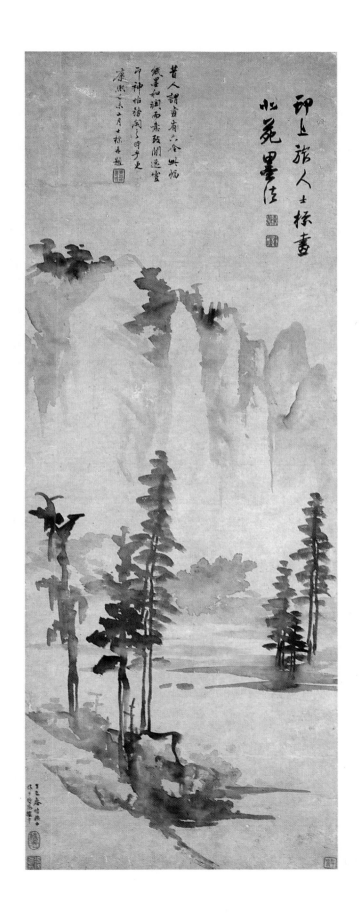

15 LANDSCAPE AFTER TUNG YÜAN (1677)
A hanging scroll in ink on paper.

Oddly constructed foreground trees drip with moisture, details of their forms merging with the rocky foreshore on which they stand and the even damper foliage on the far bank of the river. Sheer tree-topped cliffs rise wetly above the scene in an almost abstract composition intended as a riotous, almost drunken play in ink tonality.

The painting bears three separate inscriptions by Ch'a Shih-piao. The first reads: Painted after the ink manner of Pei-yüan (Tung Yüan, tenth century), by Shih-piao, the Yangchou (Han-shang) traveller; with two square relief seals of the artist: Mei-ho (Contag & Wang 8) and Ch'a Erh-chan (Contag & Wang 12). The second reads: Done in the Tai-yen lou on a day for purification in spring of the *ting-ssu* year (1677); with two seals of the artist: Lan-lao (oval, relief) and Hou i-mao jen (square, intaglio). Tai-yen lou (waiting for wild geese pavilion) was a hall name of Ch'a. The third reads: Of old, men said; "Painting has six harmonies". This scroll of paper and ink is harmoniously moist, yet in expressing meaning it falls short of the untrammelled. How can one attain a time of divine ease and cultivating leisure? Shih-piao again inscribed in the second month of the *chi-wei* year of the K'ang-hsi period (1679); with one rectangular relief seal of the artist: Huang-shan pai-ch'iu Ch'a Erh-chan.
There is one further square relief seal in the bottom right corner of the composition, probably another of the artist's: Ts'un-tzu (?).
The painting measures 37 3/4 inches × 14 inches.

An ink landscape of comparable abandoned ink play and tonality is in the collection of the Suchou Municipal Museum, catalogue p. 43. Fu, *Studies in Connoisseurship*, p. 155, note 3, lists four published works by Ch'a Shih-piao which were inscribed as having been painted in Yangchou, dated 1671, 1674, 1678 and 1687.

CHU SHENG

1618–1690 or later

tzu: Jih-ju.

hao: Hsi-an.

From Jen-ho (Hangchou), Chekiang.

CHU Sheng was a fine painter of orchids, bamboo and rocks, and from about 1635 to 1655 was the pupil of Lu Te-chih, a Chekiang calligrapher and painter of orchids and bamboo, who was himself the pupil of Li Jih-hua. There are one or two quite competent landscapes by Chu known, as well as two handscrolls in the Sickman collection, Kansas City, representing Bodhidharma crossing the Yangtze and a Taoist immortal with a dragon, but these are rarities. Chu's few known orchid paintings are mostly in fan or album leaf format, and he is best known for hanging scrolls of relatively large size depicting very atmospheric wet and dry bamboo and rocks on satiny silk. The majority of these are in Japanese private collections; of 14 paintings by Chu illustrated in Kei Suzuki, *Comprehensive Illustrated Catalog of Chinese Paintings*, 11 are from Japanese private sources and 2 more from Southeast Asian collections. Another good, large example is in the collection of the Cathay Art Museum, Taipei, catalogue vol 11 (of 12), no. 4. However, Chu was fairly prolific, as well as extremely competent in his preferred area of endeavour, and in fact there are quite a number of good paintings by him in Western collections.

One point about Chu's dating must be clarified. Siren's *Lists* describe him as active ca. 1680–1735, and mentions three paintings from American collections dated 1722, 1742 and 1734. All other sources agree that Chu was born in 1618, and as most published, dated paintings by him give only a cyclical date this must have been a source of some confusion. Other known details of Chu's life do not fit, unless he can be established to have worked only in the first half of the K'ang-hsi period. Consequently these American works must actually be dated to 1662, 1664 and 1674, which is earlier than most of Chu's work, and interesting for that reason. However, a convincingly "early-looking" orchid fan dated (cyclically) to 1664 is in the Matazaemon Nakano collection, Japan, and an elegant orchid and rock album leaf in the Cathay Art Museum, Taipei, is likewise dated to 1662 [catalogue vol 5 (of 6), no. 1]; and so it seems that we should extend his known range of activity to ca. 1662–1690. Most of his large bamboo and rock paintings, though, were done between 1680 and 1690. One typical bamboo and rock painting in the collection of Mayuyama and Company is dated to 1690, when Chu was a 74 year-old man; if he was born in 1618 it must have been in the first month of the year.

Chu Sheng is particularly well-known because he contributed the bamboo and epidendrum designs for the expanded edition of the *Chieh-tzu yüan hua-chuan* (A Repertory of Painting of the Mustard Seed Garden), edited by Wang Kai (see no. 18). The quality of design and of printing of the first edition, in 1679, was not of the highest, but in the second, expanded version to which Chu and Wang Yün-an contributed (begun in 1682 and completed in 1701) both the colour printing and the artistic quality of the bamboo and plum blossoms were superior. *The Mustard Seed Garden* remains a most influential painting manual. The Nelson Gallery/Atkins Museum, Kansas City at one time had (still has?) a gallery devoted to the manual, which featured a huge Chu Sheng bamboo and rocks hanging scroll. One curious variant of Chu's work is a recent acquisition of the British Museum; a collaborative wall scroll (tall handscroll format) of bamboo by Chu with small red birds painted by a little-known contemporary, Tai Chao.

The most interesting aspect of Chu's work, though, is in his grouping with *Ming i-min* (left-over citizens), Ming loyalist scholar-amateurs who in varying degrees declined to serve under the Manchu regime. A typical Chu Sheng wet and dry bamboo and rock hanging scroll, dated 1683, is included in *Paintings and Calligraphy by Ming i-min in the Chih-lo Lou collection* as no. 77. Characteristics of *i-min* painters, which naturally vary from one individual to another, include poetic extemporisation, and the expression of individuality; the use of the dry brush and the use of space; and a perceptive reduction from superficial complexity to simple truth. Although not enough is known of Chu Sheng's political and social relations to be didactic about his inclusion as an avowed *i-min* artist, yet his

sensitive, atmospheric brushwork (described as strong and consistent) is restrained and poetic, sympathetic in feeling to that primarily emotional approach. His early painting, on a smaller scale, is more compatible with the above parameters of *i-min* taste.

Chu Sheng is too much of a "one-subject" painter for his bamboo and rock paintings to be thought of as a powerful individual statement, but to some extent these paintings do "dream" an idealised condition, albeit a traditional, pleasing one. One interesting point which has been raised about *i-min* painters is their age at the time of the Manchu invasion. Most major, active Ming loyalist artists were still young enough at the advent of the Ch'ing to retain some idealism and rebellious instincts, and Chu Sheng was an exact contemporary. Siren lists a "screen of six panels" of bamboo and rocks by Chu Sheng, which is illustrated in a book called *Ming-jen hsieh-chu* (Album of Bamboo Paintings), 1930; otherwise Chu's use of this large, expansive format is unrecorded. Because of its scale alone, and because it permits him to ring the changes through his variant compositional forms, the example here must be considered one of his masterpieces.

16 ROCKS AND STREAM IN A BAMBOO GROVE (1681)
A set of twelve hanging scrolls forming one continuous composition, in ink on silk.

A broad, shallow stream enters from marshy ground on the left of the composition, passing around the low, clumpy foot of a tall rock cluster. In the foreground, middle and background, wet, atmospheric bamboo springs up, overhanging a large, square-cut rock in the middle of the grove. Beyond this further rocky outcrops fade into the humid mist, partially obscured by more bamboo clusters. In the foreground a dramatic dark and pale group of low bamboo dominates the scene, with misty stands of bamboo behind it arching over rocks to join the topmost nodes and leaves of a tall bamboo copse to the right. After that cluster, a steep and torrential waterfall emerges from its gouged-out channel in a rocky cliff wall to join the placid stream, passing behind one final rocky outcrop, overhung by a last, dramatic, wet and dry, near and distant group of bamboo stems and leaves.

Dated on the extreme left-hand scroll to the K'ang-hsi period, autumn of the *hsin-yu* year (1681) and dedicated to Mr. Hu-weng. The art name of the recipient is not recorded.
Signed Chu Sheng of Ch'ien-t'ang, with three seals of the artist: Chu Sheng chih yin (square, relief), Hsi-an (square, intaglio) and Pao-ku t'ang (rectangular, intaglio).
Each scroll measures 78 5/8 × 18 3/4 inches; the entire composition is 246 inches wide.

From the collection of Rudolf Sterz.

It is unusual for Chu or any *i-min* painter to incorporate a Ch'ing reign title in dating paintings. Perhaps, considering this a major work, he wanted to fully document it, and incidentally render its impressiveness more resonant; probably, by the time he came to paint his larger bamboo compositions any *i-min* sentiments had mellowed.

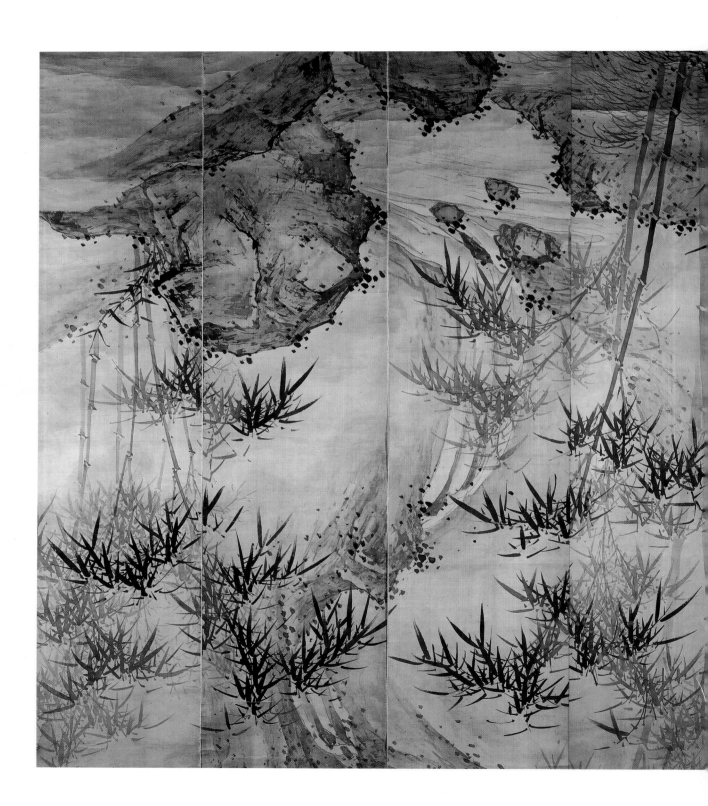

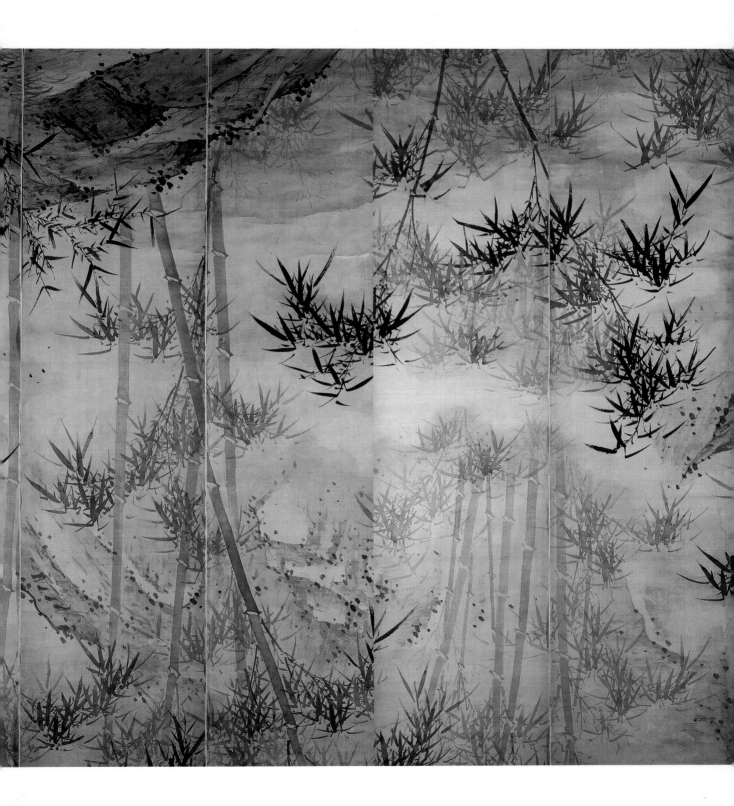

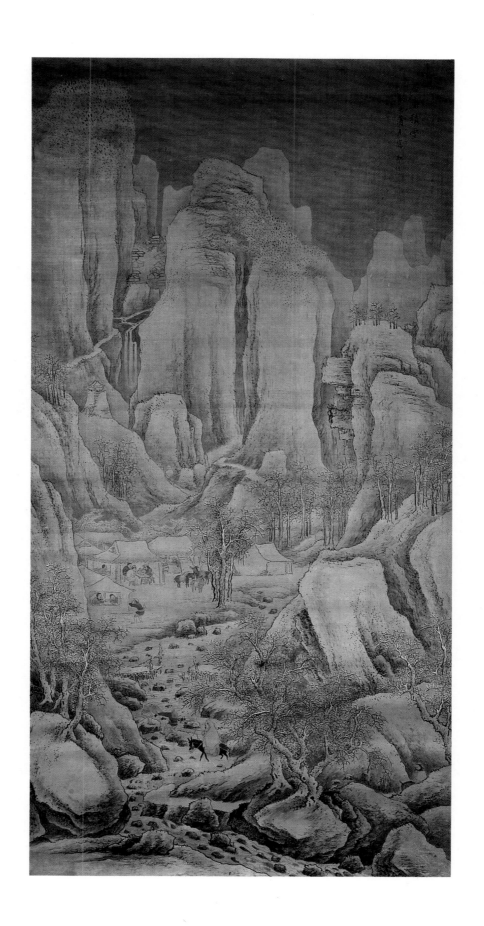

WANG KAI

active ca. 1677–1705

ming: Kai (alternative), or Kai-pen.
tzu: An-chieh.
hao: Tung-kuo.
Also known as Lu-ch'ai.
From Hsiu-shui (Chia-hsing, Chekiang); but the family moved to Nanking in Wang Kai's youth. He was the younger brother of Wang Shih, and a life-long vegetarian.

WANG Kai is known as the editor or chief compiler of the most famous Chinese painting instruction manual, the *Chieh-tzu yüan hua-chuan* (A Repertory of Painting of the Mustard Seed Garden), and as the pupil of Kung Hsien in landscape painting. In fact he was a recognised poet and writer, as well as a fine seal-carver and genre artist, capable of painting figures, flowers and animals. He is also mentioned as a fine bamboo carver; *Chung-kuo mei-shu-chia jen-ming tz'u-tien* describes a "poem-pot" by him, a little over three inches high, superbly carved in the *liu-ch'ing* (floating skin) technique, the most difficult of bamboo carving techniques; he must have known the great Nanking bamboo carvers, Chang Hsi-huang and P'u Chung-ch'ien.

Wang seems to have known most other local notables; he was described by friends, perhaps kindly, as "the most affectionate guest in the world". The Eight Nanking Masters, of whom Kung Hsien was the most notable, and Fan Ch'i the only other one of real importance apart from rarity value; were actually quite stylistically distinct (though all relatively individualistic — examples of the work of each are published, understandably, in the catalogue of the Nanking Museum's painting collection) and primarily linked through the patronage of the great connoisseur Chou Liang-kung (1612–1672). Victoria Contag, in *Chinese Masters of the 17th Century*, describes on page 36, a feast at Chou's house in 1669, the guests including the painters "Fan Ch'i, Yeh Hsin, Tsou Che, Wu Hung, Kao Ts'en (prevented from coming by illness), Wang Hui, Wang Kai and Yang Wen-ts'ung. Kung Hsien remained shut up in his country house by the river with closed gates. But later he came after all and with brush and ink painted an excellent picture of Wang Lang (AD 228)". The list incorporates all of the Eight Masters with the exception of Hsieh Sun and Hu Tsao, in addition to the interesting inclusion of the orthodox giant Wang Hui. Chou Liang-kung, despite his Ch'ing official position, had been a significantly active Ming loyalist, and his coterie in Nanking had subversive anti-establishment leanings. Kung Hsien, who grouped his own "heterodox" tendencies rather with K'un-ts'an and Ch'eng Cheng-k'uei, nonetheless admired Wang Hui and asked him to paint for him — further evidence of the artificial divisions later imposed upon late seventeenth-century orthodox and individualist painters.

Kung Hsien was the author of the *Hua Chüeh*, the first major landscape and compositional painting manual, and other variant sketchbooks (there had been specific manuals for such subjects as bamboo, or prunus); and Wang Kai's compilation of *The Mustard Seed Garden* manual can perhaps be seen as an extension of that attempt to code and define theoretical directions and principles for a new generation of painters, based on the old masters. Siren, *Chinese Painting: Leading Masters and Principles*, vol. V, pp. 135–137, discusses the evolution of the various editions and impressions, which were initially based on 43 drawings by Li Liu-fang belonging to the owner of the Mustard Seed Garden in Nanking, the wealthy amateur Shen Hsin-yu. The first edition in 1679, considerably expanded by Wang from the base material of these drawings, was notable more for his compilations of old writers than for the attempt to reproduce old painters' styles or for the quality of the printing. Nonetheless it was and remains a highly influential success, and the continuation (begun in 1682 and completed in 1701) contains the addition of superior plates of plum-blossoms (for which the drawings were done by Wang Yün-an), epidendrums and bamboo (for which the original drawings were executed by Chu Sheng, see no. 16). A third collection, published together with the second and featuring more insects and birds, seems to have been edited by Wang Kai's brother, Wang Shih.

Wang Kai was not the only pupil (and friend) of Kung Hsien, but he is the only one about whom

TS'AO YÜAN

active late
17th century

tzu: Hsing-tsu.
From Suchou, Kiangsu; lived in Hangchou.

TS'AO Yüan was the son of the Ming painter Ts'ao Chen, who was the younger brother of Ts'ao Hsi. Paintings by Ts'ao Hsi are recorded (Siren, *Lists)*, dating between 1616 and 1637; and Kei Suzuki, *Comprehensive Illustrated Catalog of Chinese Paintings*, JM3–180–3, illustrates an album leaf by Ts'ao Chen dated 1650 in the Osaka Museum of Art. Ts'ao Chen is also recorded with Suchou as his birthplace but as having moved to Hangchou, so probably Ts'ao Yüan lived most of his adult life in Hangchou.

It is recorded of Ts'ao Yüan that he was, like his father, excessively fond of wine; "every time he felt the urge to take up his brush and paint he immediately got drunk; consequently he had a tendency towards the unexpected" (*Hangchou gazetteer*). It may also help to explain the paucity of information about him, and recorded paintings by him. He was known as a painter of figures, landscapes and birds and flowers. Ferguson, *Li-tai chu-lu hua-mu* records two paintings by him; a cold riverscape, and a scene entitled *Catching Fish*.

17 MOUNTAIN PASS COVERED WITH SNOW (1683)

A large hanging scroll in ink and colours on silk.

Two donkey-borne travellers wrapped in cloaks make their way along the foreground route, past frozen prunus trees growing out of bulky rocks, each traveller is accompanied by two guides on foot. One traveller's mount has had to leave the path and pick its way up the frozen riverbed as the only way on, while the two guides leap from stone to stone. They are about to arrive at a small group of huts which serve as an eating-station for muleteers and unseasonal voyagers. From the animated scenes at the lunch-stop, with characters talking, eating and serving as their mules stand tethered outside, one lonely figure makes off into the trees on the right of the composition, while two mounted men continue on the path which leads up past a watchtower into the taller mountains to the left of the picture. Above a waterfall and between the two main foliage-topped, mountainous masses can be seen the pass itself, with a cluster of houses and a fortified, walled gate. The dark wash to the silk gives the impression of a sky heavy with snow-clouds, and every detail of the landscape is evidently covered with snow.

With the title: *Chü-yung chi hsüeh* (Mount Chü-yung's pass piled up with snow). Chü-yung (kuan), alternatively known as Chün-tu shan, is the pass between the Ming tombs and the Great Wall, northwest of Ch'ang-p'ing within the municipality of Greater Peking.

Painted on the fifth month of the *kuei-hai* year (1683).
Signed Ts'ao Yüan, with two square seals of the artist: Ts'ao Yüan chih yin (intaglio) and Hsing-tzu (relief).
With one seal of the contemporary Taiwanese collector Chang Po-chin: T'ien-yin t'ang chien ts'ang yin (square, relief). Mr. Chang was born in 1900 in Hsing-t'ang, Hopei, and was formerly ambassador to Japan from the Republic of China.
The painting measures 74 1/4 × 37 3/8 inches.

From the Chang Po-chin collection, Taipei.
Published: *Tien Yin Tang Collection: One Hundred Masterpieces of Chinese Painting*, no. 90.

much is known. Aschwin Lippe mentions, among other useful details, in "Kung Hsien and the Nanking School — II" (*Oriental Art* magazine, vol. IV, no. 4, Winter 1958, pp. 159–170), two followers of Kung named Lü Ch'ien, from Szechwan, and Ta-shan, a Cantonese monk-poet. Wang Kai, though, incorporated much of Kung Hsien's technique and feeling into his work, in combination with the more conservative style of Fan Ch'i and that of the lesser known Nanking master Kao Ts'en. Wang is artistically far slighter than Kung (one of the great Chinese painters), considerably lighter in his use of ink (like virtually every other painter, Kung Hsien was criticised endlessly for his excessive use of ink) and much more traditional in conception. He incorporates rather bland (though competent and quite appealing) figures into his landscape compositions, for example; people almost never appear in Kung Hsien's landscapes. He is said to have been a good painter of large landscapes with pine trees and stones, presumably in the manner of Kung Hsien; but only very few of these are published. The majority of his illustrated works appear to be in album form, with a small number of handscrolls, in which he was able to work out an intimate, personal style which faintly echoes the spirit of Kung Hsien without attempting to emulate him.

Two fine eight-leaf albums which are accessible in published form are in the Cleveland Museum of Art (*Eight Dynasties of Chinese Painting*, no. 220, dated 1677) and in the Tientsin Arts Museum (*Chinese Paintings of the Ming and Qing Dynasties*, no. 56, dated 1702: only four leaves are illustrated, in colour). A fine ten-leaf album in the Indianapolis Museum of Art is illustrated and discussed in *Beauty and Tranquility: The Eli Lilly Collection Of Chinese Art*, plate 130. The Cleveland album in particular incorporates a few comparable details to the album here; as the catalogue points out in connection with a Chang Feng landscape (no. 211) Wang, like Chang, Kung Hsien and Fan Ch'i, was intrigued by the problem of rendering space.

18 FIGURES IN RIVER LANDSCAPES (1702)
A twelve-leaf album in ink and light colours on paper.

a. A scholarly figure in cap and gown prepares to cross a low stone bridge, beneath pines growing on either rocky shore. From the banks grows foliage represented with massed dots in a pale, blue wash reminiscent of the soft bulkiness of Kung Hsien's landscape style.
With a short poem by the artist:
The wayward path bridges the stream;
With my staff I visit the recluse.

Signed Wang Kai, with two square seals of the artist, repeated throughout the album: Wang Kai chih yin (intaglio) and An-chieh (relief).

b. A scholar and his attendant stand at the window of one of two stilt-buildings under overhanging trees at the river's edge; a secluded retreat. The composition is comparable to Kung Hsien's, but it is only in the foliage dotting that Wang recalls his technique.

Signed Wang Kai of Hsiu-shui, with one seal: Wang Kai chih yin.

c. A scholar rests on the trunk of an old pine which overhangs a rushing stream. The composition is curiously centralised, with large blank areas on both sides.

Entitled: *Pine and Torrent; a Fountain of Ability*, in reference to the scholar (or, possibly, *Pine Rapids and Dragon Stream*).
Signed Wang Kai drew, with two seals: Wang Kai chih yin and An-chieh.

a

b

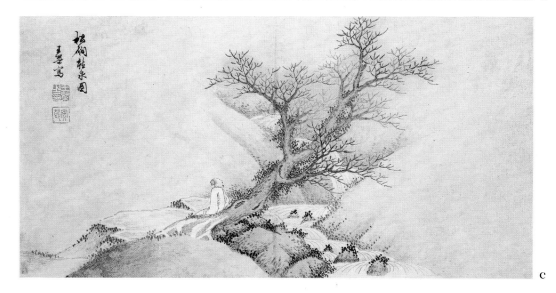

c

61

d. A fisherman on a punt emerging from thick clumps of water-bamboo looks up from his reverie as a flock of migratory birds flies overhead.

Signed Wang Kai painted on the banks of Mandarin Duck (and drake) Lake, with two seals: Wang Kai chih yin and An-chieh.

e. A lonely figure sits in his thatched hut under two stark trees, on a slightly raised promontory at the edge of cultivated land, which curls off into the river. He stares into the marshy distance, beyond two sails, all that is visible of passing boats on the misty horizon. The lack of colour accentuates his empty seclusion. (The Cleveland album description makes mention of the Western spatial formula of showing a fleet of sails on a high horizon in the eighth leaf of their album. Sailing boats and a pavilion also feature in leaf 2 of the Tientsin album.)

Dated *jen-wu* year, summer, the eighth month (1702) and signed Wang Kai of Hsiu-shui painted, with two seals: Wang Kai chih yin and An-chieh.

f. A scholar sits in the topmost room of his leafy riverside residence, a lower wing just visible through the trees. A low bridge leads over the meandering river to a pathway, and a large rocky outcrop dominates the left of the composition.
With a short poem by the artist:
Quietly facing the level wilderness,
a fresh breeze blows in from the distant hills.
Signed Wang Kai of Hsiu-shui, with one seal: Wang Kai chih yin.

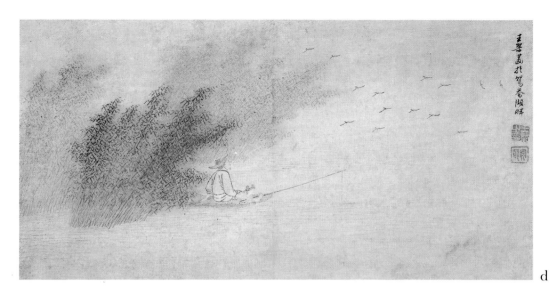

d

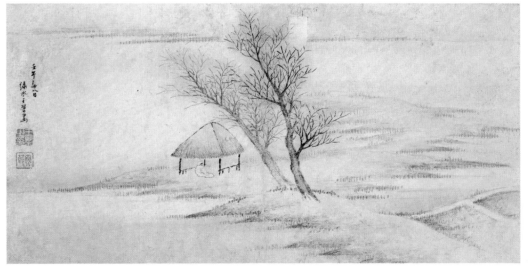

e

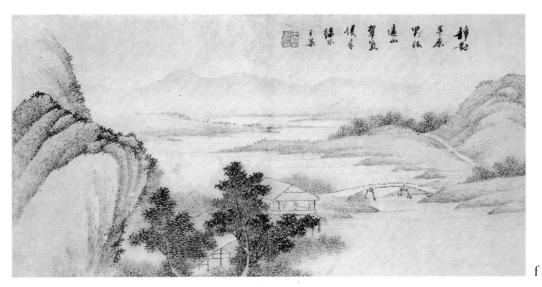

f

g. A fisherman rows a scholar to his island retreat atop an overgrown rock in hilly, meandering river country. A precarious plank bridge connects the one spit of land to another. The textured and foliate rock residence is a successfully off-centre focus, but it does leave the rest of the landscape as a rather insipid backdrop.

With a short poem by the artist:
The clear current wafts the craft along;
Seeking scenery, looking for the mountain recluse.

Signed Wang Kai, with one seal: Wang Kai chih yin.

h. A scholar stands on the low bridge connecting his simple, stone-built residence, at the end of a promontory crowned with a variety of trees, to dry land. The bridge is overhung by a huge mass of rock, compositionally derived from Kung Hsien.

Inscribed: Sketched in *jen-wu*, a summer month (1702), sitting deep among pines and creepers.

i. A scholar stands, hands clasped behind his back, at the water's edge near his secluded hut at the foot of a sheer cliff. An atmospheric, misty grove of autumnal trees surrounds the hut, and in the distance blue mountains fill the horizon. This leaf is compositionally and technically a successful reworking of Kung Hsien's style. (The trees and composition are comparable to one of the best leaves in the Indianapolis album, leaf B, p. 329.)

With a short couplet by the artist:
Stone cliffs, broaching the sky, becoming emerald;
the forest woods, glowing in bright sunshine:
the red leaves are splendid.

Signed Wang Kai, with one seal: An-chieh.
The colophon praises the painter Wang Kai's landscape as being in the tradition of Wang Wei (the great T'ang dynasty poet and painter).

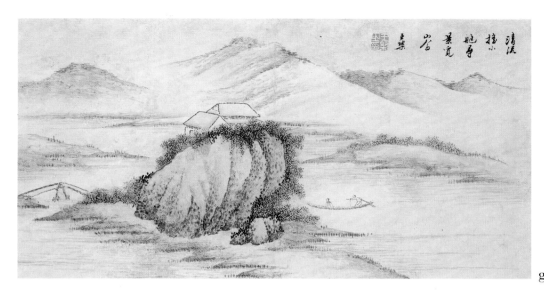

清流拂小船寻景宽山
王榮

g

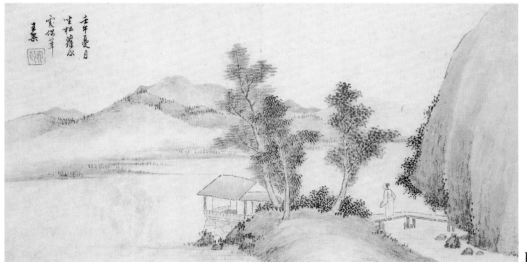

壬午夏日生松薩原
王榮

h

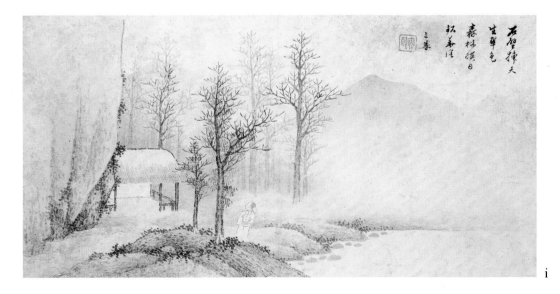

左壑揀天生華色春树晓日秋華淀
王榮

i

j. A scholar looks out along the river from the window of one of five simple, stone-based huts (a retreat complex) built in the clefts of sheer rocks descending to the water with clusters of dotted foliage around the buildings. The low prow of a boat protrudes from the last hut, and a perpendicular waterfall breaks the sheer wall of the cliffs opposite. Again, compositionally and in the soft, tactile suggestion of the rocks' bulky mass this leaf is an interesting interpretation of Kung Hsien's style.

Signed Wang Kai of Hsiu-shui painted at the Lin-t'an ko (the pavilion over the pool), with two seals: Wang Kai chih yin, and An-chieh.

k. A reclusive scholar and his guest converse in one room of his extensive complex, walled with a gate at the front but cut off to the rear and sides by mountains, waterfall and bay. The huts are surrounded by ghostly, autumnal trees and overhung by a massive rock; again, influenced both technically and compositionally by Kung Hsien's work.
With a short poem by the artist:
Building my thatched hut in the shade of grass and trees,
I constantly hear the flying falls echo like thunder.

Signed Wang Kai of Hsiu-shui painted, with two seals: Wang Kai chih yin, and An-chieh.

l. Two travellers converse as they round the last bend in their long path through a snowy mountainous landscape, before they arrive at a secluded retreat among snow-covered rocks and foliage. A rocky outcrop is dominated by three frozen pine trees. The ink wash and white paper for the snow are effective, and the palest touch of red for the figures and the hut's interior also works well in highlighting them.

Signed Wang Kai of Hsiu-shui painted, with one seal: Wang Kai chih yin.
This leaf bears a collector's seal, impressed on a pink sheet and pasted on to the corner of the composition, and repeated on the mount: Ts'eng Ts'un-t'an Ting-yü an. The owner is unrecorded.

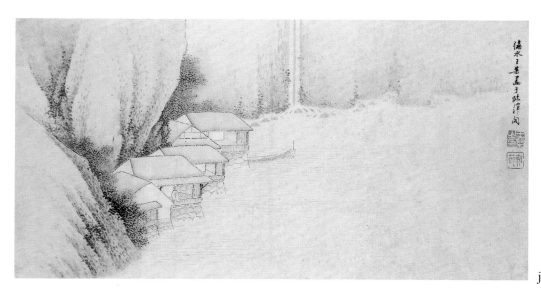

j

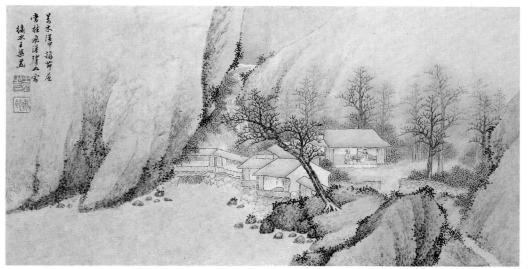

k

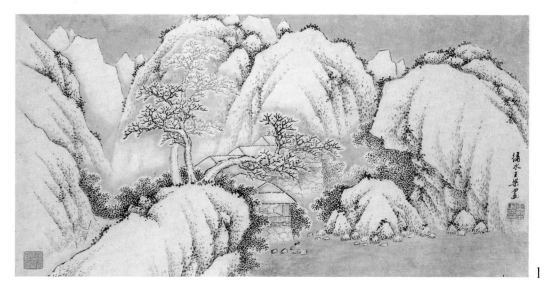

l

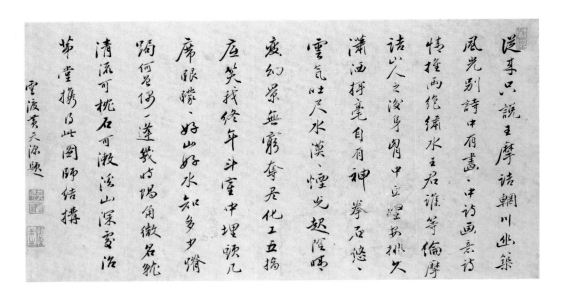

The album is mounted with a final appreciative colophon leaf by one Huang T'ien-yüan; signed, with four seals of the writer. He is likewise unrecorded.

Each leaf measures 16 × 8 1/2 inches.

WANG YÜAN-CH'I
1642–1715

tzu: Mao-ching.
hao: Lu-t'ai, Ssu-nung, Hsi-lu hou-jen, Shih-shih tao-jen.
From T'ai-ts'ang, Kiangsu.

WANG Yüan-ch'i was the grandson and pupil of Wang Shih-min, and was the youngest, most independent and original of the Four Wangs. Wang K'uei, his father, was a *chin-shih* of 1655, but never accepted government office. Yüan-ch'i himself was a *chin-shih* of 1670, in the same year as his uncle Wang Shan (1645–1738; Grand Secretary 1712–1723) and was appointed to a minor post in the Board of Civil Office. He had a distinguished official career, detailed in his biography in *Eminent Chinese of the Ch'ing Period*, rising from magistrate of Jen-hsien, Chihli (1681); through censor; secretary in the Supervisorate of Imperial Instruction (1700); expositor, reader and finally chancellor of the Hanlin Academy; to senior Vice-President of the Board of Finance in 1712, a post he held until his death in 1715.

He was often called to paint in the palace, and it is recorded that from time to time the K'ang-hsi emperor would go to the South Library, lean over the table where Wang was at work and watch him, quite fascinated and unconscious of the passing of time. Wang Yüan-ch'i was placed in charge of the imperial collections, and was charged, with four other officials, with the compilation of a comprehensive work on painting and calligraphy, published in 1708 in 100 *chüan* under the title *P'ei-wen chai shu-hua p'u*; the compilers are reported to have consulted 1844 sources.

Wang is also known as one of the painters of the long handscroll *Wan-shou ch'ang-t'u*, a celebration of the K'ang-hsi emperor's sixtieth birthday. It was presented to the emperor before it was finished, and in 1713 Wang was ordered to supervise completion of it. The draft on paper was submitted in February 1714, and Wang requested 300 feet of silk for the final copy. At the same time he recommended the compilation of a eulogistic publication honouring the emperor on that occasion, and was placed at the head of a bureau created especially for that purpose. He died before it was completed, and the work was taken over by his cousin Wang I-ch'ing (d. 1736 ?), who also collaborated with Yüan-ch'i on a 148 plate, wood-block printed version of the *Wan-shou ch'ang-t'u* which was included in the 120 *chüan* publication. The author of two small works on painting, Wang Yüan-ch'i taught a number of pupils, including Huang Ting (see no. 21), T'ang-tai, and Wang Yü. His great-grandson Wang Ch'en (1720–1797) was also a noteworthy painter; and one of his three sons, Wang Mu (1669–1754) served as governor of Kuangtung. Inheritor of the direct line of orthodox succession back through Wang Shih-min to Tung Ch'i-ch'ang, and thence to the Yüan masters and beyond, Wang Yüan-ch'i came to be regarded as the leader of the Lou-tung school, and was the youngest of the Six Orthodox Masters of Early Ch'ing. As Cahill points out in the last essay of *The Compelling Image* ("Wang Yüan-ch'i and Tao-chi: The Culmination of Method and No-Method", pp. 184–225), he was perhaps the last of the great orthodox painters. Jean-Pierre Dubose, "A New Approach to Chinese Painting" (*Oriental Art* magazine, vol. 3, no. II, 1950, pp. 50–57) compares him to Cézanne in his development of themes and variations, striving after solutions of pictorial problems.

In his "early work", that of his early middle age, dating from the 1670s and 1680s, Wang followed the style of Huang Kung-wang quite closely; throughout his life Huang was his acknowledged leading inspiration, but later Wang imposed his own personal style more strongly upon it. In the 1690s and early 1700s Wang favoured the use of a rather dry brush to delineate forms; the impression of each stroke is round and supple, possessed of a powerful inner resilience. In his own words: "One must seek the rare in the common, the needle in the fluff of cotton". During his most mature period in the 1710s he preferred a wet brush, every stroke containing a vigorous, concentrated energy; he said: "the point of the brush should act like the *vajra* (diamond thunderbolt club), which cuts off all bad habits". After his earliest period the models of other Yüan painters, especially Ni Tsan, were influential, as well as the earlier masters Tung Yüan and Chü-jan. Wang demonstrated his freedom from a strictly dogmatic orthodoxy, though, by highly successful paintings after such heterodox artists as Mi Fu and Kao K'o-

kung; he was also highly appreciative of the work of his individualist contemporary Tao-chi, at a time when such an opinion constituted a strictly minority viewpoint. The two of them painted a well-known study of bamboo and rocks together in 1691, now in the National Palace Museum, Taipei (illustrated, *inter alia, Studies in Connoisseurship*, p. 50, fig. 16).

By the time he was thirty Wang Chien and Wang Shih-min had agreed that Yüan-ch'i was already a better painter than they could hope to be. He preferred to use the finest (*Hsüan-ch'eng*) paper, a double hair brush, and *ting-yen* (top layer) ink. Perhaps even more than in the case of most literati painters' work of the period, his painting on paper is almost always considered superior to that on silk; his brushwork has a loose rawness which relies on crispness to satisfactorily convey its effect.

Wang Yüan-ch'i was an analytical and theoretical artist who constructed his multi-layered compositions painstakingly, without the flashes of inspiration and spontaneity which characterise such contemporaries as Yün Shou-p'ing. A rare description of his working method, related by Chang Keng, tells how his friend the Manchu scholar K'o-ta was invited to Wang's studio (Siren, *Chinese Painting*, vol. V, pp. 204–205): "He started by spreading the paper, and then he cogitated for a long while. He took some light ink and drew some general outlines indicating in a summary way the woods and the valleys. Then he fixed the forms of the peaks and the stones, the terraces and the folds (of the mountains), the branches and trunks of the trees, but each time he lifted the brush he would think it over again and again. Thus the day was soon ended. Next day he invited me again to his house and took out the same scroll. He added some wrinkles (to the mountains). Then he took some reddish brown (ochre) colour, mixed it with a little yellow gum-resin (gamboge) and with this painted the mountains and stones. Thereupon he took a small flat-iron loaded with hot coals, and with this he ironed and dried the picture. After that he went over the stones and the whole structure of the picture again, brushing it with dry ink. The leaves of the trees were dotted in a scattering manner, the woods on the mountains, the buildings, the bridges, ferries, streams and beaches were brought out clearly. Next he took some green colour mixed with water and ink, and with this he washed the picture quite lightly and slowly, emphasising lights and shadows and the relief. Then again he used the flat-iron as before to dry the picture, and once more went over the contours and horizontal strokes, the coloured and the dotted spots from the lightest to the darkest parts, thus making the picture gradually denser. It took him half a month to finish the picture. At the beginning it was all in a nebulous state, but gradually this was broken up, and then the scattered parts were brought together; finally the whole thing returned again to a nebulous state. The life-breath was boundless, the emptiness was filled with beauty, not a single stroke was carelessly done. This was the reason why he spent so many days on a work. The saying that the old painters used ten days for painting a watercourse and five days for a stone may not be exaggerated."

Wang took several months to paint some of his more extensive works, such as the few important handscrolls extant — most of his published landscapes are hanging scrolls of medium and large size, with several, but relatively few, albums and fans. Although these works in smaller format may not have taken such a length of time (Wang was a prolific painter) it is apparent that virtually all of his landscapes were constructed in this gradual and thoughtful manner. At times it resulted in over-elaboration, but in Wang's mature and successful works he has systematised and reduced such details, emphasising structural elements such as strong planes, sometimes tilting, and cubic volumes like building bricks, bringing to life a fresh, abstract arrangement of point and counterpoint, volume and void, full of tension but essentially simple rather than crowded.

Wang was also a powerful and original colourist. As Chiang Chao-shen notes ("Wang Yüan-ch'i: Notes on a Special Exhibition", *The National Palace Museum Bulletin*, vol. II, no. 4, September 1967, pp. 11–15): "As to ink Wang Yüan-ch'i once remarked: 'In the application of ink, one should use thin pale ink and seek the dark and full-bodied in the pale and thin.' By this statement the painter meant that in applying washes, one must begin with very pale ink staining in many layers to achieve the desired values. Thus in his paintings the deep-toned washes give one the feeling of mass, weight, and a

full-bodiedness that has become part of the body of the paper itself; while in the pale washes, which have also been achieved by the working-in of numerous layers of extremely pale ink, there is no feeling of hasty application or thready thinness, but a highly vibrant airiness. Regarding the use of colours, Wang Yüan-ch'i further remarked: 'In applying colours, the use of the brush is the same as that in handling ink; colours that are applied to fill in weak areas of ink can actually serve as a foil to accentuate the wonderful qualities of the ink itself. People today have no understanding of this concept. Colours are regarded individually as colours, ink as ink.' Wang Yüan-ch'i meant that colours need not be applied in flat layers, but worked stroke by stroke, as with ink. In his later years he liked to work with a worn blunt brush and very thick transparent watercolour greens to produce the characteristic 'piecemeal' quality of the masses. He otherwise liked to employ opaque mineral greens to produce effects which were contrary to the traditional methods of using greens" Compositionally Wang used, in addition to non-cohesive smaller units, building up a mass, such occasional bizarre features as tilting ground planes, mismatched horizons, asymmetrical arrangements of solid and void, and ponderous landscape masses "supported" by trees (e.g. Cahill, *Chinese Painting*, p. 166). His mountain forms are structured on the basis of the strong "dragon veins" which Wang Hui so successfully articulated; but unlike Wang Hui, Yüan-ch'i invested his landscapes until his death with an experimental excitement. As Cahill observes in *The Compelling Image*, Wang Yüan-ch'i was the complete establishment artist and a fierce defender of orthodoxy, at the same time continually discovering and realising in new ways fresh insights and variations upon his theme, following his own advice that a painter "should convey between the lines and in the ink that which others cannot give, and not give what others are able to do".

Wang Yüan-ch'i's landscapes are illustrated in almost every relevant publication and feature in most major collections, although he was not quite as prolific as Wang Hui. Siren, *Lists*, records 135 works by him, and *Comprehensive Illustrated Catalog of Chinese Paintings* shows 43. Fine works are depicted in addition in, among others, *Eight Dynasties of Chinese Painting*, nos. 249–252; *A Thousand Peaks and Myriad Ravines*, nos. 34–36; *The Compelling Image*; *Chinese Masters of the 17th Century*; *Chinese Painting and Calligraphy, A Pictorial Survey*, nos. 63, 64; *Chinese Paintings of the Ming & Qing Dynasties*, no. 43; *In Pursuit of Antiquity*, nos. 27, 31; *Collection of the Nanking Museum*, no. 65; *Collection of the Liaoning Provincial Museum*, pp. 69–73; *Collection of the Suchou Municipal Museum*, nos. 71–73; *The Pageant of Chinese Painting*, nos. 831–838; *Chinese Paintings: Yüan to Ch'ing Periods* (in the Boston Museum of Fine Arts), pl. 115, 116 & 147–149; and *Three Hundred Masterpieces of Chinese Painting in the National Palace Museum*, nos. 275–277.

19 LANDSCAPE AFTER HUANG KUNG-WANG
A hanging scroll in ink on paper, mounted with buffalo horn rollers.

In the foreground a small, simple hut is tucked into a cleft in dry, textured rocks by the waterside, with clumps of fine bamboo on either side. A plateau above the hut is overhung by a taller rock formation, and in the centre of the composition a wintry tree grows awkwardly from a rubbed, foliage-covered outcrop, leaning with smaller trees over a small inlet which opens out into a larger expanse of water at the bottom left corner. On the far shore a few huts are clustered on the marshy, low ground, which abruptly terminates as the dominant, central mountain rears up, with more distant hills falling back to either side. Features of the dry brushwork, contrasting ink tones and spare composition derive from both Huang Kung-wang and Ni Tsan.

Inscribed by the artist: Imitating the brushwork ideas of Ta-ch'ih (Huang Kung-wang).
Signed Lu-t'ai, Ch'i; with three seals of the artist: Sao-hua an (oval, relief, Contag & Wang 51), Wang Yüan-ch'i yin (square, relief and intaglio, Contag & Wang 34) and Mao-ching (square, relief, Contag & Wang 44).
There is one collector's seal in the bottom right corner: Yü-feng Chang shih shou-ts'ang (rectangular, relief). Unrecorded.
The painting measures 25 1/4 × 12 1/2 inches.

From the Wong Nan-p'ing collection, Hong Kong.

The dry, relatively "cotton-fluff" brushwork and composition in Wang's Huang-Ni manner (despite his inscription acknowledging Huang alone) suggests that the painting was executed early in his middle period, about the late 1690s or early 1700s.

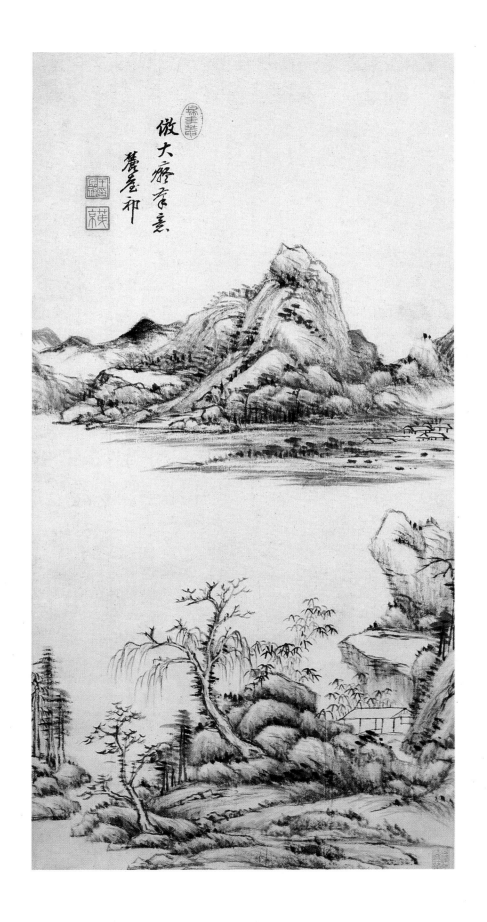

YANG CHIN
1644–1728

tzu: Tzu-hao.
hao: Hsi-t'ing.
From Ch'ang-shu, Kiangsu.

YANG Chin was the pupil of his fellow-townsman Wang Hui and frequently collaborated with him on paintings: see for example *In Scholars' Taste*, no. 11, for a 1706 portrait handscroll by Wang and Yang; and *Emperor Scholar Artisan Monk*, no. 18, for the seventh of the K'ang-hsi emperor's *Nan-hsün-t'u* series, painted between 1691 and 1698. Several court artists and assistants to Wang Hui worked on details of that series of paintings, but Yang is regarded as the most important. Yang also collaborated with Wang Hui and an unrecorded portraitist, T'u Lo, on the Cleveland Museum of Art's 1715 *Portrait of An Ch'i* (*Eight Dynasties of Chinese Painting*, no. 259), in which Yang designed the landscape and Wang added the bamboo and rocks. Another painter with whom Wang Hui collaborated was Wang Yün (see no. 23). As Siren observes (*Chinese Painting: Leading Masters and Principles*, vol. V. p. 217) Wang and Yang painted a picture (illustrated in *Shina Nanga Taikan*, III) of the Yen-hsüeh pavilion, to which Yün Shou-p'ing added a colophon in 1683; while a 1694 study of pine, bamboo and blossoming plum in the same publication was painted by Wang Hui, Yang Chin and Wang Yün. He compares a 1700 painting of peach-tree, bamboo and mandarin duck by the two Wangs in the Palace Museum collection with a comparable study of bamboo, plum and rock by Yang in the same collection (illustrated in *The Pageant of Chinese Painting*, no. 844); he describes the latter as painted with a lighter brush, more like that of Yün Shou-p'ing. Indeed, Yang was as proficient a flower-painter as he was a landscapist.

Apart from landscapes in Wang Hui's manner (and through him those of the Yüan masters) Yang specialised in painting buffalo in landscape; a typical example is illustrated in *The Pageant of Chinese Painting*, no. 845. Another, from the Morse collection (now in the Metropolitan Museum, New York) is illustrated in Whitfield, *In Pursuit of Antiquity*, no. 28. Siren, *Lists*, mentions 27 works by him, with dated examples between 1683 and 1726, and *Comprehensive Illustrated Catalog of Chinese Paintings* pictures twenty, more than half of them in private Japanese collections.

20 MOUNTAIN PASS AFTER SNOW HAS CLEARED (1713)
A hanging scroll in ink and colours on paper.

At the foot of a dramatic, snow-covered landscape travellers on donkey and on foot cross a low bridge over a fast-flowing river which emerges from the mountains. The path narrows between the rocks, overhung by trees, and then broadens into a clearing with a fenced enclosure, eating houses and a trough for the mounts. (Compare this composition with that of the Ts'ao Yüan, no. 17). In the valley, behind the small settlement, snow-laden pines crowd the slopes, but the path continues up into the mountains, a precarious man-made plank road covered with snow. First it follows the river gorge deep into the mountains, and then we see further travellers steadily climbing as the path clings to the outside of one peak, overhanging the valley and itself overhung by rocky outcrops. Finally the pathway levels somewhat as the sheltered clearing between the topmost peaks reveals the walled and fortified gatehouse or customs post of the pass itself. The sky, filled with tones of grey wash, threatens snow again. Leaving large areas of white paper for the snow, and using very few textural strokes, Yang has been able to let his uncluttered, powerful, thrusting rock formations, particularly to the right of the scene as the path ascends, dominate the composition and effect a dramatic image.

Entitled: *Kuan shan hsüeh chi t'u* (Picture of a Mountain Pass after Snow has Cleared). Kuan-shan is also the name of two specific mountains, but the common usage is as translated here.
Dated to the first three days of the eleventh month of the *kuei-ssu* year (1713), imitating the brushwork of Li Ying-ch'iu (Li Ch'eng, tenth century).

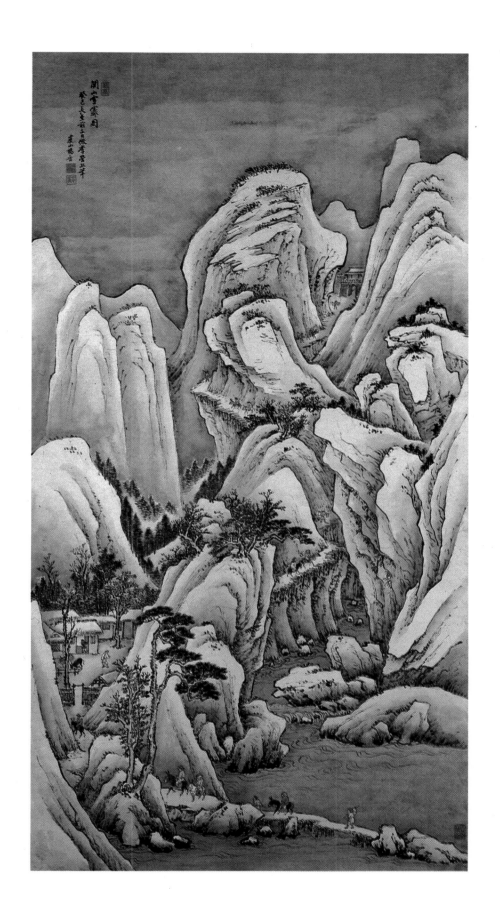

Signed Yü-shan, Yang Chin; with four seals of the artist: Hsi-t'ing (Contag & Wang 34), Yang Chin ssu yin (Contag & Wang 7), Tzu-hao (Contag & Wang 18) and Chia tsai Yü-shan ti-i-feng (Contag & Wang 43). All of these seals were impressed in an album of flower paintings, likewise dated 1713. The painting measures 42 × 22 inches.

From the Chang Po-chin collection, Taipei.

Wang Hui painted quite a different snowscape entitled *Hsüeh chi* (Snow Clearing) after Li Ch'eng in 1669: see *In Pursuit of Antiquity*, no. 30.

The small school which studied under Wang Hui was known as the Yü-shan school; hence Yang's use of the place name as a sobriquet and his seal, "the topmost peak in the Mount Yü school". Wang Hui, like Huang Kung-wang who also came from nearby Ch'ang-shu, often painted Yü-shan; see *In Scholars' Taste*, no. 10, for a 1696 example.

HUANG TING
1660–1730

tzu: Tsun-ku.

hao: K'uang-t'ing, Tu-wang-k'o, Hsien-p'u, Ching-kou lao-jen.

From Ch'ang-shu, Kiangsu.

HUANG Ting was the oldest and most important of a loose grouping of very large numbers of orthodox painters in the early eighteenth century, sometimes referred to as the Lou-tung school. These artists derived their models from the Yüan masters, as transmitted through Tung Ch'i-ch'ang and the Early Ch'ing Orthodox Masters, particularly Wang Yüan-ch'i (see no. 19). Huang Ting was the leading pupil of Wang Yüan-ch'i, but also borrowed from Wang Hui, whose rival he is sometimes described as.

Huang Ting loved to travel, and is described as having sketched from nature. Indeed, he rejected a request to serve under a prime minister to the K'ang-hsi emperor in order to preserve his freedom of movement and what is described as his "unrestrained spirit". Chu-tsing Li, in *A Thousand Peaks And Myriad Ravines*, relates both Huang's own description in a colophon of his climbing among precipitous gorges and dangerous mountains, and also the possibly hyperbolic listing of his travels by his biographer, Shen Te-ch'ien, a court scholar and favorite of the Ch'ien-lung emperor. According to Shen, in his *Epitaph of Huang Ting*, Huang climbed most of the major mountains in China, travelled through Khotan almost to India and traced the Yangtze to its source, recording in his paintings as he went strange and striking scenes which artists of the past had never sketched. Still, the stylistic grip of earlier masters upon Huang Ting's painting is in almost every case unmistakable. His work follows in the footsteps, though seldom too literally, of the Yüan masters; Ni Tsan, Huang Kung-wang, Ts'ao Chih-po and especially Wang Meng.

Much of his characteristic brushwork, strong and firm with considerable use of dark, glossy ink and short, nervous, but effectively controlled, strokes demonstrates his mastery of Wang Meng's style as interpreted by the Early Ch'ing Masters. In some of his larger compositions especially, though, Huang seems to attempt too great a profusion of detail, perhaps striving for effects descriptive of the overwhelming grandeur of nature which he had witnessed. Unlike the dense, profuse brushwork of a master such as K'un-ts'an or the layered, piled-up strokes and dots of Wang Shih-min's best landscape painting, the impression given by such works of Huang Ting is of a bewildering confusion, approaching paralysis through overambition. Though never as static as the most ordinary painting of lesser painters of the same school such as Wang Yü or Tung Pang-ta, who often tried the same thing, these large and complicated works are seldom wholly successful. Nevertheless, several contemporaries attempted to classify Huang at the same level of achievement as the Four Wangs, Wu and Yün. Indeed, he does appear, of all the traditional painters one generation or more after those Orthodox Masters, to have achieved at his best a really worthwhile personal synthesis, if only of the work of Wang Hui and Wang Yüan-ch'i; he was probably the only classic painter of his time to do so. Chang Tsung-ts'ang and Fang Shih-shu were both pupils of Huang; when he went in his old age to live in Suchou there seem to have been disappointed hopes that he might lead a new revival of the Southern school. He was not a prolific painter; nearly all of his works are landscapes, mostly in hanging scroll form, though a few albums, fans and handscrolls are known. The majority of his known paintings are in the Palace Museums in Peking and Taipei. See *Masterpieces of Chinese Painting in the National Palace Museum*, no. 49, for a 1713 hanging scroll by Huang. His work in Ni Tsan's style is relatively rare.

21 LANDSCAPE AFTER NI TSAN (1717)
A hanging scroll in ink on paper.

In a riverside landscape of simple zigzag form, a foreground promontory juts towards a nearby rocky shore; a variety of tall, gnarled trees cluster on it, almost obscuring a low dwelling planted with a finely executed bamboo grove visible behind. Beyond low banks in the wide river, wooded foothills and more abrupt rocky cliff formations rise from the far shore, a waterfall plunging from misty trees in a cleft. The ink play is more dry and loose than is the case with most of Huang's brushwork, as is fitting for a painting in Ni Tsan's style (and strongly reminiscent of Wang Yüan-ch'i), although there are effective darker ink contrasts in the trees and foliage dotting.

Dated to autumn of the *ting-yu* year (1717), after the brush style of Ni Yü (Ni Tsan).
Signed Tu-wang-k'o (lonely traveller) Huang Ting, with one seal of the artist: Huang Ting ssu-yin (square, intaglio).
There are three collectors' seals at the bottom left of the composition: Chi-tsu tu-kuo (square, intaglio), probably the inspection seal of Chiang Chi-tsu (son of Chiang Hsi-ling), a late nineteenth-century Cantonese official and calligrapher; Mei-ch'ing i-yen (square, intaglio), possibly the inspection seal of Hu Shou-ting, *hao*: Mei-ch'ing, a mid-to-late nineteenth-century graduate, calligrapher, poet, painter and friend of Chao Chih-ch'ien; and Li-tsao sheng (rectangular, relief), unrecorded.
The title slip in ink on silk seal characters, "Huang Tsun-ku's landscape after Ni Yün-lin", is signed Tsu-i and dated cyclically to the fifth month of the *chi-yu* year. Tsu-i is presumably Yün Tsu-i, a graduate of the T'ung-chih period (1862–1875), official and connoisseur, in which case the slip dates from 1909.
The painting measures 25 7/8 × 14 1/8 inches.

Of the 34 Huang Ting landscapes listed by Siren, only three are described as following Ni Tsan's style; they are dated 1714, 1715 and 1723. Kei Suzuki illustrates only eight paintings by Huang, none of them after Ni Tsan. There seem to be very few Huang Ting landscapes in Western museum collections; only Cleveland, Berkeley, Honolulu, the Fogg Art Museum and the Rietberg Museum, Zurich have published examples. The Cleveland Museum painting, which appears from Kei Suzuki's *Comprehensive Illustrated Catalog of Chinese Paintings* to have been acquired from the Chang Yün-chung collection, Japan (one photograph is lighter than the other, but the paintings appear to be identical) is the only example which is not a distant landscape, but is rather a study of an old pine among rocks. It is interesting to speculate whether this unusual work was omitted from the *Eight Dynasties of Chinese Painting* catalogue because of its poor condition, doubts as to authenticity or because it was not felt to be important or representative enough of Huang Ting's work.

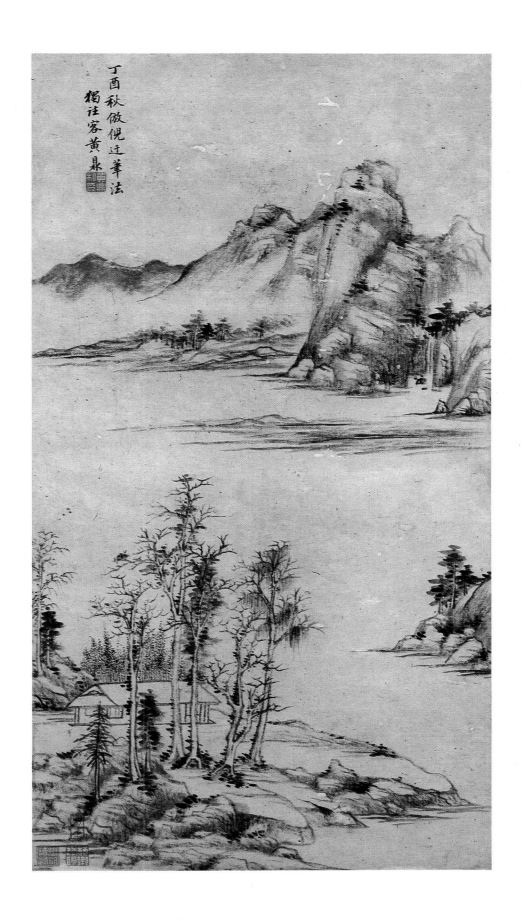

tzu: Chi-ch'en.

hao: Chin-men wai-shih, Chin-men hua-shih, Hu-shan ch'i-shih-erh feng.
From Chiao-chou (modern Chiao-hsien), Shantung.

LENG Mei was a very fine figure painter, and a court artist to the K'ang-hsi emperor. He was the pupil of another leading court painter, Chiao Ping-chen who, employed in the Imperial Board of Astronomy, studied Western perspective under the European missionaries who served on that Board. It was Chiao who was ordered by the emperor to compile a set of forty-six leaves, *Keng-chih-t'u* (Illustrations of Rice and Sericulture), which he designed in a fine woodblock edition, preserving the idea of a *pai-miao* outline technique. They were published in 1696, and it is possible that later editions were modified by Leng Mei.

Leng Mei took part in 1711 in the execution of pictures under Wang Yüan-ch'i (see no. 19) in celebration of the imperial birthday ceremonies; these are mentioned among eighteen of his works in the imperial collections. Other examples include copies of old masters, such as Li Kung-lin's *Eighteen Lohans*, Ch'iu Ying's *Spring Morning in the Han Palaces* and a T'ang painting of scholars and prunus. There are also original compositions, such as *Fruit Gatherers*, *Clothes Makers*, *Picking Cassia Flowers*, *Collecting Mulberry Leaves*, *Flying Kites* and other genre scenes. Ferguson, *Li-tai chu-lu hua-mu*, lists another 24 paintings by Leng in other collections.

Leng was capable of an extremely fine if somewhat effeminate outline style, and of a rather formal but technically brilliant coloured figures in landscape manner which made use of Western modelling of features and shadows within a perfectly controlled line of purely Chinese derivation. His Buddhist figures are another successful result of this treatment; despite the rococo and pretty effects in European taste of which he was entirely capable, Leng managed to invest much of his work with a great deal of humour. An excellent album (mounted as a handscroll) of the 18 Lohans, from the N.P. Wong collection (Sotheby's, New York, *Fine Chinese Paintings*, December 5, 1985, lot 66) combines perfect control of line and relatively rich, fleshy detail with the most absurd and freakish expressions and composition; not remotely frightening, but cleverly painted and very funny. Some other figural paintings are merely detached and static.

Examples in the Boston Museum of Fine Arts (Tomita & Tseng, *Chinese Paintings*, pl. 199 & 200) and in the British Museum, of ladies in exotic palace courtyard settings, are typical of Leng's extremely fine but rather florid style. A large painting of nine egrets (*Chinese Paintings from King Kwei Collection*, no. 56, dated 1725), is typical of the superfine, decorative and soulless court manner of which Western drawing-rooms are so susceptible. Another example in the British Museum, though, a fine outline, lightly coloured study of a beauty distractedly trying to read a book while sitting on a splendid root bench, is an irresistibly delicate study, the epitome of eighteenth-century refined elegance. Published, for example, in Binyon, *Les Peintures Chinoises Dans Les Collections d'Angleterre* (as is the other British Museum example) it was also used by Penguin Books for the cover of their classics series translation of Shen Fu's *Six Records of a Floating Life*, another exercise in rarefied aesthetic sensibilities.

Leng Mei was not especially prolific. Apart from the British Museum and Boston examples cited, Siren's *Lists* mention only another five paintings (one more each for the British Museum and Boston, curiously, the latter illustrated in Siren's *A History of Later Chinese Painting* as pl. 169. He also illustrates another of the five there as pl. 168b; an outline study of Li T'ieh-kuai in a landscape.) Kei Suzuki, *Comprehensive Illustrated Catalog of Chinese Paintings*, lists only five paintings by Leng; the two from the British Museum and three from private collections in Japan, where he is quite popular.

22 EROTIC SCENES FROM DAILY LIFE

An eight-leaf album in ink and colours on silk, mounted in lurid pink and green silk to warn viewers of the explicit nature of the contents.

a. In a small courtyard, some corner of the garden of a noble house, a servant boy sweeping leaves has unexpectedly come upon the object of his affections, a young lady of the house, who watches him distractedly from her elegant bamboo-screened window. Laying aside his besom, he has loosened his clothes and is demonstrating to her the potential growth area of his emotions. Lost in concentration, she sucks absent-mindedly on her robe as their gazes meet at this theoretical point of high expectations. The detailing of trees and plants is as extremely delicate as the scene is poignant; the *jardiniere* on the rock in the corner, the willow, symbolic of feminine grace and sexual desire, the beautiful painting of the window's details and of the young couple's dress and features — these place the innocent young lovers in an unreal setting of elegance and poetic detachment, as throughout the album. The mood thus created, and the subject matter of some leaves, might have come straight from the pages of the great novel *Hung Lou Meng* (Dream of the Red Chamber).

With two seals of the artist: Leng Mei (square, intaglio) and Chi-ch'en (square, relief).

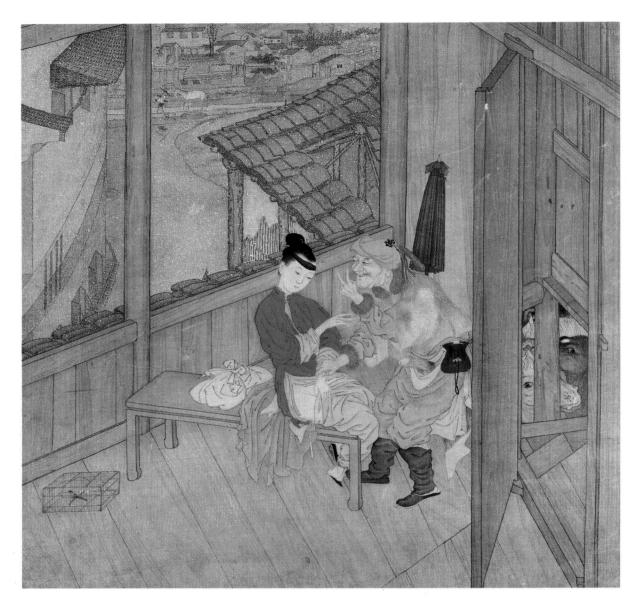

b. In a room above the stables, a Tartar groom bargains with the prostitute he has brought there; or, more likely, having consummated their deal once he is making it perfectly obvious that he has every intention of doing so a second time. The bundle on the low bench she has used as a pillow, and he is preventing her from pulling her lower robes back on. Downstairs in the stables the horses are wild-eyed and restless, perhaps an indication that they are already excited rather than merely anticipatory. The song-bird in its cage on the floor is our confirmation of the girl's vocation in life. Outside it is snowing on the canal and the city; in the corner is an umbrella, probably hers. This painting is absolutely extraordinary for several reasons, mostly because of the several Western conventions Leng has used. The perspective and the details used for the wood walls and door is something never seen in Chinese painting; likewise the complicated handling of the view through to the stables. Such details as the groom's leggings demonstrate a superb grasp of the use of shadows in the folds of clothes, and outside the man leading a horse along the canal path actually casts a clear reflection in the water. The entire snowy cityscape is a brilliant and highly unusual composition that can only have come from familiarity with Western prints or paintings.

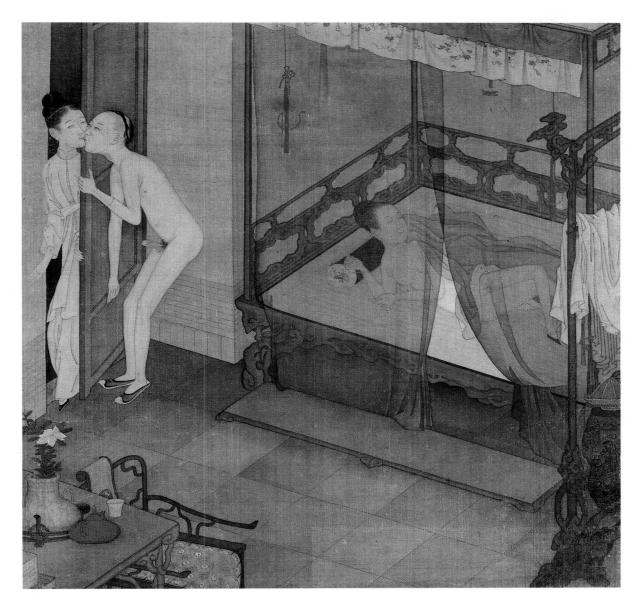

c. In the bedroom of an insatiable "before midnight scholar" one woman sleeps behind netting in an ornate four-poster bed, with her blanket half thrown off and the hint of a contented smile on her face, while our hero greets, or leaves with a kiss, another at the door, attempting to open or close it quietly. It seems unlikely in view of his caution, and the obvious preparedness of his otherwise featureless body, that all three could have already indulged in any kind of menage; so presumably if his "other woman" is to enter and they risk events taking their course it may make for an interesting denouement.

Furniture collectors will be most interested, of course, in the details of the bed, long low footstool, clothes rack, barrel seat, chair and table; other aesthetes in the paraphernalia on them. The tasteful placement of the crackle-ware flower vase, teapot, cup and seal ink or incense box and books demonstrate the scholar's pursuit of excellence in all facets of his life.

 N.B. When this album was sold several years ago in a Sotheby New York Decorative Art auction, only "attributed to" the artist, the extreme lower left hand corner of this leaf was used as the catalogue's colour frontispiece.

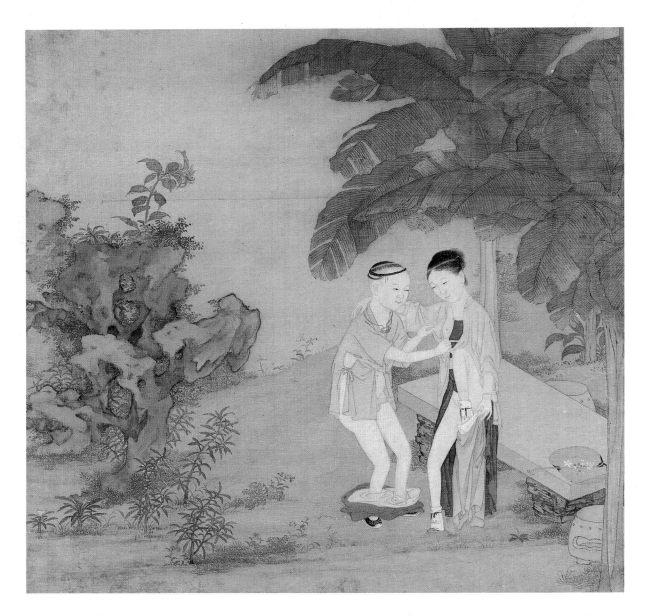

d. In the idyllic garden of some great house a young couple prepare to surrender to the force of their emotions. Shadowed by slightly fading banana leaves, near a beautiful, large *T'ai-hu* rock of mineral colours, and with rare and exotic shrubs waving towards them, they mutually undress and prepare to make love on a rather cold-looking slab of a garden seat. The young girl's fan laid casually to one side, she slides her underskirt without much resistance over her tiny foot as her young mate (and possibly relative) attempts to remove her thin jacket, unconscious of his own trousers around his ankles. Again, the direction of the gaze is one of the entertaining aspects of these leaves.

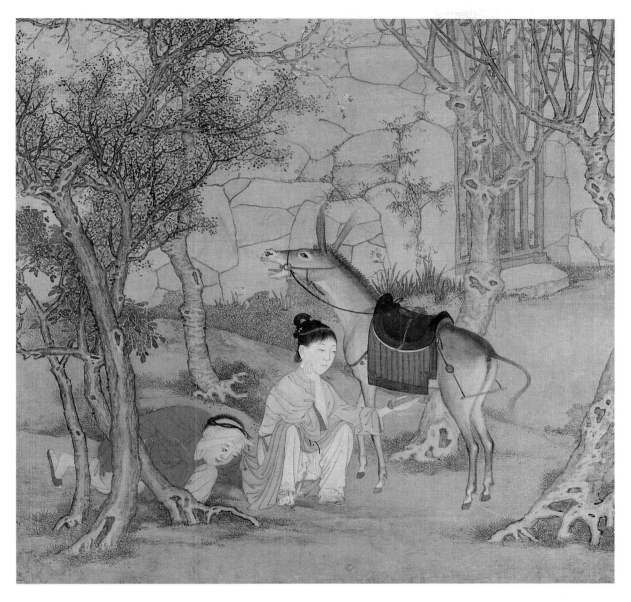

e. Just within the large outer walls of a garden, a young lady of the house has dismounted from her favourite mule and decided, squatting down, to explore other aspects of his personality. (Either Leng Mei was a keen observer of the expressions of young ladies of good family, they were bored to tears all of the time, or he could only paint female faces that way; perhaps a combination of the two.) Meanwhile a young boy of the family has crept up behind her and is doing a little exploration of his own; one of the major advantages of life in the early eighteenth century must have been the complete apparent absence of anything resembling knickers.

One suspects the inclusion of all sorts of visual and literal puns in most of these leaves; surely, a good deal of subtle allusion is taking place. Here the stark branches contrasting with the leafy, intertwining branches must infer something to do with age and youth, beauty and ugliness, but what exactly? Expressions are always equivocal, and it is impossible to be sure of what the participants are thinking. Something is about to happen here, and only the mule knows what it is.

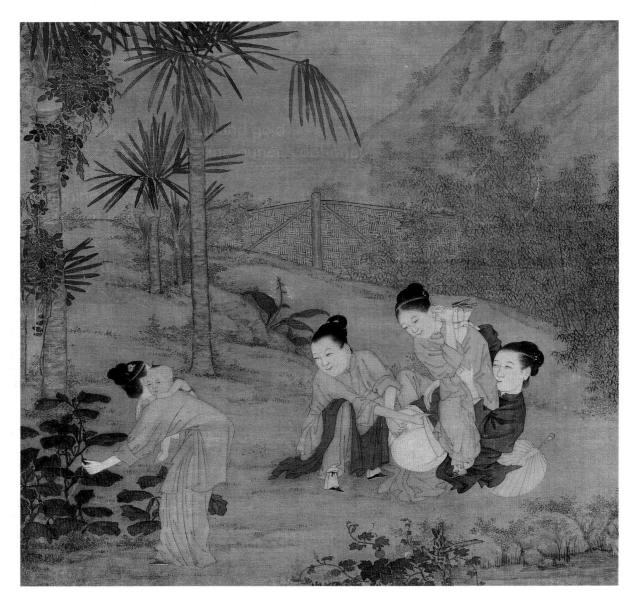

f. In a rustic corner of the gardens, a steep hill beyond the wicker fence, by a leafy pond with palm trees and a bamboo grove setting the scene, one of those institutions to be resisted at all costs reveals its true colours: the girls' day out. The ladies of the house are indulging in a little horse-play (with apologies to leaf e); indeed, the scene perhaps represents the young maids' familiarity with their mistress. The victim is being prepared to be interfered with by a foreign object; to wit, an aubergine, or eggplant. She does not appear to be horrified at the prospect. In this leaf, the gaze of the baby is the most unexpected; he appears to be looking at the viewer, the innocent asking the age-old question: what are those funny pictures you're looking at? In fact, this scene represents an early antenatal breathing class, and the presence of the baby is the clue. The heroine is demonstrating for us what fine child-bearing hips she has.

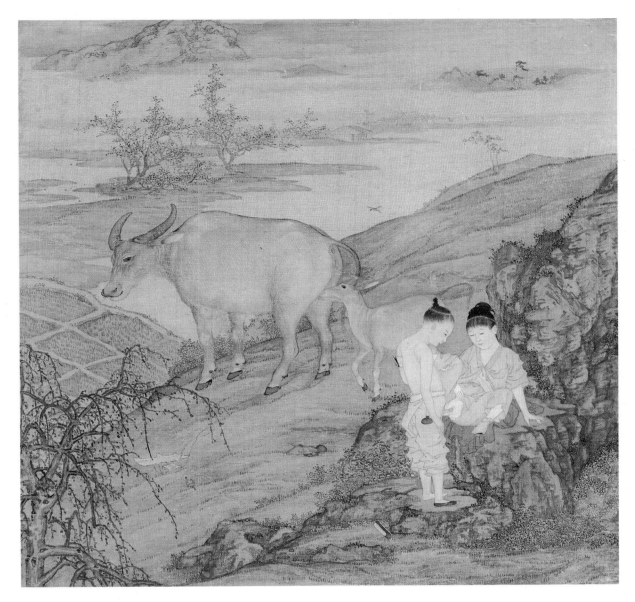

g. In a rural hillside setting, with cultivated paddies below and misty tree-studded plains beyond, a romantic encounter is taking place between a young girl out innocently flying her kite and a young lad tending buffalo. She has completely forgotten her abandoned kite, and his shoe has been lost in the rush as they make use of a conveniently flat-topped rock arrangement to cement their new-found friendship. Again, their features are lost in utter absorption. In an echo of their desperate search for love and warmth, the buffalo's calf nuzzles between its mother's flanks, though presumably with other intent. Leng Mei must have had a slight animal fixation.

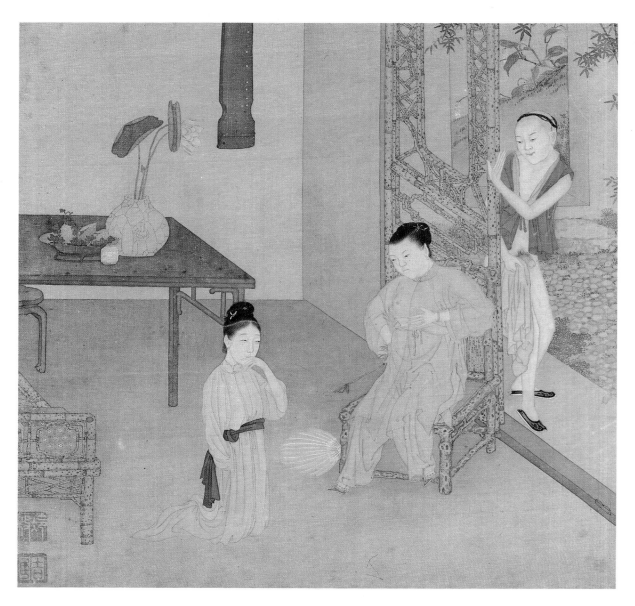

h. In the refined setting of a summer-room in a great house (maybe a summer-house in the garden) a strange scene of domination or humiliation is taking place; this leaf is the most difficult to interpret. Is the lady in the spotted bamboo chair the mistress of the house, or the chief maid? — she has a duster in her hand. Is she *en déshabillé* in transparent clothes because it is hot (the doors to the courtyard have been removed), because she always dresses like that indoors, or for some ulterior purpose? Is she ordering the kneeling girl she is chastising, to play with herself under her robe, or is the girl doing it unconsciously because she is nervous and distracted at the sight of the half-naked boy behind the woman? In any event, he is playing a trick on the woman, attempting to subvert the dressing-down behind her back and at the same time excite the girl. By the table, with its *Kuan-yao* crackle vase of lotus, covered cup and bowl of fruit, is a *ku-ch'in* hanging on the wall, perfectly positioned. The spotted bamboo fixtures are complemented by the graceful stalks of bamboo in the courtyard. Who is doing what, and with which, and to whom?

With two seals of the artist: Leng Mei (square, intaglio) and Chi-ch'en (square, relief).

Each leaf measures 11 1/2 × 11 1/8 inches.

From the Dr. Ip Yee collection, Hong Kong.

See Yang Boda, *The Development of the Ch'ien-lung Painting Academy* for details of Leng's payment and status within the Hua yüan. He was provided with official housing, and his son Leng Chien followed him into the academy. The Ch'ien-lung emperor often rewarded his painters with bonus gifts of rice, silk or money; on the most notable occasion Lang Shih-ning (Castiglione) received 100 *liang* of silver, and Leng Mei 50 *liang*; far above the gifts meted out to other artists.

This album must be one of the best examples of Chinese erotic painting published; there is nothing as fine and as allusively subtle in *Chinese Erotic Art*, for example. The convention of scenes gallant, taking place in pleasant gardens, with rocks and banana leaves and so on, is well established, but with his Westernised elements, his little jokes and his sheer quality of delicate painting Leng Mei has introduced a superior dimension of erotica, for the elevated diversion of gentlemen. This is the only example of erotic painting by Leng recorded; usually such scurrilous undertakings were anonymous.

WANG YÜN
1652–1735

tzu: Han-tsao, Wen-an.
hao: Ch'ing-ch'ih, Chu-li.
From Kao-yu, Kiangsu.

WANG Yün, a professional artist, was the son of a portrait painter, Wang Pin. He was famous in the Kiangsu and Anhui regions, and it was because of this celebrity that Sung Lo (1634–1713), poet and at the time governor of Kiangsu, recommended him to the K'ang-hsi emperor on his 1699 Southern Tour. Wang was attached to the imperial painting bureau in the Forbidden City, the Hua Yüan, and like Yang Chin (see no. 20) collaborated with Wang Hui on paintings, perhaps subsequent to assisting him with the *Nan-hsün-t'u* series of handscrolls between 1691 and 1698. Siren, (*Chinese Paintings*, vol. V, p. 217) mentions a painting in the Ku-kung Museum by Wang Yün of a peach-tree and mandarin duck with poem, dated 1700 and in the style of Lu Chih, to which Wang Hui added bamboo, as well as a 1694 painting of the *Three Friends* by Wang Hui, Wang Yün and Yang Chin.

Wang Yün brought to the academy an established, "correct" style of figure and theatrical painting after Ch'iu Ying, probably handed down by his father, and a landscape style after the Sung academicians such as Liu Sung-nien, in addition to his occasional work as a bird and flower painter and a speciality in architectural detail (like a slightly later early eighteenth-century Yangchou painter, Yüan Chiang). Although some of his landscapes, such as the undated album in the Ching-yüan chai collection, Berkeley (*Comprehensive Illustrated Catalog of Chinese Paintings*, A31–094) and perhaps the large, fantastic 1699 *Isle of the Immortals* in Kansas City (*Eight Dynasties of Chinese Paintings*, no. 257) suggest the influence of Wang Hui, it seems equally that Wang Yün was something of an influence himself upon other court artists.

Wang was also active independently in Yangchou, south of his native town on the Grand Canal; dates of activity in Peking and in Yangchou are not recorded, but he probably moved to Yangchou after his palace period, probably ca. 1691–1700 or later. *Bunjinga Suihen*, vol. 9 includes him in its survey of Yangchou painters in a volume devoted to Chin Nung and the Eccentrics, but really his work manifests no influence from that quarter at all. Two album leaves are illustrated in colour, pl. 74 & 75, one, after Wang Hui, showing a flock of birds wheeling, and the other threshing wheat in a courtyard in a mountainous riverscape, in rather more his typical Sung style, although with elements of Wang Hui. The 1717 album from which these were selected (*Illustrated Catalogues of Tokyo National Museum: Chinese Paintings*, no. 170) includes a few leaves which demonstrate fully that Sung academic landscape manner which was his forte. Another fine album, dated 1715, almost entirely in Sung style and again with compositions which relate to the large landscape from his mature period offered here, is in the Museum für Ostasiatische Kunst, Berlin (*Comprehensive Illustrated Catalog of Chinese Paintings*, E18–028). Equally notable is the large 1705 hanging scroll after Fan K'uan's *Travellers Among Mountains in Autumn* in the Boston Museum of Fine Arts (*Chinese Paintings, Yüan to Ch'ing Periods*, pl. 159).

Chin Tsu-yung's *T'ung-yin lun-hau* says that Wang painted in the Shen Chou tradition, but there is no evidence of that in published works. His Sung style landscapes lack the spirit of their original models, certainly; as do most works (with honourable exceptions) of the Lou-tung school artists with which Wang necessarily is grouped because of his association with Wang Hui. However, his was an independent professional style with high quality of execution which manages to combine grandeur with intimate charm, resulting in an appealing and noteworthy contribution. His work is relatively rare.

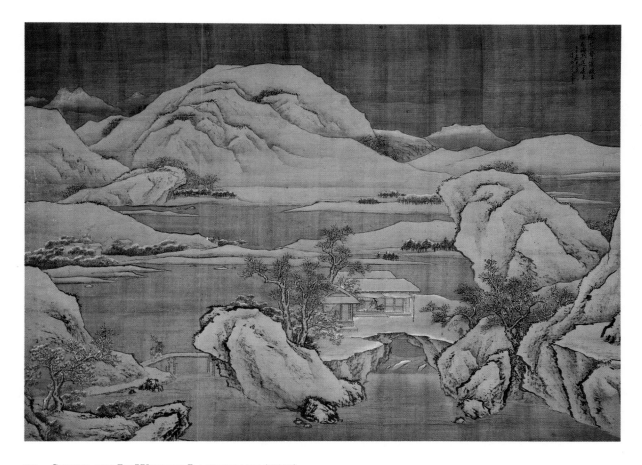

23 SCHOLARS IN WINTRY LANDSCAPE (1732)
A large horizontal hanging scroll in ink and colours on silk.

A small retreat of three buildings sits on a natural rock bridge, part of a cluster of rocky outcrops which dominate the foreground of a mountainous lake scene. Traces of snow rest on rocks and trees, and from the left two boys cross a low bridge carrying firewood. Outside the house two more small boys prepare to light a firework. In one room a scholar gazes out of the window as he burns incense, while in the other two more literati sit, apparently huddled and relatively morose in the cold, as tea heats on the fire. To the left and on the far shore of the lake are further settlements, partially obscured by snow-laden bamboo and trees, and beyond the central mountainous mass we see distant snowy peaks.
With a poem by the artist:
The bang of a fire-cracker presages the depths of winter;
the minuscule spotting of plum blossoms accompanies the coming of the clouds.

Dated to the eleventh lunar month of the *jen-tzu* year (December 1732/ January 1733).
Signed Ch'ing-ch'ih lao-jen, Wang Yün, with three seals of the artist: Chu-li ts'ao-t'ang (oval, relief),
Wang yün chih yin (square, intaglio) and Han-tsao (square, relief; Contag & Wang 9).
The painting measures 31 11/16 × 43 5/16 inches.

From the Chang Po-chih collection, Taipei.

HUANG SHEN	**tzu:** Kung-mou, Kung-mao, Kung-shou.
1687–1768	**hao:** Ying-p'iao (-tzu, shan-jen), Tung-hai pu-i.
	From Ning-hua (T'ing-chou), Fukien; also lived in Yangchou.

HUANG Shen was a professional painter, one of the leading members of the Eight Eccentrics of Yangchou. Following an education at home, he took up painting after entering a Buddhist monastery on the death of his father to secure a livelihood for himself and his mother. He was taught by Shang-kuan Chou, who also came from T'ing-chou, to paint landscapes and figures, and also rocks, birds and flowers, and architectural subjects, particularly in a fine outline style. Huang was a poet, and his fast-flowing *ts'ao-shu* calligraphy in the style of the T'ang monk Huai-su (725–785) fitted admirably with a spontaneous, expressive and innovative painting manner. Shang-kuan Chou commented that "when first viewed his painting was like a rough draft, with only a very few strokes and forms difficult to distinguish, but when viewed from a distance of ten feet or so, then the essential spirit and inner strength appeared". His praise helped to establish Huang as a well-known painter, and about 1710 he left Fukien to travel widely around Kiangsi, Kiangsu and Chekiang provinces for the next decade.

He was well received everywhere, but in Yangchou found an enthusiastic market for his paintings and a congenial atmosphere. Huang lived in Yangchou until 1730 when, because of his mother's age, he moved with his family back to Fukien, though he frequently visited Yangchou from then until his death. His two great friends in Yangchou were Cheng Hsieh and Li Shan; Cheng composed a well-known poem upon Huang's departure in 1730. Huang is associated with Shang-kuan Chou and Hua Yen as the "Fukienese group" of eccentric painters in Yangchou, but in fact the style of each is quite individual.

Huang Shen had two distinctive figural styles. One, perhaps most commonly used in his later work, is highly decorative, often on a large scale, and quite finely detailed, with richly coloured robes, use of gilding and so on; the subjects are frequently deities. His earlier style, used very often for "trembling" landscapes, figure studies of low-life characters such as fishermen (there are several deities in this style as well) and some of his bird and flower and rock paintings, is in his spontaneous, streaky, *"Ch'an"* manner; it was probably his most striking achievement and was very popular and much copied at the time. In this style Huang may be said, like others of the Eccentrics, to have attempted a fusion of painting, poetry and calligraphy into unified images. We offered a fine landscape fan after Wu Chen, which exemplifies this approach, in *In Scholars' Taste*, as no. 17.

Huang's powerful, rangy and ragged landscapes and figural works are well-known and illustrated in many publications, including *Images of the Mind*, pp. 456–461; *Chinese Figure Painting*, no. 50; *A Thousand Peaks and Myriad Ravines*, no. 52; Siren, *Chinese Painting*, pl. 459 and *Bunjinga Suihen*, vol. 9, nos. 47–49 and 52–55. There are in addition several large-format illustrations, showing the often genuinely inspired facility of his brushwork, in the eight-volume *The Selected Paintings and Calligraphy of the Eight Eccentrics of Yangchow*. There are fewer of his bird paintings published; among the notable and extremely varied examples are; *Chinese Literati Paintings from the Jorakuan Collection*, no. 56; *Chinese Paintings from the Hashimoto Collection*, no. 65; *Yang-chou pa-kuai* (Wen-wu Press 1981), pp. 76, 80 and 81; *Eight Dynasties of Chinese Painting*, no. 269; also in *Bunjinga Suihen*, vol. 9; *Selected Paintings and Calligraphy of the Eight Eccentrics of Yangchow* see in particular nos. 20, 58, 59 and especially 63, two geese near reeds, a small, extremely calligraphic work. A comparable, larger painting of a single goose is illustrated in *Im Schatten Hoher Bäume*, no. 73. However, the painting which bears a very strong resemblance to that offered here, although somewhat smaller, is in the collection of the Asian Art Museum of San Francisco (published in *Comprehensive Illustrated Catalog of Chinese Paintings*, A35–006). This painting has the same essential disposition of geese, one landing and three under the reeds, though in rather different positions; our painting has a further pair of geese swimming — and the same poem, though in a different format. Its dimensions are about 20% smaller than those of the present example.

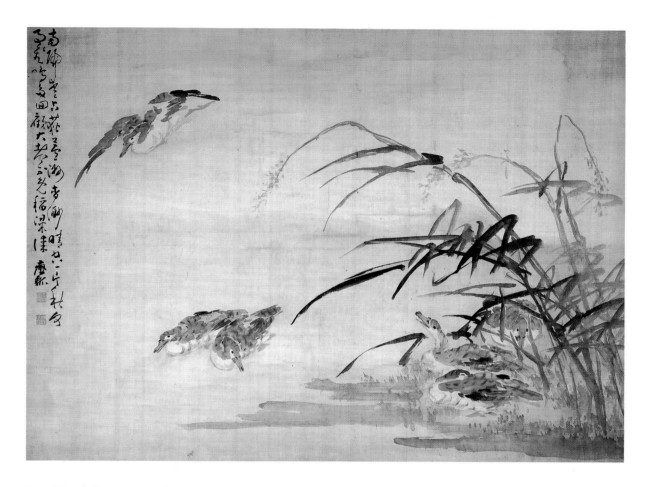

24 WILD GEESE AND REEDS
A large horizontal hanging scroll in ink and light colours on silk.

One goose flies in to land on the water, while another pair swim and look for food. On the shore, under wildly calligraphic reeds, are three geese; one preens itself, another fluffs out and settles down to rest and the third looks up to watch the flying bird land. The orange tone used for beaks and feet is more commonly associated with Pien Shou-min, a painter often associated with the Yangchou Eccentrics whose speciality this was; but the pale brown wash colouring and especially the highly successful ink tonalities brushed almost at random for the reeds confirm the hand of Huang Shen, who seems to have painted a few works related to this subject matter and treatment, though not quite of this size.
With a poem by the artist:
Returning south, they like to take possession of the reed islands,
The fragrant boundlessness, the clear void — a slice of autumn.
It can be an undertaking, flying and giving voice, often looking back;
Probably they too can't avoid having to plan working for a living.

Signed Ying-p'iao, with three square, intaglio seals of the artist: Huang Shen, Ying-p'iao shan-jen and, lower right, Tung-hai pu-i (probably Contag & Wang 15).
The painting measures 49 1/8 × 65 inches.

From the Chang Po-chin collection, Taipei.
Published: *Tien Yin Tang Collection: One Hundred Masterpieces of Chinese Painting*, no. 98.

FANG SHIH-SHU
1692–1751

alternative ming: Hsün.

tzu: Hsün-yüan.

hao: Huan-shan, T'ien-yung, Hsiao-shih (tao-jen, lao-jen).

From Hsieh-hsien, Anhui.

FANG Shih-shu was a pupil of Huang Ting (see no. 21). Although a native of Anhui, he lived in Yangchou, Kiangsu, and is known to have worked in Suchou as well. In Yangchou he was extremely successful, patronised by merchants and the new literati; a fascinating documentary 1743 handscroll in the Cleveland Museum of Art by Fang and Yeh Fang-lin, a portrait painter from Suchou, depicts a literary gathering in the Yangchou garden retreat of the Ma brothers (see under Ma Yüen-kuan, in Hummel, *Eminent Chinese of the Ch'ing Period*). Fang Shih-shu appears in the group as a member of the poetry club meeting there, the Han-chiang ya-chi, whose background and activities were described by Li Tou in his *Picture-Boats of Yangchou*, preface dated 1795. Also included in the group is Fang's younger brother, Fang Shih-chieh, like the Ma brothers a salt merchant (see *Eight Dynasties of Chinese Painting*, no. 275).

Apparently Fang Shih-shu had access to a wide range of Sung and Yüan old master paintings, possibly through his teacher, Huang Ting, and perhaps through the extensive Yangchou collections of that time, such as that of the Ma brothers, who in addition to a vast library owned large numbers of paintings, calligraphy, rubbings and engravings as well as such objects as the Chu Pi-shan silver raft cup, later in the Percival David collection. Whatever his sources, Fang's recorded landscapes do not follow only the established orthodox models; see for example his 1738 interpretation of a Mi Yu-jen landscape in Kansas City (*Eight Dynasties of Chinese Painting*, no. 274).

The great majority of Fang Shih-shu's paintings are landscapes in the orthodox manner, though, with dry, textured brushwork and successfully constructed compositions, yet at two removes from the Lou-tung school's last really creative impetus, Wang Yüan-ch'i. It is possible, however, that his early landscapes reflect the stylistic influence of his native Anhui. As Cahill points out (*Shadows of Mt. Huang*, p. 135), a 1728 album in a Japanese collection has leaves which, in dry-brush manner and with contorted compositions, portray typical Huang-shan scenes. Two leaves from the album are illustrated in *Bunjinga Suihen*, vol. 9 (dealing with Chin Nung and Yangchou painters) as plates 83 and 84; their very unusual style suggests the influence of Mei Ch'ing in particular, and a strong Anhui flavour is evident in the other leaves, illustrated in *Chinese Literati Paintings from the Jorakuan Collection*, no. 58. It may be that this album represents Fang's typical early style, but there are few other examples to compare; the earliest of his works listed by Siren is dated 1732. Siren, *Chinese Painting: Leading Masters and Principles*, vol. V. p. 218, noting that Fang's paintings are not very abundant in number, but display unusual refinement and a very sensitive brush; and quotes Chang Keng (in *Kuo-ch'ao hua-ch'eng lu*): "he used the brush in a clever fashion and aroused an impression of abundant life. At an early age he was already considered better than his teacher. He was indeed the kind of man who is seldom seen, and it was a great pity that he passed away in middle age. If he had lived some years longer, he might have shared the mat with the Four Wangs. His friend, the poet Min Yü-ching, said 'Fang Shih-shu's early works did not seem to indicate such great progress as he has made nowadays. The real advance in art he made only after he was forty'." Of course, such criticism may have been made by subjective observers who, however friendly, anticipated orthodox works rather than styles representing recent radical departures from old masters' models.

Fang is also recorded as a painter of flowers and creatures (animals and insects); although there are very few indeed published, they were apparently extremely popular in his day, and much sought-after. Two interesting leaves from an album (in which the other leaves are landscapes) in The Art Museum, Princeton, are illustrated in *Bunjinga Suihen*, vol 9, nos. 80 (a figural sketch) and 81 (an extraordinary tiger, or wild dog). Upon those paintings which he considered most successful (primarily on the landscapes) he impressed a small (black) ink seal, *Ou-jan shih-te* (arranged by chance). He was

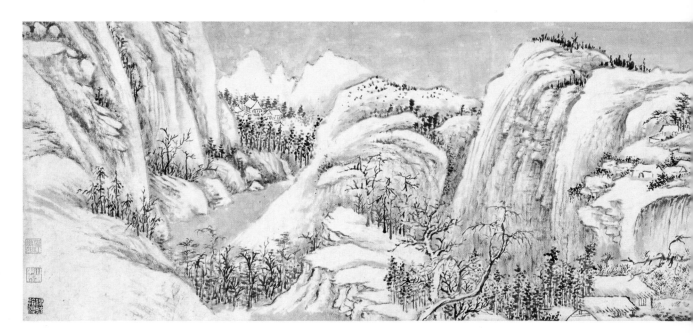

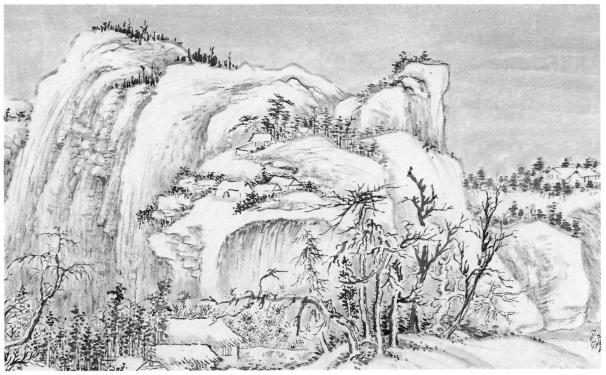

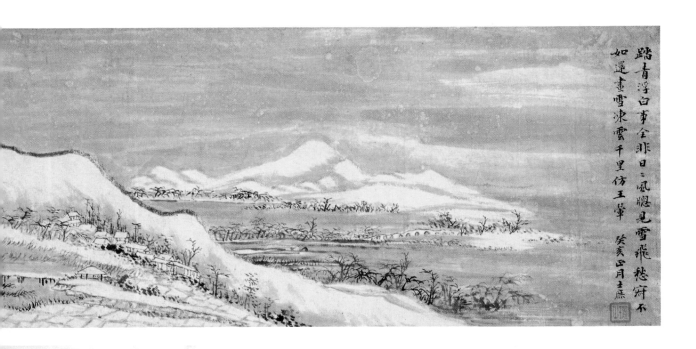

踏青浮白事全非日二風颸見雪飛愁弇不
如遶畫雪凍雲千里仿王翬 癸亥四月主楚

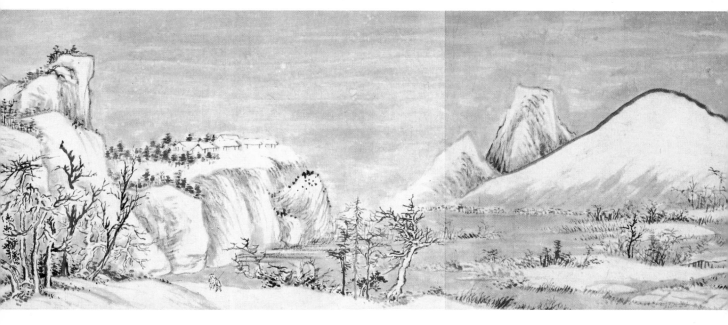

戊午九月中沐
鄂盧遉元屬德軒題

寒山積雪圖

方環山溪山雪霽圖

小冬花盦秘
戊午九月松窗審定

known as one of the best poets of his generation, and also as a calligrapher; his *hsing* and *k'ai* scripts were tightly structured, and modelled solely on his study of Tung Ch'i-ch'ang.

For examples of Fang's typical orthodox landscape hanging scrolls, see: *Collection of the Tientsin Municipal Museum*, no. 118; *Collection of the Suchou Museum*, no. 86; *Famous Chinese Paintings collected by Ping Teng Ko*, unnumbered, thirteenth from the end; *Shadows of Mt. Huang*, no. 65; *In Pursuit of Antiquity*, no. 29; and *Bunjinga Suihen*, vol. 9, no. 85. For a striking landscape in imitation of Tung Ch'i-ch'ang, see *Collection of the Nanking Museum*, no. 85; and for a wintry album leaf, only one or two features of which are comparable with the example offered here, see Siren, *Chinese Paintings*, vol. VI, pl. 436. His published albums include a few quite daring leaves; *Comprehensive Illustrated Catalog of Chinese Paintings* shows nine hanging scrolls and three albums. Handscrolls by Fang are quite rare; *Li-tai chu-lu hua-mu* records only four, out of 38 landscapes listed. One fine Mi-style example is illustrated in *Masterpieces of Chinese Painting in the National Palace Museum (Supplement)*, no. 42.

25 SNOW PILED UP IN STREAMS AND MOUNTAINS (1743)
A handscroll in ink on paper, mounted with title and colophon.

The *chuan-shu* title, in glossy ink on decorated paper, is by Ch'u Te-i (1871–1942), *hao*: Li-t'ang, Han-wei; also called Sung-ch'uang. He was a noted archaeologist, connoisseur of antiquities, seal-carver, painter and calligrapher, living in Shanghai. It reads: Fang Hsün-ÿuan's *Hsi-shan chi-hsüeh t'u* (Picture of Snow piled up in Streams and Mountains), dated to a holiday in the ninth month of 1918 and dedicated to its owner, Mr. O-lu.
Signed Te-i inscribed, with two seals of the writer: Chou-shih (oval, relief) and Ch'u Li-t'ang (square, intaglio). Ch'u also wrote the label for the Hua Yen rabbits painting, no. 27.

The painting describes the rocky but populous foothills of a steep mountain range (rising sharply to the extreme left of the composition) completely covered with snow. The streaky grey wash used for the snow-laden sky and the chilly waters does not vary much from one to the other, and the artist has deliberately water-spotted the wash of the sky to give the impression of snow still falling. The snow-capped hill rising from the shore-line, with a small settlement on the slopes near its foot, is outlined with a strong, single dry-ink brushstroke, like a Zen snowman. In the foreground of the central section two lonely fishermen make their way home to their welcoming huts, in an enclosure bounded by bamboo and a small copse, past stark, frozen trees, exposed to the wintry blast and standing out in vivid, gothic contrast to the bluff of hills beyond the river gorge. More habitations nestle there, and a temple is almost hidden in woods at the base of the mountainous cliffs to the left of the river. Distant mountains, only dimly discernible in the heavy sky, and features of the dry, restrained brushwork with contrasting ink tones lend a convincing still, raw atmosphere.
With a poem by the artist:
I walk on the green grass, and it's drifting white; things are all wrong!
Day after day, the wind at my window, I watch the snow fly.
Still, it's not like being sad and solitary; there's always the snow to paint —
A thousand li of frozen clouds, in imitation of Wang Hui!

Dated to the first month of the *kuei-hai* year (1734).
Signed Shih-shu, with two seals of the artist: Huan-shan (square, relief, Contag & Wang 16) and Ou-jan shih-te (black, square, intaglio, Contag & Wang 8).
There are two collectors' seals at the end of the composition: Teng-chiang Hsi Hsü (square, relief) and Hsiao-tung-hua an (square, intaglio). Neither is recorded; it seems likely that both are one collector's name (Hsi Hsü of Teng-chiang, Chiang-yin, Kiangsu) and hall name, Hsiao-tung-hua retreat.

The title slip, or label, like the title written by Ch'u Te-i and dated to the ninth month of 1918, is signed "authenticated by Sung-ch'uang", with a square relief seal Li-t'ang, which identifies the painting as being in the Hsiao-tung-hua an collection at the time. Consequently Mr. O-lu and the owner of the retreat are one and the same, and it is plausible that the name Hsi Hsü is his as well. However, name, art name and hall name are all unrecorded.

Following the painting is a colophon by Chu Tsu-mou (1857–1931), original *ming*: Hsiao-tsang; a *chin-shih* of 1883 from Wu-hsing, Chekiang. He was an official, rising to be a secretary in the Board of Rites, but had to retire due to illness. He subsequently lived in Shanghai, and was recognised as one of the leading scholars of *tz'u* poetry. A painter of figures and of prunus, his calligraphy was said to combine the styles of Yen Chen-ch'ing and Liu Kung-ch'üan. He quotes a poetic inscription, mentioning Fang Shih-shu and his teacher Huang Ting, which he says was inscribed in an album of wintry scenes by Fang belonging to Ch'en Ts'eng-shou [(1878–1949) *hao*: Ts'ang-ch'iu, a *chin-shih* of 1903, censor, poet and painter]; which he saw two months ago in Ch'en's house. The colophon is likewise dated to the ninth month of 1918 and signed Hsiao-tsang, with one seal of the writer: Chu Tsu-mou yin (square, intaglio).
The painting measures 8 13/16 × 59 1/2 inches.

From the Wong Nan-p'ing collection, Hong Kong.

FANG SHIH-SHU
1692–1751

26 SNAKE, TOAD AND SUMMER PLANTS
A hanging scroll in ink and colours on paper.

A comically apprehensive toad eyes a red snake, which flickers its tongue at the toad and coils itself in unlikely fashion around the stem of a tall, leafy shrub. The shrub's ink-toned leaves, like the tall, reed-like green sheaths (iris? narcissus? mother-in-law's tongue?) and the foreground grassy foliage, are painted in the boneless manner, without ink outline.

Fang's treatment of the toad's skin is comparable to that employed for the Princeton album leaf depicting a weird, hairy animal (*Bunjinga Suihen*, vol. 9, no. 81). Both snake and toad have been imbued with the sort of anthropomorphic expressions which characterise many of Hua Yen's animals (see no. 27). Examples of such subjects by Fang Shih-shu are rare.

Signed Hsiao-shih lao-jen tso (made), with two square seals of the artist: Huan-shan (relief) and Shih-shu (intaglio). Fang's use of his "old man" art name may suggest that this is a relatively late work, dating from the mid-to-late Tao-kuang period.
The painting measures 31 5/8 × 12 1/16 inches.

The title slip is in the hand of the contemporary New York collector, connoisseur and artist Wang Chi-ch'ien (C.C. Wang), probably an indication that it was in his collection.

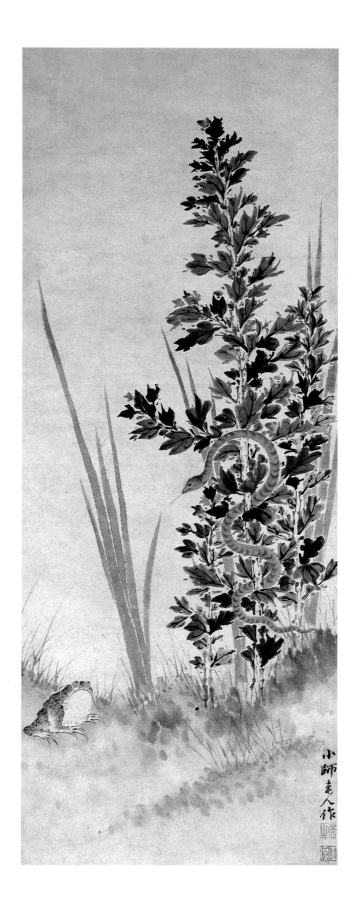

清方士庶午瑞畵紙本軸

HUA YEN
1682–1765

tzu: Ch'iu-yüeh.

hao: Te-sung, Tung-yüan-sheng, Hsin-hua shan-jen, Hsin-lo shan-jen, Li-kou chü-shih, Pai-sha tao-jen, Nan-yang-shan-chung ch'iao-k'o.

hall names in Hangchou: Chiang-sheng shu-she, Hsiao-sung kuan.

From Lin-t'ing (modern Ch'ang-t'ing), Fukien; lived and worked in Hangchou and Yangchou.

HUA Yen, a poet, calligrapher and painter, is usually, though not always, recorded as one of the Eight Eccentrics of Yangchou. Hong Kong connoisseurs generally include in the group Wang Shih-shen, Li Shan, Huang Shen, Chin Nung, Kao Hsiang, Cheng Hsieh, Li Fang-ying and Lo P'ing; but most other authorities define him as at least an occasional member of the Eccentrics, and they often include Kao Feng-han as well. Hua's painting activities and stylistic tendencies certainly qualify him for membership in that circle, and he is regarded as probably the most important, innovative and independent adherent, after Chin Nung, and, in some less eccentric aspects, as more important than Chin. He has been described as the last great painter of the literary mens' school; see for example the album of ten fans by seven masters of the Ch'ing in the Boston Museum of Fine Arts, *Chinese Paintings*, Tomita and Tseng, pl. 110–119, including fans by Wang Shih-min, Wu Li, Wang Lo, Wang Hui (2), Wang Yüan-ch'i (2), Yün Shou-p'ing and Hua Yen (2). Nowadays serious critics most admire him for his landscapes, but there is no doubt that, at their best, his well-known studies of birds and flowers, insects and animals are, in addition to their undoubted decorative worth, the most original and accomplished of their time, and of real artistic value. The problem lies in a large number of mediocre works in Hua Yen's bird and flower vein, which may be lesser, commercial works by the artist or, more likely, copies.

Hua Yen has never been underestimated by collectors, who have acquired his works if anything too enthusiastically; but critics have on the whole failed to fully appreciate his contribution, perhaps for that very reason. Like other Eccentrics, especially Chin Nung (as can be seen in the intimate album leaves of both), Hua Yen was influenced in his landscape style by Tao-chi. Yet in addition, as demonstrated by Fu, *Studies in Connoisseurship*, pp. 322–327, Hua's style in both landscape painting and calligraphy "also contains features derived from Yün Shou-p'ing and Chu Ta. The admixture shows how, a century later, a creative master could synthesize different stylistic trends of the seventeenth century in a distinctive and fresh way."

In a discussion of the Sackler painting *Cloudsea at Mount T'ai* at Princeton, Fu further elucidates the nature of Hua's fluid and expressive use of brush and ink, manipulated with an evident facility which may tempt observers to regard his work too lightly. This long quotation is from *Studies in Connoisseurship*, p. 326:

"A true individualist, Hua drew from stylistic traditions which were formally quite different and often thought to be mutually exclusive Chu Ta's influence on Hua Yen can be seen in both calligraphy and image. Hua Yen's versatile use of the round stroke with the brush held in a firm upright position is basically a calligrapher's brush-hold, and for Tao-chi and other painters who mastered its potential, it allows the line to suggest volume, creating the illusion of a third, volumetric dimension Hua's ordinary calligraphic style is usually a free mixture of 'running' and 'cursive' scripts. As seen in the inscription, his characters vary spontaneously in size and depth of ink from one to another. The columns are often close together, and one of the more distinctive features of his hand is that the axis of each character tends to slant in a different direction, creating a tangled effect. He handles his brush with a firmly centred tip, irrespective of the abrupt tilts in the axis, and it is this feature which links him with Chu Ta. Chu Ta's columns are more spacious and his characters more regular in size, but in him we recognize a source of Hua Yen's rod-like energy and succinct forms.

The fluidity in the calligrahy, as in the lengthened diagonal strokes and the graceful cloud forms, shows an equally strong influence from Yün Shou-p'ing, indicating an appreciation of this orthodox

master unusual for Hua's time. Hua himself mentioned his emulation of Yün in his inscription. Neither Yün Shou-p'ing nor Ting Yün-p'eng's depictions of cloudseas are available for specific comparison, but Yün's general influence may be further identified in Hua's landscapes, for example, the 1732 *Conversation in Autumn* in Cleveland or the 1755 *Autumn Music and Poetic Thoughts* in Osaka. Yün's inimitable sense of nuance and his feeling for movement in the brushline is reinterpreted with wit and humor in Hua's forms — the swaying trees and the extended and stretching shapes of the rocks, which suggest an animated life within, much like the moving figures of dancers whose bodies are shrouded Yün Shou-p'ing's style ('s) influence on Hua Yen has been underestimated. The expressive tone and structure of Hua Yen's later works are set by these undulating rhythms — the depiction of forms slightly off balance, either moving or imbued with potential movement. His more personal brush idiom emerges in the dry and sooty network of textures which he employs to model rocks or, as in the Sumitomo work, the giant roc. These drier areas frequently contrast with more buoyant touches of foliage dotted in wet ink or color. His fluffy, charcoal effects (with a) preference for dry textures is unusual in a period when wet brushwork dominated, for by the Ch'ien-lung era the wet, blunt and rather limited brush style of the major Yangchou Eccentrics held sway."

A description of the Cleveland 1732 landscape, *Eight Dynasties of Chinese Painting*, no. 265, describes the circles Hua Yen moved in while living in Yangchou from the early 1730s, and through them the derivation of stylistic ideas from Tao-chi. It observes that: "Hua Yen displays a technical virtuosity unmatched by other Yangchou painters, as well as a serious concern with form and structure equally rare among his contemporaries". Hua was " a follower of Tao-chi in the indirect sense of attitude and method. He began not with a preconceived idea of style but rather confronted the subject directly, worked with it, and employed whatever means necessary to achieve his desired effect". As a contemporary critic, Chang Keng, put it, he was free from the bad habits of the time, and guided by close studies of the old masters' works. Another writer, Chin Ts'u-yung, in *T'ung-yin lun-hua*, said, "Hua Yen's brush-manner was exceedingly free; he covered ('broke up') even the empty parts and produced effects of life with the tip of his brush. He revealed a new phase of art with wonderful skill. I have seen more than twenty pictures by him, and there was not a single one among them which did not reveal something new and surprising; they all seemed so natural. He could, indeed, be placed at the side of Yün Nan-t'ien; he surpassed by far the common painters" — another comparison with Yün Shou-p'ing.

Hua Yen's production was rich, varied and quite prolific. Most major collections own at least one work by him, though not all of them are of outstanding quality. Linking factors between his landscapes and the other works representing human figures, birds, flowers and rocks, animals, insects and vegetables include his assured brushwork and composition, his equally sure sense of colour, spontaneous freedom and rhythmic expressiveness of style; and his imagination and irrepressible sense of humour.

As Siren observes, in *Chinese Painting: Leading Masters and Principles*, in discussion of *A Horse In Autumn Wind*, pl. 462: "The lonely horse may serve to illustrate Hua Yen's faculty of animal characterization. It stands under a projecting cliff with a doleful expression on its raised head; the inscription says 'When autumn comes, the longing for far-away places is aroused; the neighing of the horse breaks the silence of the valley'. Like so many of Hua Yen's animals it is not an ordinary quadruped but a sentient being with thoughts and imagination, humanized by the painter's sympathy. The same is true of so many of his minor renderings of birds and animals in momentary positions."

The great majority of Hua's bird or animal paintings are in fact studies of birds on branches, and they are extremely popular despite their number. Other fine examples are published in, *inter alia*; *Art Treasures of the Peking Museum*, no. 34 (eagle); *Liaoning Provincial Museum Painting Collection*, vol. 2, p. 83 (crows); another Liaoning example in *Im Schatten Hoher Bäume*, no. 70 (parrot); *Tientsin Municipal Art Museum Painting Collection*, p. 119 (crows); *Gems of Chinese Painting in the Shanghai Museum*, no. 83 (parrot); *Nanking Museum Painting Collection*, no. 84 (diving ducks — a very

unusual, striking composition comparable to Huang Shen's style); *Suchou Museum Painting Collection*, no. 83 (ducks); *Chinese Paintings of the Ming and Qing Dynasties*, no. 71, from the Ku-kung Museum, Peking (squirrels); *T'ang Sung Yüan Ming Ch'ing hua-hsüan*, no. 94 (songbird) and 95 (crows); *Gems of Chinese Painting*, vol. 1, no. 76 (mandarin ducks); *Chinese Paintings From King Kwei Collection*, hanging scrolls volume, no. 59 (swifts; now in the Chih-lo Lou collection, Hong Kong) and 60 (birds in snow); *The Pageant of Chinese Painting*, no. 867 (songbird); *Bunjinga Suihen*, pl. 113 (squirrel and crows, Freer Gallery of Art, Washington D.C.) and pl. 114 (egrets); *Chinese Literati Paintings from the Jorakuan Collection*, no. 46 (waterbirds); *A Thousand Peaks And Myriad Ravines* (Drenowatz collection, Rietberg Museum, Zurich), nos. 63 a and b (parakeet and egret).

Of the 50 Hua Yen paintings illustrated in Kei Suzuki, *Comprehensive Illustrated Catalog of Chinese Paintings*, half of them landscapes, we should point out here a monkey painting in Princeton (A16–030); a five-leaf album in the Ching-yüan Chai collection, Berkeley, including deer, a camel and young, and a horse (A31–064); and an extensive album in the Lan-ch'ien shan-kuan collection, Taiwan, including insects (3 leaves), fish (2 leaves), cats, tiger, wild dogs or wolves, snake, fighting frogs, monkeys, an exotic bird and lotus, two other bird leaves, wasps with nest, elephant and camel, horse, crabs, squirrel, and turtle, as well as two figure in landscape leaves, one of which is illustrated by Siren (S4–056). Siren, *Lists*, records 110 Hua Yen paintings, several of which are among those illustrated by Kei Suzuki, of course, some of them bearing dates between 1721 and 1758. Among the published examples are paintings as early, if genuine, as 1711 and 1714. However, after an exhaustive search, no other rabbit painting by Hua Yen appears to be published or recorded.

27 BAMBOO AND RABBITS (1754)
A hanging scroll in ink and colours on paper.

On a grassy promontory a large black rabbit and its fluffy, white young sniff the air expectantly and look upward at, or beyond, two young bamboo shoots, perhaps eyeing their next meal. Young prunus twigs grow near the bamboo and from blue rocks at the water's edge. The composition, and its surprising but subtle colouration, are perfectly balanced. The comical rabbits are full of life and character, and the sooty ink modulation of the parent rabbit is technically superb, as are the eloquent, fluent lines and wet and dry brushwork of every aspect of the painting.

With an inscription by the artist: Painted by Hsin-lo shan-jen in early autumn of the *chia-hsü* year (1754) at the Chieh-t'ao kuan. This hall name, "Loosen the scabbard, or released and liberal, pavilion" is found on several of Hua's mature period paintings, both landscapes and bird or animal. He used a number of hall names and fancy seal names.
With two square, intaglio seals of the artist: Hua Yen and Ch'iu-yüeh.
With one collector's seal: Chou shih Pao-mi shih ts'ang (rectangular, relief). Pao-mi chai (or, shih) was the hall name of Chou Hsiang-yün, a well-known Shanghai collector in the first half of this century. He died in about 1947.
The title slip mounted on the outside of the scroll is written in the *li-shu* hand of Ch'u Te-i, (1871–1942, an early twentieth-century connoisseur; see no. 25). It reads "Hsin-lo shan-jen's Bamboo Branches and Pair of Rabbits Painting" in the Pao-mi chai collection; dated autumn of the *hsin-wei* year (1931) and signed Sung-ch'uang, with fancy seal.
The painting measures 51 × 20 7/8 inches.

Recorded: Siren, *Chinese Paintings: Leading Masters and Principles, Lists*, vol. VII, p. 344.
Published: *Chung-kuo ming-hua chi* (Famous Chinese Paintings), Yu Cheng Book Co., Shanghai, preface dated 1909, vol. II, no. 117.
Published: *Shina Nanga Taikan*, Tokyo, 1926, 12 vols: vol. 9.

甲戌初秋新羅山人寫於解硯館

新羅山人竹枝雙兔圖 寶米齋秋篋 辛未秋松窓

CH'IEN WEI-CH'ENG
1720—1772

tzu: Tsung-p'an.
hao: Yu-an, Ch'a-shan, Jen-an, Chia-hsien, Tsung-meng, Tsung-ts'ang.
posthumous name: Wen-min.
From Wu-chin. Kiangsu.

CH'IEN Wei-ch'eng was the elder brother of a good, but less famous orthodox landscapist, Ch'ien Wei-ch'iao (1739–1806). Wei-ch'eng first studied flower and fruit painting under the tutelage of his grandmother, Ch'en Shu (1660–1736), one of the best-known female painters of the Ch'ing. Later, however, he devoted himself primarily to landscape painting. Ch'ien was a scholar and official, taking his *chü-jen* degree at the age of 19, in 1738; four years later, after a special examination, he was appointed a secretary in the Grand Secretariat. He was the *chuang-yüan* (highest *chin-shih* graduate) of 1745, and was appointed a first-class compiler of the Hanlin Academy. After serving in various positions he became senior vice-president of the Board of Works, 1757–1761, and junior, then senior vice-president of the Board of Punishments, 1761–1762. Meanwhile he officiated several times as an examiner both in the provinces and the capital. In 1762 he became director of education in Chekiang; and in 1770 he helped to calm down rebellious Miao tribesmen while in Kueichou settling a default in official accounts. He returned home in 1772 to observe the period of mourning for his father, and himself died later the same year. Fuller details are given in his biography in *Eminent Chinese of the Ch'ing Period*.

Attached to the Hua yüan, or imperial painting bureau, under the Ch'ien-lung emperor, Ch'ien studied painting under Tung Pang-ta (1740–1818) and became his rival. Like Tung, he was considered by the emperor to be one of the greatest artists of his age, and was showered with favours. Almost one hundred scroll paintings by Ch'ien, and 72 fans, are recorded in the catalogue of the former National Museum, Peking; 34 of them were rescued for the National Palace Museum, Taiwan, to the chagrin of James Cahill, who is scathing about Ch'ien, Tung, Tsou I-kuei and Chang Tsung-ts'ang (*Yüan Chiang and his School*, p. 260). Several of these works had poems inscribed on them by the emperor. While the criticism, that they reproduced the forms without realising the spirit of the old masters, of these court painters of the Ch'ien-lung period in particular is accurate, nonetheless some among them did on occasion produce superior work. While such large and decorative works as the pair of landscapes offered here cater overmuch to the superficial "barbarian" and decadent tastes of the Manchu Ch'ien-lung emperor, whose connoisseurship failed to get far under the skin of traditional Chinese painting while wreaking havoc upon its very existence, yet there is a grandeur to them, a frozen, majestic presence. They were evidently created by a craftsman extremely gifted in the difficult art of composition on a large scale, but they are limited by his apparent desire to make incredibly impressive paintings; a *tour de force*, highly inventive and invested with a static power. In fact, it is Ch'ien Wei-ch'eng's large ink landscapes which are, on the whole, guilty as charged of being boring, soulless, and endowed with a degree of formal perfection without inherent life; in Siren's words (*Chinese Paintings*, vol. V, p. 220) "with all their obvious merits, they have no resonance from the world of the Immortals". Standard examples are illustrated in Siren, *Chinese Paintings*, vol. VII, pl. 439, and *The Pageant of Chinese Painting*, nos. 933–935. For his equally turgid flower paintings see the extensive handscroll in the Boston Museum of Fine Arts (*Chinese Paintings, Yüan to Ch'ing Periods*, pl. 165–166, and in *Bones of Jade, Soul of Ice*, fig. 48). Ch'ien's work on a smaller scale is usually altogether more satisfactory. A number of fans are published, which demonstrate that his dry style and compositional facility are well suited to the intimate format. Perhaps the best indication of his range and potential is shown in the diversity of his album paintings; even the critical Professor Cahill owns a small ink album of calligraphic bamboo, prunus and rocks by him (*Comprehensive Illustrated Catalog of Chinese Paintings*, A31–090). Ch'ien painted for the emperor a charming and successful 1771 landscape album in the style of Wang Yüan-ch'i (Sotheby's, *Fine Chinese Paintings*, December 5, 1984, lot 50), and a small landscape album in the Asian Art Museum, San Francisco (*Comprehensive Illustrated Catalog of Chinese Paintings*,

A35–012) likewise manifests his appeal and some inventiveness on a less imposing scale.

Ch'ien was also known as a calligrapher, modelling his writing after that of Su Shih (Su Tung-p'o), but these works are rare. His infrequent use of colour in landscape is distinctive and sure; his experience as a flower painter leads to occasional dramatic effects, which are markedly successful.

The pair of landscapes offered here are quite outside the usual terms of criteria applied to Ch'ien Wei-ch'eng. Possibly two of a set of four seasonal landscapes, or otherwise intended as a complementary pair, he must have intended them as one of his masterpieces.

28 PAVILIONS IN SPRING AND WINTER LANDSCAPES
A tall pair of hanging scrolls in ink and colours on silk.

In the right-hand scene, representing spring/summer, figures disport themselves in the green, lush surroundings; boating, fishing and sitting at civilised ease in their elegant surroundings. One scholar walks across a zigzag bridge, taking in the view, his attendant following with the master's *ku-ch'in*; while in the foreground pavilion two men of letters discuss some refined matter as a boy brings refreshment and cranes wander on the terrace. The waterfalls, though steep, are gentle, the trees primarily deciduous, and the large rocky outcrops are painted in a softened rendition of the archaic *ch'ing-lü* (blue-green) style.

In the left-hand painting, depicting the depths of winter, the mountains and waterfalls are overhanging and precipitous, the bridges and even the pavilions appearing precariously placed. The central foreground complex is a scholar's retreat with the topmost room apparently perched in the topmost branches of one of the frozen, stark trees; three travellers make their way towards it, the end of their long road in sight. To the upper left more travellers, mounted on mules, move along the dangerous road which continues, clinging to the outside of the mountains, past the temple among peaks and waterfalls towards the top of the composition. Here the foliage is that of the three friends of winter; pine, bamboo and frozen prunus, together with a tree whose orange-brown leaves contrast effectively with the grey of the sky and white of the snow, which covers everything.

Both paintings are signed to the lower left; ch'en (your subject) Ch'ien Wei-ch'eng kung hui (respectfully drawn, or painted).
Each with two small square seals of the artist: ch'ien Wei-ch'eng (intaglio), and kung hui (relief).
Each painting measures 83 × 21 1/4 inches.

Although the paintings bear no imperial seals they were presumably painted for the emperor in the Hua yüan, at some time in Ch'ien's most mature period, ca. 1760s. The emperor may have presented them to someone, or they may have been used as decoration in one of the palaces and looted from there in 1860 or 1900.

Until recently they were housed in a European private collection.

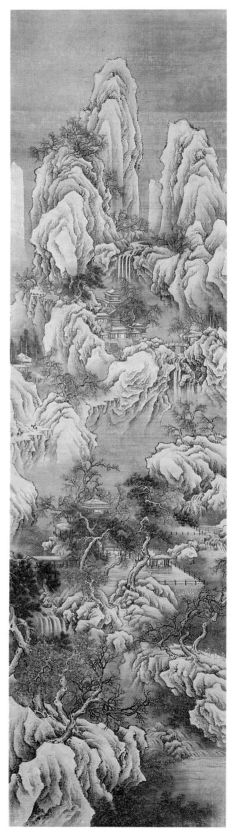

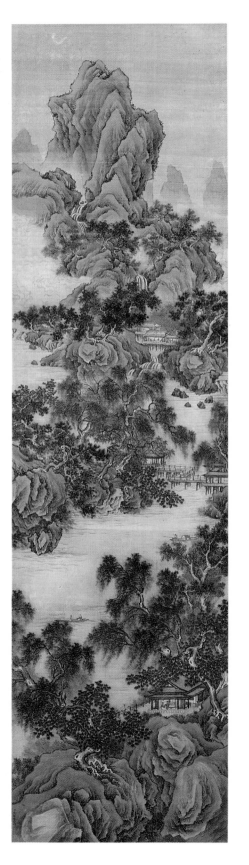

28

KAN T'IEN-CH'UNG
late 18th century

tzu: Cheng-p'an.

hao: Ch'ai-ho, Ch'ün-yü shan-ch'iao, Pai-shih shan-jen.
From Hsin-hui, Kuangtung.

KAN T'ien-ch'ung was a poor but dignified scholar of the Ch'ien-lung period, an official who gained his senior licentiate in 1770. Of a solitary and resolute disposition, he simply closed down and ceased the business of his local *yamen* in Kuangtung because of corrupt practises. Despite the extreme poverty of his family, he never manifested grief or resentment. He excelled at painting and calligraphy which, like his character, was described as lofty and elegant in spirit. The District Magistrate of Hsin-hui engaged him as a lecturer at the Ching-hsien college, and for years, although all he earned was a teacher's salary, he would donate half of it to the local cultural society. When the District Magistrate visited the college Kan would thank him unceremoniously and report on matters without once looking at him. However, when meeting people he was genial and not at all unapproachable; even shepherds and woodcutters loved and respected him.

Kuangtung painting in the Ch'ing is particularly interesting in terms of regional artistic development. Kuangtung and Fukien were the last outposts of resistance to the invading Manchu forces, and their citizens numbered many Ming loyalist martyrs. The Ch'ing army's 1647 massacre in Canton rivalled in scale those of Yangchou and Chiating; an estimated seven hundred thousand people were killed. The toll of local intellectuals must have been significant, and cultural activity in the region was considerably set back for the next century. In painting terms Kuangtung artists had much more in common with late Ming and Anhui individualist and *i-min* directions than with the orthodox Tung Ch'i-ch'ang and Four Wang school popular in Chiangnan and Peking. In the eighteenth century this trend continued, with Shih-t'ao as the painter most influential in Cantonese stylistic development. The Yangchou Eccentrics and their like were popular in Kuangtung, but those who were collected locally were the Fukien-born group of Hua Yen, Huang Shen and Shang-kuan Chou, rather than Chin Nung and Cheng Hsieh. For a signficant number of painters Shih-t'ao's approach was the liberating spirit, and the late eighteenth century saw a cultural revival in Kuangtung, with several artists working out individual styles in which innovation was held to be more important than technique.

Kan T'ien-ch'ung was best known for his bird and flower ink paintings in the style of Shih-t'ao and Chu Ta, as well as for expressive bamboo and orchid paintings. A strong and effective bird and lotus hanging scroll in Professor Cheng Te-k'un's collection, reminiscent of both of these seventeenth-century individualists, is illustrated in the catalogue (*Mu-fei ts'ang hua k'ao p'ing*, p. 59, illustrated opposite p. 58), which describes the powerful, untrammelled nature of both conception and brushwork, drawing particular attention to the qualities of the ink. A spiky wet and dry ink study of chrysanthemum and rock, a hanging scroll dated 1786 from the Hong Kong City Museum and Art Gallery collection, is illustrated in *Kwangtung Painting* as no. 22. These quite different paintings are remarkable for their spare, calligraphic application of wet and dry ink.

A section of an innovative, expressive landscape handscroll dated 1779 is illustrated in *Landscape Painting by Ming and Ch'ing Kwangtung Masters* as no. 37; it uses dramatic bulging rock forms, stark inky trees, a streaky wash and profuse dotting of random foliage to suggest that the few figures depicted are in danger of being swept away. It represents a personal direction which carries on from the expressive ink mode of Ming individualist painters, without owing specific styles or techniques to any of them. Kan's landscape painting is very rare; this is the only other example published. His calligraphy, though quite well known, must be rarer, as there is no example even in the specialist catalogue *Guangdong Calligraphy* published by the Hong Kong Urban Council in 1981.

29 MOUNTAIN RIVERSCAPE WITH LONE BOATMAN (1772)
A large hanging scroll in ink on paper.

A solitary man in scholar's garb sits deep in thought in his low punt, drifting at the mouth of a rocky inlet bordered by precipitous peaks. On the headlands to both sides is a variety of leafy trees; only a few, but attacked so vigorously with strong, calligraphic wet and dry ink strokes that they appear quite profuse. Likewise, the near and distant rocks are as much an exercise in abstract brushwork as they are an attempt to delineate form. Only the single figure and his boat are executed in anything approaching a representational outline (quite an agile line at that), a device which renders him by contrast somehow more static and melancholy.

Dated and inscribed: Spring of the *jen-ch'en* year (1772), made for presentation to Mr. Yung-pang, to raise a smile. This art name of the recipient is not recorded.
Signed Ch'ai-ho Kan T'ien-ch'ung, with two square seals of the artist: Ch'ün-yü shan-ch'iao (intaglio) and Pai-shih shan-jen (relief).
There are two square relief collectors' seals to the lower right corner: Huang shih Wei-neng chen-ts'ang and Ts'ang-wu pan-ting. The latter is the seal of the modern Macao dealer Teng Ts'ang-wu. The painting measures 47 × 22 1/4 inches.

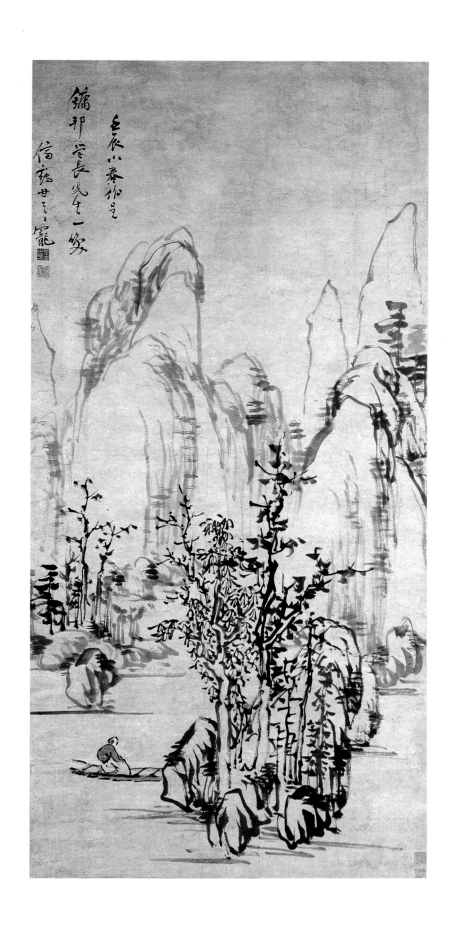

107

HUANG I
1744–1802

tzu: Ta-i, Ta-yeh.
hao: Hsiao-sung, Ch'iu-an, Lien-tsung ti-tzu.
hall name: Hsiao-lien-lai ko.
From Ch'ien-t'ang (Hangchou), Chekiang.

HUANG I was an official, a poet and a painter of landscapes and flowers, especially plum blossom, after Yün Shou-p'ing. He was known, though, as a leading seal-carver and calligrapher, excelling in the *chuan* and *li* (seal and clerical) scripts, deriving his style not only from his master, Ting Ching, but also from his own extensive studies of Han monumental inscriptions. Grouped as one of the "Eight Masters of Hsi-ling", the majority of Huang's landscape paintings were bland, dry and apparently uninspired, like much of the work of his contemporaries Fang Hsün, Hsi Kang and Tai Hsi. Indeed, the bulk of his extant calligraphic works display a comparable sameness and lack of drive, crispness or impact. His seal carving and engraving work, though, is very highly regarded, and fake examples of his seals and inscriptions on inkstones abound. We offer in this catalogue a remarkable (and genuine) inkstone ancestor tablet by Huang I, dated 1781, as no. 134.

The landscape shown here is considerably superior to the vast majority of Huang's published paintings, and of a great deal more visual appeal. As a painter he took as his landscape models Tung Yüan and Chü-jan, aiming for an effect of solitary retirement and subtle, strange beauty. Using only a lightly loaded brush he nevertheless managed (at his best) to achieve a very expressive style which captured the archaic flavour of his beloved bronze and stone inscriptions.

30 MOUNTAIN LANDSCAPE AFTER CH'A SHIH-PIAO
A hanging scroll in ink and light colours on paper, mounted with buffalo horn rollers.

Three gnarled but leafy trees of contrasting type stand on the bend of a riverside path in the mountains by a large rocky outcrop, a few sprouting young bamboo straggling behind them. In the middle distance two impressive rock pillars rear up, while in the background vaguer misty mountain-shapes loom.
Inscribed with a couplet in standard regulated verse of seven characters to a line:
Ch'ing shan i lu ho ts'eng tuan,
Ti shih Hsiao Hsiang yen i hsi.
One road, all through the green hills; how can they stop it?
Along the Hsiao and Hsiang, are the wild geese more scattered?
Tuan lu, to stop the road, has the sense of highwaymen intercepting travellers. Wild geese walk and fly in ordered columns; they also convey an image of exile and loneliness. Huang's poem mocks the scraggly nature of the trees, threatening in their awkward disposition to block the path. The Hsiao and the Hsiang are rivers in Hunan, well known as poetic references..

Inscribed: After the style of Ch'a Mei-ho (Ch'a Shih-piao), for the rectification of third elder brother Lien-k'o. The intended recipient's art name, Lien-k'o, is not recorded.
Signed Huang I, with one rectangular seal of the artist: Hsiao-sung.

With three rectangular collectors' seals: Pao Ku-shu chia chien-ts'ang (relief), Huang shih Huai-hsüan t'ang ts'ang (relief) and Hsü shih Ling-hsi sou-ts'ang chin-shih shu-hua chih-yin (intaglio). None is recorded.
The title slip is signed by one Hsi-yüan, with an illegible hall seal and a further seal of Mr. Huang's Huai-hsüan t'ang collection.
The painting measures 25 1/2 × 12 3/8 inches.

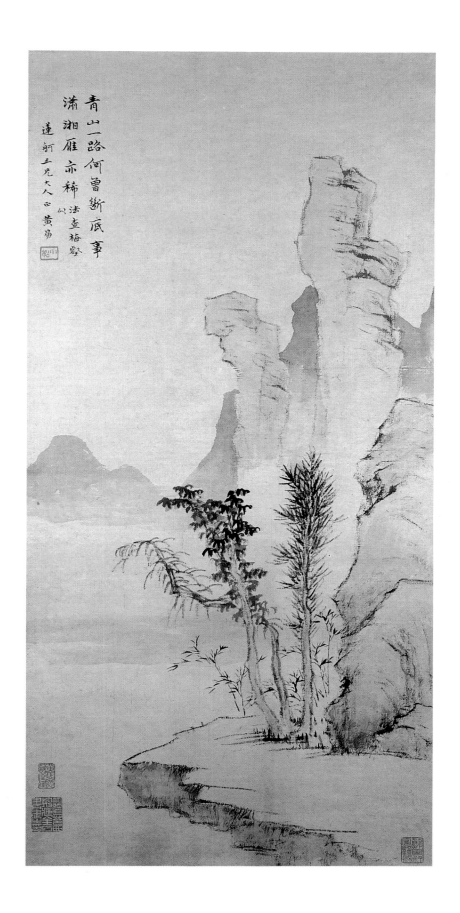

Not many of Huang's paintings are published. His lesser, insipid works abound in auction sales, and his calligraphy is met with in most of the major publications, but of his superior paintings only a few are in print. Kei Suzuki *Comprehensive Illustrated Catalog of Chinese Paintings* lists only eleven, all but one in Japanese collections. Of these several feature compositions with a clump of strange trees in the foreground; quite frequently three of them. One example is an album in the Ching-yüan chai collection, Berkeley. A handscroll with some interesting rocks is in the collection of the Liaoning Provincial Museum, catalogue vol. 2, no. 119; and the Tientsin Municipal Art Museum has a landscape album, catalogue nos. 146–147, which like the Liaoning handscroll represents the bland, insipid (*t'an*) brushwork technique rather than the crisper, archaic style using a little more outline which appears to be favoured by Japanese and Western critics.

WANG HSÜEH-HAO
1754–1832

tzu: Meng-yang.
hao: Chiao-hsi, Shan-nan lao-nung.
hall name: I-hua hsien.
From K'un-shan, Kiangsu.

WANG Hsüeh-hao was a graduate of 1786, and a direct painting descendant of Wang Yüan-ch'i (see no. 19). The young Hsüeh-hao's painting teacher was Li Yü-te, whose father Li Hsien was the maternal nephew of Wang Yüan-ch'i. Consequently Wang Hsüeh-hao is held to be an orthodox painter in immediate line of descent from the Four Wangs, and he is sometimes listed as one of the Lesser Four Wangs. The other three are Wang Ch'en (1720–1797), Wang Yüan-ch'i's great-grandson; Wang Su (fl. 1760–1766), Wang Shih-min's great-grandson; and Wang Yü (active ca. 1680–1749), pupil and nephew of Wang Yüan-ch'i. Contag and Wang list, instead of Hsüeh-hao, Wang Chiu (ca. 1768), the great-grandson of Wang Hui.

Wang Hsüeh-hao travelled extensively and was noted as a poet and a calligrapher in all writing styles (*chuan* and *li* scripts after Ch'in and Han originals; document styles first after the T'ang calligraphers Ou-yang Hsün and Ch'u Sui-liang; and late in life after the two Wangs, Hsi-chih and Hsien-chih). He was a friend of the poet and calligrapher Chang Wen-t'ao (see *In Scholars' Taste* no. 19), and probably knew others of Chang's circle, such as I Ping-shou (see no. 35) and Sun Hsing-yen (see *In Scholars' Taste*, no. 15). In his middle age he took up portrait painting, in a very dry, bland manner; one recorded example dated 1808 is probably of Juan Yüan (see *Emperor Scholar Artisan Monk*, no. 75).

Fu observes of Wang Hsüeh-hao, in discussing an 1831 landscape fan by him in the Sackler Collection, The Art Museum, Princeton, (*Studies in Connoisseurship*, pp. 336–337) that his individual statement and subtlety have not received sufficient attention today, and points out his sensitivity to the interaction of paper surface with landscape, in a manner reminiscent of his antecedent Wang Yüan-ch'i. Technically, Hsüeh-hao contrasted soft, rubbed, layered brushwork with dark, crisp detail, successfully integrating landscape and foliage masses; throughout his work it seems that the plain white paper, suggesting bulging space or volume, has played an important part in defining the overall structure and the diversity of textures and shapes.

For some of his life at least Hsüeh-hao lived in Suchou, and Fu notes a relationship to the Ming Suchou painter Lu Chih (see no. 5) in Wang's flat, oblique brushstrokes and sense of abstract design. Wang is also said to have adopted the style of Shen Chou in later life, but in its essentials the density of his landscape style and its rounded, three-dimensional volume derive from Wang Yüan-ch'i and the redirection given to the "orthodox lineage" by Tung Ch'i-ch'ang in the seventeenth century. Aware of the literati ideal in his position as a scholar-painter, Wang expressed, in a colophon, the theory become process of literati painting: "There are six styles (of calligraphy), but only one Way. It is enough to write to perceive it; the writer must have the meaning foremost before his brush (touches the paper). Then he need only pursue what he perceives, and although (the work may have the appearance of) dishevelled hair and coarse clothing, the flavour of the meaning will be naturally full, exceedingly precise and entrancing, and will convey the vitality and flavour of antique refinement. This is painting by the literary man! Otherwise how could it be distinguished from vulgar craftwork?"

As Fu notes, "Wang was not a blind follower of formal canons . . . he was alert to the dangers of perpetuating empty brush formulas devoid of a personal conception". In other words, in his best work at least Wang avoided the fate of most eighteenth and nineteenth-century orthodox painters; that of producing tedious, repetitive and totally uninspired surface pastiches of the old masters.

Siren, *Lists*, mentions only fifteen paintings by Wang, including two albums; one an early work (1792) and the other published by the Commercial Press, Shanghai, in 1923. Most of Wang's landscapes are of fan or moderate-size hanging scroll form, and seem to date from about 1792 to 1832, the year of his death. Kei Suzuki, *Comprehensive Illustrated Catalog of Chinese Paintings* illustrates only ten

landscapes by Wang, all but the Princeton fan in Japanese collections. *The Pageant of Chinese Painting* illustrates as no. 958 an album leaf (?) by Wang dated 1826; the foreground bears a marked resemblance to our leaf b.

31 SPURRED ON THROUGH MISTY CLOUDS (1817)

A twelve-leaf album in ink, and ink and colours, on paper, the two preceding leaves bearing the title, and one subsequent leaf with a colophon. Boxed.

The first two leaves have the four-character title written by Wang: *Ch'ü-shih yen-yün*; urged on (spurred on, or sent, implying the use of force) to, or through, misty clouds.
Signed Chiao-hsi inscribed himself, with two seals of the artist: Wang Hsüeh-hao yin (square, relief and intaglio; used throughout the album) and, before the title, Pu-ch'iu-ssu: Do not seek the likeness (rectangular, relief).

a. In the cave-like cleft of a bleak, rocky landscape of light, dry ink brushstrokes, a scholar on a bridge surveys spiky prunus trees, a few firs behind him on a ridge.

Dated and inscribed: The *ping-tzu* year, 12th lunar month (January 1817); plum blossoms longing to bloom, using Lao-yin's (?) style, while examining some prunus in front of me.
Signed Chiao-hsi, Hao, with one seal: Wang Hsüeh-hao yin.

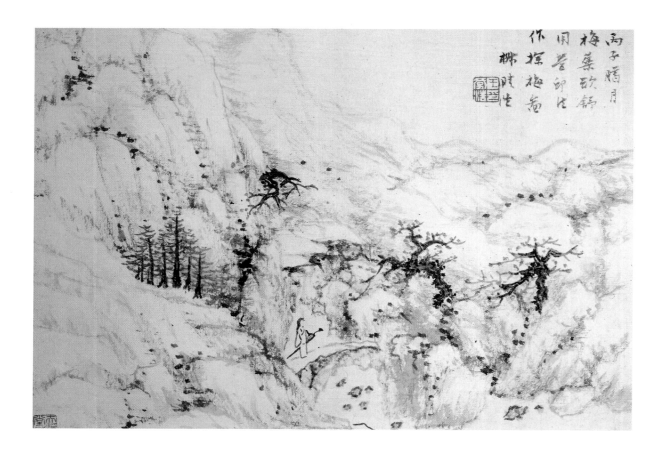

112

113

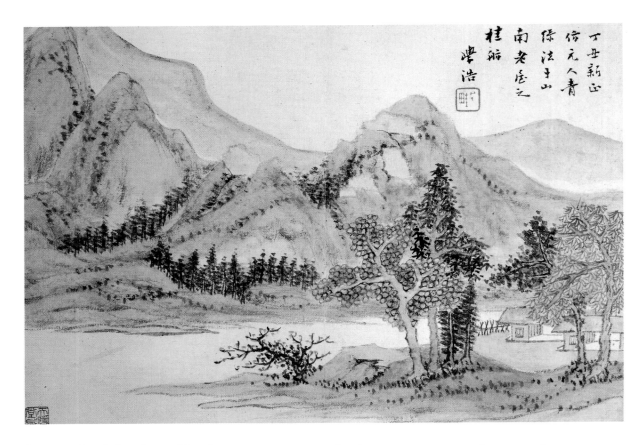

b. In a brightly coloured landscape, various trees dominate a retreat on a foreground promontory, while across the river wooded hills rise, with blue mountains beyond them; the style is not at all "archaic".

Dated and inscribed: The *ting-ch'ou* year, first month (1817); after the Yüan painters' blue-green style, (painted) at the Shan-nan lao-wu's 'cassia boat'.
Signed Hsüeh-hao, with one seal: Chiao-hsi (square, relief; used throughout the album).

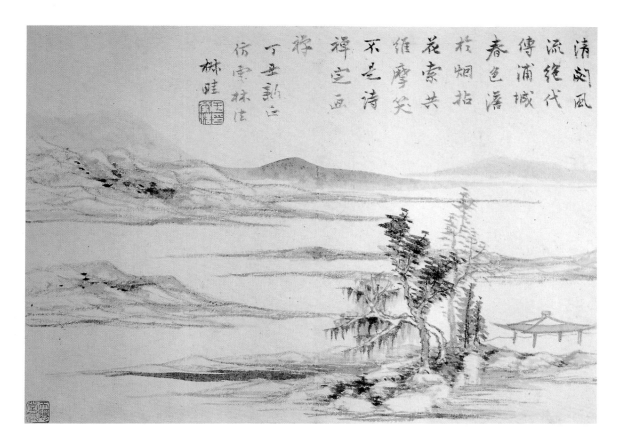

c. In a spare, pale ink landscape a low pavilion sits beside a clump of strange trees, as the opposite banks of the meandering river fade into foggy distance.

With an allusive poem:

Pure and hidden, this style (of Ni Tsan) *has been transmitted for generations;*
Banks and walls, beautiful in spring, paled by the mist.
I pluck flowers and scatter them, to draw a smile from Vimalakirti,
If this is not the Zen of poetry, it certainly is the Zen of painting!

Dated and inscribed: The *ting-ch'ou* year, first month (1817), after the style of Yün-lin (Ni Tsan, one of the Four Great Yüan Masters).
Signed Chiao-hsi, with one seal of the artist: Wang Hsüeh-hao yin.

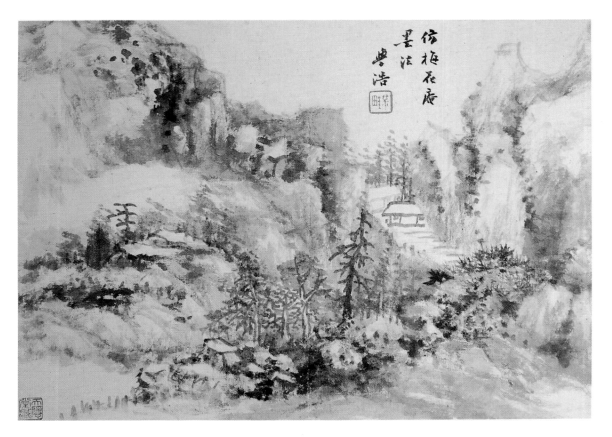

d. In a wild, unkempt landscape of textured wet and dry ink brushwork, foliage grows on all sides of the path leading to a small retreat.

Inscribed: Imitating the ink style of Mei-hua an (Wu Chen, another of the Four Great Yüan Masters). Signed Hsüeh-hao, with one seal of the artist: Chiao-hsi.

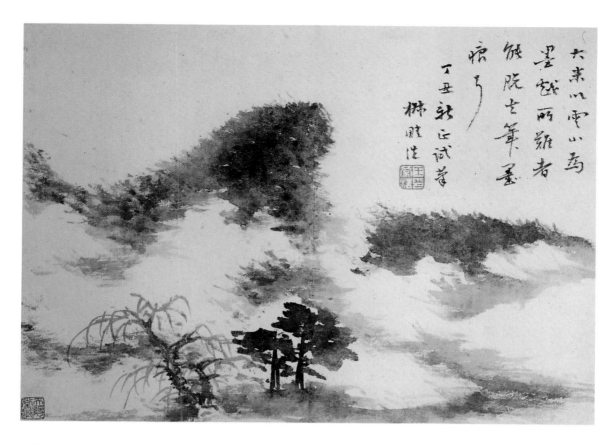

e. Wet mountains tower over atmospheric trees in an abstract, windswept landscape, painted with horizontal inky strokes in Mi Fu style.

Insribed: The great Mi's cloudy mountains represent a transcendent use of ink; the most difficult thing is to throw off the constraints (or marks) of the raw ink.
Dated and inscribed: The *ting-ch'ou* year, first month, experimenting with my brush.
Signed Chiao-hsi, with one seal of the artist: Wang Hsüeh-hao yin.

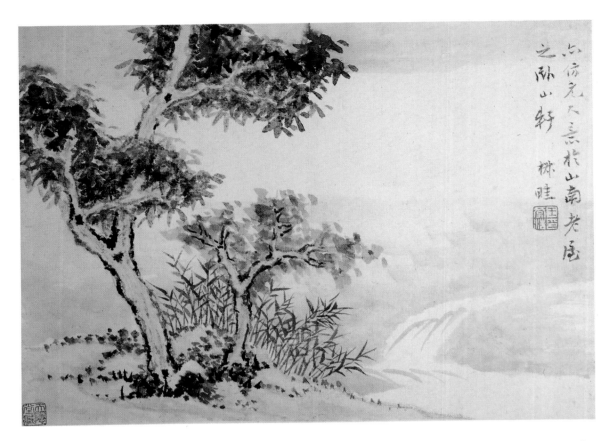

f. In brightly coloured close-up, two fruit trees blossom by a clump of bamboo, above a rushing stream.

Inscribed: My imitation of the Yüan masters' idea, (painted) at the Shan-nan lao-wu's 'Resting in the Mountains Pavilion'.
Signed Chiao-hsi, with one seal of the artist: Wang Hsüeh-hao yin.

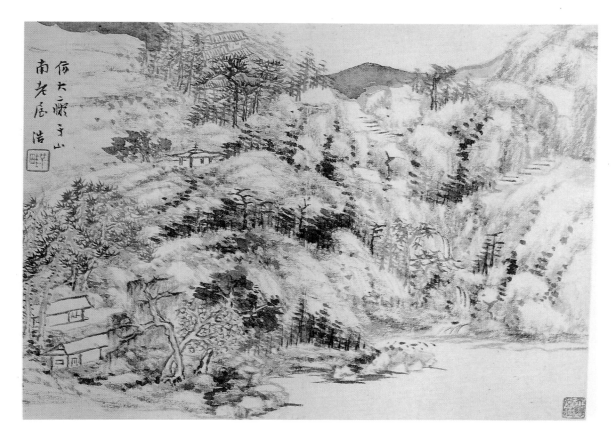

g. Buildings nestle among clumps of trees in hills rising steeply from the banks of a lake in a dry, textured ink composition.

Inscribed: Imitating Ta-ch'ih (Huang Kung-wang, the oldest of the Four Great Yüan Masters), painted at the Shan-nan lao-wu.
Signed Hao, with one seal of the artist: Chiao-hsi.

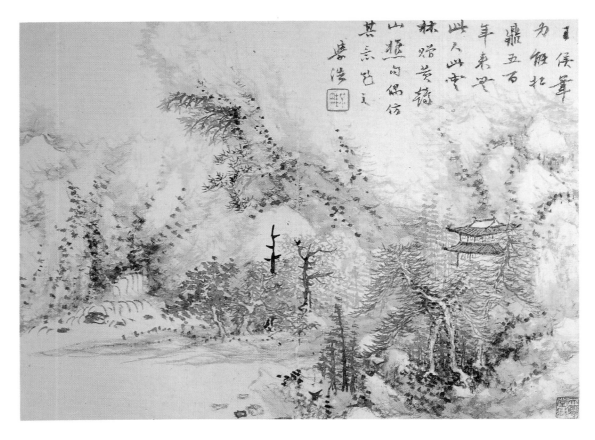

h. A solitary temple nestles among ghostly trees under a huge rocky overhang by a lake, with a waterfall emptying into it, the style reminiscent of Wang Meng, another of the Four Yüan Masters.

Inscribed: Marquis Wang's (Wang Wei) strength of brushwork can be compared to a bronze *ting*; for 500 years now we haven't had such a man. This is the couplet that Yün-lin (Ni Tsan) offered Huang-hao shan-ch'iao (Wang Meng) — I just happen to imitate his idea, and write it down.
Signed Hsüeh-hao, with one seal: Chiao-hsi.

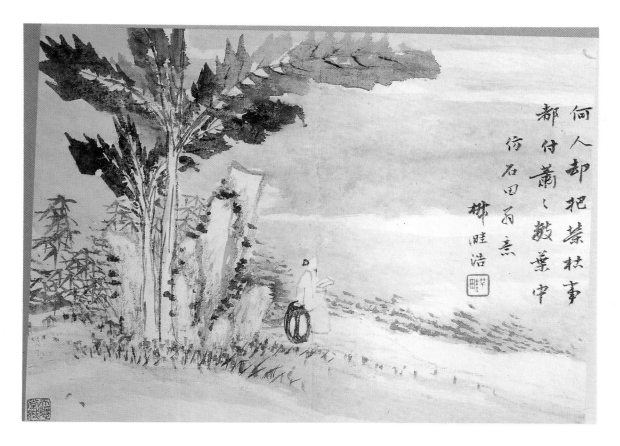

i. A lone scholar sits reading on a barrel stool under huge plantains growing with clumps of bamboo from strange rockwork, all in contrasting wet and dry ink.
With a poem:
What man would willingly take on the ups and downs (flourishing and withering) *of the official life?*
(Rather), *they all give out a mournful whistling amid the countless leaves.*

Inscribed: Imitating old Shih-t'ien's idea (Shen Chou, one of the Four Great Ming Masters).
Signed Chiao-hsi, Hao, with one seal: Chiao-hsi.

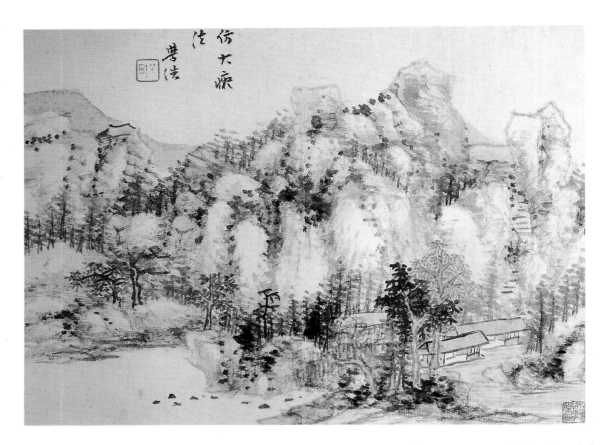

j. In a harmoniously coloured composition, a cluster of huts sits quietly among spring foliage by a lake at the foot of steep hills.

Inscribed: Imitating the style of Ta-ch'ih (Huang Kung-wang).
Signed Hsüeh-hao, with one seal: Chiao-hsi.

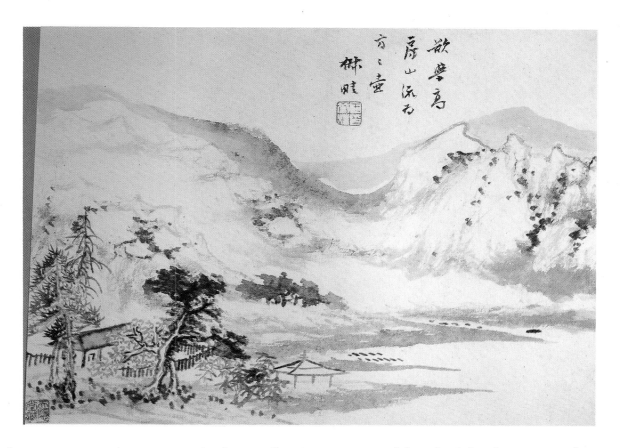

k. In a sweeping mountainous landscape of contrasting wet and dry ink a lakeside retreat is almost concealed by two pairs of strange trees.

Inscribed: I wanted to follow the style of Kao Fang-shan (Kao K'o-kung, 1248–1310), but it turned into that of Fang Fang-hu (Fang Ts'ung-i, ca. 1340–1380).
Signed Chiao-hsi, with one seal: Wang Hsüeh-hao yin.

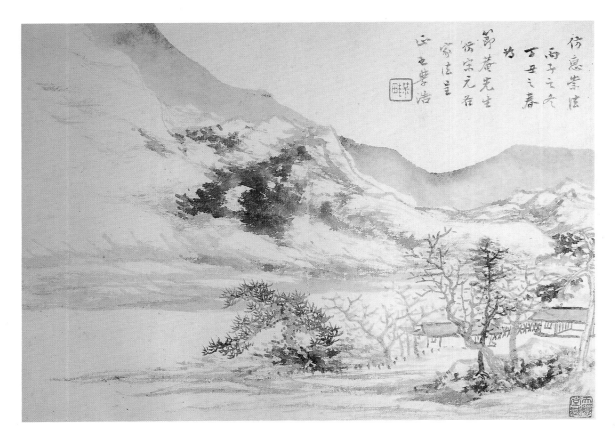

l. In a light, dry ink landscape a retreat on the wooded foreground promontory looks across the river to the range of hills rising sharply opposite.

Inscribed: After the style of Hui-ch'ung (a Sung monk painter, active in the early eleventh century). Dated and inscribed: The winter of the *ping-tzu* year and spring of the *ting-ch'ou* year (early 1817 and perhaps the end of 1816) for Mr. Chieh-an, imitating the various Sung and Yüan masters' styles, offered for your correction. (There are several figures with the art name Chieh-an, but none of them seems a likely candidate for the recipient of the album.)
Signed Wang Hsüeh-hao, with one seal: Chiao-hsi.

Each leaf bears one seal of the contemporary Taiwanese collector Chang Po-chin: T'ien-yin-t'ang ts'ang (square, relief).

Followed by one poetic colophon leaf by the painter and calligrapher Wang Chen (Wang I-t'ing, 1866–1938). See *In Scholars' Taste*, nos. 37–44, for several works by Wang.
Under his brush the clouds and mist are wrested from nature and transformed;
A mound, a gully, borne deep in the bosom (like stubborn prejudices).
Unornamented, of the divine class, returning to blandness,
A controlled stength, archaic yet attractive, with a character all its own.
With other comments praising Hsüeh-hao's naturalness and use of brush and ink.

Dated mid-autumn of the *hsin-wei* year (1931).
Signed Pai-lung shan-jen, with three square seals of the artist: Pai-lung shan-jen (relief), Wang Chen ta-li (intaglio) and I-t'ing (relief).

The title slip is also by Wang Chen: Mr. Wang Chiao-hsi's landscape album of divine quality.
Dated mid-autumn of the *hsin-wei* year (1931).
Signed Pai-lung shan-jen, with one seal of the artist: Wang Chen (rounded square, intaglio).

Each leaf measures 13 7/8 × 10 1/8 inches.

From the Chang Po-chin collection, Taipei.

CH'IEN TU
1763–1844

original ming: Yü.
tzu: Shu-mei.
hao: Sung-hu (–hsiao-yin), Hu-kung, Lao-hu, Wan-chü-shih, Wan-tao-jen, Hao-sheng.
From Ch'ien-t'ang (Hangchou), Chekiang.

CH'IEN Tu was from a wealthy Hangchou family of amateur painters; his brother, sister, daughter and several cousins all painted, and he was the seventh son of Chekiang's governor, Ch'ien Ch'i. A descendant of Ch'ien Ku (1508–1572, see no. 3), Tu's circumstances allowed him to travel extensively and devote himself to painting. Described as a man of uncommon cultivation, retiring and aloof by nature but generous with his wealth, he could spend a thousand cash without a qualm. According to Wan-go Weng, though, in his essay "The World in the Teapot" (*I-hsing Ware*), Ch'ien squandered his inheritance early and deserted his wife and daughter, travelling far and wide to escape debts as well as to seek adventure, riding elephants in Yünnan and scaling mountains in Szechwan.

Ch'ien Tu was a member of the elite literati circle of Ch'en Man-sheng (see no. 36); we offered a rare prunus painting by Ch'ien in *Emperor Scholar Artisan Monk*, no. 33, as one of a group of works by members of his set, and demonstrated the close social links between Ch'ien and such friends of Ch'en as Kuo Lin (see no. 37), Ch'ü Ying-shao, Kai Ch'i and others.

Ch'ien was a fine poet, and regarded as a notable connoisseur of painting and calligraphy; he published two literary collections which include astute notes on works he had seen. The Cleveland 1814 handscroll, *Dream Journey to Mount T'ien-t'ai*, (*Eight Dynasties of Chinese Painting*, no. 280) was purportedly based upon a T'ang Yin work in his collection and was dedicated to Ch'en Wen-shu, writer of one of the later colophons to the present example.

Ch'ien Tu's painting is highly regarded, and unlike other early nineteenth-century painting looked elsewhere than to the Four Wangs for its models. In particular, his landscapes derive from the sixteenth-century Wu school masters such as Wen Cheng-ming and Wen Po-jen, echoing the sheltered, introspective mood of their later Suchou follower Shao Mi. Fu, *Studies in Connoisseurship*, pp. 334–337, in describing a fan dated 1816 in Princeton, describes in addition the stylistic debt Ch'ien owed both in painting and calligraphy to Yün Shou-p'ing. Ch'ien's cool and refined manner describes surface rather than volume; he uses a thin, dry line, building shapes with delicate precision, his brushwork controlled and unassertive but dominating completely the forms. Characteristically, he used transparent colour washes, with bolder pastels for trees and architectural and other miniaturist details. As he grew older, his lines became drier and his forms lighter.

A handscroll in ink and colours on paper, mounted with a title and several colophons.

The title, in ink on gold-flecked paper, *Yüan yu ti-i t'u: (Hsi-hu fan-t'ing)*; *The first 'Longing to Roam' picture: (Boating on West Lake)* is dedicated (like the painting and colophons) to the third elder brother of the Ts'ai family, Chieh-hang, and signed Yao Wen-t'ien, with two square seals of the writer: Yao Wen-t'ien yin (intaglio) and Ch'iu-nung (relief).

Yao Wen-t'ien (1758–1827), *tzu*: Ch'iu-nung, was a scholar and high official from Kuei-an, Chekiang, famous for his uprightness, integrity and diligence, a *chin-shih* with the highest honours of 1799. He has his own biography in *Eminent Chinese of the Ch'ing Period*, and at the probable time of writing was president of the Censorate.

Chieh-hang was the *tzu* of the Buddhist monk Ta-hsü; it is alternatively given as Chieh-chou. A son of the Ts'ai family of Lan-ch'eng, Kiangsu, he was a pupil of Liao-ch'an, and his other Buddhistic names include Liu-pu, Pu-hsü, and Pu-pu. As his family was poor, he "put on the cassock and shaved his head", living at the San-yüan temple in Wu-men (Wu hsien, Suchou), then on Pao-hua-shan, and late in life on Chiao-shan. He edited Buddhistic teachings with P'eng Yü-lin (1816–1890), admiral, high official, one of the four outstanding leaders among the Hunan Braves and an austere official of great integrity; also a poet, painter of prunus and a fine calligrapher. Ta-hsü himself was also a good poet and calligrapher, as well as an ink painter of elegant bamboo and orchids. He was evidently a good friend of Ch'ien Tu, who painted another handscroll for him, *Picture of the Wang Stream*, 1832, mentioned through the reproduction of two seal impressions used on it in Contag and Wang, *Seals*, pp. 464–466: one of the two is used on this painting as well. The painting and colophons are an interesting documentary reflection upon the potential for social mobility afforded by the religious establishment, parallel to that of the civil service.

The painting depicts a lonely figure in a small, low craft being rowed by the standing boatman towards a figure sitting waiting in his lakeside pavilion at the far left of the composition, the estate behind him secluded from view and half-surrounded by a rich variety of foliage and clusterings of rock in all shapes and sizes. The lake shore is busily populated with a diverse array of fixtures: a temple complex; several dwellings with lawns sloping to the waterside; an elegant, low bridge; boats, boathouses and willow trees; an island temple on low stilts; lotus in paddies, in an enclosure and growing near the shore; and the wall of the city, behind which a few outlying buildings are scattered among the hills and the pines. Despite the fine, even crowded arrangement of details around the edge of the lake, the artist has managed to leave enough space to convey a sense of empty timelessness, appropriate to both the serenely anticipatory recluse and his quiescent, voyaging guest, while maintaining his compact and enclosed composition. The painting style embodies Ch'ien Tu's typical cool washes and contrasting elements of fine, dry line detail and subtle yet distinctive colouration; for example in the profusion of different trees and foliage demonstrating variant fine brush and colour modes, pointed up by the large, plain expanses of green grass or white lake water.

With an inscription by the artist: My native Chekiang is famous for the beauty of its scenery of lakes and mountains. Mr. Chieh-hang regrets never having visited the place. In autumn of this year, I met him in a tavern in Ta-liang (an old name for K'ai-feng, Honan province); he asked me to paint *Longing to Roam* as something to be enjoyed lightly on one's travels. Even though I have been away for a long time and I often find the landscape of my home town in my dreams, I paint this very sketchy idea from my memories. At the end of this scroll there are a few thatched houses, and ten *mou* of lotus fields: that is 'Sung-hu's country villa' (Sung-hu was Ch'ien Tu's *hao*)! I only wish that Chieh-hang would one day

芥航子持節河之壖既不作廣徵近遊賦又不作靈均遠遊篇無端夢落西湖
邊三生不識何因緣我聞大瀛海內州有九各標福地與洞天曲江山水最清
奧二十七處多神仙浙江二十有七此身尚未脫朝籍安得椶笠凌蒼煙惟
有西子一湖水淡粧濃抹城西偏油壁車赤馬船遊人似拍洪厓肩尋春段
家橋楊柳青絲牽夏訪冬花广枇杷爭新鮮翁山秋桂疑入眾香國孤山早
雪欲妬梅花妍馬遠一角畫不盡
至今腰臕配食夔寒泉君不見淳寧相字如斗姓名劉落殊堪憐
金翠畫塵土管領風月非徒然芥航子欲償此顛顛知何年精藍三百六十所待
君掃壁粘吟箋老對二十五萬文待君鳩鏒捐囊錢西湖樂上樂
吾將為執鞭兩家嫁娶事粗了請學尚長衛慶攜手一笑青山巔
芥航三兄大人同年教正
筍園愚弟劉彬士初葉

風邊毛狂當閒長散廁文采都亦紹沈者直動
海順雎進拔垂重柱丹大于平花潧育苑空為
有玉簫金蕤一竹帆煙作雲辱華君斫入
歸日能去仍我亡打包那作雲多倩華君斫入
兩潤庭銀床玉柱此冷亦窘宛七二城眉秀仙女
散叙岩城邢魴奧三尺艦尾臺楷梅雪白毫楂
頹石方神仙六旦自高健天新海福程以仰物柱
相顧庭一笑破笙鞍都公道任偏寫多付平
匡此山願誠去懸
若航行向太守題看許呂誠院師

風堇推若書

湖山穿窅吟僧死見國如見吾
故人泗奧勒寅實踐起君償此
新眄者時遊牙闥府搖旌旗
白水蘇公是前輩千吉颸清
接擬多足時手洗邀遊足其居
湖舫珠礴酥妙手誰為第二
畲多為君影蒚梳曲
甲申前午月二十百選松小鄉还館
芥航先生坐宝 劉存
粲

湖山穿窅吟僧死見國如見吾
八代淺中二今明月遊跟記誤額經不信花聽未曾
尋到西泠層層盡舌況王孫畫一峰翠鎖煙橫待
他時鴛鴦鵰提柳狄花迎依祿似德山靈笑
白白歸兜車波遊黃城律指千秋戲光知焉雎
青名湖悰連油惚重閒一鑑堂明定年波
影長酒天工張星凹湖道夫新草茉遊狄羽為城
水驛鷺鷗烟郵控鶴吳濃生長江南未夷湖一年
年敗幽曾探無端飄待來海把荷承換了朝
蕁負家園石腹雲酣酒洲象甘夫君懷遂澄青
志記貢郵約宿雪諛軒晃雨峯三竺圖中境閒平幂小
紫饞幌幢親見亲先天竹丁紫三竺圖中境閒平幂小
藥雜譯待相遊孫勒同寬玉版同卷
高陽臺二峯題請
芥航先生正誤
錢唐袁通

西湖吾侶星少小瓶柰
校醟去吳成熏燭畫
芥航觀察大人廣鑒印正
覺岸老鶴相形一葉舟
水月自高樓郭作翁山鶴相形一葉舟
不盡待書南北兩高峯節餞原雍通九前西泠竟顧
駐推苻何時花柳馬爭迎郭細義
覺山翠接著莊曾記苦岑化洋長伊草茉蔦藕陳心畬
官況共狄之門樹夫子會城自出更宜揚洼桂甘宗西泠不
獨散晚平粵水盡山六檀名廣西北漢百四見畢
南屏推第一與其心跡印雙清
芥航年三兄大人教正
虹舲吳第朱方濬初學

題幸

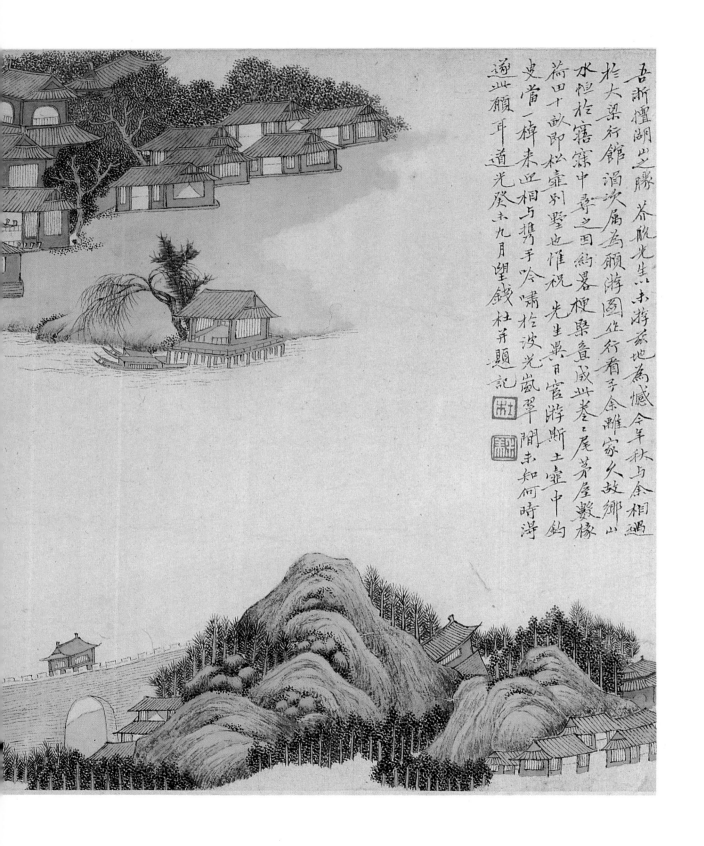

吾浙檇李湖山之勝　茶航先生以未游茲地為憾　今年秋與余相遇
於大梁行館　適次屬為顧游圖作一行看手余離家久故鄉山
水恒於寤寐中尋之因鉤絫章成此卷之尾芳屋數椽
荷田十畝即松虛別墅也惟祝先生異日宦游斯土虛中鈎
史當一榑來迎相與携手吟嘯於波光嵐翠間未知何時得
遂此顧耳道光癸未九月望錢杜并題記

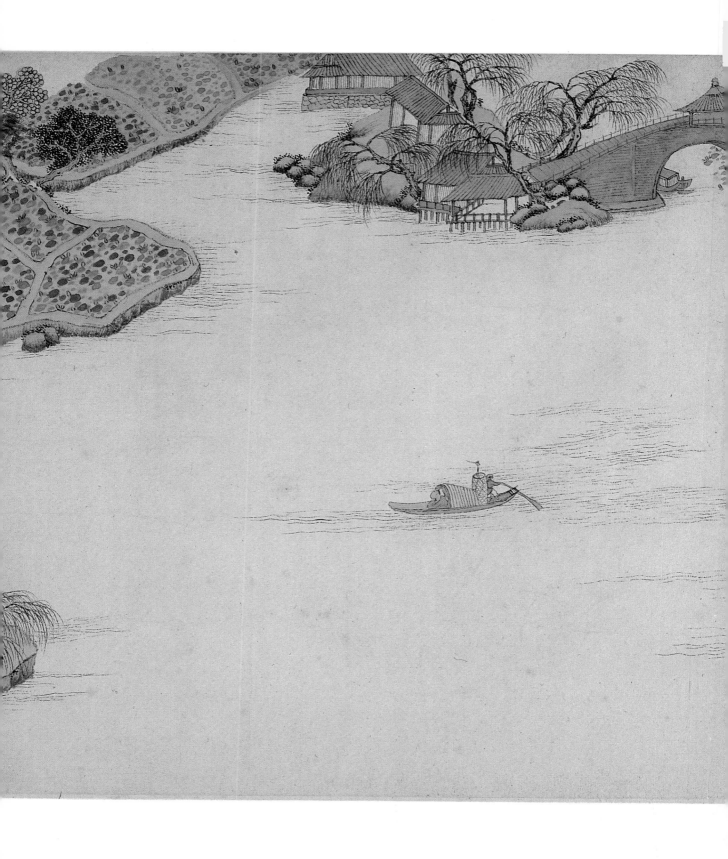

西湖泛艇

芥航三兄觀察屬

姚文田

圖

公願遊西湖寫作為第一西湖之水清澈底
夾岸青山俱倒入我遊此湘三十年吹笛
特放畫船外湖宜闊如水裏湖宜窄
花威煙冷泉亭下輪光跨偏愛緣天最深
盧遜乡落色辵江湖中陽吳山幾層
閒願公攬勝移仙櫂十日褊鮮湖上山
樹九齡十八彻涘溟郡在明漪積翠
芥航前輩大人命題歷游第一篇是為西湖
泛艇武林之妙尤在湖上謫山之文以輪光為
最故余詩云爾公餘厥暇尚多九磨光之雁
宕黃山皆者為先遊名勝卷尾主
道光四年十二月院江傳烮弟呆

豪中清景費追隨尾馬神車室育無端遍蓊州
烟九亞窟難忘慶是西湖何屬風傳萬宏松雲
中湧現豐芙蓉王生璧立原名僳合踞吳山第一
峯元圭辛筑錢東方保障金隄萬里湘水有
雲應引望恩流何日過錢塘身乘四戴莫山川
〈是西方大願船頷子頽戚慶何遊一檣先与醉波
仙州湖湖那涘許句留怆華操文後遊李白何
嘗引天妖才人一夢松于秋我点連宵入夢
頻酒痕振韶懷前塵鈎河搞雄明公事盡讓
江湖与散人
芥航河師大人鈞正
乙酉二月十九日題奉
蔣因培呈叀

山堆翠黛波開鏡西湖原是神仙境波平書舫山
權樓西湖含與神仙進龍門太華神仙客湖山思寄
神仙點染第一圖我題卷中無數烟鬟碧釋子
精藍處士家雙峯靈影六橋花香生梅樹理烟
霞俤俯仰水仙祠畔侍題襖花神廟外期停槳
蒟蒻西頭我薦廬門前便是美人湖顧攜節笠
陸清歡前輩風流話白蘇
道光丙戌七月題奉
不完可神人人鬲乏

一幅西湖水扁舟權不停波
光連岸青山色入船青日
萩聞長笛風狂繫短亭
昨宵微雨透濃抹瞑前
行塔影浮波面鐘聲

芥航先生囑正

咸行匡張湘艾棻

管自南湖汜西湖
南湖在嘉興育錢 春風駘蕩吹輕
褊舊嶺璽荒笑實相鶴夢梅老杖道林道飛未
峯嵐泉味冷波之且復烹茶盧大好花港充篇
介竹青影入段蒲孤向高飛雲北高花港荷
響天橋糊何來朱千峯若桂無後韓玉許塞驅
尺令泛艇傻触西于仿佛楊青廬小橋而已秋
谷渝來百靈驅猖長在扣舫神張玉福曼喝月往秋
優碧雙紫鵑波曲聽歙樓簸峯与到靈隱龔
咤但恐回湖破錐手玉傳拔開卜權舺願居少
安且鬢願年今俊若呈英圖

西湖泛艇圖顕奉

感咸行戌張湘艾棻

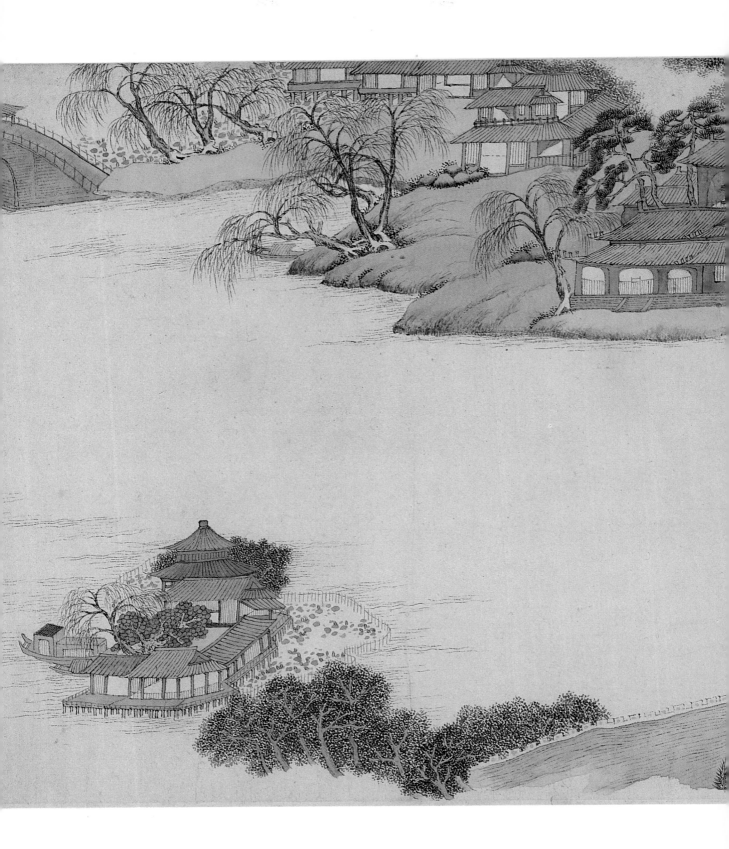

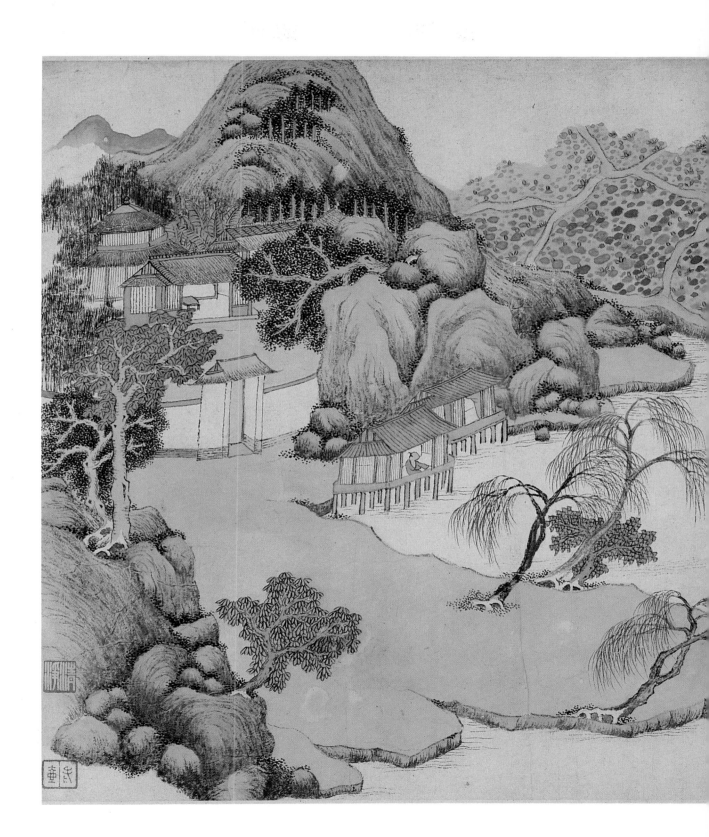

願游第一

come to this area on official duty and the angler (this may mean Ch'ien Tu) in a boat would come and receive him, and taking his hand, they would roam over the waves and green hills, reciting poems and shouting (*hsiao*, shouting, is a form of psychological release to rid the body of frustrations, long practised by the literati, monks, and sages). I do not know when this wish will come true.

Dated to the Tao-kuang period, fifteenth day of the ninth month of the *kuei-wei* year (1823), Ch'ien Tu both inscribed and recorded.

With three square seals of the artist: Tu (relief), Shu-mei (intaglio) and, at the left, Lao-hu (relief, Contag & Wang 30).

With two seals of an unrecorded collector: Ch'ing-ching (square, intaglio) and, on the mount, Ch'ing-ching Yü-chia kuan (square, intaglio).

The painting measures 45 3/8 × 12 1/4 inches.

There follow nineteen colophons, all dedicated to Chieh-hang, dated between 1823 and 1826, most of them to 1824. Not all are dated, and not all of the writers are recorded, but of those which are we mention the following:

2. Chu Fang-tseng, *hao*: Hung-fang, from Hai-yen, Chekiang. A *chin-shih* of 1801, he was a palace scholar-official and a good seal-carver and poet.

8. Ch'en Yung-kuang (1768–1835), *tzu*: Shih-shih; *hao*: Shih-ssu, was a disciple of the writer Yao Nai, a supplement to whose collected letters he edited in 1823. For his colophon to a Tung Ch'i-ch'ang calligraphic handscroll, see no. 1.

10. Ku Kao (1763–1832), *tzu*: Ching-fen; *hao*: Chien-shih, from Wu-hsi, Kiangsu. In 1801 he was the highest graduate of the Hanlin Academy, and served as junior Secretary to the Board of Revenue and Population. A poet and calligrapher, he also painted portraits, Sung-style landscapes and elegant ink orchids and bamboo.

12. Ch'u Feng-ch'un, *tzu*: Hsien-ken, from Suchou, Kiangsu. He was a scholar, *li-shu* calligrapher and landscape painter. His inscription, written in a distinctive *li-shu* hand, is dated to the second month of 1824.

13. Ch'en Sung-ch'ing, *tzu*: Fu-an; *hao*: Li-feng, from Hangchou. He served as a secretary in the Board of Civil Office, and was a fine calligrapher, specialising in the small running hand style of Tung Ch'i-ch'ang, in which his colophon is written.

17. Ch'en Wen-shu (1775–1845), *tzu*: Tui-an, Yün-po; *hao*: Pi-ch'eng wai-shih, etc., from Hangchou. A famous poet and official, Ch'en has his own entry in *Eminent Chinese of the Ch'ing Period*. He was the cousin of Ch'en Man-sheng, and in 1823 retired for a while from official life to his residence on West Lake, Hangchou, the Ch'iu-hsüeh yü-chuang; he also issued a collection of poems about West Lake, *Hsi-hsi tsa-yung*. An 1814 handscroll by Ch'ien Tu was painted for Ch'en (see above). His colophon is dated to the 7th month of 1826.

18. Chang Shu (1781–1847), *tzu*: Po-yüeh; *hao*: Chieh-hou, from Wu-wei, Kansu. A *chin-shih* graduate and calligrapher, in 1819 he was magistrate of Nan-hsi hsien (Hsü-chou, Szechwan).

19. Mu-chang-a (1782–1856), *tzu*: Tzu-p'u; *hao*: Ch'ang-hsien, Ho-fang; a Manchu of the Bordered Blue Banner, and a poet. A *chin-shih* of 1805 and a bachelor in the Hanlin Academy, Mu-chang-a held several posts in succession following quick promotions; after 1820 he came to great power, and has his own entry in *Eminent Chinese of the Ch'ing Period*. In 1823 he was president of the Censorate, in 1824 minister of the Court of Colonial Affairs, and in 1825 and 1826 acting director-general of grain transport. From early 1827 he was president of the Board of Works for six years, and he later rose to be Grand Councillor, Grand Secretary, chief tutor to the princes and chief Grand Councillor. He became the leader of the conciliation party in the struggle with England, and had enormous influence throughout the Tao-kuang period.

SU JEN-SHAN
1814–1849?

tzu: Ch'ang-ch'un.

hao: Ching-fu (Ching-hu), Ch'ang-ch'un tao-jen.

other names: Ch'i-tsu, Ch'i-shih-san sheng, Han-wang-sun, Ling-nan tao-jen, Shou-chuang, Tai-yüeh, Ch'i-hsia, Ah-ch'ing, Liu-huo.

On some paintings Su adopted a new family name: Chu-jung.

studio names: Ch'ing-meng shan-fang, Shih-ku t'ang, Chuang-yen-chien-jen t'ang.

From Shun-te, Kuangtung.

RYCKMANS, *Su Renshan*, p. 9 *inter alia*, explains the impossibility of resolving whether Ch'ang-ch'un was Su's *ming* and Jen-shan his *tzu* (or *hao*), or vice versa. He also details the endless puns and variants which Su used in his art names.

Su Jen-shan was a tragic genius, possibly the most modern and inspired Chinese artist of the nineteenth century; he completely broke the mould of literati art and painted and wrote using completely new techniques, compositions and visions. He is the subject of one of the few books on an individual artist, Pierre Ryckmans' *The Life and Work of Su Renshan: Rebel, Painter and Madman*, a passionate and comprehensive study and the only complete guide to Su's work. Other references include an article by Chu Tsing-li, "Su Jen-shan" (*Oriental Art* magazine, Winter 1970, vol. XVI no. 4, pp. 349–360), mention in the Hong Kong museum catalogues *Landscape Paintings by Kwangtung Masters during the Ming and Ch'ing Periods* and *Kwangtung Painting*, a monograph by Lee Kwok-wing to accompany an exhibition of 18 of Su's paintings from his collection at the Hong Kong City Hall Museum in 1966, and an article by T'an Ti-hua, "Su Jen-shan, His Thought and Art", in *Mei-shu-chai* (*Artist* magazine) no. 34, 1983, pp. 38–47.

In brief, Su Jen-shan was precociously gifted in painting and calligraphy from youth, probably epileptic and a political and social misfit. He failed the civil examinations twice despite an extraordinary depth of knowledge of the classics and turned full-time to painting, but regarded his art as a futile waste of time in an era when he should be working for national salvation. He was a vegetarian with a passion for pickled onions, was reportedly of monkish appearance with an obsessive desire for cleanliness and an aversion to contact with women, and he held violently anti-Manchu views. Su's father, an amateur painter, worked as a local *yamen* officer; when his son became famous for his painting he attempted to curry favour with patrons by procuring Jen-shan's works for them. His high-minded and rebellious son refused to comply, and there was a great deal of friction between the two of them. Because of one such incident, or a whole train of them, or possibly because of the community's fears of the retribution which Su's strident political opinions could bring down on them, or perhaps simply because of his increasingly incoherent behaviour, Su Jen-shan was accused by his father of filial impiety, an acutely serious charge, and thrown out of his clan and into gaol. There were even rumours of scandal or incest within the Su family; of Jen-shan's wife with his father (supposedly the young couple's marriage was never consummated); of Jen-shan with his step-mother, or with his sister. Whatever the reality of the drama, he died, probably in gaol in 1849 or very soon after, at the age of 35 or 36. Village and clan elders, who almost certainly connived at his imprisonment, closed ranks and virtually removed all details of Su from local records. Essentially it is only through his paintings, their inscriptions and the fact that a few collectors became interested in his work soon enough after his death to gather together the conflicting details of his life that we know anything at all of the man.

Su's painting is hard to define in terms of classic Chinese painting, since it not so much rejects as ignores virtually every precept. That is not to say that Su was not capable of subtle brushwork; but mostly he chose to express himself in other ways altogether. Early on he was evidently influenced by local Cantonese landscape style, which was generally heavy, laboriously constructed and not especially refined, and by the woodcut outline style of printed painting manuals. Later he became interested in engraving himself, and one of his most characteristic stylistic strengths is an outline mode.

There is modulation of ink tone in this style, but it is within the line itself; thick and thin, wet and dry. His landscapes are flights of the imagination, sometimes impossibly fragile and vast, composed in minute detail with needle-sharp lines and extraordinary natural features; at other times brutal exercises in attacking the paper. Some of Su's inscriptions on landscapes, political diatribes or sophist meanderings in the Classics, just fill up the available space until there is none left and he has to stop. It is reported that in prison, when his warders brought ink and paper for him to paint, they had to be wary of when to remove the paper, since if left to his own devices Su would keep on painting until the entire sheet was covered in black ink. His figure paintings are equally extraordinary, often in conjunction with wild and unexpected calligraphic inscriptions; Su was capable of fine writing, often in a personal variant of the *li* script, but on occasions as the mood took him his writing would become virtually unintelligible. It has recently been noted, in *Guangdong Calligraphy*, no. 87 and pp. 9–10, that Su wrote, at least on occasion, with his left hand. The question remains open as to whether he was or became disabled, like the Yangchou Eccentric Kao Feng-han, who had to agonisingly re-learn to paint and write with his left hand; or if he was ambidextrous and wrote left-handed for fun, or for other reasons.

So little is known of Su, other than through his styles and inscriptions, that it makes judgment of the experimental usages, which he introduced from time to time, impossible. Frequently his figures are fanciful renditions of Taoist or Buddhist saints or figures from history and legend, but always they are extraordinary and compelling. Their composition is often breathtakingly audacious, and the majority are painted with some variant or another of Su's totally idiosyncratic outline styles.

The range of his works is so extraordinary, with almost as many different approaches as there are works by his hand, that the only way to appreciate his achievement is to closely inspect several of his best paintings, rather than the very few available in published sources with inadequate reproduction. The Chinese University of Hong Kong's Art Gallery recently acquired a large and representative collection of his work, some of which is more or less permanently on view. More revolutionary than any twentieth-century Chinese painter who comes to mind, Su has been compared by Pierre Ryckmans and Chu-tsing Li to Cezanne and van Gogh. Although he never reached artistic maturity, in terms of the troubled vision he coruscatingly expressed, and the controversial emotions aroused by his radical aesthetics in viewers and critics, both comparisons are apt.

The leaves are listed by Pierre Ryckmans in *Su Renshan*, 1970, as nos. 271–274, at that time in the Lee Kwok-wing collection. Mr. Ryckmans' comment on the leaves was: "These four pages have great vitality but the writing on them is crude and does not inspire confidence". While this is only a tentative expression of doubt (Mr. Ryckmans' condemnations are entertainingly robust; e.g. nos. 220/221 "Obviously a forgery", no. 223 "Impudent fake", nos. 224/225 "Execution inept. Grotesque fake" and no. 227 "The most ridiculous of all the fakes"), he was evidently not prepared to confirm the unquestioned genuineness of the leaves. Although I was aware of this opinion at the time of their acquisition, and of the problems of forgery with Su's figure paintings in particular, I decided to proceed regardless — after careful study of the works. I consider that the calligraphy is consistent with the painting and with other acceptable writing of Su's on similar works — for example, no. 111 in the Ryckmans book; indeed, that the writing is as good as the painting in this context. Some other respected opinions concur that the leaves are genuine, but it must be pointed out that this is one of the "grey areas" of Chinese painting by its very definition, and that such opinions can never be wholly authoritative.

33 FOUR BUDDHIST PATRIARCHS
Four large album leaves in ink on paper.

a. Kumarajiva.
The Indian Buddhist ascetic sits in meditation on his leaf mat, with strong, strange features straining in concentration, a large robe with powerful ink lines wrapped around him.

With a large *li-shu* title: *Chiu-mo-lo-shih hsiang; Portrait of Kumarajiva*. (One of the early Buddhist "saints", Kumarajiva, 340–409, was an ascetic and a missionary.)
Signed Jen-shan painted (?) with one seal of the artist: Su Ch'ang-ch'un (square, intaglio).
With two collectors' seals: San-shih-er-t'ien jung-ch'an Man-an (square, intaglio) and Li Wei-lo ts'ang (rectangular, relief).

b. Kumaralabdha.
The Indian Buddhist ascetic squats on his square mat in a loose robe, holding a *kundika* (pouring vessel). Grasses grow from a weird spirit-rock beside him, the exaggerated contours of which echo his extraordinary features.

With a large *li-shu* title: *Chiu-mo-lo-to hsiang; Portrait of Kumaralabdha*. (He was another of the early Indian ascetics of the same period, archetypes for later renditions of exotic *Arhats*.)
Signed Ching-hu (pronounced -fu in Cantonese), with one seal of the artist: Jen-shan (square, relief).
With two collectors' seals: Man-an hsin-shang (square, intaglio) and Li Wei-lo ts'ang (rectangular, relief).

c. Kuan-hsiu.
The great Ch'an painter sits, wringing his hands, on his meditation mat, a censer and book beside him. His agitated robes and ascetic features echo the strange *Arhats* which Kuan-hsiu himself painted.

With a large *li-shu* title: *Ta-T'ang Chiang Kuan-hsiu hsiang; Portrait of Chiang Kuan-hsiu of T'ang*. (Chiang was Kuan-hsiu's lay name, and in fact he lived from 823 to 912, working in the Five Dynasties period rather than the T'ang.)
Then in an increasingly loose and slanting running hand: Chuan-hsing k'o ts'ang-mo; Treasuring (hoarding) the ink, in the Seal Stalk Pavilion. (Whether this strange hall name is meant to refer to Kuan-hsiu or to Su is unclear).
Signed Jen-shan brushed, with one seal of the artist: Su Ch'ang-ch'un (square, intaglio).
With two collectors' seals: Man-an hsin-shang (square, intaglio) and Li Wei-lo ts'ang (rectangular, relief).

d. Hsüan-tsang.
The Buddhist priest kneels in rear profile, meditating on his rough mat and wrapped in a simple robe, his long fingers clasped before him. To his side a three-legged censer emits its fragrance, and before him are sacred books.

With a large *li-shu* title: *Ta-T'ang San-ts'ang fa-shih Hsüan-tsang hsiang; Portrait of Hsüan-tsang, Three Treasures Master of the Law*. (Hsüan-tsang was the Chinese priest who in 629 went to India, returning in 646 with Buddhist relics and 657 volumes of sacred writings; San-ts'ang fa-shih was his religious title. The novel *Hsi-yu-chi* is based on his travels.)
Signed Jen-shan made, with one seal of the artist: Su Ch'ang-ch'un (square, intaglio).
With two collectors' seals: Man-an mo-yüan (square, relief) and Li Wei-lo ts'ang (rectangular, relief).

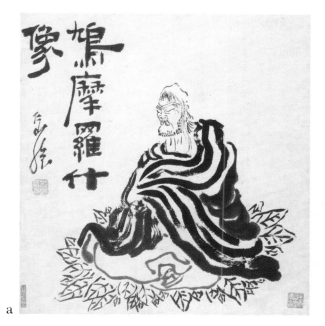

a

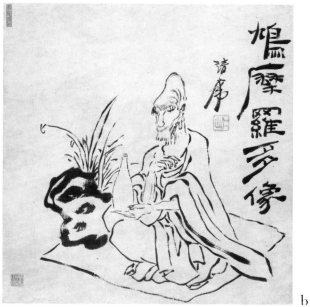

b

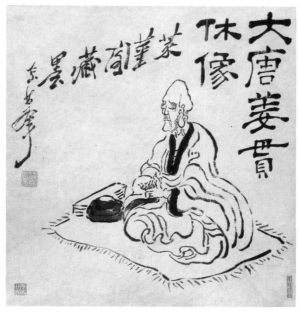

c

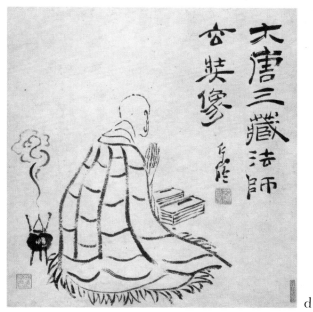

d

Man-an is the courtesy name of another contemporary Hong Kong collector, Ho Tzu-chung; probably the leaves entered Mr. Lee's collection from his.

Each leaf measures approximately 12 1/2 × 11 1/2 inches.

From the collection of Lee Kwok-wing (Li Kuo-jung), Hong Kong; Li Wei-lo is his art name.
Exhibited (leaves a & b): Hong Kong City Hall Museum, 1966, and discussed by Mr. Lee in his monograph, as nos. 10 and 11.
Published (leaves a & b): *Mei-shu-chia* (*Artist* magazine), vol. 34, 1983, p. 41, as two of twelve outstanding works by Su in Hong Kong collections.

YUNG-HSING
1752–1823

tzu: Ching-ch'üan.
hao: Shao-han, Chi-chai.
hall name: I-chin chai.

BETTER known by his title Ch'eng chin-wang (Prince Ch'eng), Yung-hsing was the eleventh son of the Ch'ien-lung emperor. In 1779 he was appointed a director-general of the Ssu-k'u Commission. He accompanied his father on several tours, and in 1789 was made a prince of the first degree with the designation Ch'eng. In 1795 he became lieutenant-general of a Manchu banner. In 1799, after the death of Kao-tsung, the former Ch'ien-lung emperor, he was appointed to three posts which had been filled by the powerful minister Ho-shen; Grand Councillor, supervisor of the Board of Revenue and in charge of the Board of Civil Office. With his brother Yung-hsüan, he was ordered by the Chia-ch'ing emperor to reorganise the administration so that Ho-shen's corrupt associates could not resume control. When Ho-shen's property was confiscated, part of his garden near the Yüan-ming Yüan was given to Yung-hsing.

After only a few months Yung-hsing was relieved of his posts in the Board of Revenue and the Grand Council; probably not because of incompetence, but because it was a policy of the dynasty not to entrust a prince with too much power. In addition he may have unintentionally been involved in the case of Hung Liang-chi, who sent him a letter critical of the government. Yung-hsing immediately passed the letter on to the emperor, thus effecting Hung's banishment, but could not avoid some suspicion by association.

Upon leaving his major government posts, Yung-hsing was able to concentrate fully on his painting (of orchids and bamboo), essay-writing, poetry and calligraphy; from youth he had been an able calligrapher, exciting the admiration of the Ch'ien-lung emperor. In 1814 (according to Hummel; 1809 according to the *Shodo Zenshu*) the Chia-ch'ing emperor ordered him to select the best examples of his writing, to be inscribed on stone and reproduced as rubbings. In 1819 Yung-hsing was deprived of all posts and fined, for a mistake made in offering sacrifices at the Temple of Earth; he died four years later. Yung-hsing's early calligraphic style was based on Chao Meng-fu and Tung Ch'i-ch'ang; later he followed the T'ang calligrapher Ou-yang Hsün; always in the "copy book", or letter-writing style of regular, running and semi-grass scripts, though; he seems not to have interested himself in the currently fashionable seal and clerical scripts based on bronze inscriptions, monuments and stele. Examples of Yung-hsing's running hand are illustrated in *Lok Tsai Hsien Couplets*, no. 34, and *Shodo Zenshu*, vol. 21, pls. 110–112. For his regular script, see *Palastmuseum Peking: Schätze aus der Verbotenen Stadt*, no. 85, pl. 4. Yung-hsing was in addition a connoisseur and a collector of books and objects on a large scale. The book of rubbings of his calligraphy was published under the name of the *I-chin chai*, the hall where he kept his collection; he also published a catalogue of it in eight *chüan*. His colophons appear on some interesting works; a Ch'ien Hsüan handscroll in the Freer Gallery (see "Notes On Five Paintings From A Ch'ing Dynasty Collection", Lawton, *Ars Orientalis*), and a Chu Ta handscroll (see *Artist* magazine, no. 4, p. 76), among others, We offered a rare ink narcissus, prunus and rock hanging scroll by the Suchou painter Wang Wu (1632–1690) from Yung-hsing's collection in *In Scholars' Taste*, no. 6. It bears on the mount, colophons dated 1775 by Yung-hsing and two of his brothers, as well as of four other officials.

34 CALLIGRAPHY IN HSING-SHU (1811)
A hanging scroll in ink on prepared paper decorated with faded sepia cloud scrolls.

Pi tsou lung she, mo wu yün yen.
The brush moving like dragons and snakes,
The ink dancing like clouds and mist.

The poetic phrase is descriptive of Yung-hsing's own writing, in the semi-*ts'ao* vein and much wilder than his characteristic *k'ai-hsing* script.

Dated to a summer day of the *hsin-wei* year (1811).
Signed Ch'eng chin-wang, with two square intaglio seals of the artist: Ch'eng chin-wang, and I-chin chai yin.
The piece measures 47 7/8 × 20 1/4 inches.

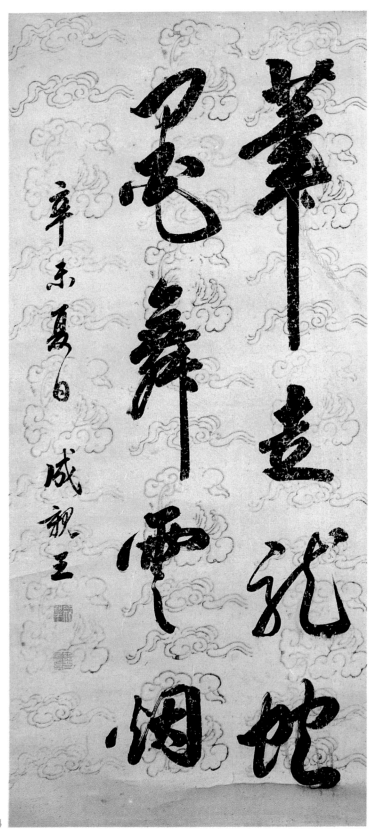

華岳三峰凭槛立
[辛未夏] [成亲王]

I PING-SHOU
1754–1815

tzu: Tsu-szu
hao: Mo-ch'ing, Nan-ch'üan, Ch'iu-shui, Mo-an.
hall name: Liu-ch'un ts'ao-t'ang.
From Ning-hua hsien, T'ing-chou fu, Fukien.

I PING-shou was a fine scholar, official, poet, seal-carver and painter of landscape and prunus, but he is best known as a calligrapher. His father, the scholar and official I Chao-tung, a *chin-shih* of 1769, gave him a strict Neo-Confucian education, and Ping-shou passed his second degree in 1777 and his *chin-shih* in 1787. He worked as a second-class secretary in the Board of Punishments before being appointed in 1798 an education inspector in Hunan and then Prefect of Hui-chou in Kuangtung. After serving there for some time he was appointed Prefect of Yangchou, where his efforts were much appreciated. He built libraries, lectured at schools and engaged with scholarly friends in various literary pursuits. He was a friend of the poet and calligrapher Chang Wen-t'ao and his circle (see *In Scholars' Taste*, no. 19) and also of the scholar Juan Yüan (see *Emperor Scholar Artisan Monk*, no. 75), with whom he co-operated in 1806 to produce a topography and a gazetteer of Yangchou, engaging for the work such scholars as Tsang Yung, Chao Huai-yü and Chiao Hsün. However, in 1807 I Ping-shou's father died, the publishing projects were shelved, and he returned to live at home for the next eight years. He returned to resume as Prefect of Yangchou in 1815, but became ill and died there in the same year. Local dignitaries at that point redesignated the well-known "Three Sages Shrine" to his memory as well to that of Ou-yang Hsiu, Su Shih and Wang Shih-chen; it has since been known as the "Four Sages Shrine".

I Ping-shou was a great and highly original calligrapher, considered by K'ang Yu-wei to have been one of the four Ch'ing calligraphic masters (with Teng Shih-ju, Liu Yung and Chang Yü-chiao, a friend of K'ang). He is best known for his *li* (clerical) script, and also for his *chuan* (seal) writing, but his *k'ai* script after Yen Chen-ch'ing (extremely rare) is said to be equally good. His *hsing* and to a lesser extent his *ts'ao* hands are also highly original and much appreciated; the former appears quite frequently on his large *li-shu* compositions, but there are also several large poetic compositions written entirely in running script (ie. *Shodo Zenshu*, vol. 24, nos. 18–21); it seems just as stylised as his *li-shu*, and somewhat influenced by it.

I's straightforward, robust manner as an official is said to have annoyed some other prominent men, and his calligraphy likewise betrays a blunt, idiosyncratic manner. Derived from study of Han stele, his *li* style admits of no subtle ink or brush modulation, but is rather forceful and thick; the ink seems to sink deep into the paper. His strong design sense derives from his seal-carving experience, with deep-set lines (with rounded ends, as in seal script) and a cultivated asymmetry which comes from stele and their rubbings. One source (*Chung-kuo mei-shu-chia jen-ming tz'u-tien*) mentions Li Tung-yang (1447–1516) as a model for I Ping-shou's *li* and *chuan* scripts, but really I's was too individual a development, and one derived directly from archaic sources, to owe much to Ming writers. It is said that the larger his writing is, the stronger and bolder it becomes. For two rare inkstones carved by I, see nos. 129 and 130.

Siren lists five paintings by I Ping-shou; his style is said to have been influenced by the Yangchou Eccentrics, and one of those listed is a finger painting. Huang Shen and Shang-kuan Chou came from I's home town. A highly individual landscape is illustrated in *Shodo Zenshu*, vol. 24, as fig. 5. Fu, *Studies in Connoisseurship*, pp. 241–243, describes a "self-portrait" of Shih-t'ao, painted in 1798 for I Ping-shou by a friend, the interesting painter Chu Hao-nien (1760–1833), copied from the original which I Ping-shou had borrowed from another friend and calligrapher, Weng Fang-kang (1733–1818). I's colophon is dated 1799.

Examples of I Ping-shou's characteristic *li-shu* are published in Ecke, *Chinese Calligraphy*, no. 95 (1813); *Lok Tsai Hsien Collection of Calligraphy in Couplets*, no. 36 (1804); Fu, *Traces of the Brush*, no. 79 (1811) and *Shodo Zenshu*, vol. 24, pl. 16 & 17. No. 147 in the 200-volume *Shoseki meihin sokan* is

devoted to I Ping-shou; most of it depicts his larger *li-shu* calligraphy. Few attempted to follow in I's calligraphic footsteps; of those who did his son, I Nien-tseng (1790–1861), was the most prominent.

35 LI-SHU CALLIGRAPHY, *with dedication, date and signature in hsing-shu* (1813)
A hanging scroll in ink on paper.

Te chih ching-t'ung chih huang-lung pai-lu chih jui.
If one is well-versed in the ways of virtuous government, it will bring about the auspicious omens of the yellow dragon and the white deer.

Emperor Huang-ti saw a yellow dragon which remained for 15 years when he practised virtuous government. In the Han-shu it was considered auspicious if when a white ox was burnt in sacrifice, a white deer was inside it. A variant symbolism involves a white bird and a hare. See for example David, *Chinese Connoisseurship*, p. 189: "It is recorded in the eulogies that Hsi had been the magistrate of Min-ch'ih, where he had improved the road leading to Hsiao and Ch'in. Soon afterwards there appeared the auspicious omens of a yellow dragon and a white deer. When Li Hsieh later became Governor of Wu-tu, there were bumper crops in the fields, adequate rainfall, and intertwining trees."

Inscribed: For the inspection and correction of Mr. Sung-ku. This may refer to Chao Tien-ch'eng, a scholar from Jen-ho (Hangchou, Chekiang), *tzu*; Sung-ku; a dating of merely "Ch'ing" is given for him in the *Chung-wen ta-tz'u-tien*. Alternatively it might possibly refer to Ch'eng Pai-ling, *tzu*: Sung-ku, a painter from Chang-lieh, Kiangsu. However, although the *Chung-kuo mei-shu-chia jen-ming tz'u-tien* gives no firm dates for him, Ch'eng was the pupil of Shen Jung (active in the Chia-ch'ing to Tao-kuang periods, ca. 1796–1850); so the probability is that he would have been too young to have been the recipient of this writing.
Dated to the fifteenth day of the fifth month of the eighteenth year of the Chia-ch'ing period (1813), your junior I Ping-shou copied.
With two seals of the artist: I Ping-shou yin (small, square, intaglio) and Mo-an (large, square, relief). With one collector's seal at the bottom right corner, that of Sun P'ei: T'ung-ch'eng Sun P'ei chin-shih shu-hua yin (square, intaglio). He is not recorded.
The piece measures 46 3/4 × 14 1/4 inches.

德沿精通致黃龍白麐之瑞

松若先生仁兄鑒正

嘉慶十有八季八月既望弟伊秉綬臨

tzu: Sung-wen, Tzu-kung, I-an.

hao: Man-sheng, Lao-man, Man-kung, Kung-shou, Chung-yü (hsien-k'e, hsien-kuan, tao-jen), Chia-ku t'ing-ch'ang, Hsü-ch'i yü-yin.

hall names: Sang-lien-li kuan, Lien-li shuang-kuei-shu lou, Chieh-ch'ung kuan.

CH'EN is generally known by his *hao*, Man-sheng, to distinguish him from the famous late Ming painter Ch'en Hung-shou. A notable scholar and official, he was also a talented artist in many media; poet, calligrapher, seal-carver and painter, centre of an elite literati circle and a one-man revitalisation of the I-hsing pottery industry, while magistrate of nearby Li-yang from 1811–1817. Details of his life are given in *In Scholars' Taste*, where we offered a fine teapot designed and inscribed by Ch'en as no. 90, and in *Emperor Scholar Artisan Monk*, where we offered a rare still-life painting (no. 29), a pair of soapstone seals (no. 100) and an inkstone (no. 73). In this exhibition we also offer a fine soapstone seal by Ch'en, no. 87. Ch'en Man-sheng's circle at Li-yang included such talents as Ch'ien Tu (see no. 32) and Kuo Lin (see no. 37). Ch'en was known as one of the "Two Ch'ens" with his cousin Ch'en Wen-shu (see no. 32, colophon 17).

As a calligrapher, Ch'en Man-sheng is best known for his strange and angular *li-shu* script, but he developed a highly personal style in *chuan* (seal) and *hsing* (running) scripts as well. See *I-hsing Ware*, nos. 66 and 67, for examples of Ch'en's *li-shu* style; *Lok Tsai Hsien Collection of Calligraphy in Couplets* shows two couplets by Ch'en; no. 44, in a dry brush *li-shu*, and no 45, in his strange seal script. *Shodo Zenshu*, vol. 24, illustrates four examples of Ch'en's writing in Japanese collections, pl. 30 is a *li-shu* couplet, pl. 28 and 29 running script hanging scrolls, and pl. 31 a running script couplet.

36 COUPLET IN HSING-SHU (1816)

A pair of hanging scrolls in ink on paper.

Shang i Chou ting Hsüan-ho p'u,
Yü tzu yin pien Yüan-wei shu.
Bronze sacrificial vessels from the Shang and Chou dynasties in the Hsüan-ho catalogue.
Jade characters and silver registers in Mount Yüan-wei's book.

The *Hsüan-ho p'u* was the registry, or catalogue, of the famous collection of Emperor Hui-tsung, the last great emperor of Northern Sung (r. 1101–1119); Hsüan-ho was his reign title for the last seven years. Objects from his collection are still identifiable; many of them bear official marks, and some are now in the Ku-kung museums, from the Ch'ing imperial collections.

Yin pien is phrase taken from a poem by Emperor Yang of Sui (605–617); Golden cupboards, pearl scabbards; silver registers and jade writing tablets. *Yüan-wei* is the name of a mountain, south-east of Shao-hsing, Chekiang; it resembles a stone cupboard (or counter?), upright, with clouds passing through it, and so it is known as Stone Cupboard Mountain; alternatively as the Jade Cone (or Tenon), and Heaven's pillar. The great sage-emperor Yü found there gold tablets with jade characters.

Dated and inscribed on the first scroll to the eighth autumn month, *ping-tzu* year of the Chia-ch'ing period (1816), written at the Spring Water Cottage in Yüan-chiang (Ch'ing-chiang, Kiangsu), dashed off with the brush hurriedly; it is really laughable!

Signed on the second scroll Man-sheng, Ch'en Hung-shou, with two square intaglio seals of the artist: Man-sheng, and Ch'en Hung-shou yin.

Each piece measures 51 × 11 1/4 inches.

商彝周鼎宣和譜

嘉慶丙子秋八月書於春江春水舍中
信筆每二殊可慨也

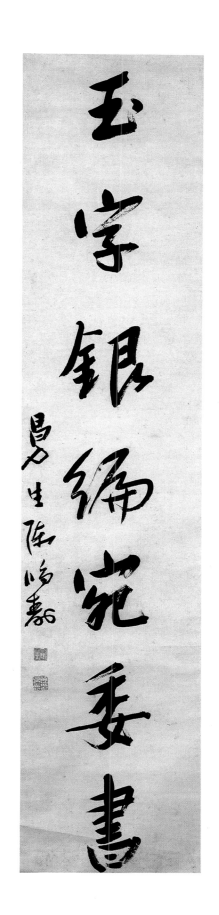

玉字銀緶宛委書

昌生陳鴻壽

tzu: Hsiang-po.
hao: P'in-chia, Pai-mei (sheng), Chu-lo ch'ang-che, Ch'ü-an chü-shih,
Fu-weng.
hall name: Ling-fen kuan.
From Wu-chiang, Kiangsu.

KUO Lin was a graduate and licentiate of the Chia-ch'ing period (1796–1820); a pupil of the
calligrapher and writer Yao Nai (1732–1815) and a protégé of Juan Yüan (1764–1849). Noted as a
seal-carver and *tz'u* poet, he was also a "drunken" bamboo and rocks painter. Kuo was employed at
some time in the years 1811–1817 by Ch'en Man-sheng (see no. 36) as secretary or consultant at his Li-
yang residence, near I-hsing. A member of Ch'en's inner circle of literati, Kuo knew such artists as
Ch'ü Ying-shao, Kai Ch'i and Ch'ien Tu (see *Emperor Scholar Artisan Monk* for details), and like them
participated in "tea cult" poetry gatherings at Ch'en's hall, the Sang-lien-li kuan. Kuo also engraved on
some of the "Man-sheng" teapots produced at I-hsing, drawing upon his training as a seal-carver and
calligrapher. One series of teapots designed by Man-sheng, potted by Yang P'eng-nien and inscribed
by Kuo records a tea-party in Ch'en's *yamen* in 1815 and lists the names of fifteen guests, including
Ch'ien Tu (see no. 32). Kuo Lin was primarily known as a calligrapher, though. His running script, with
its strong diagonal strokes, was derived from the large running style of Huang T'ing-chien (1045–1105),
through the influence of Shen Chou (1427–1509). For other examples of Kuo's immediately
recognisable *hsing-shu* in this manner, see *Lok Tsai Hsien Couplets*, no. 43, and his 1825 colophon to
Ch'ien Tu's *Entering The Pass* handscroll (*I-hsing Ware*, pp. 90 and 103–105). We offered a
comparable poem in hanging scroll form by Kuo, dated 1816, in *Emperor Scholar Artisan Monk*, as no.
30.

37 HUANG T'ING-CHIEN'S COLOPHON ON T'ANG CALLIGRAPHERS
A hanging scroll in ink on paper.

Seeing the fragmented remains of T'ang dynasty writings one discovers certain marvellous qualities.
One understands that the best calligraphy is not found only in the works of Ou, Yü, Ch'u and Hsüeh.
However, it is very difficult to discuss this with those who rely on their ears rather than their eyes.

Ou-yang Hsün (557–641), Yü Shih-nan (558–638), Ch'u Sui-liang (596–658) and Hsüeh Chi (649–731)
were T'ang calligraphic masters. Huang T'ing-chien (*hao*: Shan-ku chü-shih), one of the Four Great
Sung Calligraphic Masters, based his regular script on the writing of the T'ang calligrapher Yen Chen-
ch'ing (709–785), and found other calligraphic masters of the period inferior. He wrote in a colophon to
Su Shih's writing: "I once spoke of an untrammelled spirit in the calligraphy of the two Wangs and felt
that this quality was lacking in Ou, Yü, Ch'u and Hsüeh. Then, with Hsü Hao (703–782) and Shen
Ch'uan-shih (769–827) it completely disappeared. Only Yen Chen-ch'ing and yang Ning-shih (873–954)
still had this quality." (*Images Of The Mind*, p. 77).

Inscribed: A record of Huang Shan-ku's colophon.
Signed Ch'ü-an Kuo Lin wrote, with two square seals of the artist: Fu-weng chih yin (intaglio) and Kuo
Lin (relief).
The piece measures 51 1/16 × 15 11/16 inches.

觀唐人刻絲餘墨皆有妙處故知翰墨
之勝不獨在歐虞褚薛如唯恃耳而將
目者難與共談耳

錄黃山谷跋邊盧鄧糜書

KUO SHANG-HSIEN	**tzu:** Yüan-wen (alternatively, Yüan-k'ai).
1785–1833	**hao:** Lan-shih, Po-i.
	hall names: Fang-chien kuan, Tseng-mo an.
	From P'u-t'ien, Fukien.

KUO Shang-hsien, scholar, official and calligrapher, although a native of the seal-carving centre of P'u-t'ien, was in fact born at the home of his paternal grandfather, Kuo Chan-hsüan (*chü-jen* of 1760) who was at that time the magistrate of Li-yang, Kiangsu; a post held not long afterwards by Ch'en Man-sheng (see no. 36). Shang-hsien passed the provincial examination in 1807 as *chieh-yüan*, the highest ranking *chü-jen*, and his *chin-shih* degree in 1809. He was appointed a member of the Hanlin Academy with an assignment to study the Manchu language, and in 1811 was made a compiler of the Academy. Between 1813 and 1819 he was in turn examiner for the provinces of Kueichou, Yünnan and Kuangtung and, while home in Fukien to observe the period of mourning for his father, Kuo Chieh-nan (d. 1820) assisted in relief of the famine which struck the province in 1821. In 1828 he was made commissioner of education for Szechwan; after several promotions, was made, in early 1832, director of the Court of Judicature and Revision.

Kuo was a seal-carver and painter of orchids and rocks, but is famous as a calligrapher, specialising in the small-regular (*hsiao-k'ai*) and running (*hsing*) scripts. Regarded by his contemporaries as the equal of Chao Meng-fu and Tung Ch'i-ch'ang, his writing was in so much demand that the unusual occurrence of his hair turning white at the age of forty was attributed to over-exertion in calligraphy.

Regarded as a connoisseur, Kuo wrote many comments on the calligraphy of famous men, a collection of which was published in movable type in 1874, entitled *Fang-chien kuan t'i-pa*: the last *chüan* includes his comments on his own paintings. Various collected works were edited and published in 1845, and a small edition of his poems was also printed. Kuo's *hsing* calligraphy was influenced early on by rubbings of Yen Chen-ch'ing of T'ang, but in his middle age he followed the style of Tung Ch'i-ch'ang at least as much; some influence of the T'ang writer Ou-yang Hsün was also acknowledged. He was compared with two other Fukienese official-calligraphers, Lin Tse-hsü (1785–1850) and Liang Chang-chü (1775–1849); Lin, his close friend and then governor of Kiangsu, conducted Kuo's funeral oration.

Hsing-shu couplets by Kuo are published in *Lok Tsai Hsien Couplets*, no. 53, and *Shodo Zenshu*, vol. 24, pl. 40. A fine hanging scroll with *hsing* calligraphy, more comparable with the example offered here, is illustrated in *Chinese Literati Paintings from the Jorakuan Collection*, no. 64. We offered a fine burrwood wristrest in the form of an old lute (now in the British Museum) bearing calligraphy after Kuo in *In Scholars' Taste*, no. 104.

38 THREE POEMS IN HSING-SHU
A hanging scroll in ink on creamy, absorbent paper marbled with grey.

The three poems discuss the conflict in the poet's life between his duty as a loyal subject and self-realization. He has no choice, he must do battle for his ruler. Yet, calligraphy brightens his soul and releases him from the burden of the years. The beautiful scenery of Szechwan is the perfect place to sit and ponder, yet he must leave and follow his calling as a soldier. The third poem sees an old man, white haired and penniless but still a soldier, arming himself to do battle again because he knows no other way.

Inscribed: Recent works in Shu (Szechwan) copied for the correction of my respected elder in poetry, Yün-hsin. The art name of the recipient, Yün-hsing, is not recorded.
Signed Shang-hsien, with two square seals of the artist: Kuo Shang-hsien yin (intaglio) and Fang-chien ch'ien-kuan (intaglio).

A date of execution circa 1828 or soon afterwards is suggested by the penultimate column: "Recent works in Shu (Szechwan)"
The piece measures 20 1/16 × 15 5/16 inches.

YAO YÜAN-CHIH

1773–1852,
one source lists his
birthdate as 1776.

tzu: Po-ang.
hao: Chai-ch'ing, Wu-pu-weng, Chu-yeh t'ing-sheng.
From T'ung-ch'eng, Anhui.

YAO Yüan-chih was a scholar, a *chin-shih* graduate of 1805, and an official, rising to the position of president of the Censorate. A member of the well-known Yao family of T'ung-ch'eng, he was related to the author and calligrapher Yao Nai (1732–1815) and to earlier clan members such as Yao Wen-jan (d. 1678) and Yao Wen-hsieh (see no. 11). Yao Yüan-chih was a poet and painter of figures, flowers and fruits; the figures especially often in *pai-miao* (outline) style. His fruit paintings have been compared to those of Yün Shou-p'ing and Hua Yen. We offered a rare 1838 painting of a cat and brazier by Yao in *In Scholars' Taste*, as no. 25.

It is as a calligrapher, though, that Yao is famous, primarily for his *li-shu* style, which was rather different from that of Kuei Fu (1736–1805), the currently popular trend in *li-shu* (see the I Ping-shou example, no. 35, and the Chai Yün-sheng couplet, no. 40). Yao's style was derived likewise from Han stele, but in his case the influential manner was borrowed from the well-known Ts'ao-chüan stele (see *Shodo Zenshu*, vol. 2, pl. 118 & 119).

For examples of Yao's *li-shu*, see *Lok Tsai Hsien Collection of Calligraphy in Couplets*, nos. 48 (1835) and 49 (1826), and *Shodo Zenshu*, vol. 24, pl. 35 (1821) and fig. 6.

39 COUPLET IN LI-SHU

A pair of hanging scrolls in ink on paper.

K'ai ching wang san i,
Kao mu wan ssu shih.
Open the road and gaze upon the three useful friends;
Exalted plans treasure the four seasons.

K'ai ching, to open up the road, or develop a short-cut, is a phrase taken from the *Nan-shih*; "fell trees to open the road, and we'll arrive straightaway at the sea". *San i*, the three advantages, or "three useful friends", is a concept taken from the *Lun-yü*; there are three useful friends and three injurious friends. The three useful friends are uprightness (or honesty), sincerity and experience. It also refers to prunus, bamboo, and rocks; a different grouping to the "three friends of winter". The first line is taken directly from a couplet by Chiang Yen; If your simple heart is upright in this way, open the road and gaze upon the three useful friends. *Kao mu* means great schemes, or profound plans. A passage from the *Chin-shu* reads; "Contemplation relies on lofty plans: the great are aided by far-reaching schemes". The couplet implies that whatever your aspirations it is wise to build them on the simple virtues and nature's mundane beauties.

On the first scroll is the legend: Written at the Yün-kuo kuan (bamboo skin and berries hall, not recorded) and on the second the signature: Chu-yeh t'ing-sheng Yao Yüan-chih; with two relief seals of the artist: Yüan-chih (gourd-shaped) and Yao shih Po-ang (square).
There is one collector's seal to the bottom left of the second scroll: Chih-yün chen-ts'ang (relief, within a fancy two-dragon reserve). The name is not recorded.
Each piece measures 38 5/8 × 9 7/8 inches.

From the Dr. Ip Yee collection, Hong Kong.

高暮玩四時

款識：姚元之

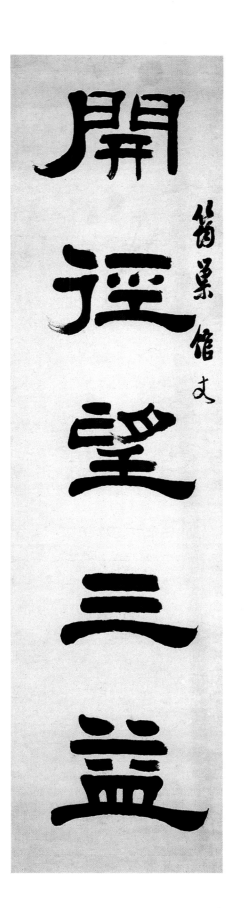

開逕望三益

款識：箌巢館文

CHAI YÜN-SHENG

1776–1860

tzu: Wen-ch'üan.
hao: Wu-t'ang.
hall name: Wu-ching sui-pien chai.
From I-hsien, Shantung.

CHAI Yün-sheng was a scholar and official, a *chin-shih* graduate of 1822. He helped in the revision of the Gazetteer of the Imperial Academy through 1833–1834; it was printed in 1836. He also published a collection of his own literary works under his hall name.

Known as a poet and calligrapher, Chai was a pupil of the famous *li-shu* master Kuei Fu (1736–1805), who was inspired by Han stele inscriptions and published a book on decorative script. It is reported that he was an eccentric who hid himself away and had his food brought to him to eat in bed for over forty years. He was addicted to calligraphy, and was competent in all styles; but he excelled in the ancient *li-shu* style, derived from his master and study of bronze and stone inscriptions. His book on *li-shu* was published in 1837. We offered a large *li* couplet by Chai in *In Scholars' Taste*, no. 26.

40 COUPLET IN LI-SHU

A pair of hanging scrolls in ink on paper.

I ching ch'uan chiu te,
Wu tzu cho ying ts'ai.
One classic propagates the old virtues;
Five words promote superior talents.

Signed Wen-chüan Chai Yün-sheng, with three square seals of the artist: Chin-shih chih-wen (relief), Wen-ch'üan (relief) and Chai Yün-sheng (intaglio).
There is one square, relief collector's seal: Ch'in-chou Ts'eng Kuan. He is not recorded.
Each piece measures 36 5/8 × 9 5/8 inches.

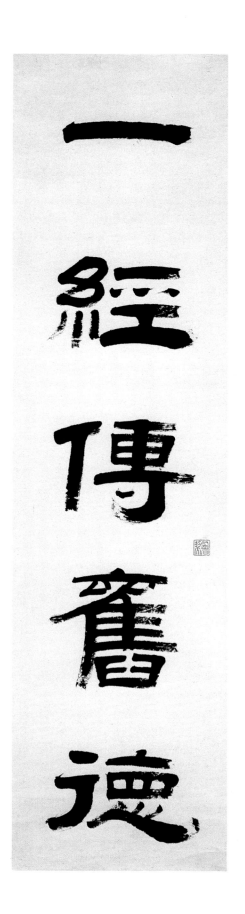

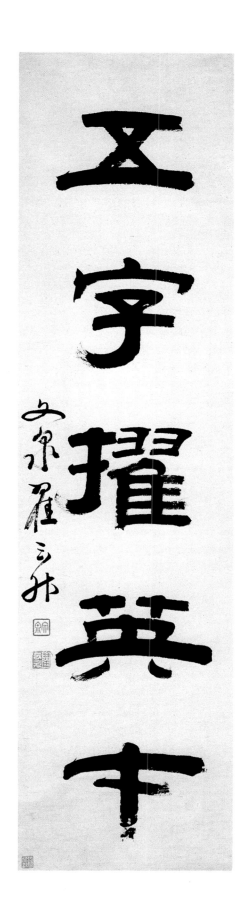

五字擢英才

一經傳舊德

P'U HUA

1830–1911, his date of birth is also variously given as 1832 and 1834.

original ming: Ch'eng.
tzu: Tso-ying.
early tzu: Chu-ying.
hao: Hsü-shan (wai-shih, yeh-shih), Ch'ung-chu tao-jen.
hall name: Chiu-ch'in shih-yen lou.
From Chia-hsing, Chekiang. Late in life lived in Shanghai.

P'U Hua's father died when he was 17, but his mother continued his Confucian education and he became a proficient scholar and player of the *ku-ch'in* as well as a poet, painter and calligrapher. He travelled widely, even to Japan, where his work is popular. P'u early on painted flowers, in the manner of Hsü Wei and Ch'en Shun, sometimes with colours, and later rather wild and free bamboo paintings after Wen T'ung, as well as ink renditions of such plants as prunus, chrysanthemum and orchids, often with rocks. Some of his landscapes demonstrate the influence of Shih-t'ao and K'un-ts'an; but in fact his styles both in painting and in his "grassy" running script (which he claimed was borrowed directly from two of the Eight Immortals) exhibit strong personal traits; they were in addition very often executed while drunk.

P'u Hua became a close friend of Wu Ch'ang-shih (see *In Scholars' Taste*, no. 36), who thought very highly of his work; they often inscribed each others' paintings and those of other artists in Wu's circle in Shanghai. P'u is regarded both in painting and in calligraphy as one of the later nineteenth-century artists most successful at interpreting traditional styles with a new-found freedom and personality. *Gems From Chinese Fine Arts*, no. 10, pp. 40–49, links him with the other leading Shanghai masters Jen I and Hsü-ku in the most in-depth coverage of his work, with an essay by Tsai Keng, "The Wildwood Artist — Pu Zuoying, Noted Artist of the Late Qing Dynasty". This publication illustrates six examples of his running grass script, in addition to demonstrating the range of his painting (including a few rare and charming album leaves) and reproductions of some of his seals. Other reproductions of P'u's paintings include an 1864 flowers fan (*Fan Paintings by Late Ch'ing Shanghai Masters*, no. 166), an ink landscape fan (*Illustrated Catalogues of Tokyo National Museum: Chinese Paintings*, no. 313), a plum, narcissus, bamboo and rock painting (*Bones of Jade, Soul of Ice*, no. 47, fig. 71), and a powerful, contorted, weird rock painting, with several inscriptions, in the Osaka Museum of Art (*Comprehensive Illustrated Catalog of Chinese Paintings*, JM3-219). Very few other examples of his calligraphy are published.

41 POEM IN TS'AO-HSING-SHU

A hanging scroll in ink on absorbent paper.

The poem records the history of the changing ownership of Huai Su's *Autobiography*, a famous piece of calligraphy in cursive script.

Signed Tso-ying, with one square seal of the artist: P'u Hua yin hsin (intaglio).
The piece measures 50 1/4 × 10 15/16 inches.

慷慨自負敢帖此貽尾款和真項氏以吳重笙待之朱翰

在家朱氏之三內府善卷蒼出余人宜物後入於大內後給之展

絹為月律朱太尉等事雄收之至初吳郡陸完伍荒花

也文衡諸名筆列傳於世

仇英

42 BAMBOO BRUSHPOT

Eight old sages sit and sprawl in the advanced stages of a drinking party which takes place among the natural grottoes of a pine grove. Two boy attendants stand among three huge wine vats to the left of the scene; one pours wine into the bowl of a bearded sage with a large ladle, and the other prepares to serve a bowl of peaches; there is a small teapot warming on a ledge above his head. Two other sages sit by the low table, which bears a bowl of fruit and *ju-i* fungus as well as a used stem-cup; one cups his chin drunkenly in one hand and proffers a bowl of wine to the other, who resists. The further group of five drinkers, gathered around their own low wine jar under a gnarled pine branch, talk in relatively animated fashion, probably surveying the weakest of their number, who is already trying to sleep it off. One other member of their group clasps his knee and is supported only by the bodily presence of his chubby companion, who offers him more wine. A futher low, twisted pine, growing from rocks near his head, closes the scene.

The squat, wide form of the brushpot, which rests on three low feet, suggests a date relatively early in the seventeenth century, very probably in the late Ming dynasty. The pierced technique used for the thick walls of the vessel was probably originated by the well-known Chu family of carvers, but as in this case was borrowed by other Chiating carvers of the period. The strong, slant-cut diagonals used for the rockwork are typical, allowing with the extremely deep-cut relief carving for dramatic contrasts of tone and texture, with attractive diamond-fleck fibrous markings exploited to the full as an indication of spatial dimension between the rounded, polished surface features and the paler background. The pine trunks and flattened needle clusters also follow relatively early conventions, as do the abrupt and truncated forms of rockwork and pine branches.

Late Ming dynasty, early seventeenth century.
Height: 5 3/4 inches. Diameter: 5 1/4 inches.

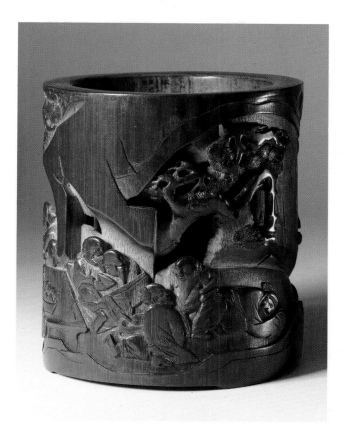

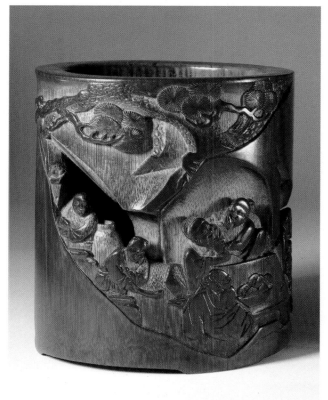

153

CHOU NAI-SHIH

late 17th century

tzu: Wan-chou, Yu-wen.
hao: Mo-shan.
From Chiating, Kiangsu.

CHOU Nai-shih was a poet, painter and calligrapher, and in each of these disciplines his work had an 'extraordinary flavour', but he was most talented as a bamboo carver. During his period of activity, in the Shun-chih and K'ang-hsi periods of the early Ch'ing, he was the most famous of the Chiating bamboo carvers, following primarily the Chu family style of carving. He excelled at banana plants and bamboo groves, and also carved landscapes and flowers. He was of a reckless nature, loved to sing and tell stories, and often met for poetry and wine parties with three scholars who lived on the same street in Chiating: Sun Sung-p'ing (1642–1709), Ch'en Tao-shan (*chin-shih* of 1649) and Chang Tzu-t'ing (who also carved bamboo).

Chinese Bamboo Carving, part II, illustrates a slender brushpot deeply engraved with a cabbage, and engraved with a *hsing* poem, signed Mo-shan, as no. 26. It records three other works by Chou (p. 161), one a brushpot carved with plantain trees and landscape. His work is quite rare.

43 BAMBOO BRUSHPOT

A single banana plant grows from a cluster of rocks on the ground, a few blades of grass at its foot. Both banana leaves and rocks are quite freely and apparently spontaneously carved, the central, topmost leaf in a few impressionistic strokes. The technique for both leaves and rocks is interesting, incorporating in places a diagonal slant carved quite shallowly from one engraved edge to quite deeply cut at another.

Engraved with a *ts'ao-shu* quatrain by the carver:

A bamboo table, a rattan bed, with a small inkstone table-screen;
Reed-laden wind against the blinds, about as fresh as seal-smoke.
A few days of leisure in my study — from yellow in the rainy season,
Suddenly the whole courtyard is green with banana leaves!

'Seal-smoke' is a reference to fanciful seal characters carved fine and curling, like incense smoke; or vice versa — incense smoke like fancy seal characters.

The second line is a play on a verse from the novel *Western Chambers* (*Hsi-hsiang chi*; see no. 46 for a brushpot design influenced by a print of a scene from the same novel); "The wind is curling up like incense-smoke — don't roll up the blinds". The first two lines seem to be contrasting useful plants and materials with the subject matter of the carving, whose sole function is celebrated in the last two lines. Even though reeds may smell so foul in decomposition that they turn the air up at the edges, they have their use as screens or blinds to keep that very air out; there may in addition be the sense intended that the still air inside is thick with incense.

Signed Mo-shan.
Early Ch'ing; second half of the seventeenth century.
Height: 5 1/2 inches. Diameter: 3 3/4 inches.

From the Dr. Ip Yee collection, Hong Kong.

154

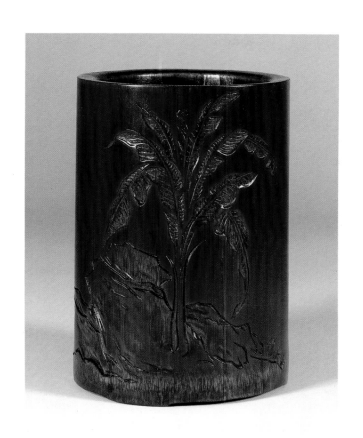

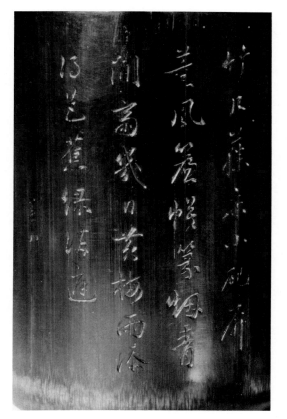

WU CHIH-FAN

active K'ang-hsi
period

tzu: Lu-chen.

hao: Tung-hai tao-jen.

From Chiating, Kiangsu.

WU Chih-fan was the greatest Ch'ing bamboo carver, and the best Chiating carver after the Chu family of late Ming, whose style he mastered. He is known to have been active in 1688; the majority of his documentary pieces are dated cyclically — if the corroborative details are correct, to the early K'ang-hsi period, late in the seventeenth century. Early on he lived at Nan-hsiang, just south of Chiating, and for much of his working life he lived on Raft Street, Chiating; several of his works have signatures prefaced by the placename Cha-hsi (Raft Stream). Late in life he settled for a time in Tientsin; at one point there he lived as the honoured guest of an official, Ma Ling.

Wu is regarded as the inventor of a technique of carving figures in low relief on a plain background, a style which was highly influential and much copied by Chiating carvers of the time; see for example no. 45, or the brushpots offered in *Emperor Scholar Artisan Monk*, nos. 42 and 43. One of his masterpieces in this style is the magnificent horse and groom brushpot in the National Palace Museum, Taipei, illustrated in *Chinese Art*, vol. 2, pl. 201, where Jenyns mistakenly dates him to the Ch'ien-lung to Chia-ch'ing periods, probably because of Ch'ien-lung imperial inscriptions added to one or two pieces. The brushpot is also published in *Bamboo Carving of China*, pp. 52–54, where Wang Shih-hsiang illustrates alongside it a weaker copy of about the same time.

Wu was also extremely capable in the deeper relief carving style of the Chu family, from which he made new departures. Giving impressions of depth and perspective, he was capable of carving in five or six different levels in very high relief, at the deepest levels in openwork; this style he took from the earlier tradition, but he was capable in his best work of adding a fluid plasticity of form and an enhanced, dramatic realism. His most outstanding work in this style is carved out of boxwood, which offers a denser and more easily modelled material than bamboo, but the stylistic effects are comparable; it is published in *Selected Handicrafts* (of the Ku-kung Museum, Peking,) pl. 88, and again in *Bamboo Carving of China*, as figs. 41, 51 and 51a; Wang compares a fine bamboo brushpot of the same subject (Hsieh An playing *wei-ch'i*) as no. 23.

Wu Chih-fan was apparently a prolific carver, and it is a problem distinguishing his ordinary works (which cannot be expected to attain in every case the levels of the above two masterpieces) from contemporary works in his styles to which his name has been added and from direct copies, bearing in mind his great fame. Publications are rarely definitive about firmly attributing works to the master; see for example *Bamboo Carving of China*, nos. 20, 21 & 22, also figs. 13 & 14, and *Chinese Bamboo Carving*, part I, nos. 43 (colour pl. 18) & 44. One criterion must be Wu's superior and fluent *hsing* and *ts'ao* calligraphy, whether brushed or carved (he is also reported to have painted figures and birds and flowers); pieces bearing stiff or inept inscriptions must be discounted as genuine.

Wu carved wristrests and vessels as well as brushpots; perhaps animals and figures in the round as well. The Julia Y. Cheng (formerly George Yeh) collection, housed in Kansas City, has nine works which purport to be by Wu, six of them brushpots. Some of his favourite figural subjects were deities (immortals) and legendary themes; he was particularly fond of carving horses and also buffalo, but could represent with equal facility flowers, plants and insects, toads, dragons and purely calligraphic pieces. Wu's son-in-law, Chu Wen-yu, was a Chiating carver who carried on his tradition; a superb brushpot carved with horses set free is in the Julia Y. Cheng collection, Kansas City. Another brushpot, carved with scholars playing *wei-ch'i* in a garden, was illustrated in *Gardens in Chinese Art*, China House Gallery, 1968, as no. 20, fig. 21, where it was described as Ming.

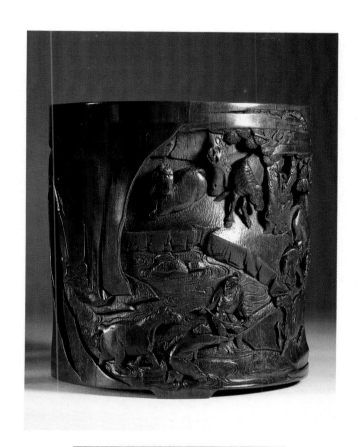

44 BAMBOO BRUSHPOT (1671)

A large bamboo brushpot, with a grooved rim, standing on three low feet. The thick walls are very deeply carved with a scene of eight horses and five grooms by pines and a stream. In a complex and well-integrated continuing composition, two grooms water and wash their horses in the stream which is fed by a waterfall issuing from a dramatic cleft in rockwork. One horse pulls back onto the bank and one of the grooms holds a brush. Above them, a horse rests and watches on the bank as another emerges from behind a pine with convincing dimensional recession, the horse's head and legs are carved in the round and undercut. Another groom kneels to feed his horse from a bowl. Some pine trunks are carved in openwork, adding to the three-dimensional impression. Further along, a groom stands holding his horse, which is next to another horse reclining in the foreground. Behind them, a groom tugs at the halter of his horse behind twin pines.

On the rockwork between the two torrents is engraved in *hsing-shu* the date, of the ninth month, autumn of the *hsin-hai* year (1671), and the signature Chih-fan chih (made).
Height: 6 1/2 inches. Diameter: 6 inches.

The finesse of carving of this brushpot cannot match that of Wu's two masterpieces mentioned above, and with very few known works by him, attribution can only be tentative. In this case the ambitious conception and competent handling of the design and different levels of depth and dimension suggest that the piece is close to Wu's Chu family style. However, without much knowledge of workshop productions and the level of Wu's commercial work it is impossible to be more positive than to point out that most 'average' and probably imitative examples are simpler, in Wu's low relief manner and less representative of *tour de force* carving. It is probably by Wu's hand or that of some close contemporary; compare *Bamboo Carving of China*, nos. 23 (which must surely be genuine) and 20, noting Wang's comments.

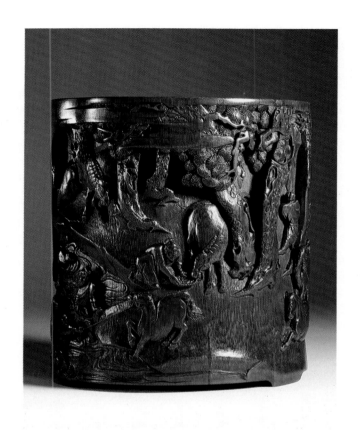

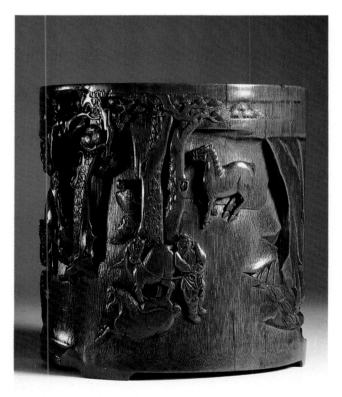

45 BAMBOO BRUSHPOT

Of straight sided, circular section and moderate size, standing on three low feet, the bamboo is carved in dramatic low relief with a scene of two scholars seeking a suitable spot to sit and play the *ku-ch'in*. One bearded sage-literatus indicates the base of three conveniently leaning pines, by a rocky waterfall; his elderly companion is followed by a boy attendant, who carries the wrapped instrument. Beyond him, distant trees cling to the jagged cliffs and rocky outcrops, whose outlines are indicated using sharp, 'axe-cut *tsun*' brushstroke gouges. The attractive markings of the bamboo are exploited using a restrained number of diagonally slanted planes across the grain, primarily for details of the chief protagonists and their immediate surroundings. The extremely fine carving is very much in the style of Wu Chih-fan's low relief manner, with its 'lightning flash' pine branches echoed in the trunks of the distant trees which cling to rocks. A slightly later date is indicated by the straight sides of the vessel and the fact that rather more detail is apparent than is usual for this style. One amusing feature, which perhaps confirms a date slightly removed from the influence of the style's originator in the K'ang-hsi period, is the cleverly concealed mark on the head of the *ku-ch'in*, Chu San-sung. This mark is that most commonly 'evoked' on the works of later carvers, here in an anachronistic style. The carver was aware, though, of Chu's predilection for tucking his signature away, as in the fine small 'aromatics container' illustrated in *Treasures from the Shanghai Museum*, as no. 119.

Like the Chu family, Wu's carving derived ultimately from the Northern, professional school of painting. Here the landscape elements are borrowed from Che school painting, and the carving with a little elaboration but great finesse of technique, from Wu Chih-fan.

Early eighteenth century.
Height: 6 3/16 inches. Diameter: 4 1/8 inches.

From the Dr. Ip Yee collection, Hong Kong.

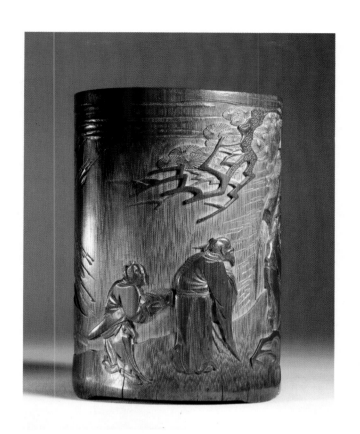

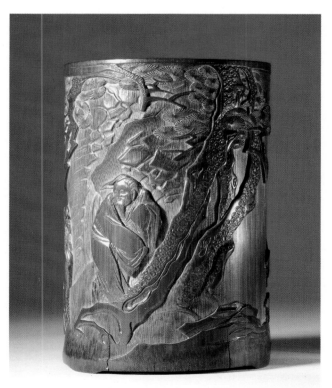

In the interior of a strange pavilion with a barrel-shaped roof a lady sits with brush, inkstone and paper and prepares to paint or write. Through the large window, with its curtain pulled back, can be seen a maid offering a bowl of food, while through another aperture a male attendant is visible, bringing tea. Behind the lady is a large floor screen engraved with a mountainous landscape. Overhung and surrounded by a large *wu-t'ung* tree and a pine issuing from spectacularly contorted rockwork, as well as plantains, bamboo and further foliage, the pavilion is engraved and carved with an impressive array of fine architectural detail. Beyond a fence, lotus leaves and flowering buds grow tall by a stream, in which two ducks swim. On the far bank stands an empty pavilion, next to two three-dimensionally carved gnarled trees by another fence.

Finely carved on three low feet with a continuous scene of unusually profuse detail (for a relatively early work), this brushpot combines very high, rounded relief carving with unusual and effective details of both technique and elements of subject matter. The rounded roof of the pavilion is a feature partly derived from a seventeenth-century (Ch'ung-chen period of late Ming) woodblock print, illustrating the popular scene *Listening to the lute* from the novel *Western Chambers* (see an illustration of the print in *Chinese Bamboo Carving*, part I, p. 27, fig. 4). The strange architectural features and stylised profusion of pine and leafy *wu-t'ung* suggest an exotic, archaistic flavour, evocative of the subject matter.

One extraordinary and practically unique technique appears to be a variant on the Japanese *ukibori* wood-carving fashion; details of lines in the stream, roofs of both pavilions, the frieze under the window and the trunk and branches of the leafy tree have been painstakingly cut open and, presumably, inked in, giving the impression of being wire-inlaid. In places the lip of the cut is swollen fractionally; in any event, this technique adds further textural richness to the already profuse array of features. In addition to the two trees on the opposite bank, the window-frame of the nearby pavilion and two holes in the rockwork are completely undercut.

This brushpot utilises so many unusual features that it is difficult to place or date with certainty. *Chinese Bamboo Carving*, part I, dated it to the K'ang-hsi period, perhaps because of the apparent influence of the seventeenth-century woodblock print. The *tour de force* nature of the carving may suggest a date towards the end of that period, but there is little to compare it with.

Probably early eighteenth century.
Height: 6 5/16 inches. Diameter: 5 1/16 inches.

From the Dr. Ip Yee collection, Hong Kong.
Published: *Chinese Bamboo Carving*, part I, no. 48.

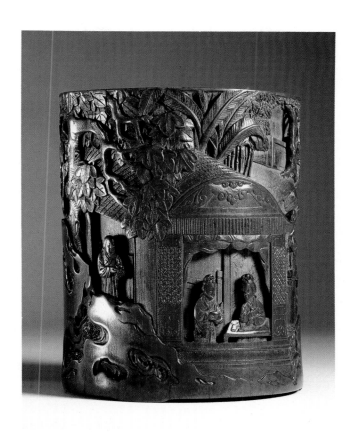

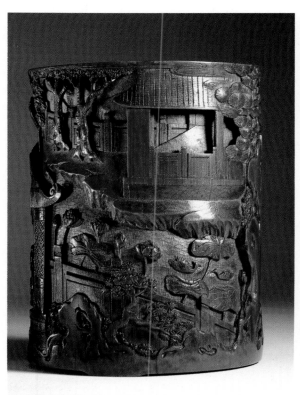

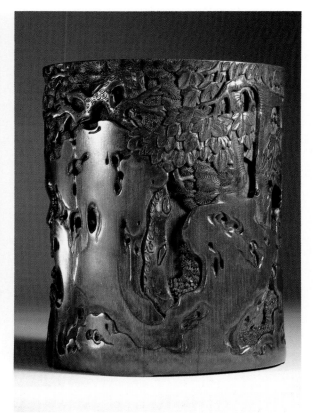

CHOU HAO	tzu: Chin-chai.
1685–1773	hao: Chih-yen (ch'iao-sou), Chih-sou, Chin-chan, Chih-tao-jen, Chün-chan, Jan-ch'ih, Hsüeh-ch'iao, Chou shan-jen, Chou-jan, Yao-feng shan-jen. From Chiating, Kiangsu.

CHOU'S dates are given as 1685–1773 in both *Chinese Bamboo* and in *Bamboo Carving of China*, where he is discussed on p. 32; sources relating to his activity as a painter list his dates as 1675–1763 or, alternatively, 1686–1774. However, a landscape handscroll in the Freer Gallery of Art is dated 1766, at the age of 81, so presumably one of the later dates is accurate. He was a poet, seal-carver and calligrapher, specialising in running and grass scripts in the style of the great Sung calligraphic master (and bamboo painter) Su Shih (Su Tung-p'o). As a painter Chou Hao was a pupil of Wang Hui, producing landscapes and bamboo paintings throughout the first half of the eighteenth century. For a fine ink painting of bamboo by Chou, which we recently acquired from the Dr. Ip Yee collection on behalf of a London collector, see *Bamboo Carving of China*, no. 37A. A painting of snowy bamboo by Chou is illustrated in *Chinese Literati Paintings from the Jorakuan Collection*, no. 41.

Chou's innovatory achievement was to carve bamboo as though it were an ink painting. Previous carvers had based their designs on paintings and prints, but Chou sought technically to imitate the effect of scholar painting on bamboo. Furthermore, he carved in the styles of both the Southern (literati) and Northern (professional) painting schools, particularly the former. The Chu family of late Ming, whose style had been the most influential up to then, had carved designs primarily taken from Northern styles, insofar as such distinctions are valid especially when applied to bamboo carving. His carving style, using the knife as a brush to represent brush strokes and ink tones, was the most influential for the remainder of the Ch'ing dynasty. Chou worked in a closed room, without interference, and used all sorts of extraordinary techniques (such as rubbing, baking and dyeing bamboo) as well both deep and shallow or thick and thin engraving. Chou's nephew Chou Li was also a good painter and bamboo carver.

There are four brushpots and a wristrest by Chou in the Julia Y. Cheng collection, now in Kansas City; two brushpots engraved with bamboo are illustrated in *Bamboo Carving of China*, no. 37 and fig. 52. The same publication reproduces ink rubbings of brushpots by Chou, published by the First Museum of Hopei Province (figs. 17, 38, 39, 39A). Another brushpot from the Cheng collection is illustrated in *Chinese Bamboo Carving*, part I, no. 67, and a wristrest by Chou as no. 98. *Bunku Mandara* illustrates a pomegranate brushpot by Chou as no. 231. We offered a small, superb prunus and rock brushpot dated 1735 by Chou in *In Scholars' Taste*, no. 56. Other documentary examples are dated 1730, 1740, 1742 and 1744.

47 BAMBOO BRUSHPOT (1723)

Of oval section and moderately small size, standing on three low, shaped feet, the bamboo is engraved and carved in shallow sunken relief with a gnarled and jagged pine tree issuing from rocks, with grass and rose hips. In addition to both fine and V-shaped engraving lines used for the tree markings and for outlines, both the tree and rocks bear shallow groovings in imitation of textural brush strokes. At the rim, the top of the tree is obscured by cloud.

Dated to an autumn day in the *kuei-mao* year (1723) and signed Hsüeh-ch'iao tso (made).
Height: 4 15/16 inches. Diameter: 3 inches.

From the Dr. Ip Yee collection, Hong Kong.

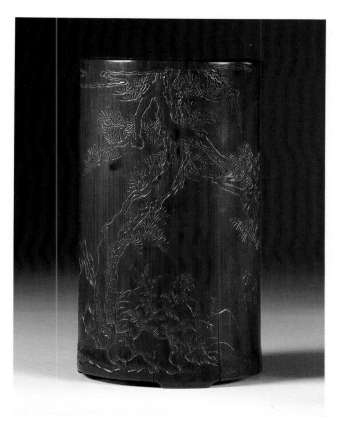

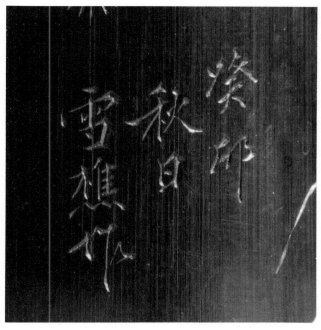

48 **BAMBOO BRUSHPOT** (1748)

Of paler tone and less pronounced oval section than no. 47, on three similar feet above a bulging base, the bamboo is engraved with an ascetic, robed sage seated holding a staff by overhanging rocks on a stool near twin pines on a riverbank. He holds a scroll in one hand, and his strange staff of naturally grotesque form is carved with a dragon's head final. Details of his sympathetic, stubbly face, with long eyebrows and bumpy cranium, are extremely finely carved. This figure represents a rare work of Chou imitating the *pai-miao* (fine outline) technique of Li Kung-lin. there are many points of comparison in the carving of the pines and rocks with those of the earlier Chou Hao brushpot, no. 47, especially in the grooved texture strokes used for both. The clouds above the rocks and the stream's current are lightly engraved with a fine line, and the pine needle clusters are more finely and shallowly engraved than in the previous example, while other details of the pine trunks, rocks in the stream and the overhanging rocky outcrop are quite deeply engraved; not, however, with the variation of thick V-shaped and thinner engraved lines of the 1723 brushpot. In keeping with the fine lines of the *pai-miao* figural outline, the engraving of other details is primarily quite shallow.

Dated to an autumn day of the *wu-ch'en* year (1748) and signed Hsüeh-ch'iao tso, with rectangular engraved seal: yin.
Height: 5 1/4 inches. Diameter: 3 7/16 inches.

From the Dr. Ip Yee collection, Hong Kong.

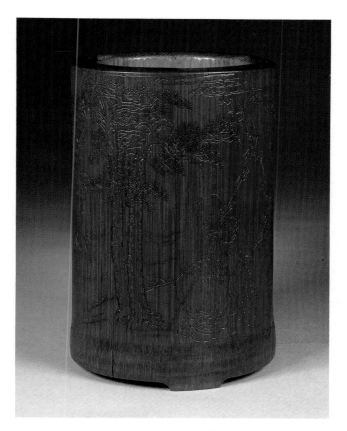

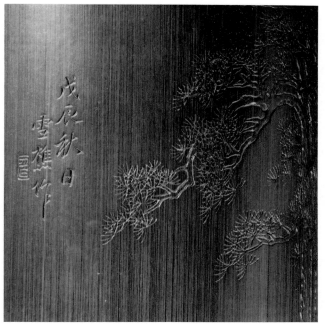

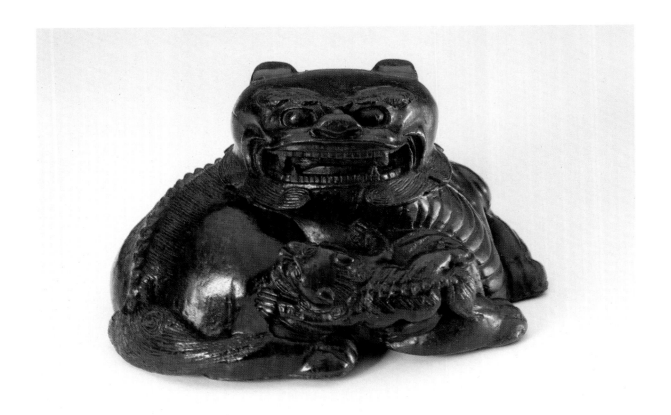

49 BAMBOO ROOT WINE CUP

Carved from bamboo root is a snarling, protective dog of Fo (sacred Buddhist lion-dog) who though reclining remains alert, its cub crawling across its front. Details of the scaly breastplate, claws and ridged backbone are carved broadly and left in relief, while the features of the open-mouthed parent and cub are more finely worked, the eyes of both being either inlaid or black lacquered. The strong relief curlicued hairwork of both is the most powerful and appealing feature; even the cub is bearded, with a bushy, curling tail. The surface of the body is otherwise carved smoothly, and the whole figure, including the hollowed interior, is paint-lacquered red-brown. The animal sits as well upside-down on its head as it does on its haunches and feet, serving in that position as a wine-cup; probably it originally had a metal liner of silver or pewter, but as is usually the case the liner is now missing. For a superb example of a rhino cup of similar model and usage, carved as a deer holding a *ling-chih* spray in its mouth, see *Notes on a Collection of Chinese Rhinoceros Horn Carvings*, no. 36. This rare vessel, from the Dr. Ip Yee collection (acquired from Sydney L. Moss, Ltd.) has now been donated to the Ku-kung Museum, Peking.

Seventeenth century.
Length: 4 9/16 inches. Height: 2 3/8 inches.

A very comparable bamboo root Fo dog and cub wine cup from the Brian McElney collection is illustrated in *Chinese Bamboo Carving*, part I, as no. 104; it is almost a mirror image of the present example, illustrated front and back, except in that it has been stripped, other than in the interior, of its original lacquer surface (assuming that it ever had one, as it presumably must have). These two cups appear to have come from the same hand, or workshop.

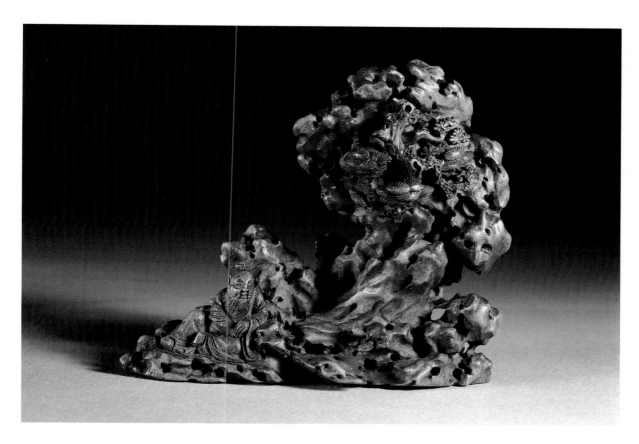

50 BAMBOO ROOT BRUSHREST

An old, bearded scholar sits in his loose robe contemplating nature, his arm resting on a natural rock ledge, by an extraordinary bulging, pierced and convoluted rocky outcrop. From the rockwork grows an aged, gnarled and twisting pine, with superbly carved details of bark, boles and needle clusters. Among the rocks at the foot of the 'growth' of spirit-rock there is a small *ling-chih* fungus. Rock, pine and scholar all share the same spiritual qualities of resilience, purity and a concentration of 'spirit-essence'; the fungus underlines the spiritual, almost magical efficacy of the combination.

Two diagonally grooved areas to the front of the composition's rockwork base demonstrate the constraints placed upon the carver by the form of the bamboo root. The back of the rockwork shows countless bulges and contortions with the attractive, natural nodal markings of the root's surface.

Probably K'ang-hsi period; late seventeenth to mid-eighteenth century.
Length: 4 inches. Height: 3 9/16 inches.

Bamboo root groups of scholars or occasionally deities by rocks or under pines are not uncommon, though those for use as brushrests and particularly examples of extremely fine quality are rare. For lesser, comparable pieces see *Chinese Bamboo Carving*, part I, nos. 19–21, and part II, nos. 104 and 105. [Part I, no. 22, the fine, hinged poem-clip (?) from the David collection, now in the Cleveland Museum of Art, is a superb piece of bamboo carving, as attributable as any other work to the great Nanking carver P'u Ch'eng, but without real points of comparison to this example.]

51 'JADE' BAMBOO INCENSE CYLINDER

An extremely fine piece of 'jade' bamboo (*yü-chu*), the most sought-after and best-marked variety of nodal bamboo, finely and cleverly pierced and carved in rounded openwork with thirty *ch'ih* (hydra) dragons with their single horns and expressions impish or ferocious, carved in every possible sinuous position over, under and around each other. Features and hairwork are finely detailed and, unusually, the eyes are inlaid in black horn. The many apertures in the design allow for incense smoke to emerge and wreathe around the twisting forms.

The attached ends are of turned dark buffalo horn, and the additional turned wood attachments of *hung-mu*.

Early to mid-eighteenth century.
Height, including all end attachments: 9 1/16 inches. Diameter of bamboo: 1 7/8 inches.

For a late Ming incense cylinder (also referred to as 'incensors' and perfume holders) with two powerful, sinuous *ch'ih* dragons confronting each other, from the Wang Shih-hsiang collection, see *Bamboo Carving of China*, figs. 12 & 12a. Not all early precursors of this type were simple, however. A large and brilliant openwork incense cylinder in the Paul Moss collection is carved in a similar spirit with eighteen writhing and confronting mythical animals of all types, not only dragons, which are comparable to the weird sea-creatures seen on Chia-ching and Wan-li ceramics and bronzes. It is carved with the maker's seal of Ch'eng Sheng-jui, an unrecorded carver, possibly the brother of Ch'eng Ch'i, *tzu*: Sheng-ch'ing, a Ming Anhui seal-carver and associate of Ch'en Chi-ju.

An incense cylinder comparable to the present example, though not as fine, was offered in *Bamboo and Wood Carvings of China and the East*, as no. 310. A markedly less appealing openwork dragons cylinder in the collection of the Hong Kong Museum of Art is illustrated in *Chinese Bamboo Carving*, part II, as no. 82.

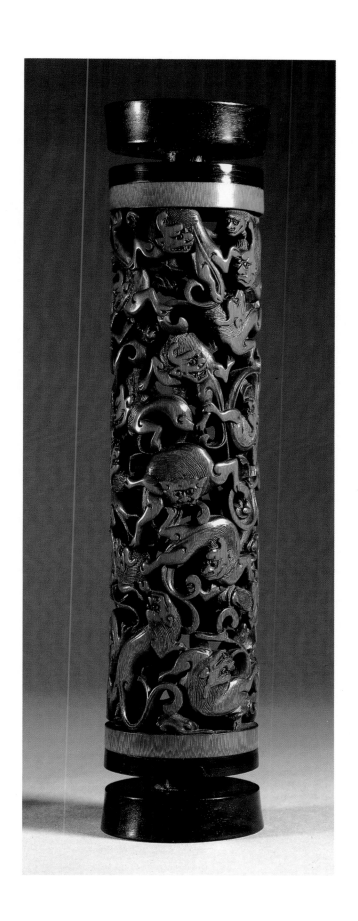

CHU YING

early 17th century

tzu: Ch'ing-fu.
hao: Hsiao-sung.
From Chiating, Kiangsu.

BETTER known by his *hao* as Chu Hsiao-sung (little pine), Chu Ying was the son of Chu Ho (Sung-lin) and the father of Chu Chih-cheng (San-sung); the three are famous as the Chu family of Chiating, the best and stylistically most important bamboo carvers of the Ming dynasty and thereafter. A painter and calligrapher, Chu Ying was active in the Wan-li and T'ien-ch'i periods of late Ming, and was a friend of the well-known Chiating artists Li Liu-fang and Ch'eng Chia-sui (see no. 7). Reputedly, the Chu family carvers improved with each generation, so that Chu San-sung was the best of them all; his name is the most commonly found on bamboo carvings, nearly all of them presumably by other hands. However, works signed Chu Ho and Chu Ying were also forged.

Chu Ying is said to have carved both bamboo and wood figures of Buddhist and Taoist immortals and divinities; he carved "lohans and rosaries with details as fine as gnats' eyelashes". A specialist in "toads, immortals and mountains", he engraved landscape scenes in ancient styles on brushpots, and was known for his bibulousness. There are two pieces attributed to Chu in the Julia Y. Cheng collection, now in Kansas City; a brushpot carved with 'The Three Religions', signed Hsiao-sung, and an incense vase (cylinder?) carved in openwork with a nobleman playing the *ch'in*, cyclically dated to 1578 or 1638 and signed Hsiao-sung, Chu Ying made, with a circular seal, Hsiao-sung.

Chinese Bamboo Carving, part I, no. 2, illustrates from above and below (and in colour plate 2) a small bamboo root toad from the Dr. Ip Yee collection, signed Chu Ying in relief seal script (the signature is illustrated in part II, p. 67). It is also illustrated twice on the cover of *Bamboo Carving of China*, and discussed on p. 20, fig. 6, and as no. 2.

In a 1975 exhibition of Hong Kong's Minchiu Society a small, fine brushwasher carved as a piece of pine trunk and signed with the circular seal Hsiao-sung in a knot-hole was exhibited.

52 BAMBOO ROOT 'PINE' BRUSHWASHER

A small piece of bamboo root with strong, attractive nodal markings is carved with further similarly oval pine-bark scales and boles, and three high relief and openwork branches of pine needle clusters around the lipped rim of the hollow interior. The vessel is meant as a brushwasher for the scholar's desk, but in fact it may always have been intended as a gentlemanly plaything, an evocative symbol of longevity, rather than for actual use. The carver has chosen a piece of material suitable not only for its striking nodal markings, but also for its areas of 'pimply' skin and patches of yellow colour under the surface, both of which he has used with restraint.

The carving is fine, and from the style of the rather thick clumps of pine needles may be as early as the late Ming. Nonetheless, the seal has the appearance of being a later addition, and there is nothing about the carving to particularly support an attribution to Chu Ying. Compare, for example, three pine or prunus water containers dated to the K'ang-hsi period in *Chinese Bamboo Carving*, part I, nos. 62–64, where as the catalogue states "these small water containers . . . were continually being made over a very long period without much change in style". Insofar as the present example can be dated, the thick pine clusters may suggest a date rather earlier than no. 62 in the above catalogue, probably sometime in the seventeenth century and quite possibly contemporary with Chu Ying.

Signed underneath with the square, sunken relief seal Chu Ying.
Length: 2 3/4 inches. Height: 1 1/2 inches.

From the Dr. Ip Yee collection, Hong Kong.

172

53 BAMBOO ROOT FIGURE OF LIU HAI

A small bamboo root figure of the immortal Liu Hai, carved in the round with avuncular features, uses the larger pimply flecks of the bamboo's skin for the top of the popular deity's head, shoulders and robe, while his back is marked with streaking and finer flecking. He reclines in his loose robes and holds a coin between thumb and fingers on his knee. The natural rockwork seat on which he reclines is pierced and contorted and is strongly marked on the reverse with multi-coloured tones of reddish brown and yellow, as are the natural nodal scars. A three-legged toad sits at the end of the rock, beyond his foot.

Liu Hai, one of the most commonly represented figures in bamboo carving, is based on Liu Hai-ch'an (the last character of his name means 'toad'), a tenth-century provincial kingdom's Prime Minister who retired into the mountains and founded the Ch'üan-chen sect of Taoism.

Early eighteenth century.
Length: 3 3/16 inches. Height: 2 1/8 inches.

This figure, carved somewhat in the style of the Feng family of Chiating, is very similar to a slightly larger figure of Liu Hai on rockwork, *Chinese Bamboo Carving*, no. 132, which bears the signature 'San-kuan'. *Chung-kuo i-shu-chia cheng-lüeh* records a 'Feng San-yüan kuan', which I take to be an error for Feng San-kuan. If this is the case, and the entry hardly makes sense otherwise, he must have been a minor carver, not as famous as the earlier Feng Hsi-lu (see *In Scholars' Taste* for a fine P'u-t'ai brushpot, no. 54) or the later Feng Shih-ch'i (see *Bamboo Carving of China*, no. 53, for an excellent *lohan* and tiger), but quite capable within the family figural tradition. The Liu Hai signed San-kuan is, to date, a unique documentary confirmation of his existence; our example is either by the same carver or another family member working in Chiating about the same time.

54 BOXWOOD FIGURE OF LIU HAI

A small, very finely and spiritedly carved boxwood (*huang-yang-mu*) figure of Liu Hai sits astride a giant three-legged toad, which has a loose ball in its mouth. the immortal's robe rides up over his knees and around his back as, with a jovial expression, he holds a coin in one hand and forces open the reptile's mouth with the other, in order to insert the coin. The frog's pupils are inlaid in horn or dark wood, and the boxwood surface is highly polished. The carving sits on its own thin boxwood base, inset into a pierced rockwork base of strongly grained *t'ieh-li* wood, a pleasing tonal contrast. This unusual miniature boxwood carving, in the style of bamboo models and symbolic of prosperity, represents one of the few occasions when Chinese miniature wood carving approaches the quality and vitality of Japanese netsuke carving.

Probably eighteenth century.
Height (including base): 1 5/8 inches.

From the netsuke collection of Miss Harriet Jaffé.

Compare it to a larger bamboo root figure (twice the size) of Liu Hai on a toad from the Dr. Ip Yee collection; *Chinese Bamboo Carving*, part I, no. 121.

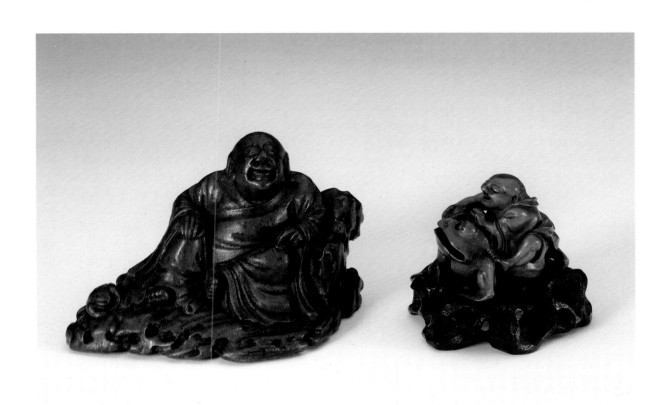

53

54

THE best known bamboo carver earlier this century was Chin Shao-fang (1890–1979). For several of his works dated between 1921 and 1963, from his family's own collection, see *Emperor Scholar Artisan Monk*, nos. 48–53; the two latest examples, both fan-frames, were carved in the *liu-ch'ing* skin technique. After Chin another very fine and delicate Shanghai *liu-ch'ing* bamboo carver was Chih Tz'u-an. Wristrests from his hand include three dated 1935, 1936 and 1937; see for example *Chinese Bamboo Carving*, part I, nos. 161 and 162. the next very fine *liu-ch'ing* carver, although he was capable in other techniques as well, was Hsü Su-pai (born Wu-chin, Kiangsu, lived in Shanghai), *tzu*: Ken-ch'üan; *hao*: Hsiao-chung, who died in the 1960s. He often took his designs from the bird and flower painter Chiang Ti (*tzu*: Han-t'ing, 1904–1963); for rubbings of two *liu-ch'ing* brushpots by him, dated 1957 and 1961, see *Bamboo Carving of China*, figs. 29 and 30. See also *Chinese Bamboo Carving*, part I, for a 1957 wristrest and a 1959 cricket cage (nos. 163 and 189, col. pl. 42 and 46).

Hsü Su-pai handed down his *liu-ch'ing* technique, the most difficult of all manners of carving bamboo, to his son Hsü Ping-fang. *Bamboo Carving of China* devotes a special section to Ping-fang's work (pp. 44–47, nos. 82–84). In Wang Shih-hsiang's words: "Xu Subai's son, Xu Bingfang, continued his father's art and has completely mastered the *liuqing* technique. In China today, those who inherited the craft of bamboo carving can be counted on the fingers, and Xu Bingfang is one of the best. Furthermore, Xu is at the prime of his life and has many more years in which to perfect his art. Here we show two wrist rests especially created by him for the present exhibition (figs. 31 to 33b). The photographs showing the work in stages explain the creative process of bamboo carving". The two wristrests carved for the China Institute in America 1983–1984 exhibition were dated 1982, and a third 1978.

55 **LIU-CH'ING BAMBOO WRISTREST**

A pale bamboo wristrest, cleverly carved in the paler skin with a design taken from a painting of a tree issuing from behind a large, pierced rock alongside a bamboo plant which can also be seen emerging under the rock. Gouged texture strokes are apparent in the rock, the tree and even the leaves.

Dedicated: For the correction of Mr. Ip Yee, (taken from a) painting by Wu Yang-mu, carved by Hsü Ping-fang, with square relief seal: Hsü. Wu Yang-mu, from Suchou, is the son of Wu Cheng (see *Emperor Scholar Artisan Monk*, no. 41) and grandson of Wu T'ao (see *In Scholars' Taste*, no. 32).
Modern, circa 1980.
Length: 8 9/16 inches.

From the Dr. Ip Yee collection, Hong Kong; carved expressly for Dr. Ip.

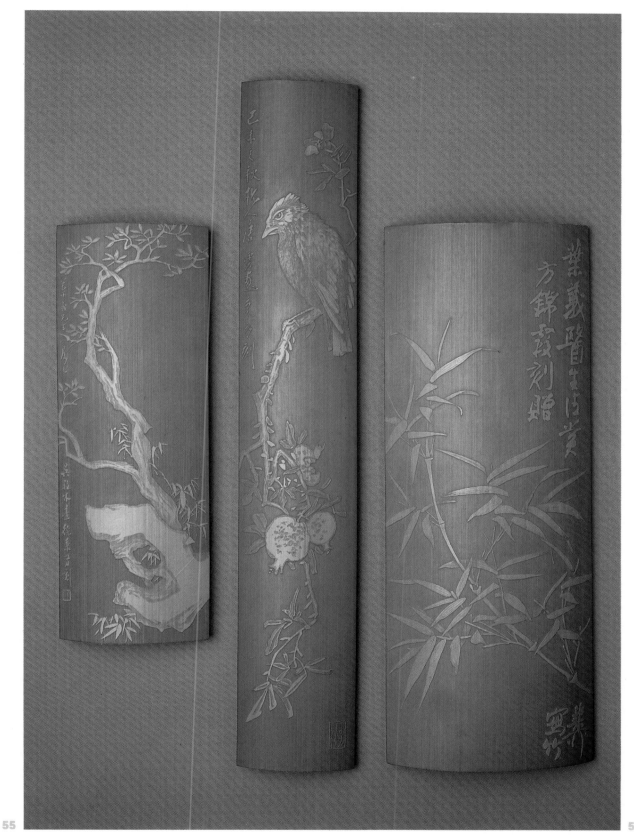

56 LIU-CH'ING BAMBOO WRISTREST (1979)

A pale, tall bamboo wristrest finely carved in varying levels of the paler skin, with a bird perched on a pomegranate branch, one blossom above it and the branch dangling down under the weight of three fruits, one of which has been half-eaten. The branch, fruits and leaves are cleverly gouged for textural effect, but the featherwork of the bird is particularly well executed in different thicknesses of bamboo skin.

Dated and inscribed: Autumn of the *chi-wei* year (1979), after a painting by T'ang Yün, carved by Ping-fang, with a rectangular relief seal at bottom right: Ping-fang k'e-chu (carved bamboo; a similar seal to one used by Chin Shao-fang). T'ang Yün, born 1910, is an artist whose designs are often used by modern carvers. The inscription follows his calligraphy, and he probably designed the entire conception specifically to be carved by Hsü.
Height: 14 1/8 inches.

From the Dr. Ip Yee collection, Hong Kong.

FANG CHIN-HSIA

Fang is an outstanding contemporary female *liu-ch'ing* bamboo carver.

57 LIU-CH'ING BAMBOO WRISTREST BY FANG CHIN-HSIA

A large, broad pale bamboo wristrest, attractively carved in the paler skin with a design of a bamboo spray after a painting by Hsieh Chih-liu (born 1910, and one of the most famous modern Shanghai painters). Leaves and bamboo twigs criss-cross, over and under each other, giving an impression of spontaneous freedom belying the technical precision necessary to capture the spirit of the individual ink painting.

Inscribed: For the enjoyment of Dr. Ip Yee, carved for presentation by Fang Chin-hsia. With another inscription at bottom right: Chih-liu painted the bamboo (in the characteristic running hand signature of the artist).
Modern, circa 1980.
Length: 11 1/8 inches. Width: 4 1/8 inches.

From the Dr. Ip Yee collection, Hong Kong; carved expressly for Dr. Ip.

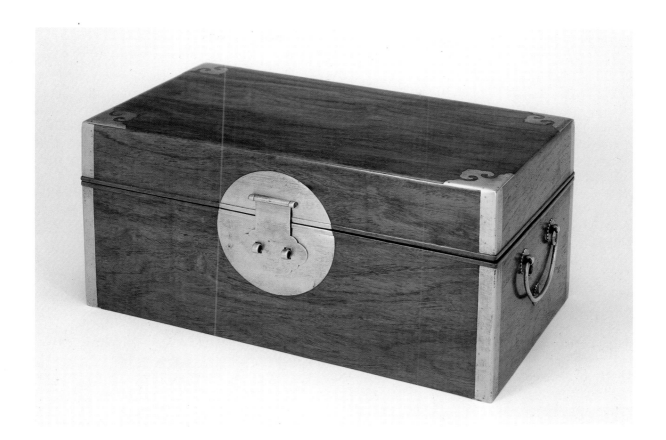

58 LAO-HUA-LI WRITING BOX

A rectangular box for documents and writing implements, (*wen-chien hsiang*) with *lao-hua-li* sides and top; the base of *t'ieh-li mu*. *Lao-hua-li* is a coarser grained and softer wood than *huang-hua-li*, probably of the same genus but with more small knot-holes. Ellsworth, *Chinese Furniture*, p. 50, considers that *lao-hua-li* may even come from the same tree as *huang-hua-li*, but closer to the sap-wood.

The rim is beaded with an integral, raised strip to front, back and sides; the metal lock plate is moulded to cover this beaded strip. The white brass (*pai-t'ung*, or *paktong*) mounts, with *ju-i* head cloud motifs to the four corners and a cloud design for the lock, are of the superior variety, inlaid into the wood rather than simply mounted on top of it. There are *pai-t'ung* loop handles and chrysanthemum head fittings at the sides.

Late Ming dynasty, sixteenth or early seventeenth century.
Length: 13 1/2 inches. Depth: 7 1/2 inches. Height: 6 3/16 inches.

Very comparable, slightly larger *huang-hua-li* writing boxes are illustrated in *Chinese Furniture*, no. 151, and *Ming-shih chia-chü chen-shang*, b&w pl. 157, both described as Ming.

TZU-T'AN (purple sandalwood) is very highly regarded by Chinese connoisseurs. To quote Ellsworth, *Chinese Furniture*, p. 52: "To the Chinese this is the most highly prized of all woods and is the heaviest and densest that was used for cabinetmaking in China. This dark purple-brown, subtly grained wood was also the most expensive and difficult to obtain, and was the most imitated of all woods. *Hung-mu* can be stained to resemble *tzu-t'an* but can never have its density or weight, both of which are necessary to produce the feeling of smooth, sun-warmed stone that true *tzu-t'an* effuses. To the touch there is a great similarity between the surface of this wood and many of the fine black jade blades of the late Chou period."

Because the subtle appeal of its dark graining and surface have, relatively speaking, escaped Western enthusiasts in comparison with the delights of such woods as *huang-hua-li* and *chi-ch'ih mu*, we offer here a selection of fine *tzu-t'an* pieces of desk furniture.

59 TZU-T'AN SEAL CHEST

A dome-topped *tzu-t'an* seal chest (*kuan-p'i hsiang*) with white brass (*pai-t'ung*) mounts. The flattened domed lid lifts, attached to the body of the chest by inlaid strap hinges, and the doors (of mitre, mortise and tenon frame, tongue and groove floating panel construction) open to reveal a traylike section with four drawers beneath it, their fronts of *tzu-t'an* but their bases, back and sides of strongly marked *huang-hua-li*, as is the interior base of the entire chest. The chest stands on an attached *tzu-t'an* base with a curvilinear apron at the front. The *pai-t'ung* front door mounts are inlaid, with a circular lockplate, cloud motif hasp and openwork fish design pull handles. The surface-mounted drawer handles are plain oval pendants on chrysanthemum-engraved escutcheons. The loop handles at the sides are likewise attached to surface-mounted plain and chrysanthemum-engraved escutcheons. The frame of the top and body of the chest are hidden-dovetailed, except for visible tenons above the upper side hinges.

Late Ming dynasty, sixteenth or early seventeenth century.
Length: 16 3/4 inches. Depth: 11 1/2 inches. Height: 16 3/8 inches.

Shallowness (of depth front to back) is considered characteristic of seal chests relatively early in the Ming period. For a somewhat comparable domed *tzu-t'an* seal chest see *Chinese Furniture*, no. 150.

Wang Shih-hsiang, *Ming-shih chia-chü chen-shang*, considers that seal chests were in fact used as cosmetic boxes.

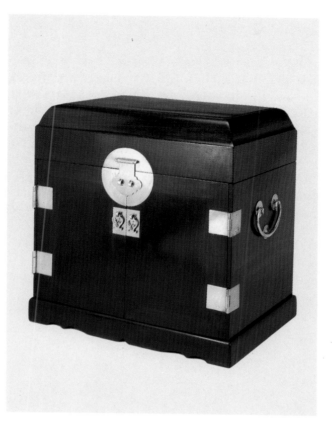

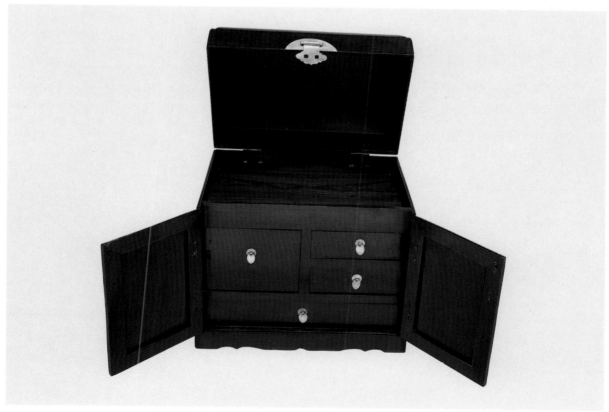

A *tzu-t'an* seal chest (*kuan-p'i hsiang*) of square, severely classic form, with white brass (*pai-t'ung*) mounts. The lid of the chest lifts, attached by inlaid strap hinges, and the doors (of mitre, mortise and tenon frame, tongue and groove floating panel construction) open to reveal at the top a traylike section and below that five drawers. Interiors of both tray and drawers are of strongly marked *huang-hua-li*, and the chest rests on an attached *tzu-t'an* base. The brass corner plates, door lock and handle plates are all inlaid, and the flat hasp is of a cloud design. Beneath it, the square escutcheon has two *hu* vase form handles; these are repeated on the interior for the drawer pulls, the surface-mounted escutcheons for which are engraved with a chrysanthemum motif. At the sides are attractive, rectangular bail handles on surface mounted quadripetal escutcheons, which enhance the masculine, square lines of the chest, contrasting effectively with the circular lock plate and shaped floral and vase mount details.

Ming dynasty, sixteenth or early seventeenth century.
Length: 13 1/8 inches. Depth: 11 inches. Height: 12 13/16 inches.

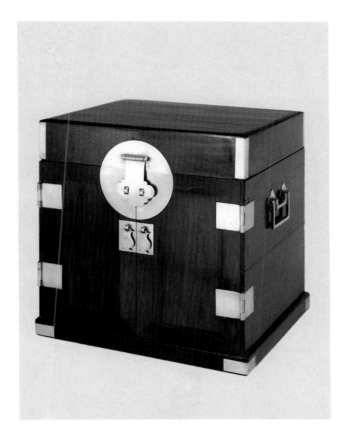

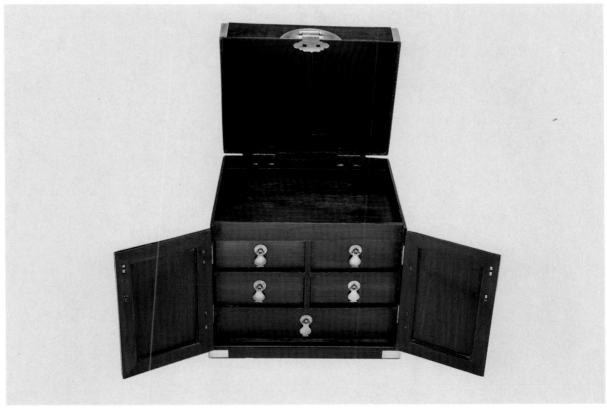

61 TZU-T'AN SMALL BOX

A charming miniature *tzu-t'an* box (*hsiao hsiang*) with beaded rim and floating panel base, the inlaid yellowing *pai-t'ung* mounts are very large in relation to the surface area of the attractive, densely grained wood. The corner mounts on top are of an unusual inverted *ju-i* head cloud design, and the hasp is likewise of *ju-i* head cloud shape and is on a square escutcheon. The loop handles have surface-mounted circular escutcheons with spiralling chrysanthemum engraving.

Ming dynasty, sixteenth century.
Length: 4 1/2 inches. Depth: 3 1/8 inches. Height: 2 7/8 inches.

62 TZU-T'AN BRUSHPOT

A reddish *tzu-t'an* brushpot (*pi-t'ung*) of slightly flaring form with attractive markings. A vertical graining with dark flecks contrasts with golden ridges of flowing veins which change position as they catch the light's reflection, their texture is silky and apparently translucent. The base has a circular plug in the centre.

Seventeenth century.
Height: 6 1/8 inches. Diameter: 5 11/16 inches.

63 TZU-T'AN BRUSHPOT

A superb, very slightly waisted plain brushpot (*pi-t'ung*), still retaining its original thin, clear lacquer coating and a lovely patina, under which subtle but strong variations of graining can be discerned. The base has a strongly concave channel and convincing wear to the foot; in its centre is a thick, rounded *tzu-t'an* plug.

Ming dynasty, fifteenth to seventeenth century.
Height: 5 15/16 inches. Diameter: 4 15/16 inches.

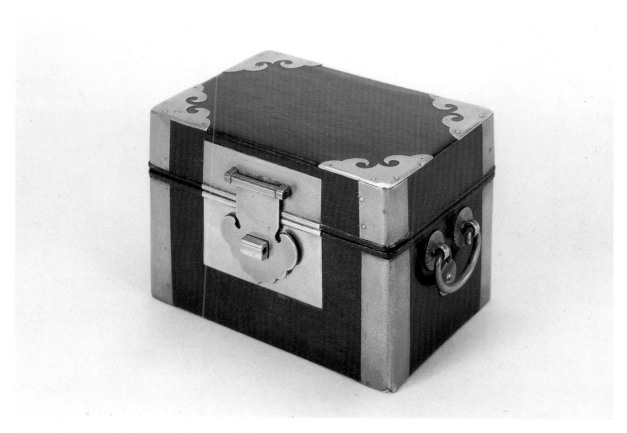

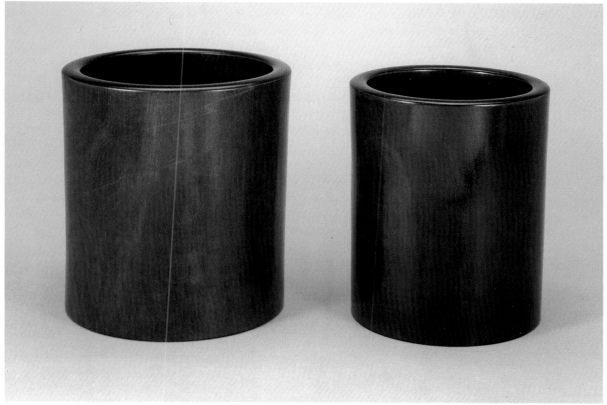

64 TZU-T'AN BRUSHPOT

A partly natural and partly carved *tzu-t'an* brushpot (*pi-t'ung*) of eccentric trunk form, probably in imitation of an old pine. Both rim and boles have their irregular features enhanced in places. Jammed while the tree was still growing in a natural split/bole to one side is a small, marbled green pebble; the wood has partially grown over the stone, suggesting the efficacy of an old, weird root, a repository of concentrated spirit-essence (*ch'i*). The base is carved across the *tzu-t'an* log, with no central hole; an unusual feature. It sits on three very slightly raised feet. The wood is attractively grained, with a variety of strong markings.

Ming dynasty, sixteenth to early seventeenth century.
Greatest height: 6 inches. Greatest diameter: 6 inches.

65 ENGRAVED TZU-T'AN BRUSHPOT

A strongly flared *tzu-t'an* brushpot (*pi-t'ung*) with attractive vertical graining, including an area of the gold-flecked *tzu-t'an* (*chin-ssu tzu-t'an*), which is an effect obtained by filling the graining of the surface with the fine orange powder produced when *tzu-t'an* is abraded. The base has a large circular plug inset in its centre.

Seventeenth century.
Height: 6 3/8 inches. Diameter: 6 1/2 inches.

The brushpot has been later lightly engraved with a very fine design of a branch and several twigs of flowering plum blossom after a painting by Wu Chün in the style of Wang Mien. The design, which is quite broadly executed for the branch and twigs but very fine for the blossoms, is shallowly carved and can only be appreciated with close examination.

Equally lightly carved is an inscription: Imitating the idea of Chu-shih shan-nung (Wang Mien, d. 1359), for the refined appreciation of the master of the Old Mountain Pavilion (Chiu-shan lou: Chao Tsung-chien, from Chang-lieh, Kiangsu), drawn by Tzu-chung, Wu Chün, and carved by Chang O (?). Wang Mien was the most famous Chinese prunus painter; see *Bones of Jade, Soul of Ice*, nos. 13, 14 and 15. No further details of Chao Tsung-chien are recorded other than a dating of Ch'ing dynasty. Wu Chün, *tzu*: Tzu-chung; *hao*: Kuan-ying, from Chiang-yin, Kiangsu, was an early nineteenth-century painter, poet and calligrapher, particularly skilled in ancient-style portraiture and in seal-carving. He lived in the capital and was highly regarded by such artists as Tai Hsi, Ho Shao-chi and Chang Mu. Chang O (the second character of the name is so shallowly carved that details of it are indistinguishable from the grain of the wood, and it must remain a tentaive reading), *tzu*: Ling-yüan, was a Ch'ing portraitist from Lou-hsien (Sung-chiang, Kiangsu).

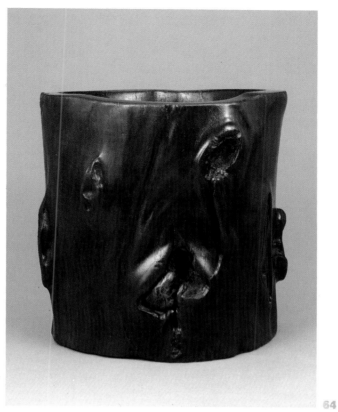

64

65

A rare *tzu-t'an* desk screen of thick, squared rectangular construction, the upright frame tenoned and mortised into shoe feet with beaded spandrels. The central part of the screen is carved with an eccentrically-shaped grooved relief reserve rising from a flat ground within beaded surrounds; the channels between the beadings, framing the flat ground, are carved as fat, rounded surfaces. Beneath the central frame is, on obverse and reverse, a frieze with a long oval relief feature on a flat ground, again within a rounded surround, and below that an apron is set on both sides at 45 degrees, carved in diagonal relief, like the curvilinear sides of the shoe feet, with a stylised *lei-wen* design. The reverse of the screen is a sliding panel which removes to permit access to the old, polished *ju-i* fungus in the shape of which the screen's central reserved aperture is formed. The leathery surface of the fungus, bulging and crackled in several layers and textures, not only wishes long life for the owner but also takes its place in the range of weird naturalistic objects, (contorted rocks, gnarled tree forms, *ju-i* sceptres or agitated cloud configurations in wood grain and porcelain decoration), which found their way onto the desk not so much as a reminder of the joys of nature but rather as vessels carrying concentrated *ch'i* spirit-essence into the daily ambit of the literatus, heightening his spiritual richness as well as his aesthetic sensibility.

Ming dynasty, sixteenth to early seventeenth century.
Length: 11 7/8 inches. Depth: 6 1/4 inches. Height: 12 1/4 inches.
The fungus is 8 1/2 inches long by 1 3/8 inches thick at its widest points.

Ju-i (literally, as you like it or, may your wishes be fulfilled) is a Chinese fungus otherwise called *ling-chih* (*Ganoderma japonicus*); it grows on tree bark in Chekiang, Kiangsi, Hunan, Kuanghsi, Fukien and Kuangtung provinces. Of dark maroon colour, with a shiny black kidney-shaped hood and stalk, it can easily be distinguished from a similar fungus, *ch'ih-chih* (*Ganoderma lucidum*), which has a yellow to red-brown hood. Both are used as herbal remedies, while not necessarily guaranteeing immortality; soaked in wine or soup they give off the bitter chemical ergosterol. The tough, unsavoury flesh of the fungus is not normally eaten.

For a punning *Pai-shih ju-i* (everything as you like it) painting by Ch'en Man-sheng see *Emperor Scholar Artisan Monk* no. 29.

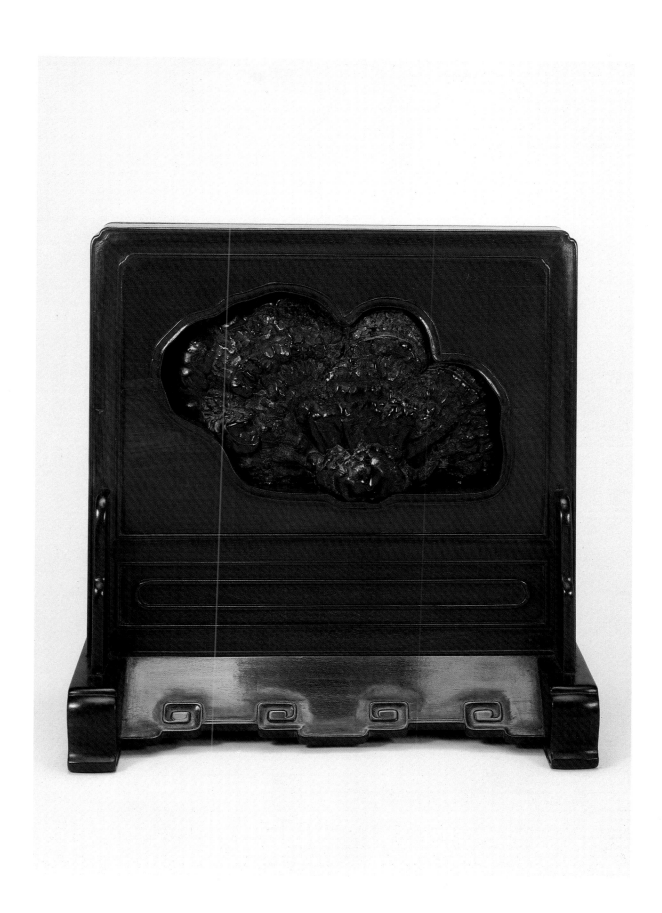

67 BURL ROOT 'WEIRD ROCK'

A splendid, polished section of burl (*hua-mu*, or flower-wood) root, probably birch burl, set in a shaped *hung-mu* stand to resemble a contorted 'spirit-rock' of ear form. The pale, yellowish skin of the root bears a strong, dense, riverine veining and graining with several gnarled boles, while the darker brown interior, which shows through the skin in places, has a more leathery, ridged surface like that of a *ju-i* fungus. The reverse is almost entirely covered with the paler skin, bearing dents, cracks and large, irregular apertures, but nonetheless far smoother and with fewer markings than the front.

Probably seventeenth or eighteenth century.
Such objects are practically undatable, and there is little point in trying to prove their age. However, it seems extremely unlikely that the above wide dating is more than a century out in either direction.
Height with stand: 19 3/16 inches. Greatest width: 10 inches.

68 BURL ROOT SCROLL POT

A large, beautifully marked piece of burl (*hua-mu*, or flower-wood) root, probably birch burl, of essentially natural form, flaring at the bulging, rounded rim with a small 'boot' at the foot, carved out in the darker, *ju-i* fungus-like interior and flat underneath for use as a scroll pot. The yellow skin of the pot is extremely attractively grained, with the dense surface veining like the waters of a rushing torrent, streaming in all directions forming whorls, whirlpools, *Ent*-faces, strands of hair, tadpoles, mad staring eyes and abstract spirals. The eccentrically-formed boles and excrescences on the rim set off the maelstrom of interface between form and surface with a modicum of balance.

Probably seventeenth or eighteenth century.
Greatest height: 9 1/4 inches. Greatest width: 13 1/2 inches.

67

68

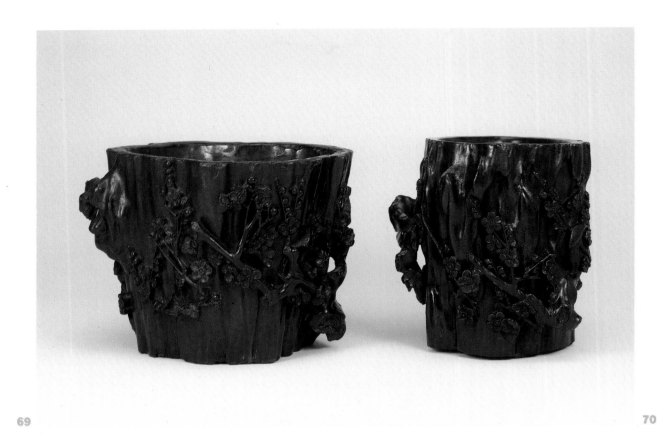

69 70

69 EAGLEWOOD PRUNUS BRUSHPOT

An irregularly-shaped eaglewood (*ch'en-hsiang mu*) brushpot formed as a section of prunus trunk, with two relief gnarled branches of prunus blossom growing from and around the naturalistic trunk. The flat base has an irregular wood plug, lacquered black as at the rim and interior. The finely carved relief details of angular prunus twigs, boles, branches, blossoms and buds are either partially or completely applied and lacquered together.

Late Ming to K'ang-hsi periods; mid-seventeenth to early eighteenth century.
Height: 5 inches. Greatest width: 6 7/8 inches.

70 EAGLEWOOD PRUNUS AND BIRDS BRUSHPOT

An irregularly-shaped eaglewood (*ch'en-hsiang mu*) brushpot formed as a section of prunus trunk, with two relief gnarled branches of prunus blossom growing from and around the naturalistic trunk, each with a bird perched on it. This brushpot, of slightly smaller size than the preceding example, has more dramatically gnarled boles to its branches and rocky overhangs and irregularities of bark to the prunus trunk. It does not demonstrate the application of the original lacquer to rim, base and interior.

Late Ming to K'ang-hsi periods; mid-seventeenth to early eighteenth century.
Height: 5 3/16 inches. Greatest width: 4 3/4 inches.

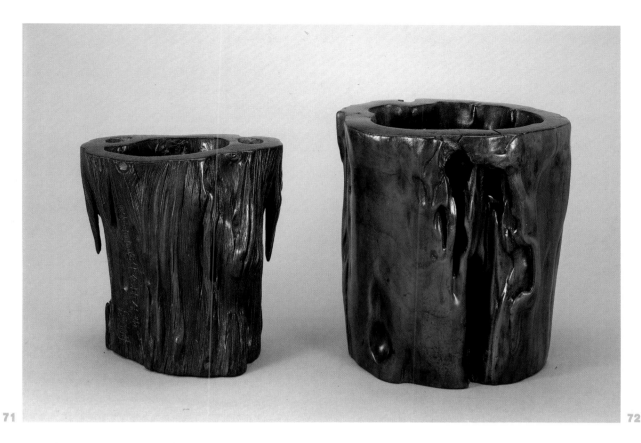

71 72

71 HARDWOOD ROOT BRUSHPOT (1642)

An eccentric hardwood root brushpot of natural form enhanced with additional carving in imitation of a prunus trunk, with an extremely dense grain, several boles and outgrowths resembling stalactites and stalagmites, sharply undercut in places. The smooth, very hard rim is thickly carved with two apertures left in its wall; there is another hole in the wall of the body of the pot, while other holes are carved (or occur naturally) within the wall of the 'trunk', passing behind large knots to emerge again on the exterior. The interior is quite roughly hacked out, as befits an object of such rustic appearance, and the base has an oval wood plug. The high relief 'stalactites' and pillars give off a variety of tones when flicked with a fingernail, an indication of the hardness of the wood.

Inscribed: In the last winter month of the *hsin-ssu* year of the Ch'ung-chen period of Ming (January, 1642) by the old man of the Fang-hsia an (the retreat for loosening, or liberation, in a Buddhistic sense); with engraved seal: treasured collection of the Ch'ien family. The owner is not recorded.
Height: 6 1/8 inches. Width: 5 11/16 inches.

72 HARDWOOD ROOT BRUSHPOT

An eccentrically formed hardwood root brushpot carved in imitation of a rotten tree trunk, the beautifully patinated wood bearing subtle tonal changes in its colouring of red-yellow-brown wood but with few grain markings. Its extremely smooth surface is carved with rounded yet dramatic boles and apertures in addition to its natural fissures. With the integral base, it is carved all of the same piece of root.

193

Seventeenth century; perhaps a little earlier or later.
Height: 7 1/16 inches. Diameter: 6 3/4 inches.

73 HUANG-HUA-LI BRUSHPOT WITH MI FU POEM

A dark, plain *huang-hua-li* brushpot (*pi-t'ung*) with slightly flared straight sides, attractive markings and an inset circular plug. Broadly engraved with a poem describing a horse, in the characteristic *hsing-shu* style of Mi Fu (1051–1107, one of the Four Great Sung Calligraphic Masters) probably a colophon from a painting:
Having all the qualities of the horses of T'ang,
possessed of surprising excellence;
one may ride it four hundred thousand times,
only then can one distinguish its true colour.
Ah! such a horse is this.

Probably eighteenth century.
Height: 5 7/8 inches. Diameter: 5 1/8 inches.

74 BURL BRUSHPOT

A plain, slightly waisted burl (*hua-mu*, or flower-wood) brushpot (*pi-t'ung*) with thick walls and attractive yellow tone, marked with a variety of grains. On two sides are whorls and inclusions similar to walnut burl, while between those sides are areas of quite different flowing grain with 'feather' markings and pale striations. The attractively marked, slightly concave base appears to be integral, carved with the body from a single piece of burl, but it has a sunken circular centre in imitation of an inset plug.

Probably eighteenth century, but perhaps somewhat earlier.
Height: 6 1/2 inches. Diameter: 5 7/8 inches.

75 HUANG-HUA-LI BRUSHPOT

A very large *huang-hua-li* brushpot (*pi-t'ung*) with slightly flaring sides and striking dark veining in the medium-toned grain. The walls are uniformly quite thick, and there is a very large circular plug in the base.

Probably seventeenth century.
Height: 8 3/4 inches. Diameter: 8 3/4 inches.

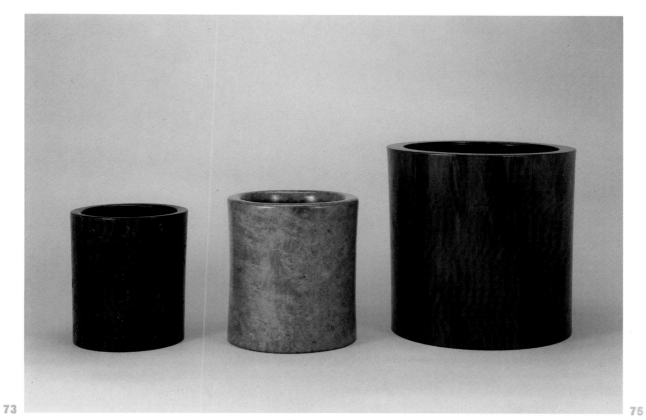

73

74

75

76 HUANG-HUA-LI BRUSHPOT

A large *huang-hua-li* brushpot (*pi-t'ung*) with slightly flaring sides and 'face' knot inclusions and mountain-range veining in the yellow-brown, strongly flecked grain. The interior is also attractively marked, and there is a circular plug in the base.

Probably seventeenth or eighteenth century.
Height: 8 inches. Diameter: 7 3/4 inches.

77 HUANG-HUA-LI BRUSHPOT

A *huang-hua-li* brushpot (*pi-t'ung*) with flaring sides and two particularly striking Ghostbuster 'face' knot inclusions in the yellow-brown, strongly marked and attractive grain. The interior is also attractively marked, and there is a circular plug in the base.

Probably seventeenth or eighteenth century.
Height: 6 5/16 inches. Diameter: 6 1/2 inches.

78 HUANG-HUA-LI BRUSHPOT

A *huang-hua-li* brushpot (*pi-t'ung*) with slightly flaring sides, relatively thin walls and several random knot inclusions in the yellow-brown, strongly flecked and attractive grain. There is a circular *huang-hua-li* plug in the base.

Probably late seventeenth or eighteenth century.
Height: 6 7/16 inches. Diameter: 6 1/16 inches.

79 HUANG-HUA-LI BRUSHPOT

A *huang-hua-li* brushpot (*pi-t'ung*) with flaring sides, carved in bucket shape with relief bands to the rim and foot; the band just above the shaped foot is strongly carved with a concave groove. The rim is also slightly concave. There are a few knot inclusions in the yellow-brown, strongly flecked and attractive grain. The entire base is inset, sunk within the protruding foot.

Probably mid-seventeenth to early eighteenth century.
Height: 5 11/16 inches. Diameter: 5 11/16 inches.

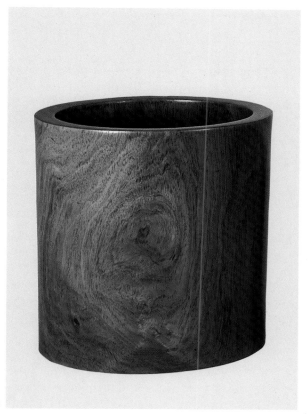

76

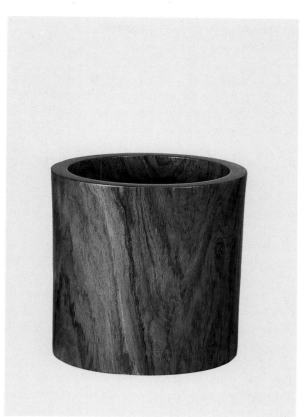

77

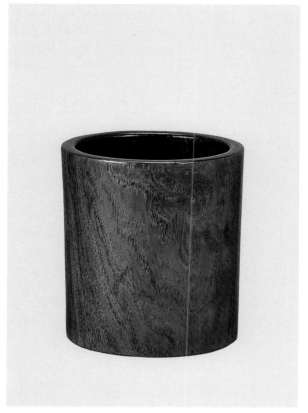

78

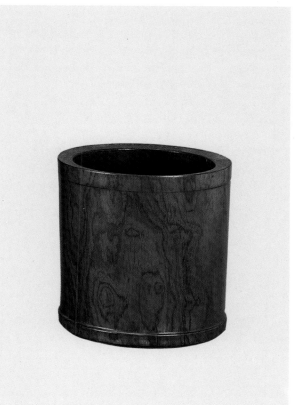

79

LI WEN-FENG	hao: Jen-pu.
mid-19th century	From Ta-yao, Yünnan.

L I Wen-feng was a *pa-kung* graduate of 1849, a poet and calligrapher; his works in both were reported to have a strange spirit. Avoiding the hostilities of the Taiping Rebellion he travelled around for several years in an unsettled fashion, lodging with friends; eventually he died overwhelmed by his worries.

80 PAIR OF HUNG-MU SCROLL WEIGHTS

A pair of *hung-mu* square-section long scroll weights, both interestingly marked on each of the four sides with the differing measurements for a standard foot during various dynasties.

The shortest side is marked off at 8 5/16 inches and inscribed in *li-shu* "The Chou dynasty foot", with the *k'ai-shu* information "from the example in the collection of the Ku family of Ch'ü-fu" (Shantung).

The next side is marked off at 9 1/8 inches and inscribed in *li-shu* "In the sixth year of the Han dynasty (201 BC) this revised bronze foot measure was made", with the *k'ai-shu* addition "from the example in the collection of the K'ung family of Ch'ü-fu (Shantung); the foot measure in the Chin dynasty was the same".

The third side is marked off at 11 1/8 inches and inscribed in *li-shu* "The Sung dynasty official (literally Provincial Treasurer, Provincial Judge and Salt Commissioner) cotton and silk foot measure", with the *k'ai-shu* addition "the foot measure carried ceremonially by sons of the Chu family (presumably the Ming imperial family) was the same".

The fourth side, measuring the full length of the scroll weights (12 7/16 inches) bears the *li-shu* inscription "In the sixth year of the Ch'ien-lung period the Board of Works and the Treasury revised and collated (previous measure) and issued a definitive, standard iron foot measure" (the standard foot was known as a Board of Works foot).

With the *k'ai-shu* signature: Made by Jen-pu.
Mid-nineteenth century.
12 7/16 inches × 13/16 inch square.

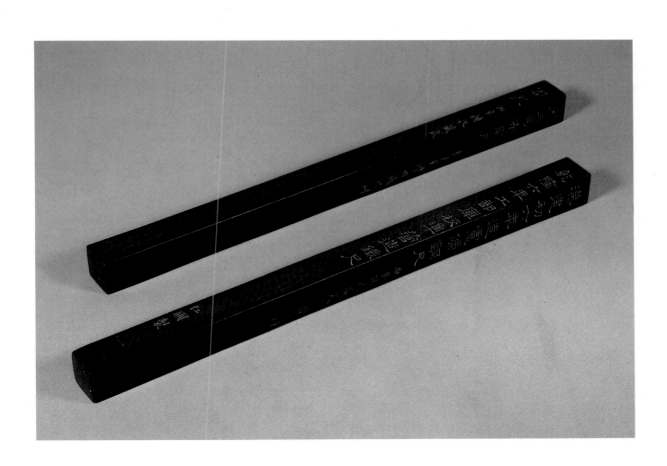

hao: Chih-sheng.

YU K'an was one of the finest carvers of rhinoceros horn; there are more works from his hand published than of any other individual carver. He worked for a while, during the middle of the K'ang-hsi reign period, in the imperial ateliers, and is listed in traditional sources. For a lengthy discussion of his work, and illustrations of a fine cockerel, hen and chicks libation cup by Yu, see *Emperor Scholar Artisan Monk*, no. 60.

A lotus and praying mantis cup by Yu K'an is illustrated in *Treasures from the Shanghai Museum*, no. 121; and a fine landscape cup in *Selected Handicrafts* (of the Ku-kung Museum, Peking), as pl. 53. Two more cups are in the Chester Beatty collection, Dublin, and another is illustrated in Jenyns and Watson, *Chinese Art*, vol. 4, no. 142. The collection of the late Dr. Ip Yee, Hong Kong, contained nine signed libation cups, four of them by Yu K'an, all illustrated in colour in *Notes on a Collection of Chinese Rhinoceros Horn Carvings* in the catalogue of the Fourth International Asian Antiques Fair, Hong Kong.

81 RHINOCEROS HORN LIBATION CUP

A low cup with flattened foot, spreading lip and beautiful, warm, pale colour is beautifully carved in unctuous, rounded high relief with a scene of a scholar at ease in his garden, sipping wine while reading poetry seated in a 'moon-viewing' chair. His boy attendant stands behind him, wine ewer at the ready, while a stream issues from rockwork and rushes by so fast that waves and spume are thrown up in the air as it breaks upon the rocky bank. Graceful stems of bamboo grow by a large spirit rock, through one aperture of which a fat, gnarled plum tree grows, and the stream passes through another. In the interior in relief and openwork grow those branches of bamboo and plum which vanished into the lip of the exterior, passing through unctuous ridges of swirling cloud. The stream continues among rocks under the foot of the cup.

As if written on a rock face on the far side of the stream, partially obscured by the large rock opposite the gentleman, is a couplet:
Han pei lo sheng ch'eng pi hsien
Yin ju ch'ang ch'ing hsi pai ch'uan
Sucking his cup, the happy sage extols his evasion of worthiness;
Drinking like a great whale, inhaling the hundred rivers.

The square, sunken relief seal Yu? is deliberately obscured by the bulging foreground rock. There is just the faintest of possibilities that the carver was not Yu K'an, but another carver surnamed Yu. However, the carving style is so close to that of Yu K'an's that it seems more likely to have been done in a spirit of self-mocking effacement and gimmickry, based on his confidence in his fame and skill. I have recorded two cups bearing the signatures Yu T'ung and Yu I-liang, probably family members and followers of Yu K'an's style.
K'ang-hsi period, late seventeenth to early eighteenth century.
Length: 5 9/16 inches. Height: 3 inches.

Yu K'an's figural cups are very rare, and this one is stylistically very close to one of the cups, fractionally smaller, in the late Dr. Ip Yee's collection, now in the collection of the Ku-kung Museum, Peking (*Notes on a Collection of Chinese Rhinoceros Horn Carvings*, no. 2). Dr. Ip considered that Yu K'an worked in the early K'ang-hsi period, and dated his cups to the seventeenth century.

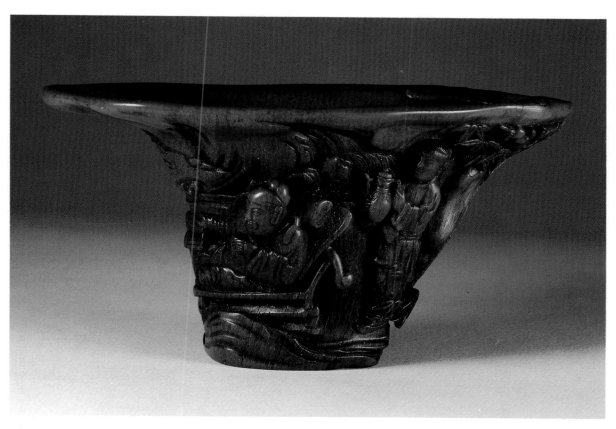

Carved from a skinned pebble of pure, translucent *t'ien-huang* soapstone with one deep, fissured flaw, is a shapeless fondling piece for use as a paper weight, scroll weight or sleeve weight, but whose real function is as an object of tactile and visual delight. Several mythical and exotic creatures (a *kuei* dragon, a phoenix, a deer (?), an elephant and at least five *ch'ih* dragons) gambol and intertwine among waves, some pursuing a pearl, their slightly worn features finely engraved and modelled. Such groups of frolicking, legendary beasts were typical decorative subject matter for carvings, ceramics and bronzes in the late Ming period, the late sixteenth and early seventeenth centuries.

Ming dynasty, late sixteenth or early seventeenth century.
Length: 3 1/8 inches. Height: 1 1/2 inches

T'ien-huang is one of the most sought-after soapstones; like chicken's-blood and the best *ch'ing-t'ien* stones it is prized by connoisseurs even if uncarved, or in plain, uncut seal form. It is very rarely found in pebble form of any appreciable size. Not every yellow translucent stone is *t'ien-huang*; see for example the seal we offered in *Emperor Scholar Artisan Monk*, no. 97, which was wrongly thought by many to be *t'ien-huang*. The genuine stone bears striations and graining marks internally, sometimes whorls, which can be seen within the warm, honey-coloured translucent stone when a good light is passed through it.

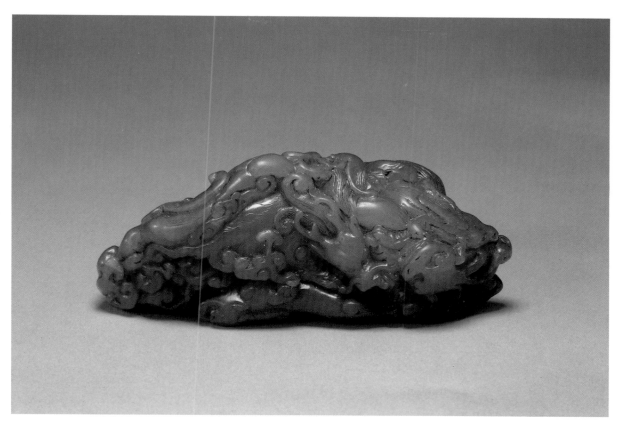

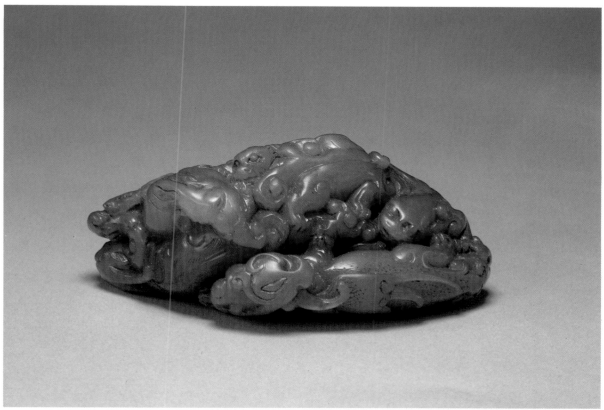

YANG YÜ-HSÜAN

17th century

original ming: Chi.
From Chang-p'u, Fukien.

YANG Yü-hsüan was, with his pupil or perhaps slightly later contemporary Chou Pin (see nos. 84 and 85), one of the top two soapstone carvers of the Ming and Ch'ing periods. There is confusion as to their dating, with some sources suggesting that they were both active as late as the eighteenth century. It is possible that Yang was active in the K'ang-hsi period and worked for a time in the imperial ateliers; see a *t'ien-huang* figure of a *lohan* and Fo dog in *Selected Handicrafts* (in the Ku-kung Museum, Peking), pl. 65. There is unproven evidence that Chou, and presumably Yang, were active in the T'ien-ch'i period of late Ming; see the discussion appended to a fine soapstone figure by the unrecorded carver Tzu-hsiu, which we offered in *In Scholars' Taste*, no. 123; quite comparable to the *lohan* offered here. In view of the few known facts available, a likely dating for Yang anywhere in the seventeenth century, from early on until the K'ang-hsi period, must be considered.

83 SOAPSTONE FIGURE OF A MEDITATIVE LOHAN

In yellow-brown soapstone of caramel colour and opacity, is finely carved the small figure of a genial *lohan* of Indian appearance, sitting cross-legged in meditation with one hand resting palm upwards on his foot and the other touching his knee in the witness, or earth-touching *mudra* gesture: calling upon the earth to witness his enlightenment. His features and hairwork are finely engraved, as are the decorative borders of his robe and cloak, which are inlaid with fifteen turquoise studs. His cloak hangs in thick, pleated rolls and he sits on a replacement mat base of red and grey tones.

Signed in *ts'ao-shu* on the reverse, Yü-hsüan.
Seventeenth century.
Height of figure, not including base: 2 5/16 inches.

From a private London collection.

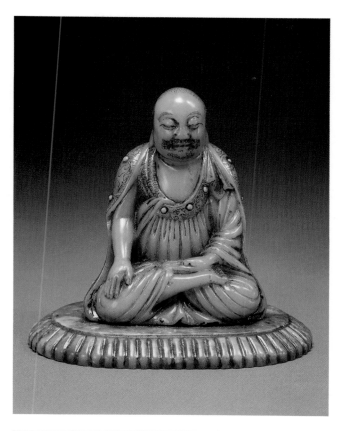

tzu: Shang-chün.

From Chang-chou, Fukien.

CHOU Pin is traditionally recorded as the pupil of Yang Yü-hsüan (see no. 83), perhaps apocryphally; they are regarded as the two finest soapstone carvers. Chou carved mostly seals ('seal knobs', not the carving underneath) and small figures, usually signing his work with his *tzu*: Shang-chün. One very fine soapstone brushpot in a Hong Kong collection, with a sage and attendant in relief on a hatched ground, is signed Chou Pin in relief, with seal Shang-chün. *Ku-wan chih-nan* relates that: "nowadays, the curio shops prize Shang-chün's work as the best", and empirical evidence suggests that the quality and originality of his finest carving outstripped that of Yü-hsüan, whose style was characterised as archaic and simple, while Chou's was 'rich' and more decorative. Shang-chün captured special features and boldly exaggerated them, bringing out personality in his carving. Like Yang, Chou Pin is recorded as a Ch'ing dynasty man, again supposed to have worked in the K'ang-hsi ateliers; but two fine works signed by him in collections known to me bear T'ien-ch'i dates, including one of 1627. Soapstone is an easily engraved material to which dates and signatures can be added, but leaving aside the point that this is judged unlikely in these two cases, even where such inscriptions are added they tend generally to correspond to the actual period of activity of the carver. Stylistic and iconographic features of Chou's work suggest a date closer to the late Ming dynasty rather than the Ch'ing, although there was a considerable carry-over of style from one to the other. Chou Pin may have enjoyed a long working life, but it probably only extended into the early K'ang-hsi period. Some traditional sources placing Chou in the Ch'ien-lung period compound their evidence by implying that such early nineteenth-century carvers as Hsü Han (who also carved seals of ivory and natural gourd) and Ma Wen were pupils, or at least followers of Chou, while other summary biographies indicate that the two later carvers were described only as the equals of Yang and Chou.

84 T'IEN-HUANG SOAPSTONE BOULDER CARVING OF KUAN-YIN

A superb and very rare *t'ien-huang* boulder group, carved in high relief from an unusually thick piece of beautifully striated *t'ien-huang* soapstone of glowing, translucent tones, backed by the mottled grey-green rock of the large pebble, with a further, thinner *t'ien-huang* skin on the reverse. The front is deeply carved in superfine, unctuous detail with Kuan-yin seated in the position of royal ease on the head of her vehicle, the Fo lion-dog, whose bushy tail and haunch coil around behind her. She rests her foot on a lotus flower growing from waves and holds an acanthus spray, while a sacred book rests upon another lotus at her side. A boy attendant on a large lotus leaf to one side clasps his hands together in adoration and genuflects, while above her head a parrot flies and a monkey climbs a branch.

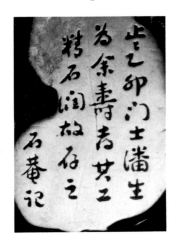

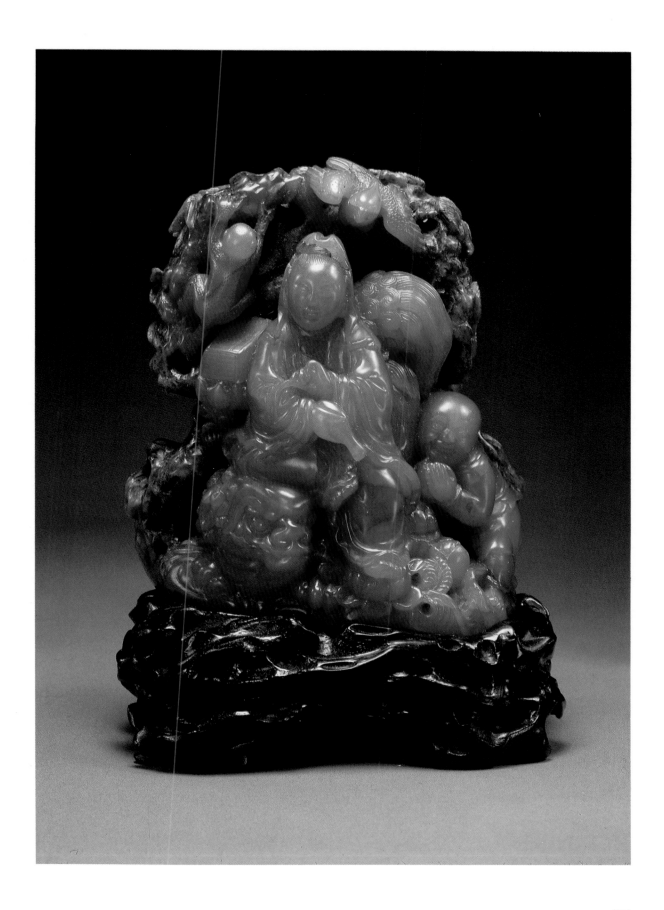

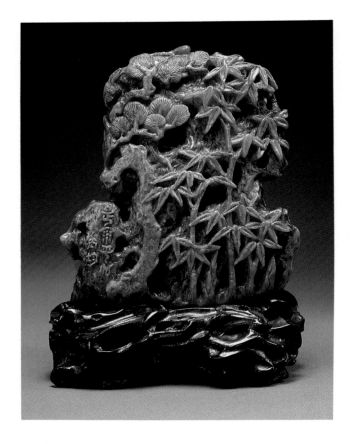

On the reverse, standing out against the contorted rockwork of the back stone, a bamboo grove and a gnarled pine are carved in still quite substantial relief, though only in one or two places with the mellow translucence of the obverse material. Also carved in relief in the reverse skin is a four-character *chuan-shu* title, and the signature Shang-chün.

Engraved underneath in his characteristic abbreviated *hsing* hand is a short inscription by the official and calligrapher Liu Yung (1719–1804), recording the entry of this piece into his collection. For a superb, similarly inscribed rhinoceros horn figure of a *lohan* which entered Liu's collection in 1781, see *Emperor Scholar Artisan Monk*, no. 56. The inscription here relates that at that time, in the *i-mao* year (1795) Liu's pupil, a certain Mr. P'an, had given him for his birthday this skilfully carved and unctuous stone for Liu to keep; he signs it "recorded by Shih-an".
The carving has a fine *tzu-t'an* wood stand, formed as a contorted rock.
Seventeenth century.
Height without stand: 3 1/2 inches. Width: 2 5/8 inches. Depth: 1 5/8 inches. Height with stand: 4 1/8 inches.

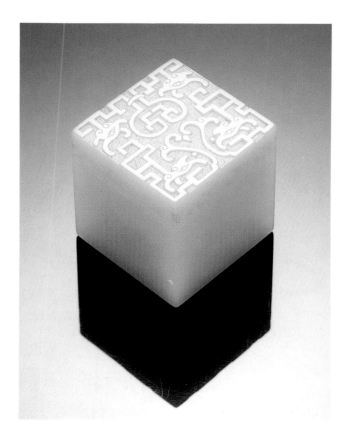

85 WHITE SOAPSTONE SEAL

A small, square-section seal of white, opaque soapstone, cut down underneath to remove the engraved seal of a previous owner. Brilliantly carved in low relief on the top of the seal, with extreme technical precision, is an archaistic design of four *ch'ih* (hydra) dragons, their bodies devolved into geometric keyfret designs, all above a very finely engraved ground of complex *lei-wen* design. The tails of the top two dragons, each of which has a pearl before his open mouth, end in bifid curls; those of the lower two are joined by a loop and end their curling in squared geometric forking.

Just under the top is an engraved band with a zigzag design between two engraved lines. At the front, within this band, is the rectangular, horizontal seal-script signature in sunken relief, Shang-chün. Seventeenth century.
The top section measures 7/8 inch square.
Current height: 31/32 inch.

A thin seal of comparable relief dragon design in the Paul Moss collection, carved in the same pure white soapstone and likewise cut down underneath, has the Shang-chün seal signature carved in sunken relief within two circular reserves.
 Seals by Chou are quite rare.

KAN KUO-PAO

18th century

tzu: Chi-chao, Ho-an.

From Ku-t'ien, Fukien.

A military *chin-shih* graduate of 1723, Kan Kuo-pao specialised in painting tigers, sometimes using a finger-painting technique. Perhaps he was born in a tiger year.

86 SOAPSTONE 'TIGER' SEAL (1760)

A highly polished, smooth soapstone seal of pebble form and mottled yellow, brown and red tones, engraved on the front with the single, large character *hu* (tiger), written with one continuous stroke.

Dated to spring of the *keng-ch'en* year in the Ch'ien-lung period (1760) and signed, Kan Kuo-pao wrote 'tiger' in one brushstroke.
The irregular intaglio seal engraved underneath reads *Ming yüeh ch'ing feng wu chia* (the bright moon and a clear breeze are priceless).
Height: 2 9/16 inches.

CH'EN HUNG-SHOU

1768–1822

tzu: Sung-wen, Tzu-kung, I-an.

hao: Man-sheng, Lao-man, Man-kung, Kung-shou, Chung-yü (hsien-k'e, hsien-kuan, tao-jen), Chia-ku t'ing-ch'ang, Hsü-ch'i yü-yin.

hall names: Sang-lien-li kuan, Lien-li shuang-kuei-shu lou, Chieh-ch'ung kuan.

From Ch'ien-t'ang (Hangchou), Chekiang.

CH'EN is generally known by his *hao*, Man-sheng, to distinguish him from the famous late Ming painter Ch'en Hung-shou. For details of his life see the calligraphic couplet, no. 36; see also the rare pair of 1794 seals by Ch'en which we offered in *Emperor Scholar Artisan Monk*, no. 100.

For examples of Ch'en's seals see *Ming-Ch'ing chuan-k'e liu-p'ai yin-pu*, pp. 158–159, and *Chung-kuo ni-yin yüan-liu*, pp. 120–121. He was regarded as a stylistic follower of Ting Ching (1695–1765) and Huang I (see nos. 30 and 134).

87 SOAPSTONE LANDSCAPE SEAL

A domed, slender, rectangular soapstone seal, the stone with brown, grey and white striations. The front is carved in low relief in the caramel brown, somewhat crystalline stone with a scene of a hut on a promontory by pines and bamboo (? or willow), with tall mountains in the background, and the foreground dominated by two tall, gnarled trees on a slope. Further rockwork is suggested on the reverse, with broad, shallow carving separating the upper grey-white stone from the pale brown 'rocks' beneath; upon the latter are engraved the four archaic seal-script characters *Chin-shih ch'ang-shou* (may you have the longevity of bronze and stone), with the engraved *hsing-shu* signature Man-sheng tso (made).

The rectangular seal itself, carved in relief in a squared, stylised seal script, reads *Chi-kuang p'ien-yü* a poetic phrase which literally translates as "auspicious and bright, a strip of feather". In its more modern usage it means "what little remains of precious works of art (is the reason for everything)".

Circa 1800.
Height: 2 1/16 inches.

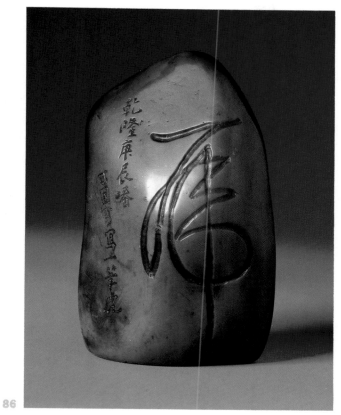

86

86

87

87

87

88 IVORY LOTUS SEAL

A large ivory seal of tapering rectangular form, finely carved with an openwork surmount of a lotus still-life. Several cut lotus stems are bound together, and the leaves, buds and flowers to which they are attached act as supports on all sides to a lotus pod, which is cleverly carved with loose seeds.

The relief, *chuan-shu* seal carved underneath reads Wei-chü shan-jen, an art name which literally translates as "mountain man living by the Wei river" (a tributary of the Yellow River in Shensi), or possibly "mountain man living by rapids". The name's owner is not recorded.
The seal has every appearance of dating from the Ming dynasty, or later in the seventeenth century. However, such styles of carving seals were continued into the eighteenth and even early nineteenth centuries, and it is unwise to be didactic about early dating.
Height: 2 1/2 inches.

89 IVORY COIN SEAL

An ivory seal carved in imitation of an archaic coin of Han dynasty Wang Meng type, with sunken areas to obverse, reverse and both sides hatched and stippled after the coin's texture. One side and the obverse are carved in relief with archaic seal characters: "longevity, happiness and profit", and "cash distribution". A third side is carved in less archaistic relief seal characters with the cyclical date, *keng-ch'en* (1740, 1800 or 1860) and a hall name, Yin-sung kuan fang-ku; imitating the ancient, in the Humming in the Pines Hall. This hall name is not recorded, but there was a Yin-sung t'ang, the hall name of Wang T'u-ping, a high official and *chin-shih* of 1712, and it is just possible that this is a variant on his hall name.

The seal carved underneath, at either end of the 'prongs' of the coin, is an unrecorded art name in intaglio and relief seal characters, reading Ti-chai.
Probably 1800. Antiquarian interest in bronze and stone scripts and objects was at a peak in the very early nineteenth century.
Height: 1 15/16 inches.

Published: *Ivories of China and the East*, no. 113, where it was dated as 18th century.

88 89

90 PAIR OF ROOTWOOD SEALS

A pair of gnarled, natural rootwood seals (perhaps prunus root) of eccentric form, probably enhanced a little by polishing but with hardly any carving. Both enjoy the feature of a root twig which has grown into another, forming a natural handle. The flat-carved base of each is engraved with an intaglio *chuan-shu* seal, intended as a poetic plaything rather than for actual impression.

The seals read *t'ing feng yü* (listening to the wind and the rain) and *kuan weng* (lonely old man). The second seal is signed on the body with a cursorily engraved art name which may read Chiai-chao. Probably nineteenth century, but perhaps earlier.
Height of each: 2 7/16 inches and 2 3/8 inches.

Bamboo root seals featuring all sorts of nodal contortions and similar poetic seal phrases were popular during the eighteenth and especially nineteenth centuries (see *In Scholars' Taste*, nos. 132, 133 and 134), but such attractive hardwood root seals as these are a rarity.

91 WOOD PAVILION SEAL

An unusual hardwood seal, the square base with an openwork surmount of a scholar seated at a low table with a pile of books to one side. The pavilion's thatched roof is supported by a pillar at each corner.

The relief *chuan-shu* seal reads *Yen-po ta tu-tu*; amid mists and ripples (mountain and river scenery), the great military provincial governor.
Nineteenth century.
Height: 1 3/8 inches.

From the H.G. and M.A. Beasley collections.

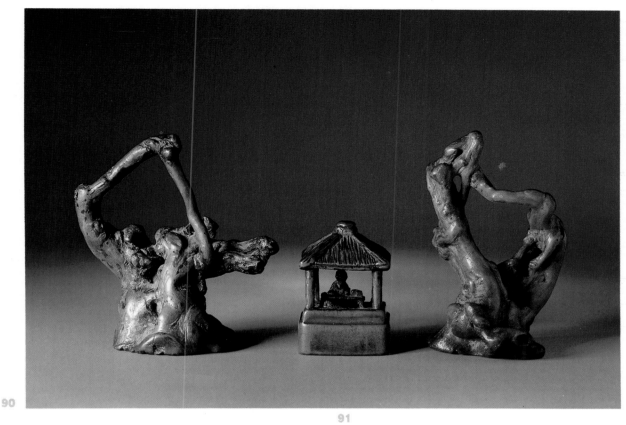

90

91

90

A brilliantly carved amber (*hu-p'o*) group of a bearded sage, perhaps intended as Confucius, sitting in a natural rockwork grotto with three children. Two of the children make respectful obeisance to him with ancestor tablets but the third, a baby without pigtail, whom the sage holds benignly on his lap, has naughtily snatched the tablet from the kneeling boy. Details of features, robes and rockwork are extremely finely carved in the efficacious material, which is opaque for some two-thirds of the height of the reverse, but beautifully translucent and even transparent for the top of the rockwork and many of the foreground features of sage and children. Details stand out more sharply in the darker, clear inclusion, particularly against the cloudy, paler background, witness to the carver's clever exploitations of his extraordinary material.

Signed on the reverse in two tiny engraved *hsing* characters I-chang. This art name is, surprisingly, unrecorded.
Probably K'ang-hsi period, early eighteenth century.
Height: 2 13/16 inches. Length: 3 1/2 inches. Depth: 2 inches.

Amber carvings of such quality are quite rare; signed works almost unknown. For other examples see *Transactions of the Oriental Ceramic Society* vol. 35, 1964, no. 439 (in colour in *The George Menasce Collection* Part I, no. 159) and *Chinese Decorative Arts*, no. 146. We offered a rare amber waterpot in *In Scholars' Taste*, no. 102. None of those pieces compared to this in terms of quality or beauty of material.

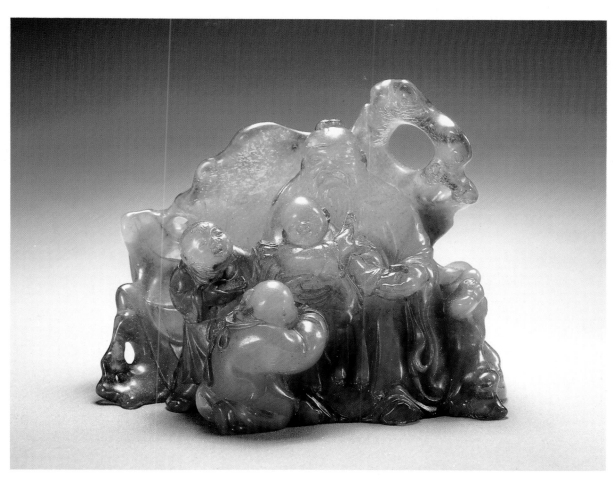

93 AMBER FINGER CITRON

An unusual amber carving of a finger citron, or Buddha's hand fruit, the resinous material darkly mottled with red, brown and yellow tones and patches of translucence. Attached to the main fruit is a twig bearing several leaves, buds and a flower, as well as a smaller finger citron growing alongside.

Probably seventeenth century to early eighteenth century.
Length: 3 1/16 inches.

The finger citron, symbolic of wealth, was one of the most popular naturalistic forms in the late Ming period, and was frequently carved in bamboo. Its representation in amber is rare. The carving is quite flat on both sides and, if intended for any function rather than as a tactile and visual plaything for the desk, it may have been meant as a paperweight. For a somewhat comparable amber pomegranate carving of similar usage, see *Bunku Mandara*, no. 253.

94 BAMBOO ROOT FINGER CITRON

A bamboo root carving of a finger citron attached to a twig and a large leaf, the bands of nodal root stumps left in rounded relief, so that the thick, clawlike 'fingers' of the fruit give a warty effect rather like the tentacles of an octopus.

Late seventeenth to mid-eighteenth century.
Length: 3 inches.

For bamboo root carvings of finger citrons in a variety of techniques, one or two quite comparable, see *Chinese Bamboo Carving*, part I, nos. 27–30, and *Bamboo Carving of China*, nos. 12–14.

95 IVORY FINGER CITRON BRUSHWASHER

An unusual ivory brushwasher in the form of a finger citron, a rounded rectangular section incorporating the three top 'fingers' removing to reveal the hollowed interior. The skin of the fruit is represented using a realistic scooping and stippling technique. The short, green-stained stem of the fruit appears to be an applied piece of ivory; the central finger at the opposite end of the container is also applied separately, to conceal the nerve-hole at the centre of the tusk.

Mid-eighteenth century.
Length: 4 3/4 inches. Height: 2 3/16 inches. Height with stand: 2 13/16 inches.
With a good (finger citron) leaf stand in strongly grained reddish blackwood.

For a remarkably similar 'box' see *Masterpieces of Chinese Miniature Crafts in the National Palace Museum*, pl. 29.

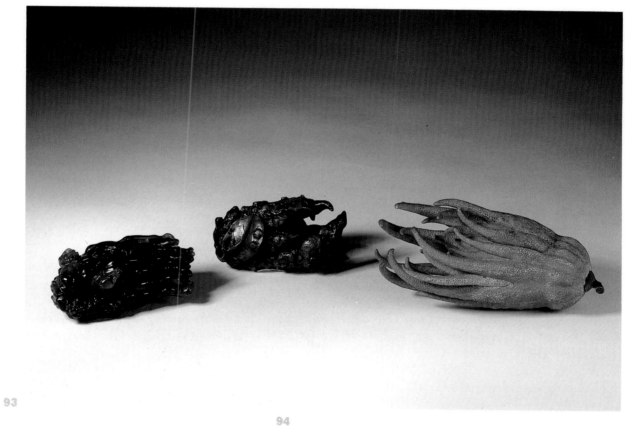

94

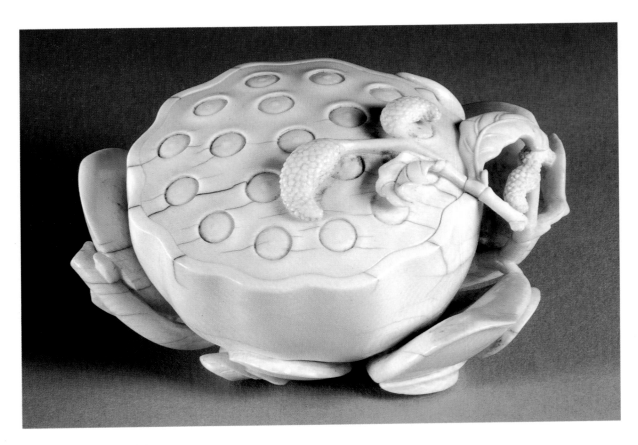

96 IVORY LOTUS WATERPOT

A fine ivory box and cover, probably intended for use as a waterpot, carved in high relief and openwork as a lotus pod with four large leaves opening away from it, the stem passing underneath with another leafy stem bearing heads of millet which continues across the top of the lid. The pale, dense ivory was taken from a section close to the centre of the tusk, and although it bears attractive age cracks shows little patination except on the underside.

Such vessels were meant as decorative desk objects for visual enjoyment and perhaps occasional use as almost any kind of box or container. Like the previous example, however, they were usually possessed of some nominal function such as brushwasher, waterpot, seal ink container or cosmetic box. In the case of such self-consciously clever desk objects of the eighteenth century, function takes second place to design, so that the concept of a brushwasher or waterpot with a lid is not at all contradictory; it was rarely if ever to be actually used. In the seventeenth century the function of a naturalistic vessel tended to be subservient to the uncluttered rendition of the fruit's form; in the eighteenth century it was a box first and a plant second.

Mid-eighteenth century.
Length: 3 3/8 inches. Height: 1 7/8 inches.

A comparable, though more ornate 'melon-shaped water container' is illustrated in *Masterpieces of Chinese Miniature Crafts in the National Palace Museum*, as pl. 33.

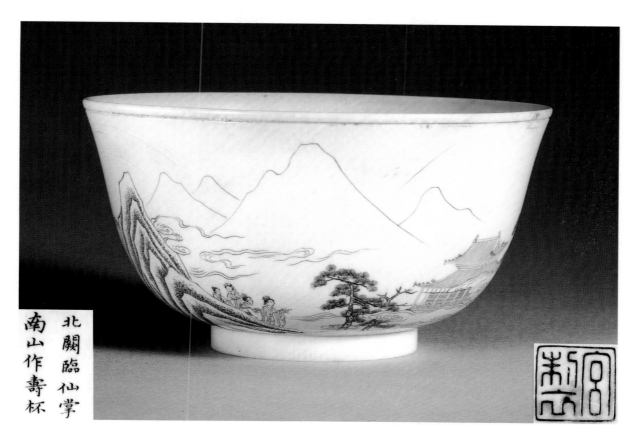

97 IVORY WINE CUP

A turned ivory cup or small bowl with an engraved rim for locating a metal liner just beneath the lip, standing on a vertical foot with a concave footrim. Finely engraved on the exterior of the cup is a scene of four Taoist maidens bearing food and drink to a cloud-shrouded pavilion among pines. A range of mountains is far off in the distance. The rocks from which they emerge are treated with a stippling technique, but other details are engraved in a fine-line style derived from the *pai-miao* painting technique.

With an engraved couplet:

At the northern gate (or imperial city: Peking), *next to the immortal's palms,*
In the Southern Mountain is made this longevity cup.
("May you live as long as the Southern Mountain" is a popular wish).

With two red engraved seals: Tan-ching. The name is not recorded but is probably the art name of some previously unrecorded ivory atelier artist.
A further red seal is engraved on the base: Kung-chih (made in the palace).
Eighteenth century; palace workshop production.
Height: 2 inches. Diameter: 3 3/4 inches.

From the H.G. and M.A. Beasley collections, acquired June 1925.

This cup is very similar to a set of four ivory cups bearing relief Ch'ien-lung marks (two of them now in the Hong Kong Museum of Art) dated 1777 and engraved by the calligrapher and seal-carver Shen Feng.

98 IVORY BRUSHPOT

A rare low relief-carved ivory brushpot (*pi-t'ung*) with a scene left on an empty ground of a seated, bearded sage holding a staff and watching two young goats, as a goose flies off above them with a scroll attached to its leg.
Engraved with a *li-shu* quatrain:
The rams are my companions,
My heart is bound to the Han emperors.
The wild goose takes pity on my loyal purity,
Propagating my epistle over ten thousand li!
The sentiments of the poem seem to be dangerously *i-min* in content, which is rare, and perhaps one reason for the poet to declare his loyalty by signing with a seal: your subject, Feng. The verse echoes a poem by Ts'ai Yen: *On the East Wind the wild geese are uniform, many in the warm vapours; know that this is the Han emperors, notifying of the sun's harmony.* A line of Po Chü-i's is also recalled: *Hear the truth from the Han emperors' messenger.*

Signed Wu-shan, with three seals of the artist: T'ien-chi (square, engraved), ch'en Feng (square, relief) and I-p'ien-yün (rectangular, engraved). The names are not identifiable.
Inset into a wood base.
Probably late seventeenth to mid-eighteenth century.
Height: 5 15/16 inches. Diameter: 4 1/16 inches.

From the H.G. and M.A. Beasley collections.

Low relief ivory brushpots are quite uncommon. For faintly comparable examples see *Chinese Art*, vol. II, fig. 125 and *Chinese Ivories from the Shang to the Qing*, nos. 174 and 175.

99 IVORY BRUSHPOT

An engraved and ink-etched ivory brushpot of particularly fine and strongly-grained material, decorated with a scene of a drunken scholar holding a wine-cup and being supported by a boy attendant bearing the next cup on a tray, as two other attendants wait with a wine ewer and yet another cup. About his study are dotted such wine containers as a vat, a large bowl and a discarded gourd, as well as scholastic paraphernalia; a flower vase on a tall stand, barrel stools and a low table bearing books, a censer and a *ju-i* sceptre in a vase, in addition to more cups.
Deeply engraved above the table is a punning, poetic line: *Clever as a jade tree, imitating the deportment of his forebears.* Jade tree is a metaphor for a handsome or talented young man.

Just below one foot of the table a triangular section has been replaced and engraved, probably originally. As is the case with most such ivory brushpots the thick walls of the rim taper towards the foot.

Height: 4 7/8 inches. Diameter: 3 3/4 inches.

From the H.G. and M.A. Beasley collections, acquired November 1928.

100 CHU HSIAO-CH'UN AND WANG WEN-CHIH IVORY BRUSHPOT (1767)

An engraved and ink-etched ivory brushpot, exploiting and enhancing the natural pale and darker markings of the tusk section to imaginatively use the latter as the bodies of two gnarled pine trees, with branches, needle clusters and textural 'brushstrokes' added.
With two engraved inscriptions:
On passing through Po-p'ing (Shantung), I saw a tall cliff with a pair of white pines; they had an air of strange purity about them, like spirited old men with cap and sword, who'd made their minds up to be nobly treelike; it really was so. I copied their forms while still on horseback and had them carved on this ivory vessel as an instructive reminder to treasure.

Dated to the tenth month of the *ting-hai* year of the Ch'ien-lung period (1767) and signed Chu Hsiao-ch'un.
With two red engraved seals of the carver: Chu-chü (rectangular) and Yü-t'ang (circular and square). These poetic phrases are found as seals on a large number of 'early group' ivory brushpots and other objects; it is interesting to find them here on a dated piece, especially one dated as late as 1767. Some brushpots with these seals are thought to be Ming or seventeenth century; it is possible, of course, that there was a tradition of using these and other names passed down through generations of carvers.

The second engraved inscription reads:
Their trunks are upright and strong, their bearing elegant yet wild;
In your drawing of this clear beauty you have provided pure relaxation.
Signed Wang Wen-chih. Wang Wen-chih (*tzu*: Yü-ch'ing, *hao*: Meng-lou, 1730–1802) was a famous calligrapher and poet. For a rare painting by him see *In Scholars' Taste*, no. 22, and for a fine calligraphic handscroll *Emperor Scholar Artisan Monk*, no. 27. When Wang went to Peking in 1754 he formed life-long friendships with Yao Nai (1732–1815) and Chu Hsiao-ch'un (*tzu*: Tzu-ying, *hao*: Ssu-t'ang, Hai-yü; 1735–1801), a *chü-jen* graduate of 1762 and official, poet and landscape painter. Chu was particularly known for 'poem-paintings' as well as landscapes.

Height: 5 1/4 inches. Diameter: 4 1/8 inches.

From the H.G. and M.A. Beasley collections, acquired December 1927.

101 IVORY FLY WHISK HANDLE

A rare ivory fly whisk handle of slender, waisted form, flaring strongly at the foot and double rimmed at the bulging, domed head. The entire surface of the handle is carved in relief; the head with *ju-i* shaped cloud scrolls, and the remainder with dragons. The narrow band at the top has a relief design of three archaistic *ch'ih* dragons, while the broad band around the foot has the same three dragons, none quite the same as the other. The body of the handle has an extensive, free design of two confronted hairy, single-horned *ch'ih* dragons among waves finely carved in low, rounded relief in the highly polished, pale ivory. The base of the handle is carved in sunken relief with a medallion design of a *ch'ih* dragon surrounded by the devolutions of its own stylised body.

The relief decoration of this example corresponds inescapably with that of comparable small ivory paraphernalia, such as seals, scroll clips, plaques, paperweights and scroll weights, emanating from the palace workshops in the K'ang-hsi period. Several recently recorded objects likewise bear archaistic *ch'ih* dragon designs in highly polished low relief, in stylistically reminiscent carving of comparable quality. This example must have been closely influenced by one of the imperial atelier's

prevailing styles at that time, if indeed it does not itself come from the hand of some anonymous palace craftsman.

Late seventeenth or early eighteenth century.
Height: 4 1/4 inches.

Published: *Ivories of China and the East*, no. 124, described as 18th century.

The fly whisk, like the *ju-i* sceptre, was an indispensable adjunct of the gentleman who, depending upon the season, seems to have bowed to overwhelming peer pressure to demonstrate that he had no need to use his hands to earn a living. Relatively few fine examples have survived into modern collections, but their ubiquitous presence in paintings and narrative decoration on works of art demonstrates how widespread their use was, or was idealized as. There is a strong Buddhistic association connected with the use of the fly whisk, and *lohan* are often seen holding them.

YÜ HSIAO-HSIEN
early 20th century

ming: Shih (alternatively pronounced Shuo).
From Chiang-tu (Yangchou), Kiangsu.

YÜ Hsiao-hsien was a painter and calligrapher, following Wang Su (1794–1877), but he is primarily known as a brilliant miniaturist engraver, especially in ivory. For a fine bamboo 1897 fan frame by Yü from the Dr. Ip Yee collection see *Chinese Bamboo Carving*, part I, no. 204. He was renowned as the most famous carver of the period; other specialist miniaturist professionals such as Wu Nan-yü and Chang Chih-yü were less well known. Yü was best known for small plaques, miniature desk screens, seals and fan-frames. There are also snuff-bottles bearing his name, though they do not appear to be as fine, and most may be copies.

Yü Hsiao-hsien's claim to fame was that it took a microscope to read his calligraphic engraving; this was considered to manifest his divine skill. It was not only in the very late Ch'ing that infinitesimal carving was highly thought of; in the late Ming and K'ang-hsi periods carvers were praised for their ability to carve the entire Red Cliff boating scene in a peach nut, with hinged doors and windows — but technical proficiency was evidently highly rated early in the twentieth century, and Yü carried his miniaturising craft to an extreme of perfection. He was much admired for his ability to carve on an ivory fan-frame only 3/10 ths of an inch wide thirty or forty lines of small *hsing-k'ai* script in characters as fine as flies' heads. One miniature desk screen he made for presentation to the Manchu Viceroy Tuan-fang (1861–1911), only three inches square, had the entire text of Ch'ü Yüan's *Li-sao* (getting into trouble poem) engraved on one side.

There are a very few recorded pieces by Yü bearing Ch'ing dates, but most seem to fall between 1913 and 1935, when according to one inscription he was 63 *sui* — so that he must have been born about 1873. He seems to have been quite prolific.

101 102

102 IVORY DESK SCREEN (1909)

A very finely engraved and ink-etched ivory miniature screen, carved more freely than is usual in Yü's work with a scene of a meditating sage and a fisherman perched, oar in hand, at one end of his punt. The sage seems immutably fixed, apparently growing from the same rocky shore as the wildly waving fronds of foliage which only accentuate his stillness. The broadly grained ivory is engraved with a long poem in minuscule characters, with a barely legible title and dedication, dated to an autumn day of the *chi-yu* year (1909) and signed carved by Yü Shih of Chiang-tu. The attractively marked reverse is left uncarved.

The ivory tablet measures 4 1/8 × 1 3/4 × 1/4 inches. Height with stand: 6 inches.
The reddish blackwood stand is probably contemporary.

226

103 CORAL GLAZED PORCELAIN WATERPOT AND LADLE

A rare porcelain waterpot with a monochrome glaze of coral tone, in the form of tentacle-like coral branches growing around an uneven and indented rock, or larger growth of coral. The design is comparable to that of the prunus trunk and branches, more frequently borrowed for desk objects. Coral is considered a highly auspicious material. The interior lip of the irregular rim is gilded, and the flat, fractionally concave base has five evenly spaced spur marks. The companion branch-form ladle has a coral growth to one side; the undersides of handle and bowl also have spur marks. Both waterpot and spoon are glazed with an orangey coral glaze of appealing depth and tone.

Early to mid-eighteenth century; Yung-cheng to mid Ch'ien-lung period.
Length: 3 1/2 inches. Height: 2 1/4 inches. Length of ladle: 4 1/8 inches.

From the Mme. Melas collection.

A similar coral-glazed waterpot or brushwasher, likewise potted in imitation of coral branches growing around the irregularly shaped vessel, but without its ladle, is illustrated in *Bunku Mandara* as pl. 216.

CH'EN MING-YÜAN
K'ang-hsi period

ming: Yüan.
tzu: Ming-yüan.
hao: Ho-feng, Ho-ts'un, Hu-yin, Shih-hsia shan-jen.

THE finest and most famous of I-hsing potters in the Ch'ing dynasty, and second only to Shih Ta-pin of the Ming, Ch'en Ming-yüan is also one of the most copied. He was reputed to have been the son of Ch'en Tzu-hsi, a fine potter known for fruit and animal form objects and naturalistic teapots after the style of the Ming potter Hsü Yu-ch'üan. Ming-yüan also made highly inventive teapots derived from natural forms, but he is best known for his desk objects, particularly those imitating fruit and plant forms, as well as those copying ancient bronze shapes. Well-known literati vied with each other to act as host to Ch'en in his wide travels, such as Yang Chung-na (1649–1719), for whom Ch'en made a teapot dated 1687. Another dated teapot, corresponding very probably to 1702, is illustrated in *I-hsing Ware* as no. 10. A third dated teapot is thought to have been potted in 1727, thought it may perhaps correspond to 1667.

Many of Ch'en's works are illustrated in *I-hsing Ware* (nos. 8–10, 28–31 and 37–42) and *Yixing Pottery* (nos. 27–34); having examined them, we consider no. 9 in the former (also illustrated in *Bones of Jade, Soul of Ice*) and no. 34 in the latter to be highly dubious. We offered a fine *trompe l'oeil* tray of nuts by Ch'en in *In Scholars' Taste* as no. 87 (now in the Victoria and Albert Museum) and a small bronze-form brushwasher in *Emperor Scholar Artisan Monk*, as no. 68.

104 I-HSING STONEWARE LOTUS WATERPOT

A very fine I-hsing stoneware waterpot modelled in clays of contrasting tones as a large concave lotus petal of beige colour splashed with russet colouring and of teardrop shape, the thin walls of its delicately undulating form with lightly incised veining. A realistically modelled olive-brown seed pod and stem form the curling handle, resting on a cut section of lotus root (rhizome) modelled from yellowish-beige clay and acting as one of the vessel's supports, its two nodal stems curl around the underside. Towards the front of the petal a tiny brown snail shell forms the other support.

Between lotus root and snail shell is impressed the square relief *chuan* seal: Ch'en Ming-yüan chih (made).
K'ang-hsi period, circa 1700.
Length: 5 1/2 inches. Height: 1 1/2 inches.
With a fine blackwood stand carved in openwork with a hydra dragon crawling among lotus.

Published: *Yixing Pottery*, no. 32.

The example from the I.M. Pei collection, illustrated in *I-hsing Ware* as no. 37, is virtually identical. A further comparable piece by Ch'en was illustrated and discussed by Helen Comstock, "Some Examples of I-Hsing Pottery", *Connoisseur Magazine*, vol. CIX, March 1942, p. 75.

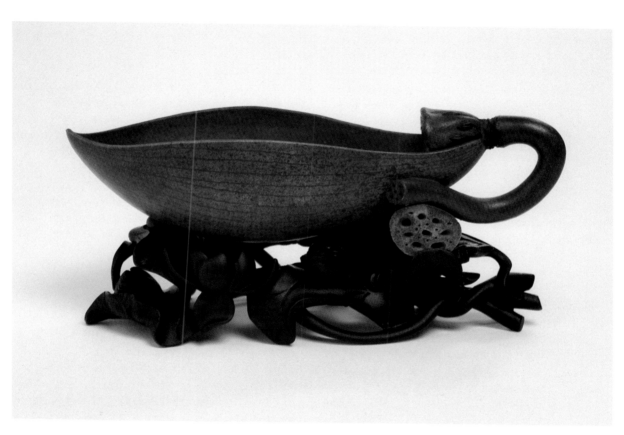

CH'EN HAN-WEN

18th century

CH'EN Han-wen is the most important individual I-hsing potter not recorded in *Yang-hsien sha-hu t'u-kao*, the most comprehensive work on the subject, but there is a considerable amount of empirical evidence to testify to the range and quality of his work. The catalogue of the Sotheby Hong Kong auction, *I-hsing Wares*, 24th May, 1978, describes Ch'en as active during the Yung-cheng period, imitating ancient forms and animals in his works. The important documentary bronze form casket and cover offered there (lot 323) was datable to the eighteenth century before 1745. We have owned a teapot by Ch'en (now in the Ashmolean Museum, Oxford) decorated in relief slip with variant Shou characters and, most unusually for I-hsing teapots, bearing the imperial reign mark of the Ch'ien-lung emperor. A comparable teapot by Ch'en in the Freer Gallery of Art is illustrated in *Yixing Pottery* as pl. 9. Consequently Ch'en Han-wen must have been active after 1736 and before 1745, however far his working life extended either side of those dates.

The variety of his products is demonstrated by a few other known objects. In addition to the bronze form casket, there is, in the author's own collection, a rare rectangular box and cover by Ch'en, in imitation of a wood box with relief archaistic dragons derived from bronze decoration, tied with a 'textile' sash — all in I-hsing stoneware; a feast of eighteenth-century cross-media gimmickry. Next to it in the collection is exactly the same box in wood, imitation sash and all, though naturally without the seal of Ch'en Han-wen.

Ch'en's animal form works are exemplified by a fine, small duck form waterpot sold at Sotheby's, New York, November 5th, 1977, lot 196, and now in the K.S. Lo collection, Hong Kong. In addition to these quite distinctly different forms there is the rather self-consciously humorous 'naturalism' of the prawn and lotus brushwasher offered here. Ch'en was obviously influenced by the work of the slightly earlier Ch'en Ming-yüan, and may well have been a family member. The personal name Han-wen might possibly be the unrecorded art name of one of the many potters named Ch'en listed as active around that period.

105 I-HSING STONEWARE CRAYFISH AND LOTUS LEAF BRUSHWASHER

Finely modelled in buff, granular clay of pearskin texture (with old, pale chippings mixed into the wet clay), the vessel acts as a container by virtue of its raised, irregular rim. The stem and the bell-shaped, veined, central part of the leaf fold over to form a natural cave, partially obscuring the crayfish which with prominent eyes and extended feelers and pincers rests on the bottom of the leaf. When water is poured into the brushwasher the crustacean seems to half-emerge from it, peering upwards amusingly.

The flat base bears the impressed square seal: Ch'en Han-wen.
Early to mid-eighteenth century.
Length: 5 11/16 inches. Depth: 4 9/16 inches. Height: 1 inch.

From the Edwin Miller collection, London.

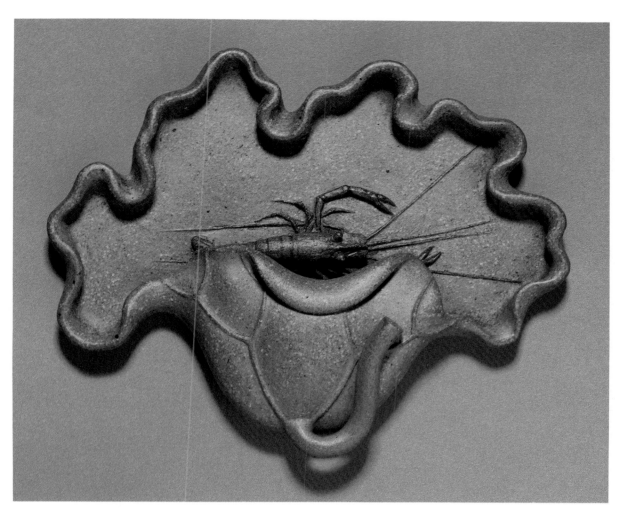

HUI I-kung was a descendant of the well-known potter Hui Meng-ch'en, active in the late Ming Transitional period (see no. 107). Apparently I-kung was the only one of Meng-ch'en's descendants able enough to resist the wholesale family workshop imitations of small, polished teapots whose type Meng-ch'en originated and which became known by the generic term 'Meng-ch'en hu'. According to *Yang-hsien sha-hu t'u-kao* Hui I-kung was active in the Yung-cheng and early Ch'ien-lung periods, making both large and small teapots. It lists two large teapots by him in one collection, but nowadays the pieces one sees bearing his signature seem to be small teapots, though not necessarily in the Meng-ch'en tradition of rounded and often highly polished examples. It also records a small teapot by I-kung incised with the cyclical date *ting-wei*, which according to Li and Chang corresponds to 1727.

Yixing Pottery illustrates a small buff teapot, unlike the usual run of Hui family works, bearing the incised mark *I-kung chien chih* [made under the supervision of (Hui) I-kung] the catalogue dates it as mid-eighteenth century. This seems to indicate that I-kung was prominent enough in the Hui family pecking order to share equal billing at least at the time with Hui Meng-ch'en, though never to displace him; there are several small 'Meng-ch'en' teapots dated 1724, around the time when I-kung was working. Later family productions and quite possibly copies evoking the family name and style were made into the twentieth century bearing I-kung's name, but never in the quantities of those inscribed Meng-ch'en.

Hui I-kung's small teapots, both credibly genuine examples and later undistinguished copies, often bear a short poetic line underneath, finely written with a bamboo knife in a crisp, flowing *hsing* hand (although apparently he was capable of inscriptions in *li*, *k'ai*, *hsing* and *ts'ao* scripts), followed by the two-character signature I-kung. A fine, squat, red-brown miniature teapot in the G.C. Hawthorn collection (no. 24) corresponds to this description, and another fine but damaged teapot from the Max Robertson collection (no. Y 56) actually bears the same short line as the example offered here. Both are probably genuine and acceptable as dating from the early eighteenth century.

106 SMALL I-HSING TEAPOT

A crisply potted small, six-sided I-hsing teapot, the bulging pear-shaped construction constrained by its vertical planes; the low, slightly loose-fitting lid and its knop follow the same six-sided configuration. The finely potted spout, of gentle S-shape, likewise has six sides, but the interior of the handle is flattened for the sake of convenient pouring, so that it has only five sides, equally crisply formed. The spout has one large hole inside for the passage of tea, and the knop has a small hole to permit the escape of steam. The tip of the spout is cut off flat at such a point that lid sits perfectly horizontally on rim and spout, and the surface of the teapot bears an attractive patination.

Inside the sunken foot is a five-character poetic line, crisply incised in *hsing-shu*: *p'ien hsin hsien tui hua* [a piece (flake) of the heart (mind, or in the centre), leisurely facing the flowers] a reference to the tea.
Signed I-kung.
Early eighteenth century.
Height: 2 11/16 inches. Length: 4 5/8 inches.

From the Max Robertson collection, no. Y 90.

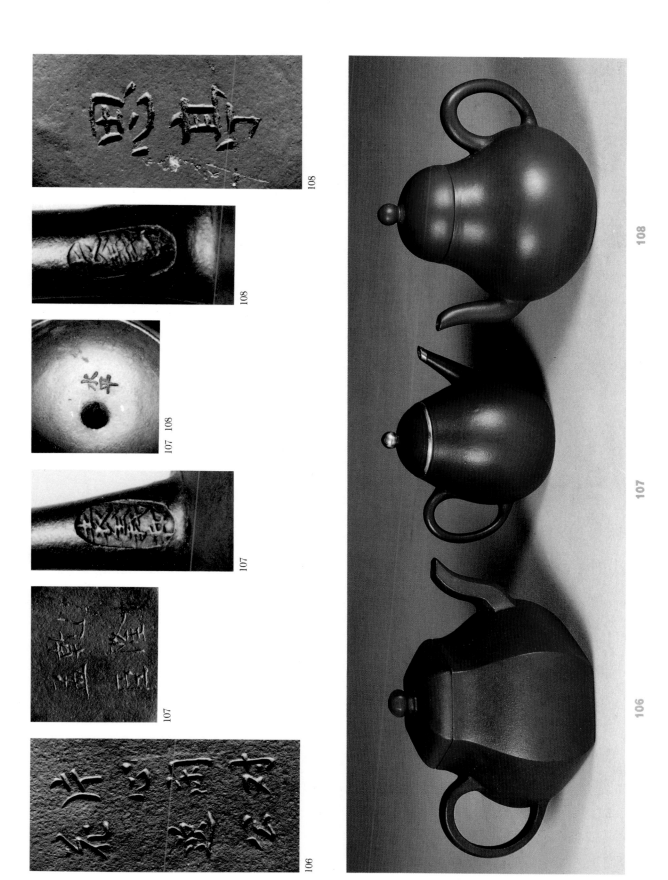

108

108

107 108

107

106

108

107

106

18th century

NOT a previously recorded potter, Yüan I-ho must have been one of the better workshop potters producing small, polished teapots for the Hui family in the mid or late eighteenth century, bearing the 'Meng-ch'en' signature or seal. Quite a number of fine, small, polished teapots of pear shape are known, occasionally dated to the Yung-cheng period but obviously by the hand of followers, since Hui Meng-ch'en is recorded as working in the T'ien-ch'i and Ch'ung-chen periods of late Ming. Meng-ch'en gave his name to a genre of small teapots (see *I-hsing Ware*, no. 5, for a small, unusual Meng-ch'en teapot in the Newark Museum, attributed to the master) made throughout the Ch'ing dynasty and into the twentieth century by workshop followers. Usually, where these bear any indication at all of an individual potter's hand it is a two-character stamped seal inside the lid or under the base of the handle.

The 1724 teapot, of which there are quite a number of variant examples, is illustrated again in *Yixing Pottery*, as no. 35, with examples of other small Meng-ch'en types as nos. 37 and 38. These small, polished teapots often had gold or gilt mounts to the rims, knop and tip of spout. Bartholomew (*I-hsing Ware*, p. 28) argues that these were teapots exported to Thailand and that the metal mounts were fitted in Bangkok. However, while this may have been the case in several instances (the vast majority of metal-fitted teapots the author saw in Thailand were highly polished purple-clay examples, not as small as most Meng-ch'en teapots) it seems extremely unlikely that the majority of such teapots were exported at all, unless they were imported back again. Most available teapots in recent years have come onto the Hong Kong market out of China, and it does not seem unreasonable to suppose that I-hsing, or some other nearby centre, could not have managed to support its own metal-mounting workshop for the production of such fittings at source. The confusion may have arisen, apart from the fact that there were undoubtedly teapots which were mounted in Thailand, by the fact that some metal-mounted polished teapots, mostly of the larger type, bear the incised inscription *kung-chü* (tribute bureau), suggesting that they might be of an export or tribute type. They may well have been, but examples of this type too continue to come out of China, and 'tribute teapots' seem to have become just another generic type, for which there was a local market in the same way as *Meng-ch'en hu*.

107 SMALL GILT-MOUNTED I-HSING TEAPOT

A small, very delicately potted I-hsing teapot of matt, slightly pimply red-brown stoneware and beautiful ovoid pear shape, with a smooth loop handle and a straight, 'bullet-shaped' spout. The lid has a long interior locating rim, and there is one large hole for the passage of tea, as well as a small hole in the knop, capped by its metal mount. The finely shaped gilt (or gold) mounts to the spout tip, knop and lid rim may well have originally had the companion mount to the body rim, now lost, as well. With the body rim the lid would perhaps have sat perfectly horizontally, balancing on the rim and the spout, as suggested by the two characters stamped (or incised?) inside the lid, *shui-p'ing* (water level).

Inside the sunken foot is the engraved four-character mark: *Ch'ien-lung Meng-ch'en* (a Meng-ch'en teapot of the Ch'ien-lung period). On the base of the handle is the impressed oval seal Yüan I-ho, the name of the potter.
Ch'ien-lung period (1736–1795).
Height: 2 3/8 inches. Length: 3 3/16 inches.

From the Virginia Atchley collection, Los Angeles.

WU HSIU
1764–1827

tzu: Tzu-hsiu, Tzu-ssu
hao: Ssu-t'ing (chü-shih), Yün-nu, Yün-ko.
hall name: Ch'ing-hsia kuan.
From Hai-ning, Chekiang; lived in Chia-hsing, Chekiang.

WU Hsiu was a scholar with a strong interest in the arts, known as a connoisseur of antiquities. He was a landscape painter, though his works are rare, and a portraitist. He collected examples of famous calligraphers' works, and engraved several works including one dealing with paintings, published under his hall name in 1824. He was a pupil of Ch'ien Ta-hsin (who carved bamboo, amid his scholastic endeavours: see *In Scholars' Taste*, no. 48) and in 1813 supplemented Ch'ien's incomplete *I-nien lu* (Record of uncertain dates) which was published by Yao Nai in 1818.

Wu is not recorded as an I-hsing potter, but given his interest in antiquity and in engraving it seems likely that the very few teapots signed with his art name might be by his hand, assuming that he was active around the period when Ch'en Man-sheng attracted scholars, artists and antiquarians into the field of potting and inscribing I-hsing teapots. A comparable small pear-shaped red-brown teapot signed Ssu-t'ing, its knop and lid rim metal-bound, is in the G.C. Hawthorn collection, no. 64.

108 SMALL I-HSING TEAPOT

An attractive orangey brick-red small I-hsing stoneware teapot of pear shape with domed lid and smooth, matt texture. The simple loop handle and slightly S-shaped spout are well-potted, of the same height as the rim of the body. The lid has a long locating inner rim, and on its interior the stamped mark *shui-p'ing* (water level). There is one large hole for the spout inside, another small one in the knop for the passage of steam. A very slight ridging around the rims of body and lid suggests that the teapot may have had, or been intended to have, metal mounts; a further indication is that the lid does not sit perfectly horizontal on the body rim and spout. These suspicions are not conclusive, however, and there is no change in surface patination or texture to confirm that the teapot was mounted like the Hawthorn collection example.

In the centre of the sunken foot is deeply incised the signature Ssu-t'ing, in attractive *hsing-k'ai* script. On the base of the handle is the impressed oval seal: Yüan I-ho, for the potter. See no. 107 for a *Meng-ch'en hu* by this potter.
If Ssu-t'ing is in fact a reference to the scholar Wu Hsiu it seems to indicate that Yüan I-ho's period of activity extended from probably the mid-to-late Ch'ien-lung period through the Chia-ch'ing period, perhaps to early Tao-kuang. If Ssu-t'ing is merely a poetic reference (pavilion of thoughts) or the art name of some unrecorded inscriber then Yüan may have potted at any time in the Ch'ien-lung period. The former scenario seems plausible; two-character poetic references were not at all common on teapots as short poetic lines were preferred. In which case a chronology might be that, as with other potters, Yüan potted as a mere workshop craftsman until Ch'en Man-sheng patronised the I-hsing industry with demands for finer, hand-crafted pots for scholars to inscribe, at which point Yüan may have been able to perform commissions for aesthetes such as Wu Hsiu.
Eighteenth or early nineteenth century.
Height: 3 inches. Length: 3 7/8 inches.

From the Max Robertson collection, no. Y 91.

109 K'E-SHEN I-HSING TEACUP

A fine and quite rare flecked buff I-hsing stoneware teacup of flared form on a low foot, the exterior decorated between bands of scrolling cloud-forms with six stylised relief hydra dragons, details of their eyes and bodies engraved within the raised outlines. The crisply modelled handle, with a strap *ju-i* head at its top, lends the cup an air of archaistic design, and there are finely incised lines at rim and foot. The plain surfaces inside and out are smooth, matt and finely finished.

In the centre of the smooth, concave foot is impressed the circular relief *chuan-shu* seal K'e-shen (alternatively K'o or ch'en). The name is not recorded.
Seals of this stylised circular *chuan* type are found on eighteenth-century teapots and other objects, generally thought to have been made early in the century.
Eighteenth century.
Height: 1 1/4 inches. Length: 3 inches.

YÜ YÜN-WEI

Tao-kuang period

YÜ Yün-wei was an I-hsing potter not recorded in *Yang-hsien sha-hu t'u-kao*. However, *I-hsing Ware* illustrates two teacups by him in the Art Institute of Chicago, one square and one footed, hexagonal example, as nos. 55 and 56, and other teacups by him are known. He seems to have been one of the leading teacup makers in the early nineteenth century, and contemporary sources do not record any other type of work by his hand. However, P'ang Yüan-chi, the great early twentieth-century Shanghai collector, recorded a teapot by Yü after the style of Ch'en Man-sheng, dated 1822, which helps to date his other wares to before or after the early Tao-kuang period.

110 PAIR OF I-HSING TEACUPS

A complementary pair (near or 'Chinese' pair) of purple-clay I-hsing stoneware circular teacups, both on a low foot with an impressed keyfret band at the rim and a five-character poetic line above a relief rope-twist around the body. In one case the impressed band design is of *lei-wen*, and the handle is of fairly plain form with a hint of *ju-i* fungus decoration; the other cup's band is of S-scrolls over dots, while the handle is of more complex mythical beast form with relief details.
The poetic lines read: *The fragrant breeze entertains* (or detains) *a beauty* and *Rising in the middle of one cup*.

In the centre of each sunken foot is the relief square seal: Yün-wei.
Early nineteenth century.
Height: 1 1/4 inches. Length; 2 9/16 inches.

From the Max Robertson collection, no. Y 16.

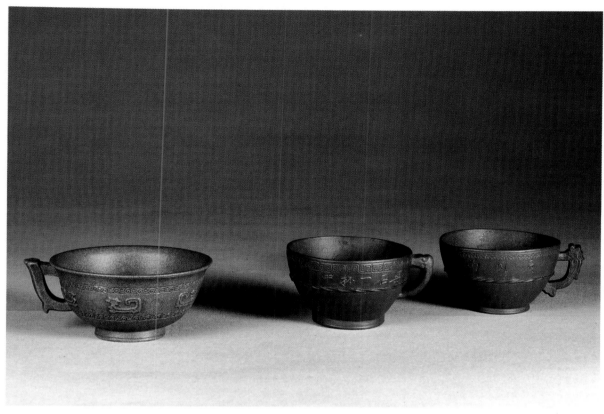

109

110

109

110

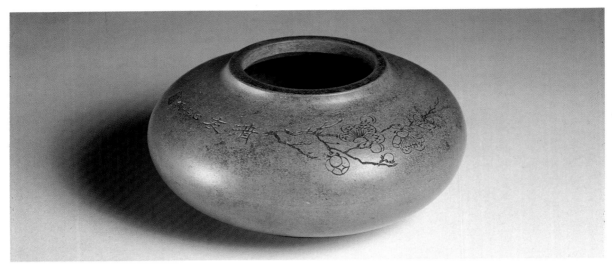

HO HSIN-CHOU other name: Shih-lin.

early 19th century

HO Hsin-chou is another fine I-hsing potter not recorded in *Yang-hsien sha-hu t'u-kao*. However, *Yixing Pottery* illustrates two small works by him, as nos. 63 and 64, both of the same smooth, buff stoneware and both demonstrating his interest in archaic scripts derived from bronze and stone inscriptions. This decorative content identifies him as a scholastic amateur and helps to place his period of activity in the nineteenth century. No. 63, a waterpot not unlike the example offered here, pictured with a small ladle, bears a cyclical date of winter in the *wu-tzu* year, catalogued as 1828, which seems likely to be accurate. According to the catalogue's introduction by K.S. Lo, Ho was one of the few potters in the early nineteenth century who attempted original work in the area of desk objects, rather than teapots. His name also appears on a number of teacups.

111 **I-HSING STONEWARE PRUNUS WATERPOT**

A small, squat, circular waterpot of polished, buff, high-fired I-hsing pottery, with a low, flattened, raised rim and correspondingly subtle foot. On the shoulder is delicately engraved a branch of blossoming prunus flowers and buds, with the title: *Ch'ing-yu* (pure friend), and the signature Hsin-chou tso (made) and the small, square, sunken relief seal: Hsin-chou. The recessed base also bears a larger impressed square seal: Hsin-chou.

Early nineteenth century, probably Tao-kuang period.
Height: 1 5/8 inches. Diameter: 3 5/16 inches.

This example, comparable to both pieces published in *Yixing Pottery*, appears to be more pleasing than either.

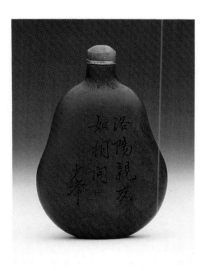

TS'AI HSI-KUNG

early 19th century

tzu: Shao-feng.

From Shih-men (Ch'ung-te), Chekiang. (*Yang-hsien sha-hu t'u-kao*) has his birthplace as Wu-men, but this is a misprint).

TS'AI Hsi-kung, nephew of Ts'ai Tsai-fu and brother of Ts'ai Hsi-lin, came from a highly respected Shih-men family and was as profoundly talented in his study of bronze and stone inscriptions as his relatives. He also had a considerable reputation as an artist.

As an I-hsing potter, Ts'ai is recorded in *Yang-hsien sha-hu t'u-kao* as one of the gentleman-potters of the early nineteenth century, between Kuo Lin (see no. 37) and Chu Chien (see no. 151). Li and Chang relate that he had in his own collection a Shih Ta-pin teapot, made for the Ming scholar Ma Yüan-tiao of Hua-t'ing. They also describe a teapot with a beautifully incised poem by Ts'ai, with the two-character seal Shao-feng, potted by Yang P'eng-nien (the best potter of the early nineteenth century, and Ch'en Man-sheng's favourite; see *In Scholars' Taste*, no. 90). They also describe two other teapots, one potted for Ts'ai and another inscribed by him and potted by Yang P'eng-nien.

Yixing Pottery illustrates as no. 69 a squat cylindrical teapot with the seal Shao-feng, pleasantly potted but with the most unfortunate blue enamel flowers; quite possibly conceived from start to finish by Ts'ai, in a short-lived experimental mood. *I-hsing tzu-sha* illustrates as pl. 74 a fine 'stone well railing' waterpot inscribed by Shao-feng.

112 I-HSING STONEWARE SNUFF-BOTTLE

A rare I-hsing snuff-bottle of smooth, matt brown surface and irregular, bulging form of flattened double-gourd shape, incised on the front with a poetic line in *hsing-shu*: *Do you have friends and relatives in Lo-yang? You seem to ask*. Lo-yang was the name for Honan-fu, the ancient capital of Eastern Han.

Signed Shao-feng.
Beginning of the nineteenth century, probably Chia-ch'ing period.
Height without stopper: 2 9/16 inches.
With a green jade stopper and ivory spoon.

No other snuff-bottle by Ts'ai appears to be recorded.

CHOU HUNG-LAI

active circa
1880–1930

hao: Yen-pin (chü-shih).
From Nanking; worked in Lin-an, Chekiang.

CHOU Hung-lai was one of the few individual craftsmen to specialise in decorating snuff-bottles, other than the interior painting specialists. He was a fine engraver of landscapes and figures, birds and flowers and calligraphy on glass and occasionally porcelain snuff-bottles. He was active around the time of greatest popularity of extreme miniaturisation epitomised by Yü Hsiao-hsien (see no. 102). On occasion Chou too would engrave minute calligraphy; see for example *Important Chinese Snuff Bottles from the Mei Ling Collection*, Sotheby's New York, March 15, 1984, lot 67, where he engraved one hundred and ninety two characters on the reverse of a small bottle. Mostly, Chou used milk-white glass snuff-bottles, but some of his better work is found on glass bottles of different colours, notably yellow and, occasionally, blue. His engraving on porcelain is not generally as well executed, and he is not known to have engraved on objects other than snuff-bottles. His art name Yen-pin has previously been mistranslated as Hung-pin.

A bird on branch milk glass bottle is illustrated in *Chinese Snuff Bottles*, Hong Kong 1977, as no. 49. Another, dated 1904, was illustrated in *Snuff Bottles of the Ch'ing Dynasty* (Hong Kong 1978, no. 245) and an example dated 1909, illustrated as no. 244, bore the information that the bottle was made in Lin-an, Chekiang; by Yen-pin, Chou Hung-lai of Pai-men (Nanking). A porcelain example dated 1909 was illustrated in *Guide du Collectionneur de Tabatieres Chinoises* (Paris 1980, p. 95, no. 1).

113 MILK GLASS SNUFF-BOTTLE (1904)

A squat milk glass snuff-bottle of rounded square form on a delicate oval, low foot, carved in relief with lion mask imitation ring handles, and engraved on the front with a scholar reading a letter or a poem on a slope overhung by a wintry tree.

Dedicated on the front as the refined plaything of the master of the I-hsiang yin-kuan (not recorded) and signed Yen-pin tso (made) with relief seal: Chou.
The reverse is engraved with a long text and is dated to the twelfth month of the *kuei-mao* year (January 1903).
Signed by Yen-pin of Pai-men (Nanking), in Lin-an (Hangchou) with incised seal: Chou (sqaure, intaglio).
Height without stopper: 1 13/16 inches.
The bottle is very well hollowed, with translucent honey-coloured agate stopper and ivory spoon.

114 BLUE GLASS SNUFF-BOTTLE (1901)

A tall, slender ovoid glass snuff-bottle of attractive pale milky blue tone, delicately engraved on the front with a scholar seated on a rocky plateau, his *ku-ch'in* across his knees, contemplating the wintry tree growing from rocks across the steep ravine.

The reverse is engraved with a long text containing selected quotations from K'ung Chih-kuei's *Pei-shan-i wen* (Essay on the removal of North Hill).
Dedicated to Mr. Chih-kuei (not recorded) and dated to a winter day of the *hsin-ch'ou* year of the Kuang-hsü period (1901), and signed Yen-pin chü-shih tso (made), with incised seal: Chou (rectangular, intaglio).
Height without stopper: 2 3/4 inches.
With a coral stopper and ivory spoon.

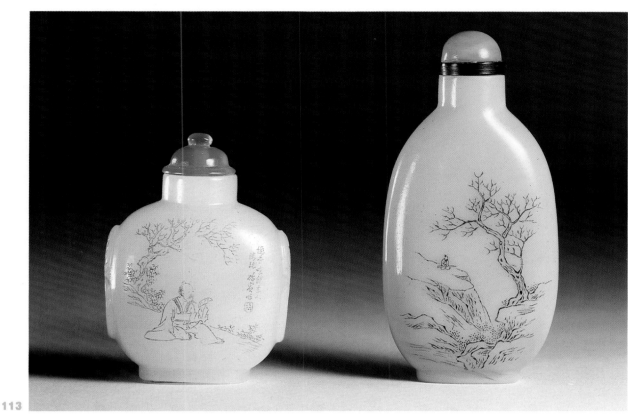

113

114

山之五君有山川名水之玉樹
有莫劉席匾斯于主庶匿怪玉
德蔵寺呂之根上曾捜躺之意人
薄言諸失有敢薄崖美絫
白丁可知蘭喜攀園崇絲絲
南陽諸萬澄西萬子雷事
孔子云何陋之有時癸卯冬十
二月録劃禹錫陋室銘一
章白門碫寶到於隙石圖

鍾山之英草堂之靈馺煙驛路勒
移山庭夫以耿介拔俗之摽蒲瀝出
塵之想度白雪以方潔干青雲而直
上吾方知言之采茱享之物表峻
霞升茶干蕓而石眤屈羨乘其如脫
問鳳吹於滄浦鐘蕀歌於延瀨圖六
有鴦餝録於孔稚珪先生北山移文時
玉光緒辛丑冬日碫寶屈士作圖

241

A very rare pure crystal small brushpot (*pi-t'ung*) carved from a large solid piece, of cylindrical tumbler form with thick walls and a sunken foot. The crystal is extremely pure and the polishing very fine; apart from its weight and refraction there are hardly any indications that it is other than particularly flawless glass.

Left in relief on a stippled ground in the centre of the sunken base is the square *k'ai-shu* seal mark: *Ch'ien-lung yü-yung* (for the personal use of the Ch'ien-lung emperor).
Eighteenth century, Ch'ien-lung period.
Height: 3 1/4 inches. Diameter: 2 3/8 inches.

From the collection of the late K.R. Malcolm, England.

There is a very small group of crystal objects, presumably made in the Ch'ien-lung imperial ateliers, which bear the same mark on the same stippled ground. A Hong Kong collection has two other simple cylindrical desk objects, one a miniature brushpot even smaller than this example and the other a tall cylinder of two or three possible uses.

A few fine, simple jade objects emanating from the palace workshops bear the same mark, though usually in a more stylised script and without the stippled ground which is relatively easy to produce in crystal. See for example *In Scholars' Taste*, no. 121, where we offered a rare two-tone jade bowl made for the emperor and discussed other examples. A feature of such jade vessels is the purity and fine marking of the stone. See also *Chinese Jades from Han to Ch'ing*, no. 147, where Watt discusses a white jade cup and stand which bear *yü-yung* marks of the Ch'ien-lung, Chia-ch'ing and Tao-kuang reigns (although the latter may be in doubt). Obviously the formula "for the use of the emperor" did not necessarily mean that the object was made in his reign; it might plausibly be engraved upon an archaic object treasured by the emperor, although none is recorded. Where an object was passed down from one imperial generation to the next it might bear the personal use endorsement of any number of emperors. There are, however, relatively few known objects which bear these marks, and for the most part it seems likely that the piece was made by the palace ateliers in the reign period marked on it; specifically made for the emperor's own use.

116 JADE PI-HSIEH CHIMERA

A superbly carved crouching mythical animal of highly polished grey-white mottled and flecked stone, with black inclusions at the nose and bifid tail, partly at least enhanced by staining, with minor additional black staining to three or four surface details. The model of the two-horned animal is clearly derived from Six Dynasties originals, but in this case their powerful, rangy sprawl, somewhat softened yet retaining some fierceness, is made more compact, and the treatment of the details is far more sophisticated. Virtually every deeply incised line has a smooth, rounded, low relief lip alongside to further delineate it; around the line of the eyes and nose, the curling end of the horns, or the end of the skin at the claws. His spine is an unctuously knobbed, curling ridge, and the ribs on the outer curve of his body are strongly and smoothly moulded. The curling spirals on his body (flames issuing from his groin and armpits, sometimes explained as remnants of wings from Persian origins) are carved in relief and grooved concave within the same smooth, lipped ridges as other engraved features. Details of his beard, jowl whiskers and hair to the underside of the legs are finely incised, and the bifid, rope-twist tail presses onto both back legs. The pads on the undersides of the feet are relief concave circles.

In addition to the development of naturalism in animal representation in Sung dynasty jade carving there was an enormous interest in antiquarian models. As Brian McElney observes in his essay "In Search of Song Jades", in *Chinese Jade Carving*, pp. 34–38; this was influenced "by the production of several printed catalogues of antique objects produced in the late 11th century and succeeding periods. These publications appeared to have stimulated great interest in reproducing copies of earlier objects and jade forms such as chimeras in the Six Dynasties sculptural style were produced at this time." This development continued into the Southern Sung, Yüan and early Ming dynasties (as can be seen in the carving of such chimera as nos. 117, 118, 119 and 120). In this case, though, the level of finesse involved and also the literal interpretation of features derived from a specific Six Dynasties model strongly suggest a Southern Sung or Yüan date. The tensile, curled posture, with legs poised in staggered positions, is a noticeable feature of a few chimera of the fourth to sixth centuries; compare for example the contours of the above and below photos of *Dr. Newton's Zoo* (Bluett & Sons Ltd.), no. 12, or the rather broad chimera of the same date in *Twenty five years* (Eskenazi Ltd.), no. 18 (also in *Chinese Jade throughout the ages*, no. 186).

Southern Sung or Yüan dynasty, late eleventh to early fourteenth centuries.
Length: 2 7/16 inches. Height: 1 1/4 inches.

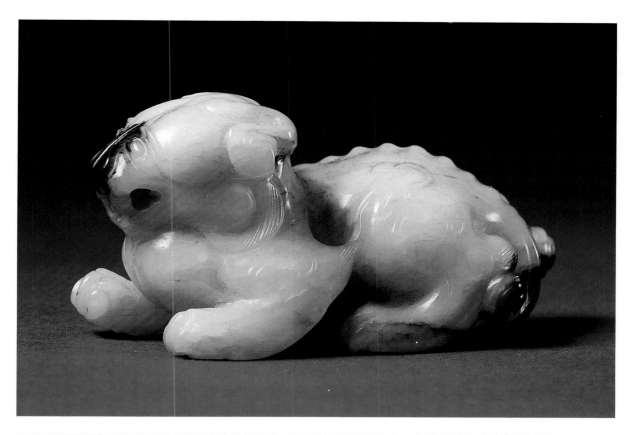

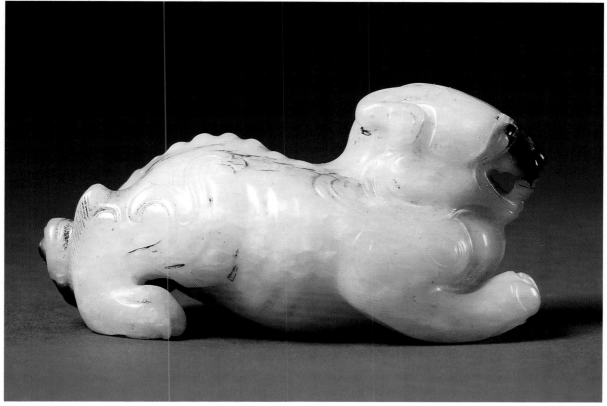

117 JADE PI-HSIEH CHIMERA

A small, crouching mythical animal with a single horn (sometimes referred to as a *t'ien-lu*; but chimera with one horn or two may be termed *pi-hsieh*), well carved in pale celadon-grey opaque stone with some interior flecking visible, and patchy russet markings. Such details as claws, nose, eyebrows, horn and backbone are attractively carved in smooth, rounded relief, as are the coiling flames which issue from his groin and armpits, carved with a strongly articulated V-shaped line which has burial traces of red earth adhering in places. The bushy triune tail has well engraved hairwork.

This chimera is equally obviously derived from Han or Six Dynasties originals, such as the example illustrated on the cover of *Chinese Jades from Han to Ch'ing* (catalogue no. 11), but at more of a distance. It is disproportionately bottom-heavy rather than alert, with a rounded rump, and though it is finely carved, the conception and quality of stone and perhaps the bulging eye pupils suggest a date in the Yüan to early Ming dynasties rather than the Sung.

Thirteenth to fifteenth centuries.
Length: 2 1/4 inches. Height: 1 5/16 inches.

118 JADE PI-HSIEH CHIMERA

A recumbent mythical animal with a single horn, its head turned back along its body to snarl, very finely carved in attractive yellow stone with striking red-brown russet inclusions and an internal grey-brown marking. Such details as claws, nose, mouth, eyebrows, ears, horn and backbone are unctuously carved in smooth, rounded relief with lipped edges; his coiling flame folds are carved with a short, stylised V-shaped line with similar rounded edges. The underside is carved flat, though with finely incised details of his bushy, forked tail. The pads of the feet are simply indicated by a short, deep line of crescent moon shape. Each leg is positioned differently; the two rear legs splay out on either side of the flattened body, one lifted with its claws resting on a front paw. The two front paws are hunched under the beast's head, one turned sideways.

This animal, its squat form dictated by the shape of the pebble, is very much in the Sung taste for a compact, rounded and more domestic pose, with fine and unctuously carved details in the pleasing yellow material. It has its origins in Han models.

Its beauty has been marred by the later addition of pierced suspension holes through the mouth.
Sung to early Ming dynasties, probably eleventh to fourteenth century.
Length: 2 1/16 inches. Height: 7/8 inch.

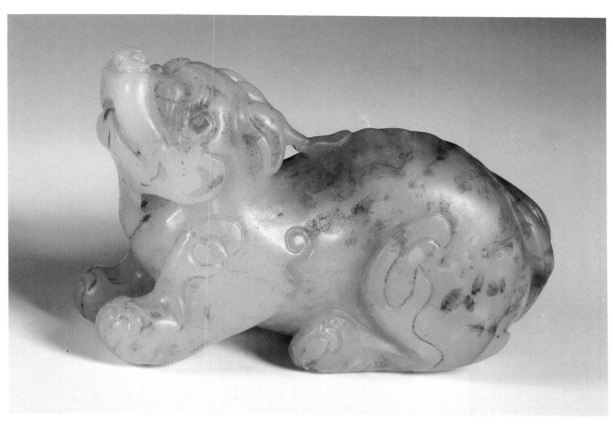

117

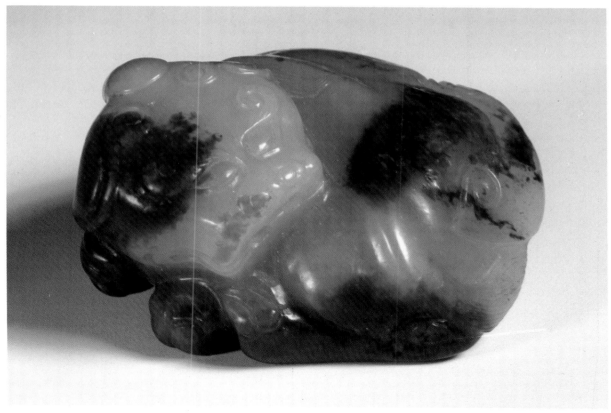

118

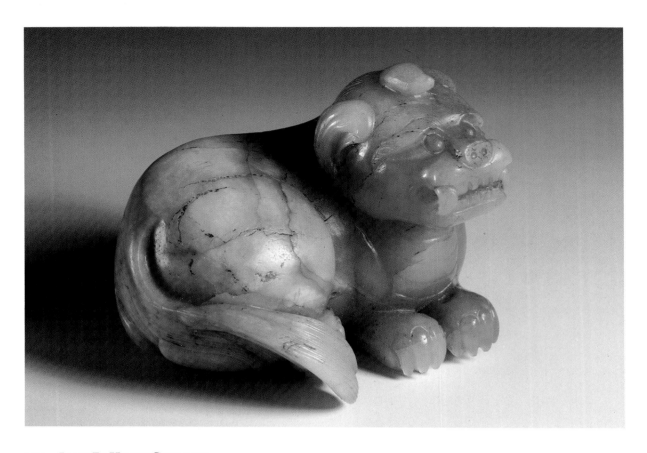

119 JADE PI-HSIEH CHIMERA

A large, powerful, single-horned mythical animal, reclining but alert and twitching his bushy tail. The figure is well conceived and carved in grey-celadon stone with white flecking, russet rivering and skin. The watchful, snarling beast rests his ribbed breast on his two foursquare front paws; an early design feature. However, the smooth carving of the rest of his body surface and the fine, low relief engraved hairwork to eyebrows, mane, armpit and tail oblige a post-Sung dating, as does the feature of one turned-over rear leg. The magnificent switch of the three-pronged, bushy tail, though, suggests that the animal is much earlier than the majority of late Ming jade animals of comparable size, and a likely date for its carving is early in the Ming dynasty.

Thirteenth to fifteenth centuries.
Length: 2 1/2 inches. Height: 2 1/8 inches. Depth: 2 1/4 inches.

From the Malcolm Barnett collection, Hong Kong.

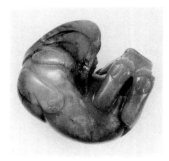

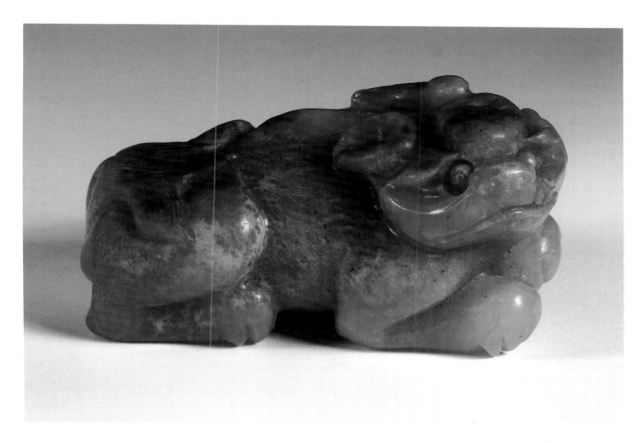

120 JADE PI-HSIEH CHIMERA

The single-horned reclining beast is carved from a jade pebble of celadon-grey tone, with the russet inclusions of the skin used to highlight features of the beast's head, back and tail. With ridged lip, deep-cut bulging eyes and large, grooved ears and eyebrows, his type with head raised and back legs spread is considerably devolved from its Han and Six Dynasties forebears. The hairs of his relief, three-pronged tail are engraved, as are his whiskers and details of his furry spinal ridge. With paws extended in front of him, one slightly raised above the other, both stone and chimera have character and some charm; despite his lack of sophisticated carving the animal has considerable power, derived from the conception (probably imposed by the shape of the pebble) of his flattened, squat rear quarters growing into the strong shoulders and large head at the fore.

Mid-to-late Ming dynasty, fifteenth to seventeenth centuries.
Length: 2 3/8 inches. Height: 1 1/16 inches.

From the Lee Younggren collection, Manhattan Beach.

For an animal with comparable features see *Chinese Jade Carving*, no. 161.

121 JADE BEAR AND EAGLE

A very fine jade carving after Han and T'ang originals of a parrot-like eagle gripping the flank and pecking at the head of a chubby, dog-like bear, which rears to turn and shake off its attacker. The stone is of a flecked celadon-grey tone on the front of the bear's body and on its tail; darkening to a deep red-brown on its reverse, and on one side of the bird, especially its right wing. Another grey-brown inclusion in the stone colours the belly and one paw of the bear; and the bird's front makes use of a mottled inclusion in the stone which is of different colouring to that of the bear's body.

The conception primarily relies upon the boldly rounded planes with relatively few deep, forceful carved lines for its execution. The wings and tail of the bird are engraved with simple diagonal and criss-cross lines, confidently worked, and the eyes of both bear and bird are simple, strong circles cut with a V-shaped line and a flick at the corner. The bear's claws are similarly finely but simply rendered in rounded relief; the most complicated features of the carving are the bear's lips and ears, particularly the former, which are carved in smooth low relief.

The powerful conception and the handling of the bear's rounded body and limb articulation are what makes the piece so successful, with the excellent highly-polished finish of his body contrasting with the bird's darker tone and engraved details.

The combination of the eagle and the bear is found from at least the Warring States period in Chinese art. Probably by late Han and the Six Dynasties the punning meaning of their names together was intended: *ying-hsiung*, also meaning 'hero'. For Han and T'ang-Sung examples of the model in jade see *Chinese Jades from Han to Ch'ing*, nos. 20 and 21 (the latter featuring a variant eagle and dog combination).

In this case the naturalistic modelling and treatment of planes is Sung in style. As with other jade animals of Sung date allowance has to be made for the fact that the stylistic conventions were continued into the Yüan and even early Ming dynasties.

Probably Sung or Yüan dynasty, eleventh to fourteenth centuries.
Length: 2 5/16 inches. Height: 2 inches.

From the Malcolm Barnett collection, Hong Kong.

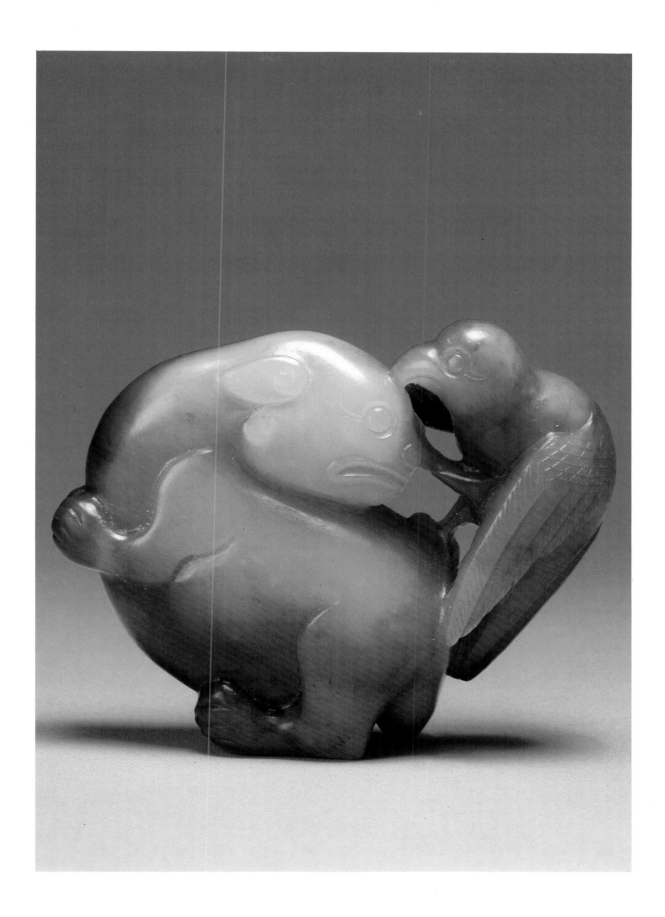

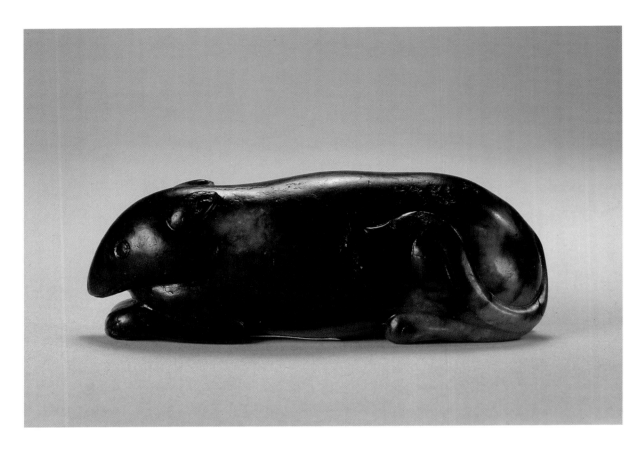

122 JADE SHREW

A simply but finely and very satisfactorily carved and conceived recumbent shrew in pale yellowish stone, flecked with white and strongly marked with black inclusions, tinged with red-brown. The smooth, slightly bulging body is lifelike, and details of ears, tail and haunches are left in rounded relief. The asymmetric legs are again simply but finely modelled, with a hole for suspension between the feet, and one paw is slightly raised. The whiskers are simply engraved from the small nose indentations, but both the long mouth and circular eye engravings are cut within a subtly and delicately raised lip.

The representation of the rodent, like the treatment of its small, rounded undercut head, is a rarity in jade carving; and its subtle, unctuous working admirably suits the nature of the tactile, superior stone. The model is best compared to post-Han recumbent dogs and pigs; the former in the posture of its legs, the latter in the disposition of its bodily proportions. A late Sung, Yüan or early Ming dynasty date seems likely; probably not especially late within those parameters.

Thirteenth to early fifteenth centuries.
Length: 2 5/8 inches.

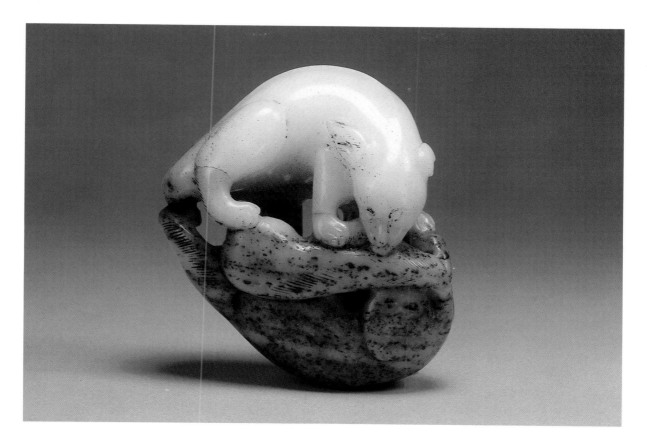

123 TWO-COLOUR JADE SQUIRRELS

Two squirrels disport themselves, tumbling and nipping at each others' long tails in play, the model exploiting the striking division of black (striated light and dark grey) and white stone, with its obvious *yin-yang* symbolism. The animals bear fine, rounded and engraved details of eyes, noses, claws, ears and hairwork, visible in the gleaming, highly polished stone only under close scrutiny. Although this popular combination is usually described as squirrels it seems likely that the animals were originally based on the tree shrew, or the mongoose.

Like other small jade carvings, this piece can be used as a small desk weight or as a fondling piece. In the case of such conceptions involving two opposing animals, though, it is likely that most were intended as pendants.

The use of two colours in jade carving was a particular feature of the Suchou school in the Ch'ing dynasty. Such strong, auspicious contrasts of stone tones are quite rare and sought after.

Eighteenth or perhaps early nineteenth century.
Length: 1 7/8 inches.

From the Jack Rose collection, London.

124 Jade Toad And Pomegranates

A large jade carving of the magical three-legged toad of Liu Hai, with a leafy branch bearing two pomegranates growing next to it. The stone, carved from a large pebble, is of rivered celadon turning to a mottled and flecked translucent grey-brown colour towards the skin; the inclusion is cleverly utilised for the pomegranate fruits and leaves. The toad's warty skin and spinal ridge are carved with dimples and bulges, and the surface both above and below suggests that the form of the toad corresponds closely for the most part to the original shape of the pebble. His three webbed feet, with long spiky 'toes', are folded underneath the body.

Three-legged toads, as well as frogs, were popular subjects for late Ming carvers, not only in jade. The combination represents a wish-fulfilling rebus: *ting-ts'ai liang-wang* (abundance of children and wealth). Liu Hai's toad symbolises wealth, and the pomegranate, with its many seeds, a large family.

Seventeenth century.
Length: 4 inches. Height: 1 3/16 inches.

From the Malcolm Barnett collection, Hong Kong.

125 Jade Crouching Frog

A jade carving of a frog about to spring, with bulging eyes and a humorously morose expression. The stone of pale grey celadon tone with russet skin inclusion. Carved from a pebble, the surface of the jade shows in places pitting marks on the skin. The body is simply carved with rounded dimples, but the interesting muscular bulges of the forelegs and the well conceived tensile musculature of the rear legs lends it a lifelike and convincing character. His long, tapering 'toes' are deeply engraved in the flattened feet underneath.

Seventeenth century.
Length: 2 1/2 inches.
With a carved blackwood stand.

From the Lee Younggren collection, Manhattan Beach.

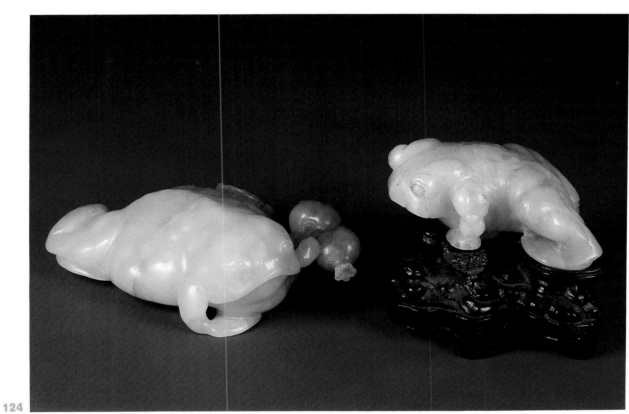

An unusual figure of the Ch'an patriarch Ta-mo (Bodhidharma, in Japanese Daruma), an Indian Buddhist missionary who came to China in A.D. 526, with a chubby pussy-cat version of his companion the tiger peering around the corner of his robe, practically rubbing its body against his leg. The stone is a celadon pebble with white interior flecking and a large, patchy area of pale caramel skin inclusion; the carving uses the skin surface of the pebble for almost all important areas of the figure, such as face, head, back and tiger. Only a few areas of the simply, expressively modulated flow of the sage's robe are carved down from the natural pebble surface. Ta-mo is carved with a broad nose and mouth, both very sensitively modelled, and his wide-set round eyes with imposing, flared eyebrows are engraved. The stripes and facial whiskers of the tiger are likewise simply engraved, in even more of a humorous, cartoon-stylised manner. The feet of both sage and beast are very simply carved in rounded relief with simple engraved delineation, and the long, pendent ears of Ta-mo are similarly modelled simply and roundly in the skin of the stone.

This unassuming group, of great charm and personality, is quite unusual and extremely difficult to date. Stylistically it stems from T'ang figures of exotic foreigners, and may possibly date from as early a period. There are not many figures to compare it with, but the iconographic depiction of Ta-mo with the tiger, the use of the skin colour and the humorous depiction of patriarch and animal suggest a relatively early date of probably Sung to early Ming. However, there is a possibility that it might be as early as T'ang or as late as towards the end of the Ming dynasty.

In terms of the carving, there are almost no stylistic indications; it is a particularly individual and broadly interpretative work, playing with the skin and form of the pebble outside the stylistic mainstreams of jade carving.

Probably eleventh to fifteenth centuries, but may be as early as ninth century or as late as seventeenth century.
Height: 2 1/2 inches.

From the Malcolm Barnett collection, Hong Kong.

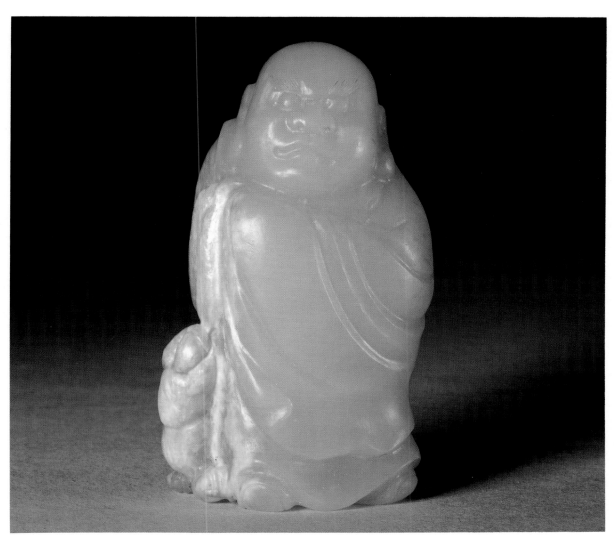

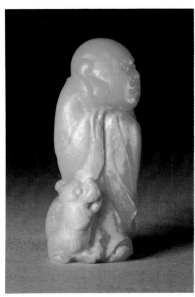

257

127 WHITE JADE BOY ON HOBBY HORSE

An extremely fine, pure white jade carving of a boy dressed in belted jacket and baggy trousers astride his hobby horse, its wheel emerging behind him from between his legs. The face and features of the horse, like those of the boy, are beautifully carved in a series of softly rounded planes. The horse's flaring nostrils, gently contoured mouth, broad-set eyes and flowing mane are attractively modelled with a generous conception of plastic sculpturing which seems quite modern, a feature of horse carving from the Sung dynasty. The horse's head has bridle trappings and a tassle under its neck; the boy holds its reins with one hand, and with the other holds a bamboo branch across his shoulders.

The boy on hobby horse is a decorative feature seen on late Ming ceramics and bronzes; for example on Chia-ching period blue and white 'hundred boys' vessels and on censers and handwarmers made by Hu Wen-ming in the Wan-li period.

The use of stone, subject matter and carving treatment indicate a dating of late Ming dynasty; perhaps not much after the sixteenth century. The carving was probably Suchou work.

Sixteenth or very early seventeenth century.
Height: 2 1/8 inches.

From the Malcolm Barnett collection, Hong Kong.

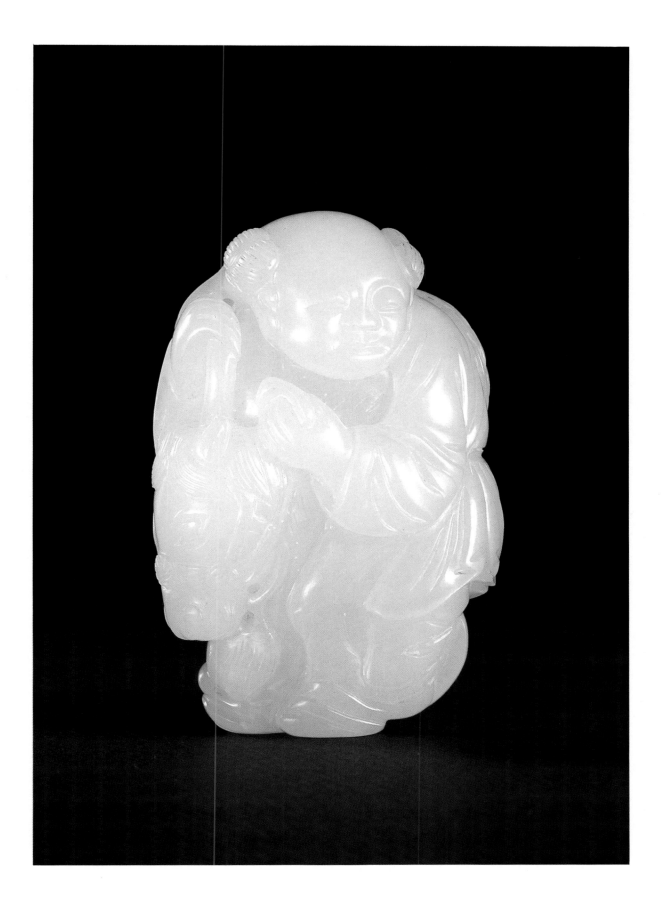

HSING-yu-heng t'ang (the hall of constancy, as it has been translated) was the hall name of Tsai-ch'üan, (d. 1854), the fifth Prince Ting, a Manchu descended from the first son of the Ch'ien-lung emperor, Yung-huang (1728–1750). Many different types of arts and crafts were patronised by Tsai-ch'üan and consequently appear with his hall name, particularly those of the Peking area. We offered a rare glass waterpot in *In Scholars' Taste*, as no. 109, and two snuff-bottles as nos. 110 and 111, and there discussed his chronology and some of the wares made with his hall name incorporated.

In addition to the objects listed there: porcelain, an I-hsing teapot dated 1849, gourd vessels bearing dates between 1801 and 1825, glass and snuff-bottles of crystal, agate, slate and hardstone; we have since then recorded several other types of ware on which this hall name appears. In a Hong Kong collection there are a plain white jade bowl and an ornate boxwood *ju-i* sceptre of fantastic form. A curious I-hsing warming vessel dated 1849 is illustrated in *I-hsing tzu-sha* as pl. 61, and a small I-hsing archaistic vase reminiscent of Ch'en Ming-yüan or Ch'en Chin-hou as pl. 58. Most interesting of all, I have seen two small paintings (both by Yangchou Eccentrics) with their mounts bearing a printed inscription in red characters indicating that the fine quality mounting paper was made for the Hsing-yu-heng t'ang in the fortieth year of the Ch'ien-lung period (1775). Although Tsai-ch'üan's date of birth is not recorded in available sources, it is impossible that he or even his father, I-shao (1776–1836) was responsible for the patronage of mounting paper at that time. The date of 1801 for gourd vessels grown and made for Tsai-ch'üan also seems suspiciously early, as in 1808 he was still in the palace school for princes. It seems likely that it was a hall name passed down through members of the enormously influential family, perhaps most used for this sort of patronage by Tsai-ch'üan, who was more famous as a connoisseur than his forebears, and whose collection of verse was published in 1848 under the title *Hsing-yu-heng t'ang ch'u-chi*.

128 WHITE JADE THUMB RING

A rare thumb ring of beautifully pure white jade, carved in an unusual form suggestive of the astragal knuckle form and finely engraved in *li-shu*:
Excellent jade of great value excavated at K'un-shan; if it had not been bathed (or polished) in the Jasper Pool (of Fairyland — another name for Peking) it could not have this dazzling white colour. Facing such beautiful jade one can be wiped clean. Hsing-yu-heng t'ang.

Probably early to mid-nineteenth century, Tao-kuang period, but perhaps earlier.
Height: 1 1/32 inch. Length: 1 11/32 inch.

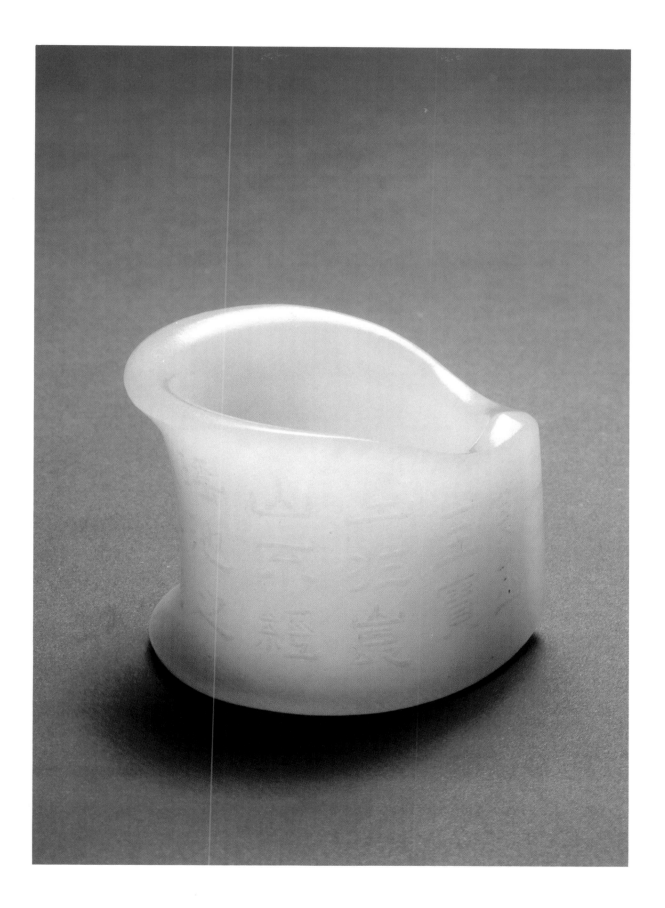

I PING-SHOU
1754–1815

tzu: Tsu-szu.
hao: Mo-ch'ing, Nan-ch'üan, Ch'iu-shui, Mo-an.
hall name: Liu ch'un ts'ao-t'ang.
From Ning-hua hsien, T'ing-chou fu, Fukien.

I Ping-shou was best known as a calligrapher, but among his other varied talents he was an excellent seal carver and inkstone carver. For details of his life and work, see the calligraphic scroll, no. 35. A fine inkstone by I Ping-shou is illustrated in *Komeigen, Tuan-hsi* volume II, no. 104.

129 T'AO-T'IEH MASK BELL INKSTONE (1803)

A fine black stone rectangular inkstone, probably Tuanstone, with a square water pool and rubbing surface. The top and sides of the upper surface well carved with a central monster mask expanding into a stylised design of *lei-wen* keyfret, diagonally arranged down the sides in a stylised bell design. There is a shallow concavity grooved between the relief walls which runs alongside the finely engraved lines of the design, carved down to a paler striation in the stone.
In the sunken centre of the underside is engraved a *hsing-shu* couplet describing the materials used for bells, in I Ping-shou's characteristic hand:
Jade is virtuous and mild; pleasant, yet dignified;
Metal (gold) is quiet and peaceful — but then it gives voice.

Dated to the birthday of mankind (the seventh day of the first lunar month) of the eighth year of the Chia-ch'ing period (1803) and signed Ping-shou, with square seal: Mo-ch'ing.
Length: 6 5/16 inches. Width: 4 7/16 inches. Depth: 7/8 inch.

A very fine striated dark buff stone inkstone with liver-red coloured streaky patches, the top carved as a bell with two dragon handles, their heads reaching down the sides of the bell. The rounded carving is finely executed in low relief. The underside is carved with a plain sunken rectangular panel which shows the attractive striations in the stone.

The left side of the inkstone is deeply engraved in a *li-chuan* script: Master Sun Po-yüan's collation of books inkstone and signed Ping-shou wrote. *Chiao-shu* (to collate books) is a punning reference which can also mean a high grade of courtesan. Po-yüan was the *tzu* of Sun Hsing-yen (1753–1818), a famous scholar, official and *chuan-shu* calligrapher; for details of his life and a fine *chuan* calligraphy by him see *In Scholars' Taste*, no. 15. He and I Ping-shou were friends, both in the circle of the poet and calligrapher Chang Wen-t'ao (1764–1814). Sun was a fine seal-carver; perhaps he and I Ping-shou carved inkstones for each other.

Circa Chia-ch'ing period (1796–1820).
Length: 5 11/16 inches. Width: 3 7/8 inches. Depth: 11/16 inch.
With a *hung-mu* box and cover.

131 PURPLE DOUBLE-POOL INKSTONE

A large rectangular stone inkstone, probably Tuanstone with purple skin, carved away to grey-green beneath, the reverse with 'rusty' inclusions in the stone. The top is finely carved with a design of overlapping circles, the larger circle with purple raised rim for rubbing the ink, with a deeper, crescent-shaped water pool.

A sunken rectangular panel on the reverse is engraved in *chuan-shu* with a title or poetic phrase referring to the stone: purple screen (or tablet) of birds' tails; superior quality.

With a square engraved collector's seal: Hsieh-yen ts'ang-wan. The name is unrecorded.

Nineteenth century.
Length: 7 5/8 inches. Width: 5 1/4 inches. Depth: 3/4 inch.
With a reddish blackwood box and cover.

An inkstone carved by Wu Ch'ang-shih (1844–1927); illustrated in *Komeigen*, *She-chou* volume, no. 56, has the same double-pool design.

132 BLACK TUAN-HSI INKSTONE

A smooth, black Tuan-hsi stone inkstone of barrel-shaped rectangular form, the dense material finely carved on the front within a continuous scrolling *ju-i* cloud band to the top and sides with a design of two *ju-i* sceptres of naturalistic form tied with ribbons, a central 'eye' between them. The edges are plain and smoothly finished, while the reverse is very finely carved in low relief with a richly robed Taoist sage of antiquity wearing an ornate hat and carrying a *ju-i* sceptre. Clouds like incense smoke hang overhead, and on and among the foreground rocks, with *ling-chih* fungus growing from them, a deer and a crane, both symbolic of immortality, turn to regard the sage.

Nineteenth century.
Length: 6 3/8 inches. Width: 4 1/4 inches. Depth: 27/32 inch.
With an attractive shaped pale *hung-mu* base and lid.

131

132

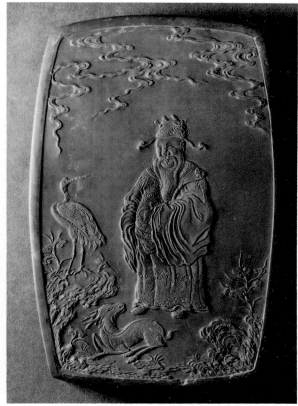

WANG T'I

1880–1960, Wang's birthdate is alternatively given as 1878.

ming: Shou-ch'i.
tzu: Wei-chi.
hao: Fu-an, Ch'ü-hu.
late hao (after 70 *sui*): Ch'ih-me lao-jen.
Also called Lo-ch'a chiang-min, Yin-yung.
hall name: Mi-yen chai.
From Hangchou, Chekiang.

WANG T'i was a noted mathematician and a scholar of antiquities, who excelled in *chung-ting* ancient bronze script, *k'ai* and *li-shu*. We offered an example of his formal *chuan* calligraphy in *In Scholars' Taste* as no. 45. Several other examples of his writing are illustrated in *Selected Works of the Cathay Art Museum*, vol. 2, nos. 47–72.

He was best known, though as a seal-carver; he designed the Grand Seal of the Chinese Republic, and is listed as the last of 37 great Ming and Ch'ing seal carvers (before Ch'i Pai-shih) in *Chung-kuo ni-yin yüan-liu*. He is best known for his Che style seals, but later in life he carved both Wan and new Che school seals after Wu Hsi-tsai and Chao Chih-ch'ien.

An inkstone carved by Wang T'i is a rarity.

133 SMALL RED INKSTONE

A reddish stone of irregular pebble form, the sides enhanced and worn but left essentially in their natural rough state, while top and bottom are polished smooth within an irregular ridged border, leaving a slightly concave rubbing surface with a deep water pool on top and space underneath for a Confucian quotation engraved in a version of archaic bronze script:
The sage (Confucius) said: Those who follow me to Ch'en and Ts'ai (feudal states in Honan) must all forswear any wrangling among my pupils, and must conduct themselves according to the Six Virtues (wisdom, benevolence, sincerity, righteousness, moderation and harmony). Yen Yüan (Yen Hui), Min Tzu-han (Min Sun) and Jan Po-niu (Jan Yu, three leading pupils of Confucius) were men of the Mean (or, moderation).

Signed Fu-an Wang T'i.
Early twentieth century.
Length: 3 7/16 inches. Width: 2 13/16 inches. Height: 1 inch.

From Ch'ien-t'ang (Hangchou), Chekiang.

For details of Huang I see no. 30.

134 INKSTONE ANCESTOR TABLET (1781)

A small, rectangular votive inkstone tablet of pure, buff stone carved in sunken relief on the front with a meditating Buddha on a mat within low relief scrolling ribbon borders beneath a *ju-i* head cloud scroll frieze. The reverse is engraved within similar low relief borders with a long *li-shu* inscription: On the sixth day of the fourth month of the *hsin-ch'ou* year of the Ch'ien-lung period (1781) this Buddhist disciple Huang I respectfully made for his father and mother this image of Sakyamuni, to cause his father and mother to be reincarnated in heaven, in some joyful, contented part; that the scars of desire and bitterness be completely removed and departed, and that they be born again in the pure region where all alike are blessed.

The tablet measures 3 1/16 × 1 13/16 × 3/4 inches.

Such a personal, devotional family memento by the hand of a major seal-carver and inkstone carver is a considerable rarity; more so than any seal or inkstone by his hand. Other, comparable votive tablets are not published or recorded.

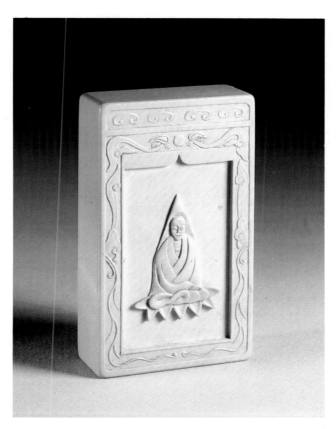

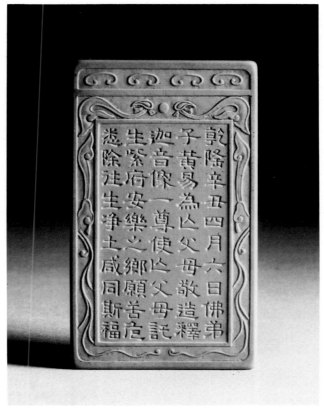

乾隆辛丑四月六日佛弟
子黃易為亡父母敬造釋
迦音像一尊使亡父母託
生紫府安樂之鄉顧苦愆
速除往生淨土咸同斯福念

271

A very rare *cloisonné* travelling pricket candlestick for the use of a journeying scholar-official, which dismantles and packs away into a circular box formed by its own base and drip pan. There are five separate *cloisonné* pieces and two bronze fittings. A long screw passes through the fat, bulbous fitting between base and drip pan and fastens into the base of the slenderer bulbous fitting above. Into the top of that section screws the pricket, securing as it does so, the cup-shaped bowl for the candle. The decoration, in bright red, yellow, dark green, pale green, pale purple, dark blue and white enamels within thick gilt wires on a pitted pale blue ground, is of scrolling lotus flowers within *ju-i* head cloud lappet borders. On the base and drip pan (box and cover) both lotus and cloud lappets are linked by two-ring loops. The fat, lower bulbous element has simply scrolling lotus head between scrolling floral borders, while the slenderer, upper connecting element has both scrolling lotus and cloud lappets within long necks of green 'tobacco leaf' design. The circular bowl is decorated with simple scrolling flowers under cloud lappets with a stylised lotus flower motif in shades of blue at its centre, like the base and drip pan.

Mid-eighteenth century, Ch'ien-lung period.
Height: 7 3/8 inches. Diameter: 3 15/16 inches.

The box is fitted with replacement brocade liners and individual pouches for the component pieces.

Even the encyclopaedic *Chinesisches Cloisonne* does not include such a travelling candlestick, although it does picture as no. 205 a late seventeenth century long-necked vase in two parts, with a pricket head inside, which can be screwed into the mouth of the vase.

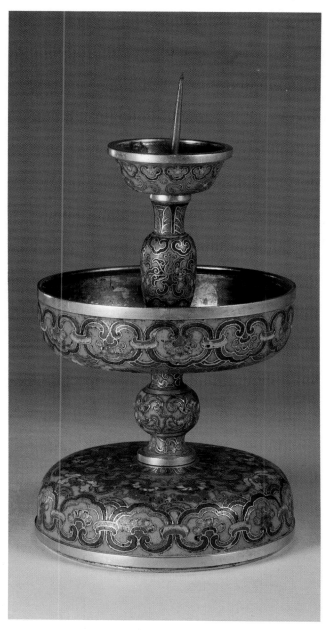

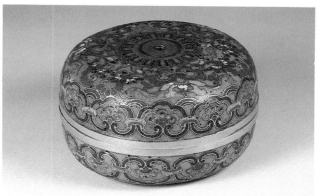

We discussed the background of and literature pertaining to gourd vessels in *Emperor Scholar Artisan Monk*, where we offered a rare cricket cage by Ch'en Chin-t'ang as no. 112. The most comprehensive, illustrated, available survey is "Chinese Decorated Gourds" in the catalogue of the 1983 International Asian Antiques Fair, Hong Kong. There the imperial wares, the most identifiable groups, are analysed, and it is observed that although vessels such as bowls and brushpots with moulded decoration were made in the palace in the K'ang-hsi and Ch'ien-lung reigns, it was not until the Tao-kuang period that cricket cages with moulded decoration were produced; all examples from the previous reigns bear carved designs. There are no known imperial gourd wares known from either the Yung-cheng or Chia-ch'ing periods.

Outside the palace museum collections in Peking and Taipei only three K'ang-hsi and four Ch'ien-lung gourd cricket cages are recorded. "Chinese Decorated Gourds" illustrates all three of the K'ang-hsi examples and two of those dated Ch'ien-lung. The known Ch'ien-lung examples all share similar features, with a pattern of finely incised designs on a formalised ground with considerable use of cross-hatching. The published examples ("Chinese Decorated Gourds", nos. 24 and 25) both have a cross-hatched honeycomb background to their decoration, with a pendent leaf border above; they bear the engraved base seals Ch'ien-lung yü-wan (24) and Ch'ien-lung nien-chih (25). Imperial gourd vessels of the Ch'ien-lung period are considered to be the most elegant and varied of all; in the words of Wang Shih-hsiang, "really the best scholarly objects from the Imperial Household".

136 IMPERIAL GOURD CRICKET CAGE

A large, very finely engraved and relief-carved gourd cricket cage with slightly flattened base, broad body and wide mouth, bearing the decoration of stylised peony flowers with branch and leaves, profusely carved with fine engraved details, on a background of honeycomb design with fine cross-hatching engraved in the cells, all underneath a border of pendent leaves. On the base is carved in relief within a square cartouche the *hsing-k'ai* seal: Ch'ien-lung yü-wan [imperial curio (or treasure) of the Ch'ien-lung emperor].

The interior is fitted with a spiralling metal fixture and a thick turned ivory collar. The lid has a domed, turned ivory collar with a circular tortoiseshell plaque set into its centre, very finely carved in openwork with a relief spray of narcissus showing the contrasting tones of the material, above a honeycomb design of interlocking circles.

Eighteenth century, Ch'ien-lung period.
Height: 5 7/8 inches. Diameter at collar: 3 1/4 inches.

From the Edwin Miller collection, London.

16th century

WU Pao-su is listed in *Ku-wan chih-nan* as one of the extensive Wu family of Ming dynasty inkmakers. In fact, other inkmakers also carved lacquer, and vice versa. One famous example (slightly later) is that of Wu Shih, from Hsiu-ning, Anhui, who carved very fine lacquer vessels in addition to making inks and *ku-ch'in*; he was also a painter and calligrapher. One of his inks is dated 1628. The famous Lung-ch'ing period lacquerer Huang P'ing-sha, also from Hsiu-ning, likewise made *ch'in* and carved other materials.

No other lacquerwork signed by Wu Pao-su has so far been recorded. There are very few listed lacquer artisans; most are found in *Oriental Lacquer Art*, appendix V, pp. 362–363.

137 CARVED RED LACQUER CHA-TOU

A *cha-tou*, or leys jar, with a dramatic flared rim above the bulging body; the bulbous lower section, foot and neck are lacquered on a metal base, while the rim is built up from a lighter construction which must have had a wood base, perhaps with cloth. The deeply and sharply cut, extremely fine red lacquer decoration of the vessel is of twelve ogival panels on the body, neck and inner rim, the remaining space filled with relief peony sprays upon a carved red diamond lozenge florette ground. The foot and rim are carved in relief with a continuous *lei-wen* keyfret design, and the band between body and neck is carved with an attractive continuous flowing water design.

Within the large panels on the body and the smaller panels on the inner rim is repeated, eight times, the design of a five-clawed dragon and an imperial phoenix disputing a flaming pearl amid clouds, on a deeply-cut red ground diaper of horizontal 'air' pattern. The combatants are very finely carved in several layers, and the deeply engraved surface details are brilliantly executed and polished.

The four panels on the neck of the vessel each contain, carved in similarly sharp, deep relief, two of the Eight Precious Things of Buddhism (*pa-chi-hsiang*): cornucopia and endless knot; vase and lotus flower; awning and twin fish; and fiery wheel and parasol. The sunken base and footrim, and the interior of the neck, are lacquered a smooth black.

The confronted dragon and phoenix, though not as commonly found as confronted or single dragons, was a popular motif in lacquer decoration throughout the Ming period. A majority of the elongated dragons found on lacquer of the Chia-ching period have (or had) five claws, perhaps indicating an imperial provenance for even such an individual work as this.

On the base, incised in large, gilt-filled characters, is the signature: Wu Pao-su chih (made). Sixteenth century, circa Chia-ching period (1522–1566). Height: 5 3/4 inches. Diameter: 6 9/16 inches.

The *cha-tou* form, popular in porcelain of the Chia-ching period, is rarely found in lacquer. Compare a Chia-ching mark and period multi-coloured lacquer leys jar, with dragon and phoenix decoration, from the Hosokawa collection, illustrated in *Chinese Lacquer*, pl. 77. Compare also the form of a flower-pot in the Palace Museum, Peking, carved with a floral design, illustrated in *Chinese Lacquer*, pl. 47, and dated 16th to 17th century.

This example is very rare in terms of form, subject matter of the Eight Precious Things represented in such a manner, and of course in the signature of Wu Pao-su, a previously unrecorded lacquerer of great technical capability. Any signed lacquerwork is a rarity.

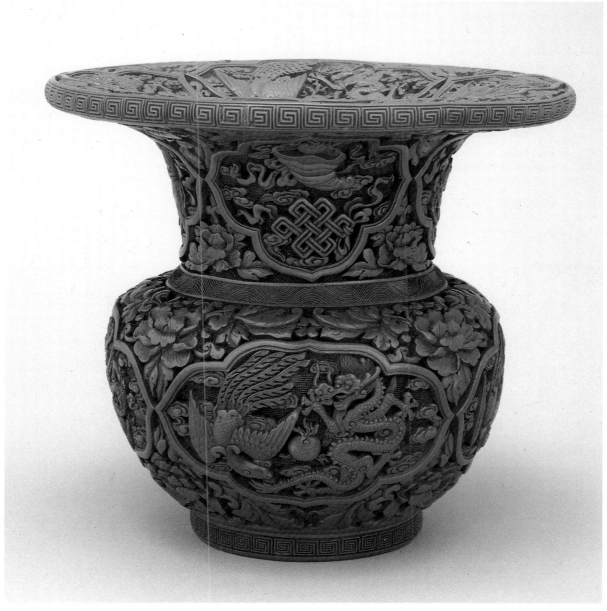

CHIANG Ch'ien-li was a late Ming master of the *p'ing-t'o* technique of inlaying lacquer with mother of pearl, gold and silver. His work, and that bearing his name throughout the Ch'ing dynasty into the twentieth century, was discussed at length in *Emperor Scholar Artisan Monk*, where we offered a pair of small egg-shaped cosmetic boxes as no. 116. Those boxes were technically very comparable to this example, with points of stylistic similarity, and the arguments presented there apply here. The Ch'ien-li inlaid signature appears on so many works of varying quality that it is hard to draw dividing lines between genuine, workshop, Ming, Ch'ing, fake and new. However, we consider these small boxes, of all of the available types, to be very close to the master's time and workshop. They are most comparable to the jewel box attributed by Lee to Chiang (*Oriental Lacquer Art*, no. 140) and to the items in *Chugoku no Raden*, nos. 102–103, which we consider to be probably earlier than the dates of seventeenth to eighteenth century ascribed to them.

138 SMALL INLAID LACQUER COSMETIC BOX

A small box of squat circular form very finely inlaid in the black lacquer with flakes of gold and different-coloured mother of pearl. The top of the box is decorated in three bands separated by rows of overlapping pierced mother of pearl discs; at the centre is an eight-sided starburst in gold and iridescent green mother of pearl. The other two bands contain a design, repeated around the lower half of the box, of sexangular honeycomb construction formed by strips of mother of pearl inlay, each cell with a florette of four diamond-shaped gold flakes in its interior. The interior, rims, foot and base are of smooth, black lacquer, the inside of the lower half with a simple, single floral spray inlaid in green and purple mother of pearl and gold flakes.

The base is signed in *chuan-shu* with a gold lacquer square seal: Ch'ien-li.
Probably seventeenth century, late Ming dynasty or perhaps K'ang-hsi period.
Diameter: 1 7/16 inches. Height: 3/4 inch.

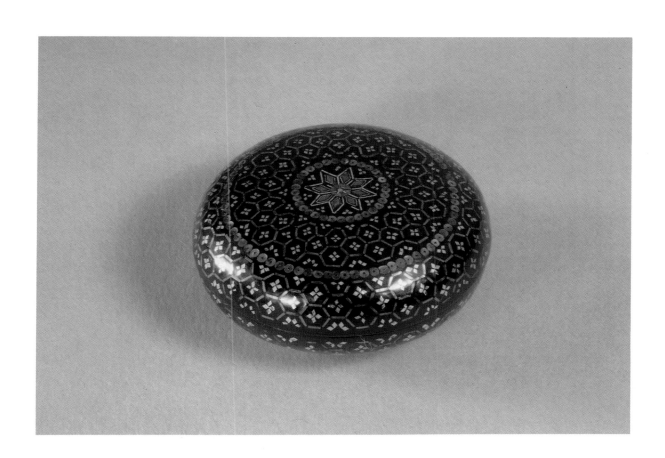

ming: Tung.

From Yangchou, Kiangsu.

THE work of Lu K'uei-sheng has been described at length in *In Scholars' Taste* (no. 147) and *Emperor Scholar Artisan Monk* (no. 117). He was the most individual of Ch'ing independent lacquerers, working in the Tao-kuang period in Yangchou, although it is possible that some large carved red lacquer items by him date as marked to late in the Ch'ien-lung period, and presumably some other articles as well. He was the grandson of another recorded Yangchou lacquerer, Lu Ying-chih, who made versions throughout the mid-Ch'ien-lung period of a Sung inkstone box; *Oriental Lacquer Art* shows a table by Ying-chih dated 1757.

Lu K'uei-sheng specialised, perhaps later in his career, in small lacquer objects of refined literati taste and usage. Apart from the set of four panels and the lacquer inkstone and cover offered in our two previous exhibitions, other lacquer articles of a scholastic flavour by Lu include two wristrests imitating bamboo, with designs derived from paintings, one in *Chinese Bamboo Carving*, part II, no. 50; a lacquer imitation of an I-hsing pewter-covered 'sand-womb' teapot (*Chinese Art*, vol. 2, pl. 69); another engraved inkstone and box, of fruiting gourd form (*Bunku Mandara*, no. 38); and two inlaid prunus design inkstone boxes, one in *Komeigen*, vol. 5, no. 102. As the inkstone box offered in *Emperor Scholar Artisan Monk*, avowedly influenced by the Lung-ch'ing lacquerer Huang P'ing-sha reveals, Lu was particularly interested in interpreting and recreating lacquer designs and techniques of previous periods.

139 INLAID LACQUER WRITING BOX

A rectangular writing box and cover, the base with four low, stepped feet and a tray section above a single long drawer. The cover is carved away, open on either side leaving a curvilinear panel revealing the inner sides and facilitating lifting the lid. The visible exterior top and sides have a matt purple-brown lacquer surface, the top with tiny bright red dots in it, while the interior and base are lacquered a mottled brown-black. The top is inlaid with mother of pearl, stained ivory, coconut shell and soapstone with vari-coloured backings in the *pai-pao-chien* technique, with a scene of two geese on a rocky shore overhung by branches. The inlaid pieces are strongly carved, with round edges and a high polish, and the details of goose feathers and flower petals are finely engraved. The black lines indicating water ripples, reminiscent of the treatment used for the engraved inkstone box in *Emperor Scholar Artisan Monk*, may have been inlaid in wire under a layer or two of clear lacquer. The birds' eyes are inlaid in jet or horn.

Signed underneath with a red paint-lacquer four-character enclosed square seal: Lu K'uei-sheng chih (made).
Early nineteenth century.
Length: 10 inches. Width: 6 inches. Height: 2 3/4 inches.

The box is a clever imitation of a type popular in the late Ming dynasty and seventeenth century, even down to the style of the seal signature. *Pai-pao-chien* was a style of inlay in semi-precious materials invented by Chou Chu in the sixteenth century.

K'uei-sheng has been one of very few artists to be featured in all three of our exhibition catalogues on these broadly related areas (with Ch'en Man-sheng, Ch'en Ming-yüan and Hu Wen-ming, unless one includes Wang Wen-chih's brief, vicarious appearance on an ivory brushpot. no. 101). The objects depicted have been of the most widely varied lacquer techniques and styles imaginable. We have showed this box, out of interest and without concealing the mark, to a number of leading London dealers and specialists, all of whom have dated it seventeenth century to K'ang-hsi at the

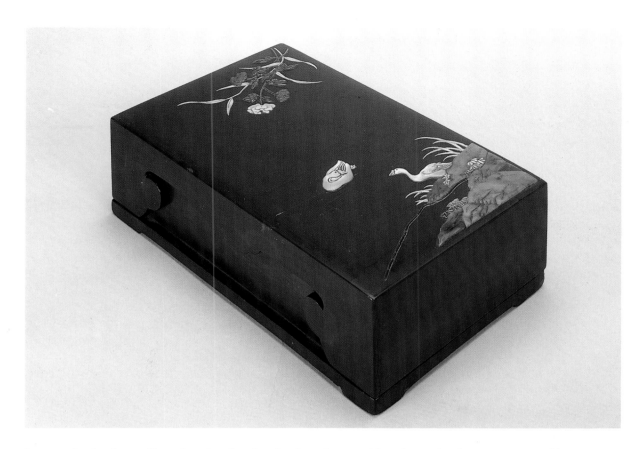

latest. This bodes well neither for the depth of reading and heeding of reference material by experts, nor for the acuity of connoisseurship applied to the many fine and beautiful unmarked boxes of this type available at some considerable cost in the marketplace, all of them presumably genuinely seventeenth century.

SUN KUO-HSIN art name: Chu-ch'en.

19th century

\intUN Kuo-hsin is not recorded as a lacquerer, but he must have been a workshop member or follower of Lu K'uei-sheng in Yangchou in the early to mid-nineteenth century. We have recorded one other work by his hand, a table screen with relief cock and hen decoration signed Sun Kuo-hsin, with seal Chu-ch'en; of not quite as fine quality as the present example.

140 CARVED RED LACQUER PANEL

A large panel of solid carved red lacquer on a wood base, with a relief carved scene of a lady playing a four-stringed lute while sitting in moonlight on the trunk of a gnarled old prunus tree growing by rocks on the banks of a rushing river. The sky background is carved in a complex octagonal interlocking rosette diaper, and contrasting diapers, with relief medallion details, are used for the lady's robes. Flowers grow from behind the foreground rocks, and bamboo from behind the prunus trunk, which has subtly rendered details of boles and blossoms. The dense lines of the river's rapids and current echo the curls of the lady's hair. Two methods are used for the depiction of rocks; one is the deep incision of angled contour lines on smooth and tilted, rounded planes, and the other is an unusual polished stippling of amorphous, lava-like masses.

The panel is sunk within an integral frame, likewise carved in high relief red lacquer with branches and sprays of prunus in the style of Wang Mien, on a *wan* diaper background. The sides and reverse are lacquered smooth black.

Signed in relief *hsing-shu* to the the lower right Chu-ch'en k'e (carved), with engraved relief square seal: Chu-ch'en, and with the additional engraved relief rectangular seal to the lower left: Sun Kuo-hsin yin.
Early to mid-nineteenth century, probably Tao-kuang period.
The panel measures 23 5/8 × 18 1/8 inches.
With an openwork brass hanging fixture.

See *In Scholars' Taste*, no. 147 for a set of four comparable panels by Lu K'uei-sheng, the innovatory master of several of the unusual red lacquer techniques demonstrated in this example. We discuss there the possibility of Lu's carved red lacquer objects (these rare panels, two folding screens and a low table have all surfaced in London in the last few years) dating as early as the late Ch'ien-lung period. This example by Sun shows a few features not evidenced in those works of Lu (the stippled rockwork and rushing torrent, in particular) and it is possible that they were his own innovations. One particular feature elaborating upon the Lu K'uei-sheng panels is the presence of the attractive integral border, or frame. No other works by Sun Kuo-hsin are published; nor are any other comparable wall or screen panels.

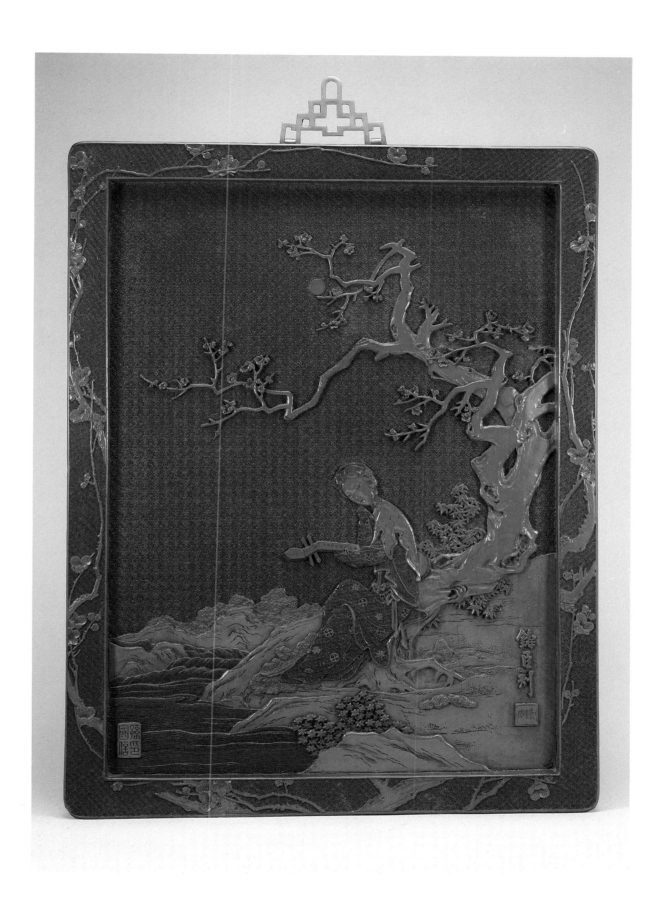

283

140

140

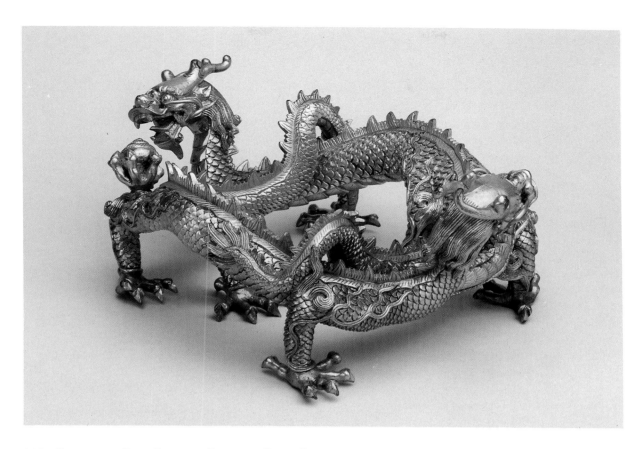

141 **IMPERIAL GILT BRONZE CRYSTAL BALL STAND**

A large, very heavy and extremely strongly and crisply cast and worked, thickly gilded bronze stand for a crystal ball with a diameter of about 11 1/2 inches, formed as two five-clawed dragons circling and intertwining, each holding a pearl or jewel in one clawed foot and standing on the other three. The scales, hairwork and flames of the dragons are chunkily and powerfully but expressively and finely worked; square-cut and rounded features of claws, horns and facial details complement each other well. The dragons' whiskers are of thick gilt wire.

Such an impressive, brilliantly gilded five-claw dragon stand for a large crystal ball must have been made for the emperor, probably in the palace workshops. The style strongly suggests for date the K'ang-hsi period, although a timing as late as early in the Ch'ien-lung emperor's reign is possible.

Late seventeenth century to early to mid-eighteenth century.
Greatest width: 9 5/8 inches. Height: 4 1/8 inches.

HU WEN-MING

active Wan-li period

From Yün-chien (Sung-chiang), Kiangsu.

HU Wen-ming was the most famous and influential metalworker of the late Ming period. Other well-known metal craftsmen of the period are recorded, but their listing tends to be empirically supported by a range of works of dubious signature and dating, as in the case of Shih-sou (see *Emperor Scholar Artisan Monk*, nos. 131 and 132), or by a much smaller corpus of available examples, with the issue of authenticity an added problem, as in the cases of Chang Ming-ch'i and Wang Feng-chiang (see nos. 153–160). There is a relatively large amount of Hu Wen-ming's *oeuvre* available, ranging from masterpieces obviously involving the master, through good workshop pieces down to quite poor end-of-bin workshop productions. While there are a very few bronze works bearing Hu Wen-ming signatures which are of fairly awful quality, nonetheless there seem to be virtually no fakes of his work. His style of parcel gilding and inlaying gold and silver into bronze vessels, a majority for the burning of incense in the scholar's study, was apparently hardly imitated after the fall of the Ming dynasty; so we are able to deal with a homogeneous group of wares within a short time span, which is not the case with other metalworkers.

It seems that enthusiasts of the literati aesthetic have not yet, by and large, appreciated in the object of their affections the worthy place of bronze incense vessels. A long quotation from the great Ming connoisseur Hsiang Yüan-pien's *Nine essays composed under the Banana Window* is apposite:

When elegant hermits sit around to discuss ethics, the burning of incense can clear the mind and please the spirit.

Having studied under the vanishing moon until the deep of the night, when tiredness and boredom engulf you, incense will enliven your senses again.

Under the bright window, making a rubbing of calligraphy, or idly waving your dust whisk; while reciting or composing poetry, burning midnight oil to study, the burning of incense drives away the devil of sleep.

With your lady-friend at your side, whispering secrets, holding hands, caressing the incense burner, the burning of incense warms your heart and your desire.

Closing the windows to the rain, just awakened from the noon-day sleep, you come to the desk to practise calligraphy; you taste delicate tea and as the incense smoke becomes warm the smoke surrounds and stimulates you.

Having drunk too much at a banquet, the guests awaken under a bright moon on a clear night. You slide your fingers over icy strings (of the *ku-ch'in*), humming filling the empty mansion. You extend your vision to distant hills. The incense burner is hot and fragrant incense smoke faintly surrounds the curtains, driving away uncleanliness.

A later work on Hsüan-te bronze censers, purporting likewise to be written by Hsiang (preface dated 1626, after his death) offers advice about the number of vessels which a scholar ought ideally to have in his collection:

In our studios we use no more than ten incense burners. We change them by rotation and feel refreshed because of the new look each day as we handle them and rub them one by one. If in our collection we have only one or two burners left on the stand or desk, remaining there day and night throughout the year like a pillar, stuck, unmoving, our eyes will become accustomed to the sight and be easily bored. Therefore it is preferable to have more bronzes in our collection.

Our survey of Hu Wen-ming's works in *In Scholars' Taste*, illustrating seven objects by Hu and two by close followers, was the first such detailed examination of his work, accompanied by an essay by Ulrich Hausmann: "In Search of Later Bronzes". It was followed by the comprehensive exhibition at the 1984 International Asian Antiques Fair, Hong Kong, with a fully illustrated essay in the catalogue; "Chinese Metalwork of the Hu Wenming Group" by Gerard Tsang and Hugh Moss (from which the above translations are taken, with thanks). In *Emperor Scholar Artisan Monk* we offered a further

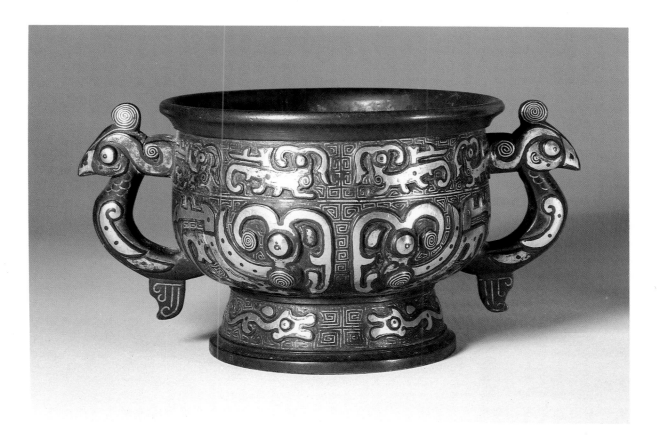

seven Hu Wen-ming works, plus another by a follower. Our ground-breaking exhibitions have offered two of five known handwarmers by Hu, one of four known *ku* beakers, the only recorded Tibetan character censer, the only known *ju-i* sceptre and the only recorded brushpot signed by him, in addition to both the published censers by his son Hu Kuang-yü and both by his pupil or rival Chu Chen-ming. In this exhibition we also offer the only known piece by his only other named follower, Li Ch'i-yün, and the third known example of Hu's large, solid cast *kuei* censers with extensive gold and silver inlays on a continuous silver inlaid *lei-wen* ground, among his best and probably earliest works. Apart from these rarities, the solid body of selected mainstream incense vessels offered in our three exhibitions presents an impressive introduction to the work of Hu and his associates. The 1984 Hong Kong exhibition managed to list altogether 77 pieces of the Hu Wen-ming group; we have managed to select and publish twenty-four rare and fine examples.

142 PHOENIX HANDLE KUEI CENSER

A superb solid-cast *kuei* bronze censer with large, integral phoenix-decorated tab handles, a most originally interpreted and powerful archaistic design. The handles are inlaid and onlaid in silver and gold wire and foil. The body is decorated on each side with three relief bands of stylised mythical animals: in descending order, four small phoenix, two large phoenix and two small *kuei* dragons around the foot, all in silver and gold foil above a ground of complex silver-inlaid spiralling *lei-wen* keyfret design. There are three plain bronze bands, at the foot, the rim and under the handles at the base of the bulbous body.

The interior and base are of plain turned bronze, with a three-character archaic inscription in the centre of the interior: Jih-wu i (Jih-wu's bronze vessel).

Unsigned.
Wan-li period, circa 1580s.
Width: 7 1/8 inches. Height: 3 5/8 inches.

Compare the two other known examples of this type, illustrated as nos. 1 and 2 of "Chinese Metalwork of the Hu Wenming Group"; one a little larger, the other a little smaller. They are, with the *P'u-t'ai* box and cover previously in the former Edward Chow and Ip Yee collections, the finest examples of Hu Wen-ming's work known. The handles of both, likewise integrally cast, are of self-consuming *t'ao-t'ieh* monsters; the present example's phoenix represent a stimulating variant. As the essay observes of these two censers: "the personal productive involvement of the master would appear to be considerable". Exactly the same relief gold and silver foil dragons can be seen as the main band of decoration on the unsigned *ting* censer illustrated as no. 15 in "Chinese Metalwork of the Hu Wenming Group", confirming its authorship, as well as on the foot of no. 1. This larger censer is one of the most interesting of Hu Wen-ming's *oeuvre* in that it is dated, to relatively early in his career, 1583; a literary reference of Hsiang Yüan-pien's indicates that he was already working in 1573. One other dated piece is known, a fine *p'ou* vessel made for the scholar and painter Tsou Ti-kuang in 1613. We may conjecture that the similarities of the dated *kuei* (also illustrated and discussed in "Two archaistic bronzes of the Ming dynasty", Aschwin Lippe, *Archives of the Chinese Art Society of America*, XI, 1957, p. 78, and *Dated Chinese Antiquities 600–1650*, Sheila Riddell, 1979, p. 140) to this example suggests that they may both be of a type made early in the Wan-li period. The smaller *kuei*, no. 2 in the exhibition, is also unsigned. Both censers 1 and 2 have the archaistic inscription tzu-tzu sun-sun yung-pao (to be treasured eternally by innumerable descendants) in the interior.

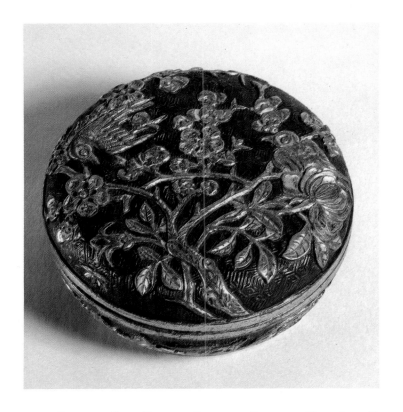

143 **PARCEL-GILT BRONZE INCENSE POWDER BOX AND COVER**

A heavily cast and worked circular box and cover of thickly parcel-gilded bronze, its form taller and less squat than most comparable examples, though with flattened top. The heavily cast and gilded inner rim prevents fine incense powder from blowing away. The top is decorated in high gilded relief with a design of two birds perched among the branches of a blossoming prunus tree, with a butterfly hovering nearby; all on a double-Y diaper ground. A band around the base is similarly decorated on the same ground with two roses and a lotus; the rims and footrim are gilt.

Engraved in the centre of the base is a gilded four-character *chuan-shu* seal: Hu Wen-ming chih. Wan-li period, circa 1600.
Diameter: 3 1/4 inches. Height: 1 1/2 inches.

These boxes and covers all have naturalistic designs, including floral motifs which refer to the fragrance of the powdered incense. Their decoration seems closely related to that of lacquer boxes of similar form, both of the same period and earlier in the Ming dynasty. Compare the examples (including our *In Scholars' Taste* lotus on waves example) illustrated in "Chinese Metalwork of the Hu Wenming Group", nos. 18, 19 and 20; all three have purely floral decoration.

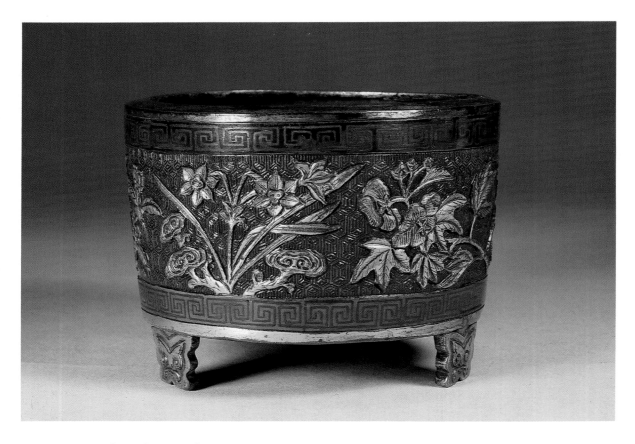

144 PARCEL-GILT COPPER CYLINDRICAL TRIPOD INCENSE BURNER

A copper-bodied cylindrical tripod censer, probably based on the Han *lien* form, with inturned rim. The gilded copper rims and feet are separately applied and the working of the exterior decoration is partially visible in the interior. The body is decorated within two bands of continuous silver-inlaid *lei-wen* keyfret with several plants in high gilt relief on a double-Y diaper ground; roses, peony, lotus, *ling-chih* fungus, narcissus and camellia. The irregular feet each have a relief butterfly in outline; this feature on other censers has been described as a *ling-chih*/butterfly design.

Engraved in the base, within a large circle, is the gilded *chuan-shu* seal in a rectangular cartouche: Yün-chien Hu Wen-ming chih [made by Hu Wen-ming of Yün-chien (Sung-chiang)].
Wan-li period, circa 1600.
Diameter: 4 5/8 inches. Height: 3 1/2 inches.

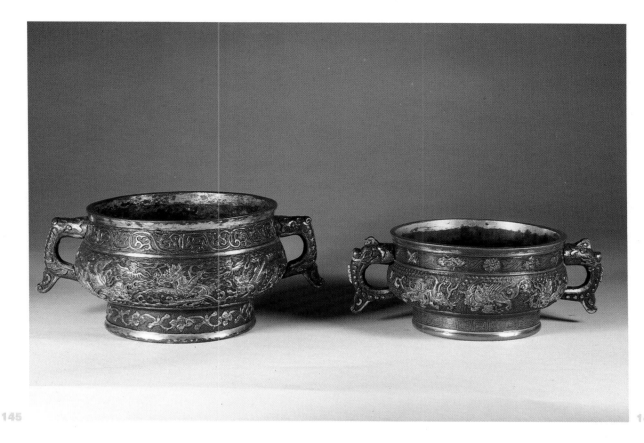

145 PARCEL-GILT COPPER KUEI INCENSE BURNER

A large, copper-bodied *kuei* censer, with separately applied self-consuming *t'ao-t'ieh* tab handles with ring-punched ground. The central band of decoration, on a wave ground studded with spray-drops, is of ten mythical sea-monsters and four birds, some of the smaller monsters (which include fish-tailed dragons, sea-horse and lion-dog) emerging from shells. These animals, popular decoration on a range of works of art including ceramics from the fifteenth and sixteenth centuries, are probably taken from the *Shan-hai-ching t'u-lu*, an illustrated account of early animal myths. The rim, footrim and separating bands are gilded; the upper band of decoration is of a continuous scrolling lotus design on a ring-punched ground, and the decorative band around the deep foot has a continuous design of prunus twigs and flowers with *ju-i* head leaves.

In the centre of the foot is the engraved *chuan-shu* seal in a gilt rectangular cartouche: Yün-chien Hu Wen-ming chih [made by Hu Wen-ming of Yün-chien (Sung-chiang)].
Wan-li period, circa 1600.
Width: 8 1/2 inches. Height: 3 5/8 inches.

Compare the example we offered in *In Scholars' Taste*, no. 158, as well as those illustrated in "Chinese Metalwork of the Hu Wenming Group", nos. 4, 5, 8 and 9.

146 PARCEL-GILT COPPER KUEI INCENSE BURNER

A copper-bodied *kuei* censer of squat form with separately applied self-consuming *t'ao-t'ieh* tab handles with ring-punched ground. The central gilt relief band of decoration, on a floral diaper ground, is of six strange mythical animals, some issuing flames and each carrying an auspicious attribute: *a kuei* dragon with an axe or pike in its mouth, a Fo dog with a jade chime in its mouth, a *ch'ih* dragon with a *ju-i* sceptre in its mouth, a strange elephant beast with a canopy/hat on its back, a phoenix with a tasselated box (?) in its mouth, and a *lung* dragon with a brush in its claws.

In the thin upper band of decoration, on a silver-inlaid scrolling plant background, are ten gilt relief leaf and flower heads, and the lower, foot band of decoration has a continuous silver-inlaid *lei-wen* keyfret design. Raised details of rims, separating bands, lip interior and handle features are all gilded, and the copper is of a particularly appealing milk chocolate tone.

Engraved in the centre of the sunken foot is the horizontal and interestingly stylised seal in a rectangular cartouche: Yün-chien Hu Wen-ming chih [made by Hu Wen-ming of Yün-chien (Sung-chiang)].
Wan-li period, circa 1600.
Diameter: 7 3/4 inches. Height: 2 7/8 inches.

Like the unusual mark, such features of the decoration as the upper decorative band and the mythical animals carrying attributes have not previously been found on Hu Wen-ming censers.

145

146

292

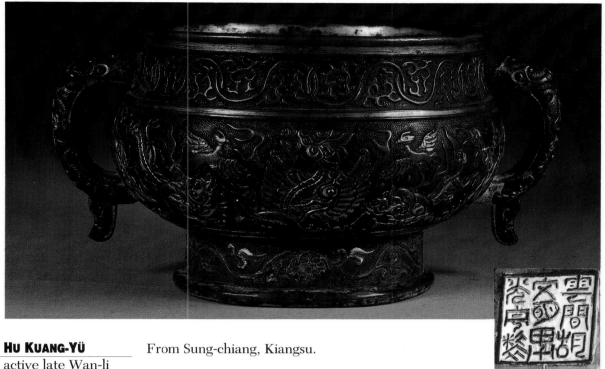

HU KUANG-YÜ
active late Wan-li
period

From Sung-chiang, Kiangsu.

HU Kuang-yü, the son of Hu Wen-ming, is known through only two published *kuei* censers, the first of which we offered in *In Scholars' Taste*, as no. 160. Both are illustrated in "Chinese Metalwork of the Hu Wenming Group", as nos. 43 and 44. They vary considerably in style, but both feature mythical animals. Hu was said to have employed in his workshop and taught the secrets of his art only to those with his surname — in other words, family members. Kuang-yü presumably signed the small body of works bearing his name when he became a recognised workshop master himself, or after his father's death, some time after 1613. In any case, it is likely that he worked in the second half of the Wan-li period and perhaps a little later; early in the seventeenth century.

147 PARCEL-GILT COPPER KUEI INCENSE BURNER

A tall, rounded copper *kuei* censer with separately cast bronze self-consuming *t'ao-t'ieh* tab handles, decorated on body and handles in gilt relief on a ring-punched ground. The central band of decoration is repeated on each side with five mythical creatures (fish-tailed dragon, chimera, lobster, *ch'ih* dragon and deer) and two birds among flames and waves. The handles have shells (one with a creature emerging) and a coral branch for decoration, and the thin upper band has a continuous relief scrolling lotus design. The lower, foot band has a continuous scrolling *ju-i* headed floral decoration.

The foot is engraved with the *chuan-shu* seal set in a square gilded cartouche: Yün-chien Hu Wen-ming nan Kuang-yü chih [made in Yün-chien (Sung-chiang) by the son of Hu Wen-ming, Kuang-yü]. Late Wan-li period, early seventeenth century.
Width: 6 1/4 inches. Height: 3 3/16 inches.

From the Dr. Ip Yee collection.
Published: "Chinese Metalwork of the Hu Wenming Group", no. 44.

LI CH'I-YÜN

17th century

L I Ch'i-yün is a metalworker not recorded in Chinese sources, as is the case with most metalworkers. His work is known only through one example, which betrays the clear stylistic influence of Hu Wenming. Although it is a shallow bowl, a form which to date has found no parallel in Hu Wen-ming's *oeuvre*, its technical and stylistic decoration clearly derives from that impetus. Bearing in mind our conclusions about Hu Wen-ming's wares being produced in a relatively homogeneous style and time frame, we must acknowledge that neither Chu Chen-ming (see either of our two previous catalogues, or "Chinese Metalwork of the Hu Wenming Group") nor Li Ch'i-yün had the Hu family name; and it was specifically reported, perhaps hyperbolically, that he protected his secrets by employing only those of the same name. It is possible that either or both married into the clan, of course. Nonetheless, while Chu Chen-ming's work does seem very closely related in form, style and content to Hu Wen-ming's, that of Li Ch'i-yün gives the impression of being quite out of that mainstream, and quite possibly later. He may have been a copyist rather than a pupil or workshop member. A date of much after the mid-seventeenth century, however, seems unlikely.

148 PARCEL-GILT COPPER LANDSCAPE BOWL

A very rare heavily cast copper shallow bowl of attractive reddish-brown patinated tone, the interior plain, decorated in a band on the exterior within gilded separating bands with a mythical landscape scene depicting immortals; the footrim is also gilded. The Queen Mother of the West rides a crane, emerging from a rocky landscape with a natural rock bridge and *ling-chih* fungus and a longevity peach tree growing from rocks. She rides across the sea, represented by freely engraved waves, under a cloudy moon, to a rocky grotto on a plateau, with large pine trees growing on either side and extraordinary rock formations overhanging the scene, again with *ling-chih* fungus growing from rocks. One sage stands with his staff in the grotto, while the other sits meditatively outside gazing beyond the pines, waves and rocks into infinity as he burns a large container of incense in front of him.

Engraved in stylised *chuan-shu* in a sunken square gilt cartouche in the centre of the foot: Li Ch'i-yün tsao (made). When this bowl, described as a *jardiniere*, was included in the Oriental Ceramic Society exhibition, The Arts of the Ming Dynasty, the signature was read as Li Ch'i-pao.
Early to mid-seventeenth century, probably Ming dynasty.
Diameter: 5 7/16 inches. Height: 1 5/16 inches.

Ex H.R.H. Norton collection, no. 182.
Published: *Transactions of the Oriental Ceramic Society*, vol. 30, 1955–1957, "The Arts of the Ming Dynasty", no. 288.

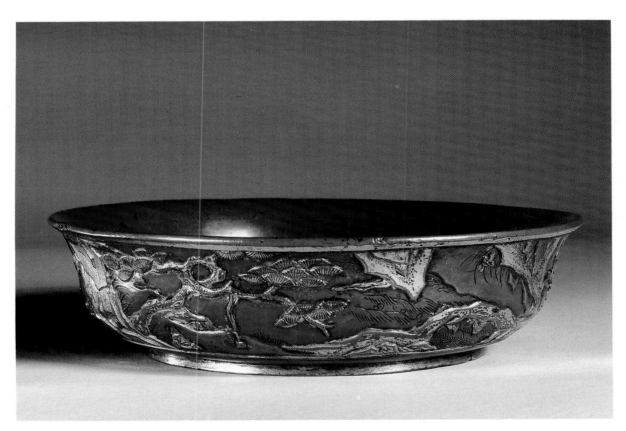

149 INLAID HARDSTONES GILT BRONZE JU-I SCEPTRE

A very rare gilt bronze *ju-i* sceptre cast, worked and polished in natural branch form with nine settings of different sizes for fungus heads. The *ju-i* heads, with the characteristic cloud whorls of *ling-chih* fungus where the stalk joins the head, are inset with jade, agate, turquoise matrix, amethyst quartz and lapis lazuli, finely carved with rounded, unctuous details. An iron ring is fixed through an openwork branch at the foot.

Seventeenth or early eighteenth century.
Length: 13 1/2 inches.

We once owned a rare gilt bronze massager, now in the Robert Blumenfield collection, Los Angeles, which had the same unusual combination of materials and was strongly reminiscent in taste of this item; possibly they came from the same hand or workshop, certainly about the same period. The five separate roller discs of the massager were carved of jade, agate and other quartz hardstones of contrasting colours.

150 IMPERIAL SILVER AND GOLD-INLAID BRONZE JU-I SCEPTRE

A bronze *ju-i* sceptre of simple arched form, slightly tapering towards the head, whose bulbous eye formation is echoed at the foot. The stem is finely inlaid in silver with a diaper keyfret design, within which are medallions enclosing eight symbols, attributes of the Eight Immortals: fan, gourd, scroll, flute, sword, castanets, basket of flowers and lotus flower on stem. In the central medallion a stylised *shou* (longevity) character is inlaid in gold.

The fungus-shaped head is inlaid in thick silver wire with two bats beneath stylised scrolling clouds of bug-eyed design; between them is another gold-inlaid *shou* character. The foot is inlaid in silver with a further bat beneath scrolling bug-eyed clouds, possibly derived from a stylised cicada form.

The reverse is plain but for an unenclosed *hsing-k'ai* silver inlaid inscription in the centre of the stem: Ch'ien-lung nien-chih nei-ts'ao (made in the palace during the Ch'ien-lung period).

The inscription indicates that the sceptre was one of the products of the imperial ateliers in the Ch'ien-lung period. One may speculate that it may have been one of a number of celebratory objects produced on the occasion of the emperor's sixtieth birthday in 1771, but in fact it might have been made at some other time in the Ch'ien-lung period for some Manchu prince, or as an imperial gift.

Eighteenth century.
Length: 16 1/4 inches.

Exhibited: The Oriental Ceramic Society, 1979 exhibition, no. 97.
From the collection of the late K.R. Malcolm.

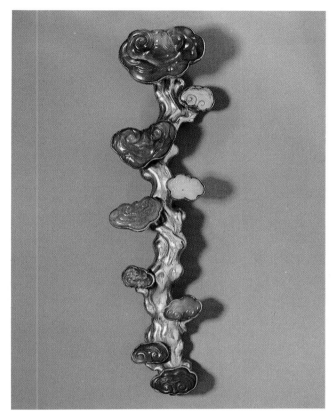

149

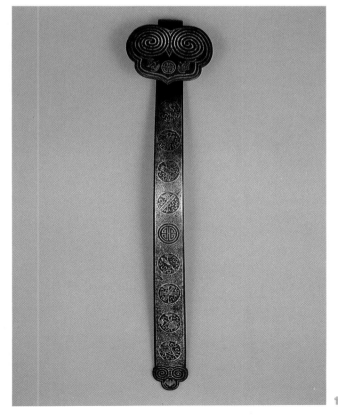

150

297

CHU CHIEN

early 19th century

tzu: Shih-mei.

From Shan-yin (Shao-hsing), Chekiang.

CHU Chien was active in the Chia-ch'ing and Tao-kuang periods, well known as a connoisseur and an artistic innovator with several ingenious ideas. He was the inventor of the 'sand-womb' I-hsing teapot, in which an I-hsing stoneware liner is surrounded by a pewter casing, with the lid knop, handle and sometimes the spout tip of jade. Chu's original models (for an example see *Yixing Pottery*, no. 66), with the pewter casing engraved by him or a contemporary, are quite simple (square, round or moon-shaped) in form, while versions made later in the nineteenth century are made in all kinds of convoluted and ornate shapes. Chu's interest in I-hsing wares extended also to inscribing straightforward stoneware teapots after the impetus of Ch'en Man-sheng; see for example *I-hsing tzu-sha*, nos. 41 (dated 1823, which Chu designed and Yang P'eng-nien potted) and 72. See also the fine 'stone well railing' waterpot inscribed and potted by Chu, illustrated as no. 59 in *I-hsing Ware*.

Chu was also a fine painter of ink prunus with a hoary, antique flavour, and a good seal-carver. He furthermore excelled at engraving (with his 'iron brush', or stylus) on bamboo, stone, copper and bronze, as well as pewter. Apart from teapot engravings, though, his work is rarely found. He died aged 70 *sui*.

151 SILVER INLAID COPPER-BRONZE JU-I SCEPTRE (1849)

A reddish copper-bronze *ju-i* sceptre with sharp, squared end and formalised centre section, concave on the reverse, inlaid in thick and thin silver wire inlay with inscriptions and auspicious designs. The sides are inlaid with a continuous *lei-wen* keyfret, and within the same design on the face of the head are outlined a deer, a peach spray, two bats and clouds. The pentagonal foot is inlaid within a more forceful keyfret with a lotus design. On the upper and lower sections of the stem of the sceptre are inlaid in thick wire two conventional *chuan-shu* longevity wishes; Yen Nien I Shou and Ch'ien Ch'iu Fu Kuei.

The central section is similarly inlaid with a longer inscription:

Made in mid-winter of the *chi-yu* year of the Tao-kuang period (1849), to add to the eminent congratulations on the fiftieth birthday of the master of the Chung-kao hall. The recipient is not recorded.

In the concavity of the reverse of the central section is inlaid in fine silver wire the *chuan-shu* legend: Shih-mei chien-chih [made under the supervision of Shih-mei (Chu Chien)].

Similarly finely inlaid in a square seal within the foot of the sceptre is the seal: Ma Yü-shan ts'ao (made). The previously unrecorded Ma Yü-shan was probably a metalworker commissioned by Chu Chien to make the sceptre to his design, but he may have been Chu's pupil, artist rather than craftsman.

Length: 16 1/4 inches.

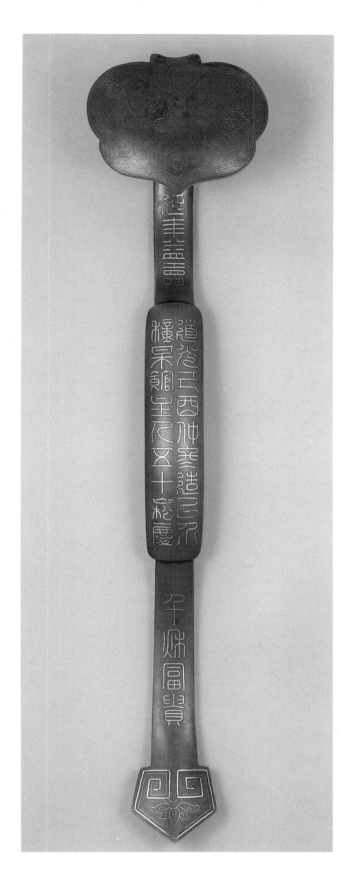

CHAO NAN-HSING
1550–1628

tzu: Meng-po.
hao: Ch'ai-ho, Ch'ing-tu san-k'o.
posthumous name: Chung-i.
From Kao-i, near Peking.

CHAO Nan-hsing was an official and scholar known for his independence of thought, honesty and outspoken behaviour. From youth he was famous for precocity and wit, and his long biography in *Dictionary of Ming Biography* outlines the details of his involved career in the late Ming court. A prominent member of the Tung-lin party, he was in and out of office, spending almost three decades in noble isolation teaching and studying in his home town and returning only in 1622 to serve as a Vice-minister of Works. As soon as he arrived in the capital he was made head of the Censorate, and instituted several measures against corruption and laxity in government. When the eunuch Wei Chung-hsien started in earnest his purge against Tung-lin group members in 1624 Chao was obliged to resign, and was fined and given a light sentence of exile. In his exile Nan-hsing renovated an adobe house and named it Studio of Yellow Bark (bitter medicine). It is said that, when the Ch'ung-chen emperor ascended the throne in October 1627, an order for Chao's pardon was issued, but the governor held up his release, awaiting a document from the Ministry of War; in the meantime Chao died, in January 1628. He was given the posthumous name Chung-i in the same year.

Chao Nan-hsing is known to have supported a metalworker named Chang Ao-ch'un, who made iron *ju-i* sceptres for him, inlaid with silver. One such from the Sedgwick collection, decorated with a *yin-yang* head and constellations and dated 1622, is illustrated in *Chinese Art* vol. 2, pl. 70.

152 SILVER INLAID IRON JU-I SCEPTRE

An iron *ju-i* sceptre of slender, slightly arching form with rectangular handle, thin neck and quatrilobe head, inlaid with silver. The long handle is inlaid on the reverse with constellations, Buddhistic seed syllables and the date: Winter of the *jen-wu* year of the T'ien-ch'i period (1622). The obverse is likewise inlaid with constellations and the *chuan-shu* inscription: Its hook has no barb; it is upright without giving injury. With it sing and dance; if it disapproves it will break. Chao Nan-hsing.

The neck is inlaid with *lei-wen* keyfret and stylised phoenix designs, and the head with a strange winged animal, found in late Ming prints and on Wan-li to T'ien-ch'i dated inks, including one by Fang Yü-lu. The reverse of the head bears an inlaid leaf design and around the head a *chuan-shu* inscription: Made at the capital in imitation of Chao Chung-i's original iron *ju-i*, dated to summer of the thirty-third (*ting-wei*) year of the Kuang-hsü period (1907), to be held and collected by Liu Shih-heng. The recipient Liu Shih-heng (1875–1926), *tzu*: Chü-ch'ing, Ts'ung-shih, a son of the official and diplomat Liu Jui-fen and a *chü-jen* of 1894, was a well-known bibliophile who published a number of works, one on famous dramas and one on the small stringed instruments known as *hu-lei*. See Liu's entries in *Eminent Chinese of the Ch'ing Period* for details.

1907, imitating an original of 1622.
Length: 20 3/4 inches.

The Sedgwick collection *ju-i*, inlaid in gold and silver and signed Chang Ao-ch'un (made to be held and used by one Sun Shen-hsing), presumably a genuine original, is dated to the same year and bears the same inscription by Chao Nan-hsing.

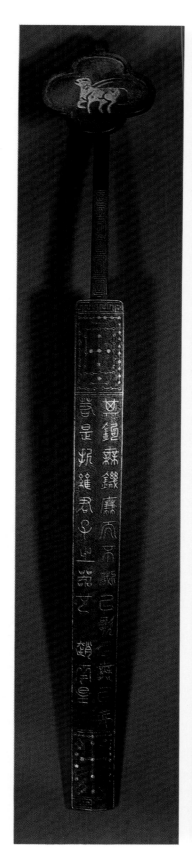

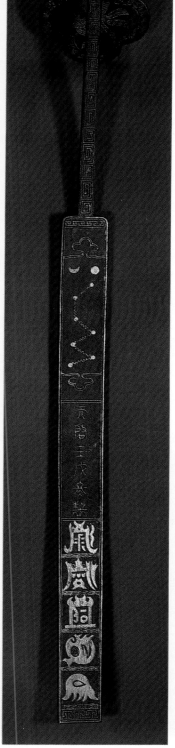

CHANG MING-CH'I

late 16th century
to Wan-li period

Worked in Chia-hsing, Chekiang.

CHANG Ming-ch'i specialised in the making of copper-alloy handwarmers (*shou-lu*) in the late Ming dynasty, although he may also have made some other metalwork forms. We offered a very rare copper-bronze grotesque, almost abstract brushrest by him in *In Scholars' Taste*, as no. 149. He met the greatest of late Ming collectors, Hsiang Yüan-pien (1525–1590), for whose interest in bronze censers and incense see entry no. 142. Hsiang was so impressed with Chang and his work that he encouraged him to move to his home town of Chia-hsing, where he achieved great fame. The relationship of patron and metalworker was later immortalised in poems by the famous Chia-hsing, scholar-poet Chu I-tsun (1629–1709). Chang is also reported to have made a handwarmer with calligraphy engraved around the lip for the famed courtesan and painter Ma Shou-chen (1548–1628? according to some sources she died in 1604; see *Emperor Scholar Artisan Monk*, no. 5). Consequently Chang must have been active at the very latest early in the Wan-li period, and perhaps throughout that long reign — a near-contemporary of Hu Wen-ming, probably a generation older. Traditional miscellanies (gathered in *Chung-kuo i-shu-chia cheng-lüeh*) characterise Chang's work as using copper of a notably even tone, beautifully figured and finely worked, with four feet underneath and entirely worked by hammering, with no inlaid, soldered or cast details. The lids of his warmers are primarily where he expends the extreme finesse of his technical skills; they too are beaten out, leaving no indentation. Moreover, the lids are very strong and tight-fitting; even if used for a long time they will not loosen. In the case of his most marvellous handwarmers, even with coals burning fiercely inside, the body of the vessel with not conduct the heat.

Chang is listed in one or two miscellanies as one of the outstanding craftsmen of the late Ming, in the company of P'u Chung-ch'ien, the bamboo carver; Chiang Ch'ien-li, the lacquer inlay master; and Shih Ta-pin, the great I-hsing potter. Later forgeries of his work were many, but they never penetrated very far into the secrets of his art. In the late Ming his handwarmers were famous nationally, known as *Chang lu*.

Most of Chang's handwarmers bear either the engraved four-character square seal Chang Ming-ch'i chih or a two-character engraved signature in *chuan-shu*, Ming-ch'i. Most of the large numbers of nineteenth-century copies are signed Ming-ch'i; there are exceptions to both of these generalisations. The openwork lids of his warmers, decorated with floral or abstract designs, complement so subtly the simple, restrained forms of the bodies that it is easy to see why aesthetes such as Hsiang Yüan-pien should have approved of them. Of the three completely stylistically distinct great late Ming recorded metalworkers whose works survive in any quantity — Hu Wen-ming, Shih-shou and Chang Ming-ch'i — only Hu's *oeuvre* is fairly safely identifiable. There will continue to be controversy about the works of Shih-sou and Chang Ming-ch'i, debating which pieces were made by the master's hand, his workshop (if there is any difference), later followers and copyists. The only criteria are of quality and of consistency within acceptable guidelines; for example, the traditional observation that his handwarmers stood on four feet proves empirically to be true of only a minority.

153 COPPER HANDWARMER

A very fine and unusual copper-alloy or copper-bronze handwarmer of bulging rectangular form, the material with a hint of 'golden rain' markings and the entirely plain shouldered body, with a locating rim, standing on four hollow L-shaped feet. The domed openwork cover is beaten and pierced with a linear criss-cross design in simulation of woven basketry, slightly undercut at alternate crossings. The pierced area is framed by a narrow plain band with a lipped rim.

153 154 155

153

154

155

Engraved on the base is a short poetic inscription and signature, both in *chuan-shu*: *I don't know when the freezing cold arrives; I am only aware of the return of spring.* Chang Ming-ch'i chih (made).

Chia-ching to Wan-li period, probably late sixteenth century to circa 1600.
Length: 5 inches. Width: 3 3/4 inches. Height: 3 1/4 inches.

From the Dr. Ip Yee collection, Hong Kong.

The following small group of fine warmers represents the first attempt to discuss the field and to publish a representative selection of examples. See Ulrich Hausmann's essay, "Keeping Warm in a Cold Study" at the end of this catalogue.

154 COPPER HANDWARMER

A fine copper handwarmer of bulging rectangular form, with flat base and plain, shouldered sides terminating in an upright mouth. The domed openwork cover is beaten and pierced with a linear criss-cross design in simulation of woven basketry, slightly undercut at alternate crossings and treated slightly differently to either side from the previous example. The pierced area is framed by a narrow plain band with a lipped rim. A single swing handle of rounded rectangular section, hinging on small vertical strips of metal, with a delicate beading is virtually invisibly riveted to the body.

Engraved on the base is the four-character *chuan-shu* seal within a square: Chang Ming-ch'i chih (made). The seal mark on this handwarmer corresponds exactly to that on a fine oval Chang Ming-ch'i handwarmer, without handle, formerly in the collection of Sir Percival and Lady David, sold at Sotheby's London, 14th December 1976, lot 240.
Chia-ching to Wan-li period, probably late sixteenth century to circa 1600.
Length: 5 5/16 inches. Width: 3 9/16 inches. Height without handle: 3 1/8 inches.

From the Dr. Ip Yee collection, Hong Kong.

155 COPPER HANDWARMER

A good copper handwarmer of rounded rectangular form, with gently bevelled footrim, sunken base and plain, shouldered sides terminating in an upright mouth. The flattened openwork cover is beaten and pierced with an intricate diaper design suggestive of flowers, pomegranates or rose-hips and fish, and is framed by a narrow plain band with a lipped rim. A single swing handle of rectangular section hinging on small vertical strips of metal is riveted to the body.

Deeply engraved on the base is the four-character *chuan-shu* seal within a square: Chang Ming-ch'i chih (made).
Late Ming dynasty, late sixteenth century to early seventeenth century.
Attributed to Chang Ming-ch'i's workshop or a contemporary follower.
Length: 5 1/4 inches. Width: 3 7/8 inches. Height without handle: 2 3/4 inches.

156 COPPER HANDWARMER

A fine, small copper-alloy handwarmer of 'super-elliptical' oval form, curving in from a flat base and widening to a bulging, shouldered upper section with locating rim. The very slightly domed, tight-fitting cover is beaten and punched with a most unusual abstract design suggestive of lotus rhizome, or perhaps snowflakes and ice, and is framed by a narrow plain band. The single swing handle of rectangular section is fixed onto protruding hinges, internally joined to the main body; the hinges are probably replacements, but the bamboo cane plaiting around the handle gives every indication of being original.

Engraved on the base is the four-character *chuan-shu* seal within a square: Chang Ming-ch'i chih (made).
Chia-ching to Wan-li period, late sixteenth century to circa 1600.
Length: 3 5/8 inches. Width: 3 inches. Height without handle: 1 13/16 inches.

From the Dr. Ip Yee collection, Hong Kong.

157 COPPER HANDWARMER

A fine, small copper-alloy handwarmer of lobed 'super-elliptical' oval form, the upright sides rising from a flat base and narrowing at the top to form a small locating rim. The domed cover is finely beaten and pierced with a regular design of florettes linked by petal-clusters of circular and oval openings, and is framed by a narrow plain, lipped band. The single swing handle of rounded rectangular section and domed form is held by nail-like protruding hinges, internally secured by rivets.

Engraved on the base is the same convincing four-character *chuan-shu* seal within a square as on the previous example: Chang Ming-ch'i chih (made).
Chia-ching to Wan-li period, late sixteenth century to circa 1600.
Length: 4 1/32 inches. Width: 3 1/16 inches. Height without handle: 2 9/16 inches.

158 COPPER WARMER

A large copper warmer of rounded rectangular form, the upright sides rising from a flat base and narrowing at the top to form a small shoulder. The almost flat cover is beaten and pierced with a design of prunus branches, blossom and leaves on a fishnet diaper ground, the surface area of the prunus enhanced by carefully detailed chasing. A single swing handle of rounded rectangular section is hinged onto long vertical metal strips riveted to the body.

Deeply engraved on the based is the two-character *chuan-shu* signature: Ming-ch'i.
Eighteenth to nineteenth century.
Length: 7 1/8 inches. Width: 5 1/2 inches. Height without handle: 4 1/8 inches.

From the Dr. Ip Yee collection, Hong Kong.

This is a relatively good example of the many later copies of Chang's work.

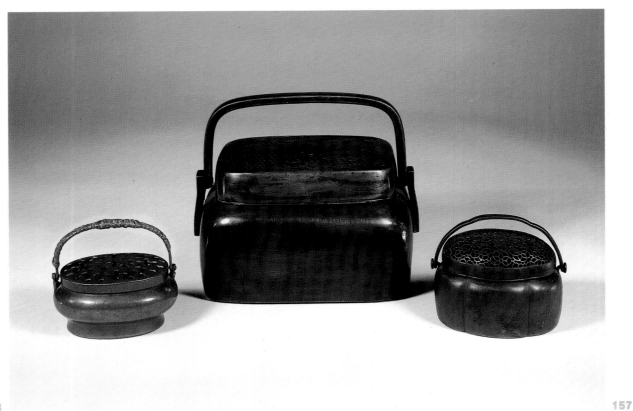

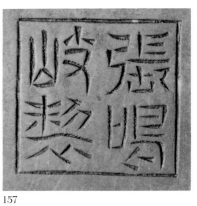

156 158 157

WANG FENG-CHIANG From Chia-hsing, Chekiang.
late Ming dynasty

WANG Feng-chiang is recorded in *Chung-kuo i-shu-chia cheng-lüeh* and other traditional miscellanies as a Chia-hsing maker of copper handwarmers about the same time as Chang Ming-ch'i, whose reputation was not as high as Chang's but whose skill did not yield first place. Handwarmers of his are described: one is only a little over two inches long, rectangular and with the two-character *chuan-shu* signature Feng-chiang underneath; another of which the author has only heard and never, alas, seen, in the collection of a Peking doctor's family, is very finely engraved on the body and bears calligraphy by or for Ma Shou-chen (1548–1604 or 1628); and a third small and rather exceptional example with finely engraved calligraphy like that of Chang Ming-ch'i, is wide on top but sloping underneath, the base with four feet.

159 COPPER FOOTWARMER

A large copper footwarmer of rounded square form, gently curving inwards at the top to form a shoulder with upright mouth. The plain sides bear an attractive green patination. The domed lid is beaten and pierced with an intricate openwork design of circles of different sizes with decoration of florettes and stylised petal and *ju-i* head designs, with interspaces likewise decorated in openwork with an interlocking Y-diaper similar to those used in the pebble-paved areas and lattice windows of Suchou scholars' gardens. The broader bands of the design bear a ring-punched surface decoration within engraved borders. The unusual, complex openwork design gives an effect of great firmness and variety, reminiscent also of textile designs.

The single swing handle, of rectangular section, is hinged on vertical metal strips riveted to the body. The top of the handle is finely inlaid in silver with a long Y-diaper panel incorporating the silver-inlaid *chuan-shu* signature: Tsui-li Wang Feng-chiang chih (made by Wang Feng-chiang of Tsui-li).

In the centre of the slightly sunken base is a four-character *chuan-shu* square seal: Chang Ming-ch'i; presumably added later by someone wishing to enhance the footwarmer, having failed to notice the inlaid signature in the handle which had perhaps patinated almost out of sight. It seems doubly ironic that this typical addition of a famous name should have been visited upon what must be one of the finest works of Wang Feng-chiang, who laboured during his lifetime in Chang Ming-ch'i's shadow.

Late sixteenth to early seventeenth century.
Length at handles: 8 3/4 inches. Width: 8 1/2 inches. Height without handles: 5 1/4 inches.

160 COPPER HANDWARMER

A small brassy copper-alloy handwarmer of 'super-elliptical' oval form without a handle, the sides gently rising from a flat base and narrowing at the top to form a shoulder with upright mouth. The domed cover, framed by a narrow, lipped rim, is beaten and minutely pierced with lozenge-shaped openings, giving it a gauze-like fishnet appearance.

The base is engraved with a four-character *chuan-shu* seal within a square: Wang Feng-chiang chih (made).
Late sixteenth to early seventeenth century.
Length: 3 inches. Width: 2 7/16 inches. Height: 2 1/4 inches.

From the Dr. Ip Yee collection, Hong Kong.

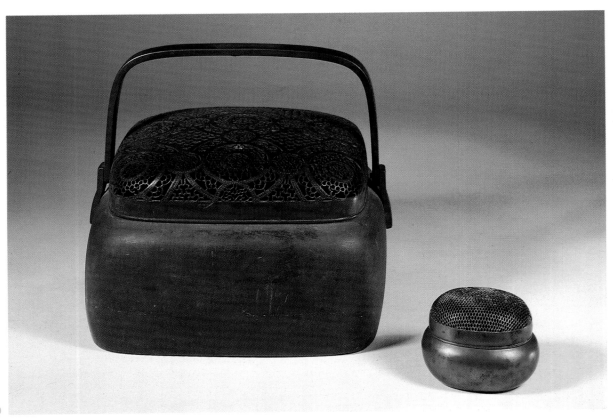

159

160

160

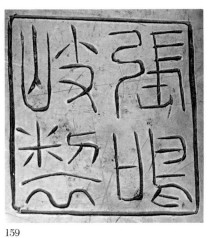

159

159

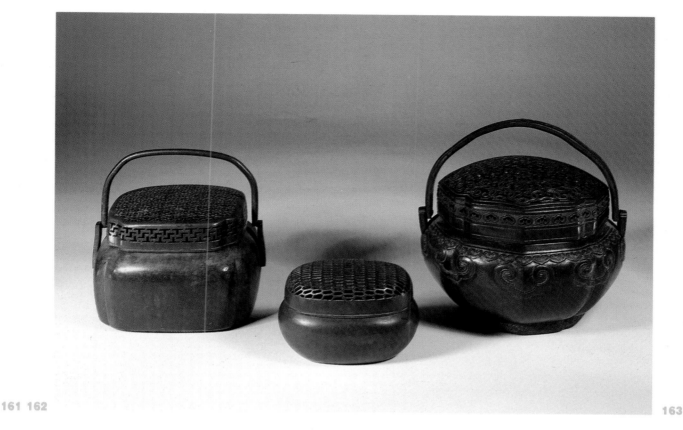

161 COPPER HANDWARMER BY CHU HO-MAO

A good copper handwarmer of rounded square form with indented corners, the sunken base with a bevelled footrim and the plain sides gently curving inwards towards the upright mouth. The very slightly domed beaten and pierced top of the cover is worked with an intricate design of different florettes, giving an impression of airy, formalised lacework. The sides of the cover are pierced with a continuous T and S latticework design. The split rounded handles are hinged on vertical metal strips riveted almost invisibly to the body.

Engraved on the base with the four-character *chuan-shu* seal within a rounded square reserve: Chu Ho-mao chih (made). The artist is not recorded. He seems technically and stylistically derivative of Chang Ming-ch'i.
Probably early seventeenth century.
Length at handles: 5 3/8 inches. Width: 5 inches. Height without handles: 3 7/16 inches.

Among other unlisted makers of handwarmers during their late Ming heyday we may include Wang Yü-yen, T'ien Wen-cheng, P'an Chün-lai and the T'ing-ying chai. An interesting footwarmer craftsman named Ch'en Ju-lin seems likely to date from the eighteenth or nineteenth centuries. Hu Wen-ming also made a small number of parcel-gilt copper handwarmers, one of which we offered in *In Scholars' Taste*, as no. 159. "Chinese Metalwork of the Hu Wenming Group" illustrates three, plus a very large and strange ungilded footwarmer, the first warmer we ever acquired.

162 COPPER HANDWARMER MADE BY THE YUNG-CH'UN T'ANG

A good, small but heavy copper-alloy handwarmer of 'super-elliptical' oval form, without a handle, with attractive patchy liver-red patination around the foot. The plain, gently bulging sides rise from a bevelled footrim, curving inwards towards the upright mouth. The thick domed lid is finely beaten and pierced with a woven or netting-like design of rows of lozenges extending down to the plain frame with its narrow lip. In the interior can be seen dozens of tiny hammering marks.

Strongly engraved in the sunken base is the three character *chuan-shu* mark: Yung-ch'un t'ang (The Hall of Enduring Spring). This hall name is not recorded. It seems more likely to be the maker's hallmark than the studio name of the recipient.
Probably early seventeenth century.
Length: 4 1/8 inches. Width: 3 1/8 inches. Height: 2 1/2 inches.

163 COPPER WARMER BY P'AN HSIANG-LI

A good thin-bodied copper warmer of quatrilobed circular form, on a broad, flat footrim with recessed base. The four main lobes of the body are each further defined by a central rib, resulting in a rounded octagonal shape. Each lobe divider, bulging out from the low foot, is relief decorated with a *ju-i* head cloud collar design and a smaller band of the same relief clouds before curving inwards to form the plain shoulder, which terminates sharply in the upright mouth. The short, upright footrim is also decorated with a relief *ju-i* head cloud collar band on a stippled, ring-punched ground. This hammered and worked relief decoration is initially beaten out from within, as is easily visible on the interior walls of the thin-bodied vessel.

The domed lid is beaten and pierced with a design of intertwining *ju-i* heads, carefully chased and engraved to simulate overlapping and undercutting. A separate openwork band of *ju-i* heads set against a ring-punched background between further defining lines frames the cover.

The split, rounded rectangular shaped swing handles, decorated with ring-punching and engraving, hinge in an internally riveted socket whose external tab is finely engraved with a *ling-chih* fungus and leaves.

The recessed base is deeply engraved in sunken relief with the four-character *chuan-shu* seal within a relief square: P'an Hsiang-li chih (made). The artist is not recorded, but seems likely both technically and stylistically to date from the K'ang-hsi period, or soon before or soon after that time.
Late seventeenth to early eighteenth century.
Diameter: 6 1/2 inches. Height without handles: 4 7/8 inches.

162

161

163

Keeping Warm in a Cold Study: The Warmer

by Ulrich Hausmann

In our modern, centrally-heated world we have largely lost the feeling of intense joy experienced with the advent of spring. In traditional China, the arrival of warmer and lighter days was welcomed by a series of festivities, expressions of the relief felt by young and old alike.

Even in the more moderate climates of central and southern China the winters could become unpleasantly cold, the thin-walled buildings designed for the warm summers giving only little protection from the elements. In the severe climate of the north, keeping warm in winter became a matter of survival rather than mere comfort. Traditionally, the Chinese approach to keeping warm has been an individual one. Due to the chronic shortage of cheap fuel in China, it was not usual to heat entire rooms or houses. It was left up to the individual to eat and drink well, and to wear thick layers of protective clothing — the northern *k'ang*, a large heated bed made from bricks, being only an extension of this idea. Among the people relative degrees of cold were even expressed by direct reference to the number of jackets worn.

At some time in history someone thought of complementing these general measures of staving off the cold by filling small portable containers with burning fuel; thus the feet, hands and face (largely unprotected by clothing) could be kept warm. In keeping with the concept of providing warmth for each individual, these warmers had to be portable and energy-efficient. The date of their origin remains unclear. Primitive forms were probably in use in Neolithic times. The more sophisticated warmers, similar to those under discussion here, which rely on charcoal as fuel, will most likely have been in use before Sung times, although I have never come across a metal warmer of pre-Ming date.

Two main reasons appear to be responsible for the apparent sudden increase in the popularity of warmers: first, the emergence of charcoal, with its excellent weight/energy ratio and its good lighting and burning properties; and second, the manufacture of vessels made of copper and its alloys, with their great strength, durability and superb heat-conducting properties. The demand was clearly there, and as soon as the fuel and the vessels could be produced at affordable prices, a whole industry became engaged in the supply of warmers. By the end of the Ming period virtually all well-to-do households, and many poor ones also, possessed at least one and, quite probably, several.

What may have been just an extra welcome comfort for some became an absolute necessity for one class of the population: the scholars. Quietly engaged in reading, writing, painting or playing musical instruments — often until the early hours of the morning — the scholar would have intermittently hugged his favourite warmer, his eyes following the warm smoke swirling from the darkness of the vessel until it reached the ceiling of his study; occasionally he might have sprinkled a little incense on the charcoal to add a pleasing scent to the sensations already experienced.

I have always been attracted to these utilitarian objects for a variety of reasons. Initially what struck me was the intricate and refined beauty of some of them. On closer inspection and handling, their superb practicality gradually revealed itself — an often perfect answer to the eternal problem of designing something with a specific purpose, in a way that makes it sensible as well as sensuous.

Some of the solutions which I have seen over the years are truly outstanding. Among the warmers brought together for the first time in this exhibition are some of the finest examples of the late Ming period.

DESIGN AND CONSTRUCTION OF WARMERS

It is obvious that without a clear understanding of the design requirements of warmers, we will not be in a position to pass judgement on the merits of individual examples.

A warmer must fulfil a formidable number of demands: it should be strong, yet not too heavy; it should be easy to pick up, yet not dent easily; it should be able to accommodate a large quantity of fuel, yet should not look clumsy; it should be easy to fill and to empty; the fuel should burn well inside it; and the surface of the vessel should remain at a relatively uniform temperature. Above all, it should be safe to handle, that is, it should withstand the temperature of burning charcoal.

The most commonly used metal in the manufacture of warmers was copper or one of its alloys such as brass, bronze or *pai-t'ung* (*paktong*). Great care had to be taken with the less malleable alloys such as bronze and brass which, in order to avoid cracks, had to be heated numerous times while being "raised" ie. beaten. Working these metals when cold produced an extra strong vessel. All examples in this exhibition are raised (although cast examples are known to exist) and appear to be made of copper. The main body of the vessel, including any feet, was raised from a single sheet of metal, in itself a highly-skilled and labour-intensive process. Because of its low melting point, solder could not be used in the manufacture of warmers except on the rare *cloisonné* or *champlevé* examples which have a separate lining to protect the enamel from heat. Rounded shapes naturally favoured by the technique of raising produced a more homogeneous surface and reduced unwelcome tension. This in turn made thinner walls possible, thus minimizing the overall weight of the vessel while retaining its strength. Furthermore, a rounded shape greatly reduced the risk of denting and guaranteed a more uniform surface temperature.

These warmers appear strong and elegant, sometimes as if they are almost bursting with inner energy. Some, cleverly designed in rounded shapes reminiscent of tea or wine pots, look quite small, yet have a surprisingly large inner capacity. (A separate article by the writer entitled "The Divine Curve", discussing these unique shapes will be published soon in *Orientations* magazine). Such shapes are a pleasure to touch and handle; indeed, the smaller warmers were meant to be held for long periods.

Once the body of the warmer had been raised, it was carefully smoothed from the outside and decorated, if so required, by means of engraving, chasing or punching. External decoration of this kind, although widespread in the workshops of the late Ming metalworker Hu Wen-ming, is evident on only one warmer in this exhibition (for another example see *Documentary Chinese Works of Art In Scholars' Taste*, Sydney L. Moss 1983, no. 159).

THE HANDLES

One problem encountered in the manufacture of the main vessel was that of attaching handles. Given the relative thinness of the side walls and the often considerable weight of a warmer once it was filled, this was no easy task. There were two main types of attachments: those entirely attached to the outside of the vessel by rivets, and the concealed ones which were riveted onto the inside. In the concealed attachment, a long narrow strip of metal or pin was pushed from the outside — near the point where the handle should hinge — through a slit into the inside, where it was internally riveted to the side. The handles were either single swing handles, or split handles resting on either side of the lid. Occasionally the attachment as well as the handles was cast, although fixed to a raised vessel. The most successful of these attachments are small masterpieces in ingenuity and precision. Some handles are still as securely fixed by the attachments today as when they left the workshop almost four hundred years ago. In many ways, the handles and their attachments are a hallmark of the quality of the warmer.

THE LID

Invariably the lid was made by the same process as the main body: was cast for cast vessels and raised for raised vessels. It was often considerably narrower than the supporting vessel. Aesthetic considerations apart, this gave the somewhat fragile pierced lid more protection, and provided a surrounding shoulder on which handles could rest unobtrusively without interfering too much with the overall shape. Therefore, if handles were used, the height of the lid was functionally influenced by the narrowness of the vessel: a high lid would not give enough clearance for swing handles. Some warmers, however, were obviously designed to be produced either with or without handles, according to the wishes of the customer. The lids ranged in shape from high-domed ones with extensive openwork to flat-topped ones with sparsely pierced areas. The possibilities were endless.

THE PIERCED LID: THE BATTLE OF YIN AND YANG

At its most abstract, the lid was a perfect stage for the eternal battle of the opposites of *Yin* and *Yang*: the positive remaining areas define the negative areas cut out as much as the cut-out areas define the existing ones. At the threshold of warm and cold, darkness meets light in a truly dialectic way.

As most warmers were placed in a low position, in order that the owner should benefit from the rising heat, and thus were viewed from above, it was no wonder that the openwork design of the lid was treated with such enthusiasm and care by the artisans. For some connoisseurs such pierced lids are most fascinating when on plain supporting vessels.

The repertoire of the creators of these openwork designs seems to have been endless, ranging from entirely abstract designs right through to naturalistic landscape scenes. The former depended almost exclusively on the black and white contrast, the upper surface of the lid not being further decorated. Some semi-abstract designs of openwork may occasionally have received sparing additional surface treatment such as punching or engraving. Landscape scenes, however, often relied on the decoration of the upper surface to such an extent that the openwork itself no longer gave an identifiable picture. In this exhibition examples of lids from all three categories are included.

The openwork designs of the lid were framed by a surrounding band which helped to disguise the inner mouth of the vessel as well as to secure the lid. According to the general shape of the vessel and the lid, great variations were possible; most of the rims ended in a small upturned lip, occasionally in an incised groove, finely distinguishing the lid from the main body. The lip, additionally, acted as a reinforcement — being broader it could be rounded to avoid a cutting edge.

As solder could not be used to correct faults in the openwork of a lid, the slightest lapse in concentration could ruin days, if not weeks, of labour. The piercing of the lid was most probably carried out by transferring a paper matrix of the design onto the raised and smoothed lid before drilling and cutting began. Each tiny opening had to be drilled separately before a narrow file or fretsaw could be inserted, only to be taken out again once the individual opening was cut.

The basic requirement of allowing oxygen to reach the charcoal inside the warmers provided a most welcome opportunity for generations of metalworkers to demonstrate their great skill and to impress with their artistic creations.

Looking at the different openwork designs, many associated areas of design spring to mind. The more abstract ones are closely related to the lattice design so impressively used in China's classic garden architecture. Even the less abstract designs incorporating florets and auspicious symbols like *ju-i* heads or cash patterns share this intimate relationship. Some openwork recalls textile or printing designs, whereas other designs share a distinct feeling closer to that other great folk art of China: silhouette-cutting. Finally, some openwork recalls motifs more familiarly found in garden paving.

On close inspection, it becomes evident that some of these lids are marvels of craftsmanship as well as being important and lively manifestations of contemporary design.

PROBLEMS OF CLASSIFICATION, DATING AND ATTRIBUTION

CLASSIFICATION

The first problem one encounters is that it is sometimes not even clear whether one is dealing with a warmer or an incense-burner. Products of the Chang Ming-ch'i workshop, for instance, are frequently and incorrectly referred to as censers, possibly because some of them are not of the more common square or rectangular shape associated with warmers.

Whatever the answer may be, one should not be too categorical — one is tempted to suspect that at least occasionally these warmers gave off the pleasant scent of incense.

The next question which arises is to decide which specific role each warmer may have played in its environment: were these hand or footwarmers, and how were they used? The very small warmers were carried around either tucked away in clothing or held close to the body (in either case they required a very tight-fitting lid). The medium-sized warmers were placed on tables, benches and shelves nearby and also served as handwarmers. Small feet or padded cushions helped to avoid scorch marks on furniture. The larger ones were undoubtedly used as footwarmers or general warmers to heat a small section of a room. The large square warmer by Wang Feng-chiang in this exhibition belongs to this group. Close inspection shows that the upper surfaces are worn — the tell-tale sign of a footwarmer.

DATING

As in so many areas of later Chinese metalwork, the problem of dating is a difficult one, and it is largely through painstaking research into the production of individual workshops that gradually more general conclusions can be drawn. The dating of warmers is, however, facilitated by certain factors. First, compared with other metalwork, an unusually large proportion of warmers bear a maker's name. This may have been due to the fact that the products themselves were often not sufficiently distinct from those of the many other workshops. Second, the design of the warmers seems to reflect to a large extent contemporary folk design rather than archaistic trends. This may well open up a whole new world of comparative study. It has already been pointed out that some openwork designs of warmers bear a strong resemblance to lattice design. It is possible that a more detailed study of the work carried out in China in the 1920s and 1930s by Professor D.S. Dye (*A Grammar of Chinese Lattice*, Harvard University Press, 1949) will reveal valuable information, especially concerning the much overlooked regional aspects of folk art.

As time progresses both of these factors — the existence of signed pieces and the use of contemporary folk design — will greatly facilitate the task of dating and may eventually help to achieve a more comprehensive understanding of the artistic tradition of the late Ming period. The great problem of dating individual pieces stems from however the very fact that these folk designs *were* so popular and, it is only reasonable to assume, continued to be used until very recently.

The strong feeling for tradition together with the unbroken demand for warmers until recent times makes individual dating of warmers once more a matter of judgment.

ATTRIBUTION

The warmers brought together in this exhibition bear the signatures of five different makers: Wang Feng-chiang, Chang Ming-ch'i, Chu Ho-mao, P'an Hsiang-li and the Yung-ch'un t'ang. The last three of these appear to be unrecorded.

WANG FENG-CHIANG

Very little seems to be known about Wang Feng-chiang. He is listed in the *Chung-kuo i-shu-chia cheng-lüeh*, a list of artists and artisans, as a metalworker of the Ming period.

There are two signed examples of his work in this exhibition: a very small handwarmer without handles (formerly in the Dr. Ip Yee collection) and a large square footwarmer with a handle. The lid design used for the large footwarmer seems to be one of Wang Feng-chiang's favourites. The writer recalls four handwarmers with a very similar pattern, three of which were signed. The design of the lid as well as the sculptural quality of the warmer is superb. The openwork design is unusual, being based on a gradual subdivision of units which are finely connected by wide surrounds. The overall visual impression is one of diminishing units, suggesting almost a spatial dimension. The surface of the openwork is subtly enriched by a variety of floret-type punches. There is a striking similarity to some of the paved areas in the famous Suchou scholars' gardens where multicoloured pebbles were used to create a similar effect.

As the craftsmanship is so outstanding there can be little doubt that the footwarmer, and possibly the small handwarmer also, are works by Wang Feng-chiang or his immediate workshop.

CHANG MING-CH'I

Of all metalworkers of the Ming period engaged in the manufacture of warmers, Chang Ming-ch'i is perhaps the most celebrated. There is a reference in the *T'ao Shuo* comparing him in fame with Shih Ta-pin, the I-hsing potter, and P'u Chung-ch'ien, the bamboo carver, among others. Few details are known about the life of Chang Ming-ch'i. We do know, however, that he lived towards the end of the Ming Dynasty in Chia-hsing Hsien in Chekiang Province, that great cultural centre of the time, southwest of Shanghai and south of Lake T'ai.

It would be interesting to establish whether Chang Ming-ch'i ever became acquainted with his famous contemporary, Hu Wen-Ming, who worked not very far away in Sung-chiang.

Works which can be safely ascribed to Chang Ming-ch'i or to his immediate workshop seem to be rare: the obvious popularity of his products and their almost timeless appeal makes dating very difficult. The writer has seen several almost identical warmers bearing the signature of Chang Ming-ch'i which on closer examination proved to be of a later date. Once again careful scrutiny must be given to many similar pieces before judgement can be passed. Up to now we know very little about the range of products made in the Chang Ming-ch'i workshop. Did he really devote all his effort solely to the manufacture of warmers? Or will we at some point discover hitherto unknown authentic metal objects made by him? In the writer's view this may be possible. Some indication that he may have tried his hand at other art forms besides warmers was given when a small irregular brush rest cast in bronze was found to bear his signature (see *Documentary Chinese Works of Art In Scholars' Taste*, Sydney L. Moss 1983, no. 149).

For the first time several pieces are exhibited here which we can reasonably claim to be either by Chang Ming-ch'i himself or by his immediate workshop.

Technically, these warmers display the skills of a great craftsman. There is one small yet superb detail which may yet prove to be a characteristic of the Chang Ming-ch'i workshop, possibly even an invention of Chang Ming-ch'i himself — the concealed attachment.

The work of Chang Ming-ch'i is not overtly spectacular; the immediate impression one gets looking at this rare group is one of tranquillity, restraint and refined elegance. In the discerning atmosphere of the scholars' world the hidden subtleties gradually revealed themselves and the true sophistication became apparent.

The best work of Chang Ming-ch'i shows a rare combination of an exquisitely developed sculptural sense and an equally pronouced sensitivity for graphic design. The finest pieces of Chang Ming-ch'i reflect these qualities to the highest degree — superbly executed in detail, his warmers achieve the ultimate union of a utilitarian object with an *objet d'art*.

INDEX

BIBLIOGRAPHY

Addiss, Stephen & Wong, Kwan S.; *Obaku: Zen Painting and Calligraphy*, The University of Kansas, Lawrence, 1978.

Barnhart, Richard M.; *Peach Blossom Spring*, Metropolitan Museum of Art, New York, 1983.

Bartholomew, Therese Tsu; *I-hsing Ware*, China Institute in America, 1977.

Beurdeley, Michel, et al; *Chinese Erotic Art*, Fribourg, 1969.

Bickford, Maggie, et al; *Bones of Jade, Soul of Ice: The Flowering Plum in Chinese Art*, Yale University Art Gallery, 1985.

Brinker, Helmut; *Zauber des chinesischen Fächers*, Museum Rietberg, Zurich, 1979.

Brinker, Helmut and Lutz, Albert; *Chinesisches Cloisonné Die Sammlung Pierre Uldry*, Museum Rietberg, Zurich, 1985.

Bunjinga Suihen (A Miscellany of Literati Painting); vol. 7 (Wang Hui, Yün Shou-p'ing), 1979: vol. 9 (Chin Nung), 1976.

Bush, S. & Murck, C. (eds.); *Theories of the Arts in China*, Princeton, 1983.

Cahill, James; *Chinese Painting*, Lausanne, 1960, reprint, 1977.

Cahill, James; *The Compelling Image*, Harvard University Press, 1982.

Cahill, James; *The Distant Mountains*, Weatherhill, 1982.

Cahill, James; "The Early Styles of Kung Hsien", *Oriental Art*, vol. 16 (1970), pp. 51–71.

Cahill, James (ed.); *Fantastics and Eccentrics in Chinese Painting*, The Asia Society, Inc., 1967.

Cahill, James; *Hills Beyond a River*, Weatherhill, 1976.

Cahill, James; *Parting At The Shore*, Weatherhill, 1978.

Cahill, James (ed.); *The Restless Landscape: Chinese Paintings of the Late Ming Period*, Berkeley, University Art Museum, 1971.

Cahill, James (ed.); *Shadows of Mt. Huang*, University Art Museum, Berkeley, 1981.

Cahill, James; "Yüan Chiang and his School", *Ars Orientalis*, vol. 5 (1963), pp. 259–272: vol. 6 (1966), pp. 191–212.

Capon, E., & Pang, M.A.; *Chinese Paintings of the Ming and Qing Dynasties, 14th–20th centuries*, International Cultural Corporation of Australia, Ltd., 1981.

Chan Po-chin (ed.); *T'ien-yin-t'ang Collection: One Hundred Masterpieces of Chinese Painting*, 2 vols., Tokyo, 1963.

Chang Kuang-yüan; "Chang Jui-t'u (1570–1641): Master Painter-Calligrapher of the Late Ming", *National Palace Museum Bulletin*, Taipei, 1981, vol. XVI, nos. 2, 3 & 4.

Chang Wan-li & Hu Jen-mou (eds.); *The Selected Painting and Calligraphy of the Eight Eccentrics of Yangchow*, 8 vols., Cafa Co. Ltd., Hong Kong, 1970.

Chapman, Jan; "The Chester Beatty Collection of Chinese Carved Rhinoceros Horn Cups", *Arts of Asia*, Hong Kong, May-June 1982, pp. 73–83.

Ch'en Jen-t'ao (J.D. Chen); *Notes and Comments on the Paintings in King Kwei Collection*, 3 vols., Hong Kong, 1956.

Ch'eng Hsi (ed.); *A Study of Some Ming and Ch'ing Paintings in the Mu-fei collection*, Hong Kong, 1965.

Chiang Chao-shen; "Wang Yüan-ch'i: Notes on a Special Exhibition", *National Palace Museum Bulletin*, vol. 2, 1967, pp. 10–15.

Chin Shao-fang; *Chu-k'e i-shu* (The art of bamboo carving), n.d.

China Academy; *The Encyclopedic Dictionary of the Chinese Language*, 10 vols., Yang Ming Shan, Taipei, Taiwan, 1973.

Chinese Jade throughout the ages, Oriental Ceramic Society, 1975.

Chinese Literati Paintings from the Jorakuan Collection, Museum Yamato Bunkakan, Nara, 1979.

Chinese University of Hong Kong; *Lok Tsai Hsien Collection of Calligraphy in Couplets*, 1972.

Chinese University of Hong Kong; *Paintings and Calligraphy by Ming I-min from the Chih-lo Lou Collection*, Hong Kong, 1975.

Chinese University of Hong Kong; *Proceedings of the Symposium on Paintings and Calligraphy by Ming I-min*, 1975.

Chung-kuo ni-yin yüan-liu (Chinese seal carvers), Hong Kong, 1974.

Chung-kuo mei-shu-chia jen-ming tz'u-tien (A dictionary of famous Chinese artists), Shanghai Peoples' Press, 1980

Contag, V., and Wang, C.C.; *Seals of Chinese Painters and Collectors of the Ming and Ch'ing Periods*, Hong Kong, 1966.

d'Argence, R-Y. L. (ed.); *Treasures from the Shanghai Museum: 6,000 Years of Chinese Art*, Shanghai Museum and the Asian Art Museum of San Francisco, 1983.

David, Sir Percival; *Chinese Connoisseurship*, Faber & Faber, 1971.

Ecke, Tseng Yu-ho; *Chinese Calligraphy*, David R. Godine, 1971.

Ecke, Tseng Yu-ho; *Poetry on the Wind*, Honolulu Academy of Arts, 1981

Ellsworth, Robert H.; *Chinese Furniture*, New York, 1970.

Ellsworth, R.H. and Link, Howard; *Chinese Hardwood Furniture in Hawaiian Collections*, Honolulu Academy of Arts, 1982.

Ferguson, John C.; *Li-tai chu-lu hua-mu* (Index of Recorded Chinese Paintings of All Periods), 2 vols., Peking, 1934; reprint, Taipei, 1968.

Fong, Wen C. et al; *Images of the Mind*, The Art Museum, Princeton, 1984.

Fu, Shen C.Y. et al; *Traces of the Brush*, Yale University Art Gallery, 1977.

Fu, Shen & Marilyn; *Studies in Connoisseurship*, Princeton, 1973.

Garner, Sir Harry; *Chinese Lacquer*, Faber & Faber, 1979.

Gems from Chinese Fine Arts, no. 10, Shanghai, 1980.

Goodrich L. & Fang C. (eds.); *Dictionary of Ming Biography*, Columbia, 1976.

Gulik, R.H. van; *Chinese Pictorial Art as viewed by the Connoisseur*, Rome, 1958.

Gulik, R.H. van; *Mi Fu on Ink-stones*, Peking, Henri Vetch, 1938.

Harada, Kinjiro (ed); *Chugoku meiga hokan: The Pageant of Chinese Painting*, Tokyo, 1936.

Hedley, Geoffrey; "Yi-hsing Ware", *Transactions of the Oriental Ceramic Society*, vol. XIV, 1936–37, pp. 70–78.

Ho, Wai-kam et al; *Eight Dynasties of Chinese Painting*, Cleveland, 1980.

Hong Kong Museum of Art; *Fan Paintings by Late Ch'ing Shanghai Masters*, 1977.

Hong Kong Museum of Art; *Guangdong Calligraphy*, 1981.

Hsü Shen-yü (ed.); *Hua-yüan to-ying* (Gems of Chinese Painting), 3 vols., Shanghai, 1955.

Huang, C.P. (ed.); *The Collections of Pai Yüan Tang*, Cathay Art Museum, Taiwan, 1981.

Hummel, Arthur M. (ed.); *Eminent Chinese of the Ch'ing Period*, Washington, 1943.

Hyland, Alice R.M.; *The Literati Vision: Sixteenth Century Wu School Painting and Calligraphy*, Memphis Brooks Museum of Art, 1984.

I-hsing tz'u-sha [Purple clay (wares) of I-hsing]; Chugoku Toji Zenshu series no. 23, Shanghai Peoples' Press (printed in Japan), 1982.

Illustrated Catalogue of the Chinese Government Exhibits for the International Exhibition of Chinese Art in London, 4 vols., Shanghai, 1936.

Ip Yee; *Chinese Jade Carving*, Hong Kong Museum of Art, 1983.

Ip Yee; "Notes on a Collection of Chinese Rhinoceros Horn Carvings", *International Asian Antiques Fair Catalogue*, Andamans East International Ltd., Hong Kong, 1982.

Ip Y. & Tam L.; *Chinese Bamboo Carving*, Hong Kong Museum of Art, part I, 1978, part II, 1982.

Jenyns, S. & Watson, W.; *Chinese Art*, Oldbourne Press, Fribourg, vol. 2, *The Minor Arts* (I), 1963, and vol. 4, *The Minor Arts* (II), 1965.

Kei, Suzuki; *Comprehensive Illustrated Catalog of Chinese Paintings*, 5 vols., Tokyo, 1983.

Keverne, Roger; *Bamboo & Wood Carvings of China and the East*, Spink & Son Ltd., London, 1979.

Keverne, Roger; *Ivories of China and the East*, Spink & Son Ltd., London, 1984.

Kokka (An illustrated monthly of the arts of the Far East); Tokyo, 1889.

Komeigen (Famous Old Inkstones); 5 vols., Tokyo, 1976.

Laing, Ellen; *Chinese Paintings in Chinese Publications 1956–68*, Ann Arbor, Michigan, 1969.

Laufer, Berthold; *Insect Musicians and Cricket Champions of China*, Field Museum of Natural History, Chicago, leaflet no. 22, 1927.

Lawton, Thomas; *Chinese Figure Painting*, Freer Gallery of Art, 1973.

Ledderose, Lothar; *Mi Fu and the Classical Tradition of Chinese Calligraphy*, Princeton, 1979.

Ledderose, Lothar, et al; *Palastmuseum Peking: Schätze aus der Verbotenen Stadt*, Berlin, 1985.

Lee Yu-kuan; *Oriental Lacquer Art*, Weatherhill, 1972.

Li, Chu-tsing; *A Thousand Peaks and Myriad Ravines: Drenowatz Collection*, 2 vols., Ascona, 1974.

Liao-ning po-wu-kuan ts'ang-hua-chi (Liaoning Museum Paintings Collection); 2 vols., Peking, 1962.

Lippe, Aschwin; "Kung Hsien and the Nanking School", *Oriental Art*, vol. 2 (1956), pp. 21–29 and vol. 4 (1958), pp, 159–170.

Mei-shu-chia (Artist magazine); Hong Kong, April 1978.

Ming-Ch'ing chuan-k'e liu-p'ai yin-pu (Ming & Ch'ing seal carvers and schools); Shanghai, 1980.

Mino, Y. & Robinson, J.; *Beauty and Tranquility: The Eli Lilly Collection of Chinese Art*, Indianapolis, 1983.

Morgan, Brian; *Dr. Newton's Zoo*, Bluett & Sons Ltd., 1981.

Moss, Paul; *Documentary Chinese Works of Art In Scholars' Taste*, Sydney L. Moss Ltd., 1983.

Moss, Paul; *Emperor Scholar Artisan Monk: The Creative Personality in Chinese Works of Art*, Sydney L. Moss Ltd., 1984.

National Palace Museum; *Catalogue of Wang Hui's Paintings in the Collection of the National Palace Museum*, Taipei, 1970.

National Palace Museum; *Proceedings of the International Symposium on Chinese Paintings*, Taipei, 1972.

National Palace Museum; *Style Transformed: A Special Exhibition of Works by Five Late Ming Artists*, Taipei, 1977.

Okada, Y., & Aoyama, S.; *Bunku Mandara*, Tokyo, 1980.

Osaka-San Francisco Exchange Exhibition; *Paintings from the Abe Collection and other Masterpieces of Chinese Art*, San Francisco, 1970.

Ryckmans, Pierre; *The Life and Work of Su Renshan: Rebel, Painter & Madman*, Paris — Hong Kong, 1970.

Selected Handicrafts, Ku-kung Museum, Peking, Wen-wu Press, 1974.

(The) *Selected Works of Calligraphy and Painting of Cathay Art Museum*, Taipei, 6 vols., 1979.

Selection of Masterworks in the Collection of the National Palace Museum, Taipei, 1974.

Shanghai po-wu-kuan ts'ang-hua (Paintings in the Collection of the Shanghai Museum); Shanghai, 1959.

Shodo Zenshu (New Series); 26 vols., Tokyo, 1954–68.

Shoseki meihin sokan (Collection of Chinese and Japanese Calligraphy); 125 vols., Tokyo, 1964–66.

Siren, Osvald; *Chinese Painting: Leading Masters and Principles*, Lund Humphries, 1956–58.

Sotheby Parke Bernet Ltd.; *I-hsing Wares*, Hong Kong, 24th May, 1978.

Speiser, Prof. W. et al; *Chinese Art*, Oldbourne Press, Fribourg, vol 3, *The Graphic Arts*, 1964.

Su-chou po-wu-kuan ts'ang-hua-chi (Paintings in the Collection of the Suchou Museum); Peking, 1963.

Ti P'ing-tzu (ed.); *Famous Chinese Paintings*, 2 vols., Shanghai, 1939.

T'ien-chin-shih i-shu po-wu-kuan ts'ang-hua-chi (Collection of Paintings from the Tientsin Municipal Museum); 1 vol. and supplement, Peking, 1963.

Tokyo National Museum; *Chugoku no Raden* (Chinese Mother of Pearl Inlaid Lacquer), 1981.

Tokyo National Museum; *Illustrated Catalogues of Tokyo National Museum: Chinese Paintings*, 1979.

Tomita & Tseng (eds.); *Portfolio of Chinese Paintings in the Museum: Yüan to Ch'ing*, Boston Museum of Fine Arts, Boston, 1961.

Transactions of the Oriental Ceramic Society, "The Arts of the Ming Dynasty", vol. 30, 1958; vol. 35, 1965 and vol. 40, 1976.

Tsang, G. & Moss, H.; "Chinese Decorated Gourds", *International Asian Antiques Fair Catalogue*, Andamans East International Ltd., Hong Kong, 1983.

Tsang, G. & Moss, H.; "Chinese Metalwork of the Hu Wenming Group", *International Asian Antiques Fair Catalogue*, Andamans East International Ltd., Hong Kong, 1984.

Urban Council, Hong Kong; *Yixing Pottery*, Hong Kong, 1981.

Waley, Arthur; *An Introduction to the Study of Chinese Painting*, Benn, 1923.

Wang Shih-hsiang; *Ming-shih chia-chü chen-shang* (Connoisseurship of Ming Furniture), Hong Kong, 1985.

Wang Shih-hsiang & Wan-go Weng; *Bamboo Carving of China*, China Institute in America, 1983.

Watt, James; *Chinese Jades from Han to Ch'ing*, The Asia Society, Inc., 1980.

Wen-wu (Journal of Chinese Culture); Peking, 1950–66, 1972.

Weng, Wan-go; *Chinese Painting and Calligraphy; A Pictorial Survey — 69 Fine Examples from the John M. Crawford, Jr., Collection in 109 photographs*, New York, 1978.

Whitfield, Roderick; *In Pursuit of Antiquity*, The Art Museum, Princeton, 1969.

Wong Nan-p'ing (ed.); *Ming-Ch'ing shu-hua hsüan-chi*, Hong Kong, 1974.

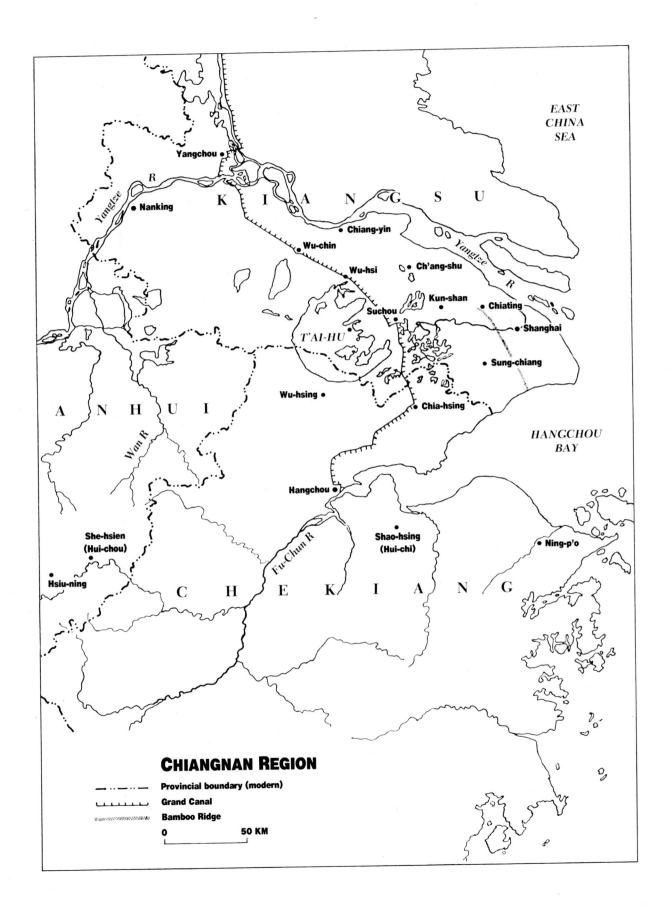

EAST CHINA SEA

K I A N G S U

Yangchou

Yangtze R

Nanking

Chiang-yin

Wu-chin

Wu-hsi

Ch'ang-shu

Yangtze R

Suchou

Kun-shan

Chiating

Shanghai

T'AI-HU

Sung-chiang

A N H U I

Wu-hsing

Chia-hsing

Wan R

HANGCHOU BAY

Hangchou

She-hsien
(Hui-chou)

Fu-Chun R

Shao-hsing
(Hui-chi)

Ning-p'o

Hsiu-ning

C H E K I A N G

CHIANGNAN REGION

— · — · — Provincial boundary (modern)
—|—|—|— Grand Canal
〰〰〰 Bamboo Ridge

0 50 KM